D0908959

THE PICTURE RESEARCHER'S HANDBOOK

N4000
.E8
1975b

THE PICTURE RESEARCHER'S HANDBOOK

*An International Guide to Picture
Sources — And How To Use Them*

Evans, Hilary

HILARY AND MARY EVANS AND ANDRA NELKI

CHARLES SCRIBNER'S SONS
NEW YORK

INDIANA
PURDUE
LIBRARY
OCT 27 1977

FORT WAYNE

INDIANA
PURDUE
LIBRARY
DEC 1 1982
FORT WAYNE

Copyright © 1974 Hilary and Mary Evans and
Andra Nelki

Copyright under the Berne Convention

All rights reserved. No part of this book
may be reproduced in any form without the
permission of Charles Scribner's Sons.

1 3 5 7 9 11 13 15 17 19 I/C 20 18 16 14 12 10 8 6 4 2

Printed in Great Britain
Library of Congress Catalog Card Number 74-19684
ISBN 0-684-14133-7

CONTENTS

ILLUSTRATIONS

Between pages 32 and 33

Woodcut, 1484
Wood engraving, 1887
Line engraving, copper, 1712
Line engraving, steel, circa 1850s
Mezzotint, late seventeenth century
Etching, circa 1850
Aquatint, 1804
Lithograph, circa 1858

All illustrations supplied by the Mary Evans Picture Library

ACKNOWLEDGEMENTS

A book such as this can be prepared only with the co-operation of a great many people. Our thanks are due first and foremost to all the sources who replied to our questionnaire — and especially to those who went beyond its narrow limits and generously offered advice, information and suggestions. Some of the information we requested has not been reprinted verbatim in the individual entries, but has none the less enabled us to establish general notions as to the way sources operate, how they structure and charge their fees, how they tackle the problems of copyright, picture lending, picture copying and so forth. We are very grateful to all who helped us to compile this general material, which we believe will help many to see how they can become more 'professional' without losing their individual character.

We owe special thanks to those sources who went to the trouble of answering our questions, but whom we regretfully felt, for one reason or another, that it would be inappropriate to include in this book. More general thanks to all those individual researchers who have encouraged us throughout the long months of preparation, and helped us to feel that our project was a worthwhile one. We trust they will find that the finished product comes up to their expectations.

Specific thanks to these individuals among so many: *Freda Evans* for her conscientious editing; *Will Glover* of the Granger Collection for his general encouragement and for his highly personal assessment of the American picture scene; *Antoine Tavera* and his friends for their translation skills, also *Hans-Jürgen Jagau; Neil Rhind* and *Bruce Coward* for injecting their professional know-how at crucial moments.

The following active members of the picture business for their special contributions:

Gail Buckland
Colleen Chesterman
Janet Grillet
Renate Hof
Naomi Narod

David Paramor
Judith Schecter
Jennifer Tombs
Frances Vargo

PART ONE

GENERAL

Introduction

INTRODUCTION

Finding illustrations is seldom a simple matter. First, pictures themselves come in a bewildering variety of forms — original paintings and drawings, tapestries and carvings, photographs and transparencies, master engravings of great value and old postcards which have only narrowly escaped the waste-paper basket.

Second, they are to be found in many different situations — in museum files or on library shelves, painted on the walls of caves or hung on the walls of galleries and private homes, drawn on the sides of vases or carved on the bases of monuments. Third, the sources where they are to be found vary enormously in type — from vast national archives to tiny specialist collections, from high-pressure news agencies to austere and leisurely professional libraries. And lastly, even with a particular category, sources differ according to the scope and standard of their service, their expertise and their readiness to help, their convenience and their reliability.

The more a picture researcher knows in advance about pictures and picture sources, the easier the job will be. A bulging notebook, crammed with addresses and comments, is the most vital and valuable tool of the trade. No publication can replace the personalised dossier with its subjective comments recording hard-won experience and knowledge. But this handbook does set out to do the basic work; it contains the essential information which is the starting-point of every research assignment.

For the experienced professional researcher, we provide a basic list of the most important sources with up-to-date information, set out in convenient form. For the casual or inexperienced researcher in need of illustrative material, we present a choice of sources which should be adequate for almost any need — for it does, after all, embody the private lists of a number of experienced researchers who for years have been seeking out, combing and using the world's picture sources. The indexes and cross-references, and the more general introductory chapters, will all prove of value to researchers who need the background information of their trade at their fingertips. It will never be a substitute for personal experience, but it can be a very convenient aid.

A HANDBOOK, NOT A DIRECTORY

This book does not set out to be complete — if it were, it would be too unwieldy for convenience, it would be confusing, and it would be very, very expensive. So we have set ourselves limits. We have excluded museum and gallery sources for which a viable commercial alternative exists or for which outside reference is available; individual photographers whose stock material is limited in scope and easily duplicated elsewhere; sources we believe to be of very limited value, either as regards material or service, and for which reasonable alternatives exist.

This has entailed some awkward decisions, and in some cases we have had ultimately to reject sources who have gone to the trouble of completing our questionnaire; for this we are sorry, but the exigencies of the book leave us little choice. But just because a source is not found in these pages does not necessarily imply that it is worthless; simply that its worth is either very limited or specialised.

The information contained in this Handbook has come to us almost entirely from the sources themselves, by means of questionnaires which were sent to every one of them. Inevitably there will be mistakes, and no doubt some of these will be ours, not theirs; but by and large the information you read here was supplied by the source itself, supplemented where relevant by our own personal knowledge and experience.

An additional word on the choice of entries and the way we have described them: no source paid to be included, and as you see, this Handbook carries no advertising. This was deliberate policy, adopted so that we could feel free to include or exclude solely on merit. No source has been included unless we believed it has a certain value for the researcher.

HELP US TO HELP YOU . . .

This is the first issue of what will, we trust, be a periodic publication, revised and brought up to date at regular intervals. In this first edition, it is inevitable that despite all our efforts, some worthwhile sources will have been omitted; and also that, though in every case we have checked with the source itself, some mistakes will have found their way in.

Please tell us of any such errors and omissions, so that we can correct them in the next edition. We shall of course get in touch with every source before we republish, to check the data; but don't wait till then. We need to keep our records up to date with every change and development which occurs in the interval. So please send us all information, changes of address or ownership, new catalogues and subject lists, and so on.

Finally, two exhortations – *First, to researchers: get to know your sources personally.* True, most of your work can be done perfectly satisfactorily by phone or letter, but you can save yourself a lot of time – and keep the goodwill of the sources on which you depend – if you try whenever possible to go to the right source for the right material. Sources will co-operate much more readily when they feel that a researcher has come to them specifically because they are the right source for this particular assignment. And you as a researcher can achieve this much more efficiently if you have personally visited the source, met its staff, seen the sort of material it contains and the way in which it is arranged. Even the atmosphere of a source can make a difference: some like to be quick, efficient and absolutely businesslike, while others prefer to take things more easily, establishing personal relationships with their clients which can make for more efficient working in the long run.

Second, to sources: a brochure, or better still a catalogue, will help both you and your clients. We were surprised to find that fewer than 50 per cent of sources publish any kind of printed information about their services. Naturally, it isn't always practicable to issue a catalogue or even a typed subject-list; but some kind of leaflet or brochure, giving basic information about the character and scope of the collection, is of real value to researchers, and can help to save you valuable time both in answering inquiries and in ensuring that the right people come to you for the right kind of material.

HOW TO USE THIS HANDBOOK

PART ONE: GENERAL

Sections 1 to 9 contain practical information which can make your job easier, faster, more efficient and more economical. You should at least skim through them to see what information they contain, even if you do not feel the need to study them in detail!

PART TWO: DIRECTORY OF SOURCES

These are listed in two main sections, General and Specialist. You can save a lot of time in your search if you can decide from the start which type of source is likely to be most suited to your needs. Ask yourself:

1 Are your needs relatively straightforward or specialised?
2 If straightforward (eg photo of Eiffel Tower, portrait of Goethe) then one of the general sources is likely to be most convenient.
3 If more specialised, are you looking for a variety of subjects in a given field (eg history of entertainment in the 20th century) or a specific aspect (eg Edwardian music halls in London)?
4 If varied, check if there is a specialist source in that field. If not, try one of the general sources, or consult the subject index.
5 If highly specialised, consult the subject index directly.

Within each section the sources are listed, first by country, then alphabetically within each country. Listing is by surname in the case of personal names (eg 'Bolt, Anne') or by key-word (eg 'Maritime Museum, The National').

Within each entry, information is set out as follows:

1 Name of source
2 Brief description of scope
3 Address; phone; individual to apply to; etc
4 The material — its scope, the period it covers, the approximate number of items
5 Availability — who does the research, how, and when
6 Procedure — how to obtain prints, fees charged, catalogue availability etc
7 Notes on other information

Most of the information was obtained directly from the source by means of a standard questionnaire, supplemented when necessary by further correspondence or personal visit. Consequently most of the facts were supplied by the sources themselves. When sources did not reply to our request, we have printed entries in italic type; this implies that the information is based on personal or secondhand knowledge, and may not be correct. While this does not necessarily imply that the source will not be co-operative to researchers, it does suggest that this could be the case.

Addresses are written in the language of the source, except that the name of the country is in English. We apologise to non-English speaking readers for this, but there is no practical alternative.

PART THREE — INDEXES

1 General Index to subjects referred to in Part One, including general aspects of picture research (eg copyright, rates) and detailed information (eg half-tone process).
2 Geographical Index: providing cross-references to broad regional subjects — eg Topography, History, News etc. It does not include specialist subjects (eg Japanese tramways) which should be traced via the subject index.
3 Subject Index: by looking up any subject, you will be referred to the most practical sources, by number. If you do not find a particular subject listed, it means we know of no specialist source and you should approach a general source.

The Subject Index is planned on the principle of referring from a specific subject (eg witchcraft) to a general subject (eg occult). At first you may find this irritating, but you will find that it cuts down duplication and enables you to locate related fields without having to look up several independent references — thus psychical research and magic will be listed with or adjacent to witchcraft in 'occult'. You will soon become familiar with such general headings as Education, Industry, Transport, etc.

4 Alphabetical list of sources by name.

COMMENT EMPLOYER NOTRE OUVRAGE

PREMIERE PARTIE: GENERALITES

Vous trouverez là des informations pratiques qui peuvent contribuer à rendre votre travail plus facile, plus efficace, ainsi qu'à réduire vos frais. A parcourir, pour vous en faire une idée, même si vous n'éprouvez pas le besoin d'étudier nos suggestions en détail.

DEUXIEME PARTIE: REPERTOIRE DES COLLECTIONS

Deux grandes sections: 'généralistes' et 'spécialistes'. Vous abrégerez vos recherches si vous savez déjà au départ quelle sorte de collection répondra mieux à vos besoins; posez-vous ces questions:

1 Vos besoins sont-ils relativement simples, ou spécialisés?
2 S'ils sont simples (une photo de la Tour Eiffel par exemple, ou le portrait de Goethe), la section 'généraliste' est celle qui conviendra probablement le mieux.
3 S'ils sont spécialisés à quoi vous intéressez-vous: à des questions qui forment un ensemble (disons, par exemple, l'histoire des spectacles au XXe siècle), ou à un aspect spécifique (disons: le music-hall, à Londres, au debut de ce siècle)?
4 Dans le premier cas, faites le tour des 'spécialistes': peut-être l'un d'eux a-t-il ce qu'il vous faut. Sinon, essayez l'un des 'généralistes', ou consultez l'index 'sujets'.
5 Dans le second cas, allez directement à l'index 'sujets'.

Dans chacune des sections, les collections de documents sont classées selon leur nationalité, puis, á l'intérieur de chaque pays, dans l'ordre alphabétique (des noms: 'Bolt, Anne' par exemple, ou des mots-clcl dans les autres cas: 'Maritime Museum, The National').

Pour chacune des collections, voici comment se présentent nos renseignements:

1 Raison sociale
2 Idée sommaire du champ couvert
3 Adresse, téléphone, l'individu à contacter, etc.
4 Etendue de la collection, périodes couvertes, nombre approximatif des documents classés
5 Conditions d'accès: qui s'occupe des recherches, et de quelle facon: heures de travail, etc.
6 Méthodes et conditions de travail: types de copies fournies, d'honoraires demandés, catalogues mis à la disposition du client, etc.
7 Autres remarques

Dans la majorité des cas ces renseignements nous ont été fournis directement, par retour d'un questionnaire adressé à chacun: des échanges de lettres ou des visites sont souvent venus compléter ces informations. Il s'ensuit que, dans l'ensemble, ce sont les responsables des collections qui nous ont fourni la plupart des détails qu'on trouvera ici. Dans le cas contraire, c'est à dire lorsque nous n'avons pas reçu de réponse, nos renseignements sont imprimés en italique: cela signifie que les informations sont indirectes, et peuvent n'être pas exactes. Il ne s'ensuit pas que ces archives docomentaires soient nécessairement peu disposées à vous aider, mais ce pourrait être le cas.

Les adresses sont rédigées dans la langue de leur pays, mais le nom du pays lui-même est traduit en anglais: nous nous excusons auprès de nos lecteurs étrangers, mais c'était là une standardisation nécessaire.

TROISIEME PARTIE: LES INDEX

1 General Index concernant tous les généralités traitées dans notre première partie: méthodologie, aspects commerciaux, techniques etc.

2 Geographical Index: topographie, histoire ou information, pour prendre ces trois exemples, ont en commun un aspect régional: c'est à cet égard surtout que ce second index vous sera utile. Vous n'y trouverez néanmoins de référence à des sujets très particuliers ('tramways japonais' par exemple), pour lesquels il convient de vous référer à l'index par sujets.

3 Subject Index: Cet index vous renvoie aux collections qui vous seront utiles dans tel ou tel cas. Si vous ne trouvez rien pour le sujet qui vous occupe, cela signifie qu'il n'y a pas, à notre connaissance, de collection spécialisée dans ce domaine: il faut alors confier votre cas à un 'généraliste'. Cet index a été conçu de telle façon qu''il renvoie chaque fois de tel sujet spécifique (par exemple sorcelleries) à un autre plus général (par exemple occultisme). Cette façon de faire peut sembler fastidieuse au premier abord, mais elle permet de découvrir d'un seul coup d'oeil d'autres sujets en rapport avec les vôtres: ainsi, spiritisme et magie sont indexés non loin de sorcellerie sous la rubrique 'occultisme'. Des rubriques telles qu'Education, Industry, Transport, vous seront bien vite familières.

4 Liste alphabetique des archives.

TIPS FUER DEN GEBRAUCH DIESES HANDBUCHES

1 TEIL: ALLGEMEINES

Die Abschnitte 1 bis 9 enthalten praktische Hinweise, die Ihnen helfen sollen, Ihre Aufgabe leichter, schneller und ökonomischer zu erfüllen. Selbst wenn man es nicht für notwendig hält, diese Abschnitte genau zu studieren, so sollte man sie doch kurz überfliegen, um welche Informationen sie beinhalten zu sehen.

2 TEIL: QUELLENVERZEICHNIS

Die Quellen sind in zwei Hauptgruppen aufgeteilt: Allgemeine und besondere Quellen. Man spart viel Zeit, wenn einem von vornherein klar ist, welche Art von Quelle man benutzen will.

1 Wenn Sie etwas relativ Einfaches suchen (z.B. ein Foto vom Eiffelturm, ein Porträt von Goethe), dann bedienen Sie sich der allgemeinen Quellen.

2 Wenn Sie verschiedene Aufnahmen zu einem bestimmten Thema (z.B. Geschichte der Unterhaltung im 20. Jahrhundert) oder zu einem speziellen Aspekt (z.B. das Edwardian Varietetheater in London) benötigen, so wenden Sie sich an die besonderen Quellen.

3 Sind Ihre Ansprüche vielfältig, überprüfen Sie, ob zu diesem Gebiet eine Spezialquelle vorhanden ist. Ist das nicht der Fall, so benutzen Sie bitte die allgemeinen Quellen oder bedienen Sie sich des Schlagwortindexes.

4 Für besondere Spezialgebiete benutzen Sie sofort den Schlagwortindex.

Die Quellenangaben in jedem Abschnitt sind zuerst nach Ländern, dann alphabetisch innerhalb des jeweiligen Landes, geordnet. Die Anordnung richtet sich bei Personennamen, nach dem Nachnamen (z.B. 'Bolt, Anne') oder nach dem Stichwort (z.B. 'Maritime Museum, The National').
Jede Eintragung ist wie folgt aufgegliedert:

1 Name der Quelle
2 Kurze Beschreibung des Bereichs
3 Anschrift, Telefonnummer, Kontaktperson, usw
4 Das Material — Bereich, Zeitraum, ungefähre Anzahl der Objekte
5 Verfügbarkeit — wer sucht, wie und wann
6 Vorgehen — wie man Abzüge erhält, Preise, Verfügbarkeit eines Katalogs, etc
7 Anmerkungen über weitere Informationen

Die meisten Auskünfte wurden mittels eines Fragebogens, evtl. ergänzt durch weitere Korrespondenz oder einen persönlichen Besuch, eingeholt. Folglich stammt die Mehrzahl der Informationen von der Quelle direkt. Wenn die Quellen überhaupt nicht reagiert haben, sind die Eintragungen kursiv gedruckt. Das kann bedeuten, dass die Information ungenau oder veraltet ist, was aber nicht ausschliesst, dass man mit der Quelle noch einmal Kontakt aufnehmen kann.

Die Adressen sind in der jeweiligen Landessprache gedruckt. Der Name des Landes ist immer in Englisch. Die nicht Englisch sprechenden Leser mögen dies entschuldigen, aber es gibt keine praktische Alternative.

3 TEIL: REGISTER

1 Das erste Register enthält die im 1. Teil behandelten Themen einschliesslich allgemeiner Gesichtspunkte bezüglich der Beschaffung von Bildmaterial (z.B. Copyright, Preise) sowie detaillierte Information (z.B. Halbtonreproduktion, Rasterreproduktion).

2 Das geographische Register liefert Hinweise zu grossen regionalen Themen (z.B. Topographie, Geschichte etc.) Es enthält keine speziellen Angaben (wie z.B. japanische Strassenbahnen). Diese sollte man mittels des Schlagwortverzeichnisses suchen.

3 Schlagwortverzeichnis: für jedes Thema findet man hier die bestmögliche Quelle. Falls man hier etwas nicht finden sollte, gibt es dafür keine besondere Quelle, und man müsste in den allgemeinen Quellen nachsehen.

Das Schlagwortverzeichnis ist so aufgebaut, dass es vom speziellen Begriff (z.B. Hexerei) zum Oberbegriff (z.B. Okkultismus) verweist. Dies mag zunächst umständlich erscheinen, aber man wird herausfinden, dass man dadurch unnötige Wiederholungen vermeiden und verwandte Themen leichter finden kann, ohne nochmals nachschlagen müssen. So wird z.B. 'Magie' mit oder neben 'Okkultismus' aufgeführt sein. Beim Arbeiten mit diesem Buch wird man bald mit solchen allgemeinen Begriffen wie Erziehung, Industrie, Transportwesen usw vertraut sein.

4 Und Schliesslich gibt es noch ein alphabetisches Quellenverzeichnis.

COME UTILIZZARE IL NOSTRO MANUALE

PRIMA PARTE: GENERALITA'

Le sezioni 1/9 racchiudono informazioni pratiche che contribuiranno a rendere il vostro lavoro più facile ed efficiente, riducendo nello stesso tempo le vostre spese. Vi sarà utile scorrerle, semplicemente per farvene un'idea, anche se non avvertite l'esigenza di approfondirne lo studio.

SECONDA PARTE: FONTI DELLE RACOLTE

Si dividono in due grandi sezioni: 'generalie' e 'specialistiche'. Risparmierete molto tempo, sapendo in anticipo quale delle due fonti risponde meglio alle vostre esigenze. Chiedetevi quindi:

1 Le vostre esigenze sono di carattere relativamente semplice o specialistico?

2 Se sono semplici (per esempio una fotografia della Torre Eiffel o l'immagine di Goethe), vi converrà indubbiamente consultare le sezioni 'generali'.

3 Se sono specialistiche, di che cosa si tratta? di argomenti che formano un insieme omogeneo (a titolo di esempio, la storia degli spettacoli nel XX secolo), o di un settore specifico (ad esempio: il music-hall, a Londra, all'inizio di questo secolo)?

4 Nel primo caso esaminate le sezioni 'specialistiche' forse troverete in una di esse quello che cercate. Altrimenti provate con una sezione 'generale', oppure consultate l'indice per soggetti'.

5 In caso di estrema specializzazione delle richieste, consultate direttamente l'indice per soggetti.

Sia nell'una che nell'altra sezione, le raccolte di documenti sono classificate per nazionalità e quindi, all'interno di questa divisione, per ordine alfabetico (dei nomi: 'Bolt, Anne, per es. o delle parole-chiave, es: 'Maritime Museum, The National').

Ecco come si presentano le informazioni all'interno delle raccolte:

1 Nome o ragione sociale
2 Breve cenno sull'argomento o l'attività
3 Indirizzo, telefono, persona da contattare
4 La raccolta: periodi coperti, numero approssimativo dei documenti classificati.
5 Come accedere alla raccolta: chi si occupa delle ricerche e in che modo, orario di lavoro ecc
6 Metodi e condizioni di lavoro: come ottenere copie, stampati e cataloghi messi a disposizione dei clienti e come sapere l'entità degli onorari richiesti
7 Altre osservazioni

Nella maggioranza dei casi le informazioni ci sono state fornite direttamente, in risposta a un questionario e sono sesso state completate da scambi di corrispondenza e da incontri. Ne deriva che, in generale, sono proprio i responsabili delle raccolte ad averci fornito la maggioranza delle notizie riportate. Nei casi in cui, invece, non abbiamo ricevuto risposta al questionario, le informazioni sono stampate in carattere *italico*: ciò significa che le notizie scaturiscono da fonti indirette e possono essere quindi inesatte. Il che non significa automaticamente che queste fonti di documentazione non siano completamente disponibili; tuttavia una simile eventualità non e da escludere.

Gli indirizzi sono redatti in lingua originale, solo il nomme del paese e tradotto in inglese e ci scusiamo coi nostri lettori stranieri di questa inevitabile standardizzazione.

TERZA PARTE: GLI INDICI

1 Questo indice raccoglie tutti gli argomenti (*Generalità*) trattati nella Prima Parte: metodologia, aspetti commerciali, tecnici ecc. utili alla ricerca dei documenti.
2 Indice geografico: topografia, storia o informazione, per esempio, hanno in comune un aspetto *regionale* ed e da questo punto di vista che questo secondo indice potrà esservi utile. Mancano i riferimenti a soggetti decisamente specialistici (es: tram giapponesi), per i quali converrà consultare l'indice per soggetti.
3 Per *soggetti*: questo indice vi indirizza alle raccolte che vi saranno utili. Se non trovate niente sull'argomento che vi interessa, ciò significa che, almeno per quanto e a nostra conoscenza, non esistono raccolte specialisiche nel campo. Sarà allora necessario indirizzarvi a una roccolta 'generale'.
Questo indice a stato concepito in modo da rimandare sistematicamente da un soggetto specifico a uno più generale (per es: da 'stregoneria' a 'occultismo'). Questo metodo in un primo tempo può sembrare fastidioso, ma consente di scoprire in un solo coplo d'occhio altri soggetti in rapporto col vostro. Cosi per esempio: 'spiritismo' e 'magia' sono posti nell'indice non lontano da 'stregoneria', sotto la rubrica 'occultismo'. Rubriche come Educazione, Industria e Trasporti vi diverranno rapidamente familiari.
4 Il quarto indice, infine, raccoglie l'elenco, in ordine alfabetico, delle fonti.

COMO UTILIZAR NUESTRO MANUAL

PARTE PRIMERA: GENERAL

Los capitulos 1 a 9 recogen información prática que facilitará su tarea y la hará más rápida, eficaz y económica. Se debe hojearlos por lo menos para darse una idea de su contenido, aunque no tenga la necesidad de estudiarlos a fondo.

PARTE SEGUNDA: GUIA DE FUENTES

Las fuentes se dividen en dos secciones principales: General y Especializada. Puede ganarse mucho tiempo en la investigación sabiendo de antemano la clase de fuente que corresponda mejor a sus necesidades. Pregúntese lo siguiente:

1 Sus necesidades: son relativamente sencillas o especializadas?

2 En el primer caso (por ejemplo, fotografía de la Torre Eiffel, retrato de Goethe) es probable que le convenga mejor una de las fuentes generales.

3 En el segundo caso i se trata de una serie de temas dentro de un campo determinado (por ejemplo la historia de los espectáculos del siglo viente) o algún aspecto más específico (por ejemplo, el music-hall en Londres a principios del siglo comiente)?

4 Tratándose de una serie de temas, examínese las fuentes especializadas en ese campo. En caso contrario, pase a una de las fuentes generales o bien al indice de temas.

5 Si se busca un tema estrechamente especializado, consúltese el indice de temas.

Dentro de cada sección las fuentes se clasificán primero por país y después en orden alfabético, apuntándose por apellido si se trata de una persona (por ejemplo 'Bolt, Anne') o por palabra-clave (por ejemplo 'Maritime Museum, The National').

Dentro de cada clasificación los datos se presentan de la sigueinte forma:

1 Identidad de la fuente

2 Breve descripción del campo cubierto

3 Dirección, teléfono y persona a quien dirigirse, etc

4 Material: amplitud, período cubierto, número aproximado de ilustraciones

5 Disponibilidad: quien se ocupa de la investigación, la manera en que se realiza, y horario de trabajo

6 Procedimiento: como obtener las copias, los catálogos puestos a disposición del cliente, honorarios cobrados

7 Datos adicionales

La mayoría de los datos se han conseguido directamente de cada fuente mediante un cuestionario, completado donde hacía falta por correspondencia posterior o visita personal; es dicir que las fuentes mismas han suministrado la mayoría de los datos. En algunos casos donde nuestro pedido de información no ha sido contestado, los datos están redactados en letra cursiva; esto significa que la información se basa en conocimientos personales o indirectos y puede que no sea correcta. Esto no implica automaticamente que la fuente no esté dispuesta a prestar su colaboración, pero puede que sea el caso.

Las direcciones están redactadas en el idioma original de la fuente, menos el nombre del pais que por razones prácticas está en inglés, cosa que esperamos nos perdonen nuestros lectores extranjeros.

PARTE TERCERA: INDICES

1 Indice General de los temas tratados en la Parte Primera, incluyendo aspectos legales, comerciales y técnicos de la investigación.

2 Indice Geográfica, con referencias segundarias a temas regionales más amplios, por ejemplo, topografía, historia, información, etc. Sin embargo no incluye temas especializados (por ejemplo los tranvías japoneses) que deben buscarse en el indice de temas.

3 Indice de Temas. Bajo cada título se encontrará una referencia por número a la fuente más apropiada. Si no se encuentra un tema determinado en el indice, esto significa que no conocemos a ninguna fuente especializada y habrá que dirigirse a una fuente general.

El Indice de Temas se basa en el principio de dirigirle al investigator desde in tema específico (por ejemplo brujeriá) hasta un tema general (por ejemplo ocultismo). Al principio puede que resulte molesto este sistema pero pronto se dará cuenta de que facilita la localización de campos relacionados al tema de interés principal sin tener que buscarse varias referencias independientes. Por ejemplo, el espiritualismo y la magia se clasificarán junto con la brujería, bajo 'ocultismo'. Se familiarizará rápidamente con los encabezamientos generales como Educatión, Industria, Transporte etc.

4 Lista alfabética de fuentes nombradas.

2 THE TECHNIQUES OF ILLUSTRATION

HOW PICTURES ARE MADE AND HOW THEY ARE REPRODUCED

How a picture is made is generally of little concern to the researcher; but how it will reproduce is of great importance. And the second depends largely on the first. The researcher who has a few general notions about how pictures are made in the first place, and how they will reproduce in the second, will be better able to choose the most effective illustration for any specific purpose, more expert at identifying and dating material, and more appreciative of its quality and character.

The notes in this section will not turn you into an expert on the techniques of illustration. They have been kept short, simple, and above all practical. The information they contain will help you to understand pictures better — and that is certainly one aspect of what picture research is all about.

An illustration originates in one of two forms:

1 As a one-off item, such as a printing or a drawing. In this case it must pass through a second stage (copying or photographing) in order to be reproduced.

2 As a print or a photograph, specifically designed for reproduction.

Both types of material are to be found in the picture sources listed in this handbook. Thus a big national archive like the Bibliothèque Nationale will possess hand-illuminated manuscripts, drawings, paintings and the like, of which only one example exists in the world. You will almost certainly not be allowed to borrow such an item, but will be supplied with — or will be allowed to make your own arrangements to make — a copy. Before the invention of photography, this would have meant a print of some kind; today it simply means making a photograph.

At the same time, such an archive is also likely to possess material in forms intended from the outset for reproduction — prints, photographs, and so on. These may or may not be rare; if they are not, you may be allowed to borrow them; if they are, once again you will have to accept copies. But now a new factor must be considered: such material is not necessarily exclusive to that particular source — it is possible that the same item may be found in two or more collections. In this case, you will have to decide which source you want to use — a decision based on cost, the time taken to make copies, the convenience of the location, the facilities of the source and so on — the section on Types of Source will guide you in this respect.

The bulk of historical illustration consists of prints — by which is meant pictures reproduced by one or other of the many techniques evolved over the six centuries since printing was invented. The history of illustration over those six centuries has been one of continued experiment, trying to devise more and more sophisticated ways of reproducing pictures in order to provide maximum information or achieve maximum impact.

Each has its own characteristics — and each its own value, for increased sophistication in one respect usually means loss in another. The force and clarity of a 15th century woodcut was not surpassed by the elaborate wood engraving of the 19th century; it was simply that the later form offered a different set of qualities, better in some respects, worse in others.

If you want to know more about prints than is given in the notes which follow, the following books in English may be found helpful as a general introduction. Beyond them are thousands more, describing specific techniques in greater detail.

John R Biggs, Illustration and reproduction, Blandford Press, London, 1950
Hilary and Mary Evans, Sources of illustration, Adams & Dart, Bath, 1971
Therle Hughes, Prints for the collector, Lutterworth Press, London, 1970

'ONE-OFF' ITEMS

This category comprises a diversity of techniques. Those most commonly met with are: drawings and sketches; paintings of various kinds; illuminated manuscripts; tapestries; sculptures, carvings, medals; other three-dimensional objects such as vases, plates, monuments, etc.

For the purposes of illustration, all these must be photographed. If the illustration is to be in monochrome, this is simply a matter of obtaining a print. If it is to be in colour, you have a choice between:

1 *transparency* — convenient to handle; can be viewed in its true colours; but can be duplicated only by costly and awkward re-photography.
2 *colour negative* — difficult to evaluate, because colours are false (this doesn't matter if you know the original); costly to make prints from; but has the advantage that any number of prints can be made from it.

Any picture source which possesses one-off items which it makes available to the public, usually operates some kind of photo-copying service, or is prepared for you to make your own arrangements. (Wherever possible, we have tried to indicate the situation for each specific source in the entries for this handbook.) In addition, many archives — the Bodleian Library at Oxford is a good example — have built up a considerable collection of immediately available transparencies of the material most in demand, which is a great help to the researcher who should always collect the catalogues of such sources as a basic research tool.

PRINTS

For about five centuries between 1400 and 1900, virtually all illustration took the form of prints — that is to say, copies which were taken as required from a 'master' of some kind.

Prints differ according to the technique whereby the master is prepared. All have one factor in common; their image is created by the contrast between those parts of the surface that are printed and those that are not.

This contrast is achieved by using masters of one of three kinds:

1 *Relief* — in which the surface is cut away except for the image which is to be printed. The projecting areas are then inked and pressed onto paper.

12

2 *Intaglio* — in which the image is cut into the surface, leaving the rest untouched. The cuts are filled with ink which is transferred onto the paper when the block is pressed onto it.
3 *Flat-surface* — in which the image is distinguished from the rest by treating the surface with a material so that some areas can be made to hold ink while others repel it.

The most important types of print are: *Relief*: Woodcut; Wood-engraving. *Intaglio*: Line-engraving, copper or steel; Mezzotint; Etching, Aquatint. *Flat-surface*: Lithograph.

WOODCUT

Woodcuts date from the 14th century, though examples from before 1500 are rare. They are usually bold and simple in character, with little detail but strong overall effect. They are made by cutting away the surface from a block of wood, leaving only ridges which form the lines of the image when the block is inked and pressed onto paper.

Because they were in relief, woodcuts could be printed at the same time as the text of a book, since type-matter also is in relief. This was a great advantage from the printer's point of view. However, the woodcut gave the artist very limited freedom of expression, even though a master like Dürer could achieve remarkable subtlety. Consequently, after about 1550, the woodcut was superseded for most purposes by the copper engraving, and was used chiefly for popular printwork, such as ballads and broadsheets, where subtlety was not important.

WOOD-ENGRAVING

A wood-engraving is essentially the same as a woodcut; the difference stems from the fact that the harder end-grain of the wood is used, and usually a harder wood in the first place. This requires a different technique on the block-maker's part: he has to engrave, rather than cut. Though this takes longer and is harder work, it gives him greater freedom in handling his material and allows him to achieve more subtle results.

Wood-engraving was evolved only towards the end of the 18th century; it rapidly become popular in the 19th century because it meant that high quality illustrations could be printed alongside type-matter — an important factor in the revolution in cheap reading-matter which occurred at this period. Wood-engraving made possible periodicals like *The Illustrated London News, l'Illustration* or *The Scientific American*, and copiously-illustrated school and technical books.

The majority of 19th century illustrations are wood-engravings. In practice it is not easy to distinguish a wood-engraving from a woodcut — nor, indeed, is it very important to be able to do so, for this is really only a technical matter. One sign is the presence of white lines, which are hard to achieve in a woodcut but relatively easy in a wood-engraving. They are very noticeable in the marvellous engravings of Thomas Bewick, who was artistically the greatest of all wood-engravers. However, it is in the later developments of the technique, as exemplified by American magazine illustration towards the end of the 19th century, that the full potential of the wood-engraving was realised.

LINE-ENGRAVING — COPPER

Line-engraving in metal was introduced in the mid-16th century to give the illustrator more flexibility than the woodcut allowed him. The earliest line-engravings retained much of the formality of the woodcut — only gradually did engravers realise the potential of their medium and develop it into the form which was to dominate illustration through the 17th and 18th centuries.

Copper plates were generally used, because they combined a reasonable degree of softness for the engraver to work in with a reasonable degree of hardness for the printer to be able to take sufficient copies before the lines began to thicken. The engraver gouged his lines freely through metal, and the lines held more or less ink depending on how widely or how deeply he gouged them, producing a bold or a delicate image accordingly.

Basically, a line-engraving is made up of lines; but skilful engravers were soon using dots and scratches of all kinds to achieve distinctive stipple effects or even textures so subtle that they can be mistaken for chalk drawings. The great majority of prints made between 1570 and 1820 are copper line-engravings; the diversity of styles to be found is a tribute to the flexibility of the medium.

LINE-ENGRAVING — STEEL
Engravers started to use steel about 1820. The fact that it was harder to work than copper was balanced by the fact that many more prints could be taken by the printer before the block started to deteriorate. But, as always, the technical aspects of the change were accompanied by artistic ones: the harder metal made possible finer lines, allowing the engraver to achieve remarkable subtleties of light and shade. So we find the process leading on the one hand to precisely detailed architectural and mechanical illustrations, on the other to highly finished landscapes and romantic scenes. In addition, faithful if somewhat lifeless copies of portraits and well-known paintings were turned out by thousands between 1820 and 1870, and copper went out of use almost entirely.

It is usually fairly easy to distinguish a steel engraving from a copper engraving; the far greater detail is usually sufficient indication. On the negative side, steel engravings usually lack the expressiveness and individuality that the copper engravers achieved with the softer metal. If an engraving is bold, clear and tending towards the crude, it is generally copper; if it is fine, subtle and tending towards the lifeless, it is generally steel.

MEZZOTINT
The mezzotint was a brave attempt to produce a print which would imitate a painting by being made up of areas of light and shade rather than lines and dots. It was in fact made up of lines and dots — but you'd hardly know. It was made by first roughening the entire surface of a metal plate, then scraping away the resulting 'burr' to a greater or lesser degree. Where the burr was lightly scraped, it would still hold a fair quantity of ink and so print dark; where it was heavily worked, it would hold less ink and so print light.

The technique was laborious in the extreme — but often very effective, producing prints which have their own unique value as works of art. The mezzotint was in regular use, particularly for copies of painted portraits, from its introduction around 1650 until about 1850. It is usually easy to recognise by its soft texture and its lack of sharp lines; but be on your guard — for lines were sometimes added to a mezzotint at a later stage, to give special effects.

ETCHING
Etching is basically a kind of metal engraving which involves two-stage working rather than one, indirect rather than direct. The etcher cuts, not into the metal, but into a coating of soft resin which has been laid over the metal. Then the plate is dipped into acid, which cuts into the metal only where he has exposed it.

By varying the time of this acid treatment, he varies the depth of the cut and consequently the weight of the resulting line. The technique is, if anything, even more laborious than that of the mezzotint; but, once again, substantial advantages are the reward. From the working point of view, the etcher has the advantage of working in a very soft medium; this gives him far greater flexibility in the way he creates his image. Etchings are consequently distinguished by their freedom and their individual expressiveness, which can often include a wide range of texture within a single illustration. These considerations have meant that etching has been used more for artistic effects than for practical illustration; but a number of important illustrators — two notable examples are Callot and Hollar in the 17th century — used etching to achieve their distinctive personal styles.

AQUATINT
The aquatint was another attempt to simulate flat areas of tone, this time exploiting the techniques of etching. A metal plate coated with acid-resisting resin is heated, which causes the resin to coagulate,

leaving gaps between the particles. Acid is allowed to bite into these gaps to a greater or lesser degree by stopping-out selected areas with acid-resisting material as required. Thus, some areas can be left almost unbitten — to print dark; while others are bitten deeply or scraped away completely — to print light or even bare. Etched lines are frequently added to give greater definition.

Aquatints have a characteristic stippled texture which is usually easy enough to identify — though stipple engravings, a deliberate attempt by copper engravers to achieve similar effects by their own means, can cause confusion. Aquatints were generally printed in pale sepia ink, another distinguishing characteristic.

Aquatints are well adapted to the reproduction of water colours, and it is no accident that the vogue of the aquatint corresponds closely to the great age of the water-colourist — that is, the first decades of the 19th century. The finest examples tend to be landscapes, but portraits and most other forms of illustration made some use of the medium. Because the technique was so tedious, the aquatint was largely superseded by the lithograph; but at its best it was able to produce effects which no other form of print could achieve.

LITHOGRAPH

Many flat-surface techniques of print making have been attempted; the lithograph is the only really successful one. It has the great merit that no intermediary process has to come between the original and the print; the drawing is made or transferred directly onto the stone or zinc plate, using a water-repellent chalk or ink. When the stone is dampened, the drawn areas repel the water while the rest holds it — when the stone is subsequently inked, it is the wet parts which repel the ink while the drawn parts hold it for printing.

The lithograph is thus able to reproduce the exact texture of a pencil, chalk or ink sketch; a good lithograph is easily mistaken for a drawn original. The technique was very popular for all kinds of illustration throughout the first half of the 19th century, being particularly favoured for the reproduction of eye-witness sketches of such subjects as the Indian Mutiny or the War in the Crimea. Though unsuited to fine detail, the lithograph has an immediacy and vividness which no other form of print can offer.

COLOURED PRINTS AND COLOUR PRINTS

Before about 1840, virtually all prints containing colour had that colour added by hand. Usually it was painted on freely in water-colour, but sometimes stencils were used to speed up the process — over-tidy edges often betray when stencils have been used. Another method, though rarely used, was to dab the printing plate itself with patches of colour before each impression was taken, the result being more or less precise according as more or less care was taken. Such methods could be used on any kind of print; the results should be termed 'coloured' rather than 'colour' prints.

The first practicable successes in true colour printing were achieved around 1835, though to begin with colour-printed books tended to be costly rarities, chiefly decorative or artistic in nature, seldom containing illustrations of the kind we are concerned with. The new processes were used in combination with relief blocks, either wood or metal, or with the lithograph; in each case the basic principle was the same — additional colours were added one at a time by re-printing with a separate block. Different printers had their own methods; thus Baxter in England used both metal and wood blocks on a single print, and gave it between 10 and 20 printings to achieve the richness he wanted. There was such fierce competition between printers that processes were kept secret and their details often died with them; today it is often difficult if not impossible to tell how a particular print was made.

From 1850 on, colour printing from wood blocks was a busy industry. Magazines like *The Illustrated London News* used it for special plates, and countless gift books and children's books were published, some delicately coloured, others splendidly gaudy: German printers were particularly noteworthy in both categories.

15

Similar processes were based on lithography. First came the lithotint, in which one or two extra plates were used to lay large areas of fairly neutral tone — buff and grey, for example — over the black and white print. Sometimes, as with Simpson's *Views of the seat of war in the East* of 1855/6, a book was published in two forms, one with simple lithotints, others with additional colour added by hand.

Soon, however, the chromolithograph was developed, in which all the colours were added by successive printings. The use of heavy oil inks led to the richly coloured 'chromos' so characteristic of late 19th century printing.

It is not important to anyone but the specialist to be able to distinguish between these various processes. But one basic fact *is* important to keep in mind: any colour print dating from before 1840 has almost certainly been coloured by hand. It can be important to know whether the colouring was done at the time or added at a later date to make it more attractive. Unfortunately, there is often no way of telling; and guesswork is not made any easier by the fact that contemporary and later colouring alike can be either crude and gaudy or subtle and tasteful.

MODERN REPRODUCTION TECHNIQUES

Until the end of the nineteenth century, virtually all books were printed by letterpress, which in practice meant that unless illustrations were wood-engravings, which could be printed together with the type-matter, they had to be printed separately and bound-in expensively.

Then, from the 1890s on, a series of technical advances introduced new mechanical processes. First came photo-mechanically produced relief blocks — the line block for line illustration, the half-tone block for paintings, photographs and other illustrations containing areas of tone. The half-tone block was to dominate the printing of illustration for many decades, but in the course of time rivals appeared, based on the other print reproduction techniques of the past. Today there are three main processes, each of which can be seen as a translation into modern mechanical terms of an old printmaking technique. The relief block (woodcut or wood-engraving) led to the line and half-tone block; the intaglio plate (engraving, mezzotint, aquatint) led to photogravure; the flat-surface plate (lithograph) led to offset litho.

HALF-TONE AND LINE BLOCKS

Simple line illustrations are easily reproduced by processing them into line blocks, the modern equivalent of the old wood-engraving; the main difference is that today such blocks are photo-mechanically produced. There is no question of drawing onto the block by hand: the drawing is photographically transferred to the block and then mechanically cut.

The half-tone block extends this technique to illustrations which contain areas of tone. A screen placed over the original reduces the image to a mass of tiny dots, whose varying density creates darker or lighter effects. The finer the screen, the greater the subtlety, the greater the precision with which the original is reproduced; on the other hand, a fine screen block must be printed on a correspondingly high quality paper.

The fineness of screen ranges from some 150 lines to the inch (as might be used in an art book or glossy magazine) to 55 (for a cheap newspaper). In the hands of a skilled printer, half-tone reproduction can be superb, but it can also be responsible for some of the worst printing ever seen. Inevitably, much of the original is lost, however fine the screen; and there is the further drawback that any subsequent attempts at re-reproduction (as might be necessary, for instance, if the original photograph had been lost — this happened to a great many photographs during World War Two) will be inhibited by the screen. On the other hand half-tone, being a relief process, achieves a sharpness and strength which the rival processes rarely achieve.

PHOTOGRAVURE

This process is in effect a sophisticated form of intaglio print, made by taking up ink from cuts in the plate; the difference is that here the cuts are artificially made, being a series of pits cut into the plate in

regular rows, their varying depth creating the darker or lighter shades. The creation of the image is effected by a screen as with the half-tone; but here 150 to the inch, which is regarded as fine for a half-tone, is normal for gravure, so that any piece of gravure work will have the fineness of texture associated only with the finest half-tones.

On close examination the network of fine white lines left by the ridges between the pits can often be seen; but by choosing the right paper and ink, the printer can generally ensure that the image seems to spread continuously across the paper. This effect is of course illusory, the detail having in fact been lost between the pits just as in the half-tone it is lost between the dots; nevertheless the overall effect is smoother.

Another advantage of gravure is its high degree of contrast, caused by the fact that the darker areas are in fact more heavily inked than the others, whereas in the half-tone the ink is always the same thickness, just more or less widely dispersed. Gravure can be combined with type-matter, but the loss of crispness is noticeable; so the process is generally reserved for popular books and magazines where the pictures matter more than the words.

OFFSET LITHO
This is an elaborate version of the lithographic process. The image is photographically transferred onto the plate as in the lithograph; a roller takes up the ink and so transfers the image to the paper. Just as the lithograph avoids the interpolation of engraver, so offset litho avoids the artificial breaking-up of the image into either pits or dots, and gives a genuine continuous tone, without loss of detail.

In the past, the drawback of litho has been that it gives a soft overall effect, without the strength of impression of the relief block or the high contrast of gravure. But a great deal of development has taken place in offset litho in recent years, and it is widely considered to be ultimately the most promising method of printing illustrations.

SILK SCREEN
Although not a serious competitor with the three forms of reproduction just described, as it is not practicable for normal book printing, silk screen is widely used for posters and for three-dimensional objects such as cans. It is a form of mechanised stencilling — ink is forced through unmasked areas of a silk mesh to form a continuous printed area which gives strong solid effects, particularly when printing in colour.

COLOUR PRINTING
All these process can be employed for colour printing, by the use of additional plates for each colour. Here again, considerable technological advances have been made of late, exploiting the science of colour to achieve more effective results with the minimum of printings.

TIME-CHART OF ILLUSTRATION TECHNIQUES
The chart shows the approximate time-span during which each technique was significantly in use. A dotted line indicates that the process is still being used, but chiefly by amateurs for aesthetic rather than commercial applications.

	1400	1500	1600	1700	1800	1900
Manuscript	*******************					
Woodcut		*****************************				
Etching			************** ..			
Copper engraving			**********************************			
Mezzotint				**********************		
Aquatint				*************		
Wood engraving					******************	
Lithograph					***************	
Steel engraving					*********	
Photograph						******************

3 PHOTOGRAPHY: A BRIEF HISTORY

For most of the last hundred years, photographs have provided the most important source of visual documentation. But while today we take it for granted that photographs will answer almost every illustrative purpose, this state of things has been achieved only in successive stages. For the picture researcher it is important to know what *kind* of photographs were being made during each period; so a general notion of the historical development of photography is an important background aid to picture research.

This highly concentrated version of the history of photography is not, needless to say, intended for serious students. They can hardly do better than study Helmut and Alison Gernsheim's excellent *The History of Photography* (Thames & Hudson 1969) which contains some 600 pages of detailed information. What this chapter aims to do is summarise the development of each form of photography in general terms, and serve as a guide to what you can expect to find as a photographic legacy from the different periods of that development. The dates are intended only to be approximate, to give you a general sense of what you can expect to find. Thus, if you are asked, say, for colour photographs of Hitler, you can quickly check the chart and see that though colour film was around in the 1930s, it was not in common use, so that while there may indeed be colour photographs of Hitler, they are not going to be easy to trace.

THE PREHISTORY OF PHOTOGRAPHY

The *camera obscura* (Latin for 'dark room') was the original ancestor of photography, and its name is still applied to our modern equipment. Originally it consisted of a darkened chamber, with a small aperture in one wall through which the image of an external, brightly-lit object or scene would pass, to form a picture on a screen placed parallel to the aperture. The device was mentioned by Aristotle in the 4th century BC, and used periodically after his day; in the 14th century the method was being used only for observing solar eclipses, but two centuries later it was noted that the device was suitable for the observation of any brightly-lit external object.

Improvements were made, and by 1685 a fairly sophisticated portable box had been manufactured, with reflex lens and adjustable focus. The camera was ready — but the photochemicals, which would

enable the image to be made permanent, were not. And so the camera obscura became a plaything of 18th-century society, a sideshow at fairs; its only practical application was for commercial artists, who found it a useful aid to perspective drawing and portrait-making.

In 1725 a German scientist noted the interesting discovery that silver nitrate turns black when exposed to sunlight. Further experiments recorded that light reflected from mirrors or plain white walls had the same effect. Apart from such games as 'secret writing' (which could be made to appear in sunlight as if by magic) the crucial discovery found no immediate practical application. Just before the end of the 18th century, however, a member of the Wedgwood family, seeking to preserve an image in a camera obscura, tried to use plates treated with silver nitrate. Unfortunately he found that the image was too weak to have any effect on the plate within a 'reasonable' time. How long a time he considered reasonable is not recorded, and clearly the Wedgwoods were too practical to spend much time on experiments which seemed to promise little in the way of rewarding results.

THE FIRST PHOTOGRAPHS

While Wedgwood was experimenting in his dilettante way in England, a Frenchman named Joseph Nicephore Niepce was tackling the problem in a more determined way; his first experiments date from 1793 and he was still experimenting when he died 40 years later. In 1816 he had his first success with silver nitrate when he left some treated paper in his camera obscura for an hour, and partially fixed the resulting image with nitric acid. The images could be inspected by candlelight, but any further exposure damaged the image.

Niepce found no sure way of fixing silver nitrate images and turned to a resinous material known as bitumen of Judea; this material, when softened with oil of lavender, could be spread thinly, and hardened when exposed to strong light; sheltered areas remained soluble in a mixture of oil of lavender and turpentine. Niepce took an engraving and made it translucent by oiling it; he laid it over a plate prepared with bitumen of Judea and left it in the sun for 2 or 3 hours. Where the black lines shaded the plate from the sun, the bitumen was soft enough to be washed away, leaving an 'engraved' plate from which a Paris printmaker was able to pull two prints. (A print obtained in the same way can be seen at the London Science Museum.)

Later Niepce made a similar experiment using his camera obscura, and with an 8-hour exposure successfully recorded a view from his window; the resulting plate was permanent, unalterable by light. It was, effectively, the first photograph. (Now in the Gernsheim Collection, Texas University.)

Niepce's attempts to interest the public in his discovery, and to raise funds for its further development, met with little success. However, another Frenchman, Daguerre, who had also been experimenting along similar lines with light-sensitive materials, persuaded Niepce to collaborate with him. Not that Daguerre had any discoveries of his own to offer; but he had enthusiasm — and he had some money.

But not even enthusiasm and money could bring quick success. Experiment followed experiment; after Nicephore Niepce's death in 1833, Daguerre continued with his son Isidore Niepce. A lucky accident revealed the possibility of *latent images* — roughly describable as images created thanks to one chemical process, but which require a second process to make them permanent. One day Daguerre put some apparently under-exposed plates away in a cupboard, intending to re-polish them for re-use; returning to the cupboard some days later, he found that distinct images could be seen on them — and he established that this was caused by mercury vapour, escaping from a broken thermometer. The images were direct positives. Soon afterwards, in 1837, the ultimate success came when Daguerre managed to fix the image with a solution of common salt and hot water.

RAPID DEVELOPMENT

Daguerre tried hard to make some financial profit from his discoveries; the best he could achieve was a government pension in return for allowing his findings to be published. His book, published in 1839,

ran into 29 editions in the first year, and was translated into six languages. The photography boom had begun. By the 1840s the Daguerrotype was the rage of society in Europe and America. Nearly every major city in the United States had its own Daguerrotype Artist's studio, and it became the 'done' thing to have one's photographic portrait made.

In England the news of Daguerre's discoveries alarmed the inventor Fox Talbot, whose own researches were almost perfected. However, his *calotype* employed a quite different process from the daguerrotype, and even offered some advantages: the daguerrotype was sometimes difficult to see because of the polished silver background, and could not be copied — the calotype, which used a 'fine writing paper' as the basis for its plates, escaped both these disadvantages.

Throughout the succeeding decades experiments brought results in rapid succession; the basic work had been done, now it was a matter of constant improvement of every facet of the process. Plates were made of albumen on glass, waxed paper, wet collodion, ambrotypes, emulsions and many less successful experimental substances hopefully put forward by enthusiastic amateur inventors. Equipment gradually became less bulky. The need for perfect lighting was gradually reduced as exposure speeds increased; at the same time, it no longer became necessary to clamp sitters for portraits to prevent the slightest movement, and so more naturalistic photographs made their appearance.

FROM AMATEURISM TO PROFESSIONALISM

During the years of development, photography was entirely a field for the amateur. The only professional exploitation of the discovery was by the portrait studios, who took advantage of each successive innovation to offer their clients an even better means of filling the pages of the family photo albums with their stiff, awkward likenesses.

Documentary photography scarcely existed, except for the work of a few imaginative individuals who realised the potential of the new medium, and whose work is now collected avidly in museums. Roger Fenton, who recorded the scenes and personalities of the Crimean War in the 1850s, was the first great war-photographer, to be followed in the following decade by Matthew Brady, whose studio provided posterity with a vast photographic record of a crucial period in history. But neither Fenton nor Brady could record movement — they show us generals and private soldiers, they show us battlefields and camps, but they cannot show us the battles themselves. So action documentation remained — and was to remain throughout the 19th century — the province of the artist.

But there was improvement, slow but continual; the pictures might be of stationary subjects, but they looked more relaxed. And the first experiments with moving subjects were being made — notably those of Muybridge, whose use of multiple camera techniques enabled him to create those landmarks in photographic history, *The Human Figure in Motion* and *Animals in Motion*. When high-speed photography became commonplace in the 1930s, the public was amazed by pictures of drops of milk in the act of falling and so forth; but in fact the first such photographs has been made four decades earlier.

Electric lighting was an important aid to the photographer. Until its general introduction, it was almost impossible to take photographs in normal lighting conditions — it had to be the studio or nothing if you wanted an interior shot. Consequently you are unlikely to find many photographs of shop interiors, schools and the like, especially including people, until the turn of the century.

The most effective way of showing how photography developed is by means of the following table, which shows when each successive stage of development took place, and therefore what degree of availability you can expect for that type of subject-matter.

20

	First tried	Early development	Wider application	General use
Portraits	1840	1850's	1860's	1900
Scenic	1839	1840's	1850's	1900
News	1850's	c1870	1900's	1914
News agencies		1920's	1930's	1930's
Aerial	1858	c1914	1920's	
Underwater		c1900	1935	1950's
Colour		1910	1940's	1960's
Availability	Museum items	Few examples	Specialist archives	Common

4 THE PICTURE RESEARCHER: THE ROLE AND THE RESPONSIBILITIES

Picture research is still a relatively new and largely unknown profession. Although the need for good picture researchers has been greatly increased by the growth of television and the escalation of illustrated book production made possible by modern printing technology, their work still tends to be underestimated by editors, authors and other employers. Unless you have been personally involved in the job of finding a picture, it is hard to appreciate the sheer quantity of time and trouble needed to find a single, apparently simple, illustration — let alone the amount of skill needed to find it quickly and without involving too much expense. As for larger projects, they may well call for a great deal of time to be spent even before the search itself is started, reading up the subject to collect information about associated themes and to discover fresh ways of illustrating hackneyed themes.

The wise employer will regard the researcher as a valuable member of a creative team, whose work can make a substantial contribution to the finished result. For many projects it is easy enough to find a picture that 'will do' — with the result that in unimaginatively prepared books the same old favourites tend to turn up time and time again. But a creative picture researcher will set higher standards, and be forever seeking for new material.

There is no basic training for a researcher, no specific qualifications required. Some have studied art or art history, some have university degrees in one specialised subject or another. Others have had no academic training, but possess an instinct and love for a good illustration; thanks to their flair and their experience, these will often surpass the more highly trained researchers in the freshness and originality of their approach.

Over a few years, good researchers will have built up a large collection of names and addresses — archives, agencies, photographers, museum staff and private collectors all over the world. They will have made notes on quick sources, 'tricky' sources, slow but sure sources, and above all the helpful sources. They will know the type of material available from each, and the sort of fees charged; they will know which collections are adding to their stock and which are decaying.

They will be familiar with filing systems and methods of classification, they will know how to use catalogues and indexes, they will know the short cuts that only experience can teach, and they will have learnt how to persuade busy people to help them. They will know how to write letters, not only to commercial sources but also to bishops or professors or noble lords, or to the jealous guardians of private treasures. They will have learnt to collect accurate captioning information, to ensure that

publication rights are available, to recognise when material is or isn't suitable for printing. In short, they will have learnt to programme each assignment so that their employer receives, comfortably before the deadline, a collection of judiciously chosen pictures — each one adequately captioned, its source indicated, its holding rights negotiated, its rights cleared, its fee agreed — from which to select for publication.

THE PICTURE RESEARCH PROGRAMME

PREPARATION
The researcher needs to know: picture budget; time schedule; number of black and white and colour illustrations; selection date; deadline date; jacket picture date; publication rights required; title of book or programme; probable publication or screening date.

It is surprisingly easy to overlook any one of these factors. Employers who employ researchers regularly generally find it desirable to prepare printed research forms itemising all the information listed above, which along with the author's text or synopsis provides the researcher with a basic brief for the assignment.

PRIMARY RESEARCH
A proper understanding of the scope of the project is essential, and the researcher will need, as available, in this order of preference: author's manuscript; author or editor's picture list; synopsis of the project.

Notes on the market for the project are also helpful, as styles of approach can be affected. For example, a popular historical book on the French Revolution would tend to use a different choice of illustrations than an academic work on the same subject.

Having studied the manuscript or whatever material is provided, the researcher's next move is to a good reference library where other books on the subject, or on related topics which help to increase the range of information, may be consulted. Public libraries are generally adequate, but busy professional researchers will find that a subscription to the London Library, or comparable institutions elsewhere, is amply repaid in the facilities it provides and the convenience it offers.

Where possible, other illustrated publications on the same or related topics should be examined, as this helps to start a list of suitable sources, and, if it does nothing else, at least makes the researcher familiar with the 'usual' pictures on the subject and indicates the general character of the material that is to be found.

If none has been provided, a picture list is now drawn up. Source suggestions are added. A good list will include not only the names of people and places, but also dates, background information, events and so on. Details should be added of any special requirements, such as end-papers, decorative motifs or documents.

The sources should now be selected. Many factors will influence the choice, and these are discussed in chapter 10. Naturally, distant sources, and those which you know from experience to be slow in replying, should be approached at the earliest possible date. But in other respects, it is sensible to make your first calls on sources you know to be helpful, who will perhaps be able to make further suggestions which will make your search easier.

Suggestions for further possibilities of research will be found in the introductory paragraphs to each of the sections in the Directory part of this handbook.

ORDERING MATERIAL
Until you are really familiar with a source, and they know both you and your company, it is always advisable to apply in writing in the first instance. This is true even if you propose to make a personal visit to the source. However, if your time schedule is a tight one, it can save time if you start by

phoning the source to check if they are likely to have the material you need, before you apply in writing.

In your letter — which should always be on your employer's letterhead even if you want the pictures sent to your own address — you should state: who you are; title and author of publication; publication rights required; clear description of what you require; selection date; final deadline date;

Don't send your complete picture list to every source, unless you think it possible they can supply every picture you need; ask only for what you think them capable of supplying. If you *have* to send the complete list, then cross out the items you don't expect them to supply, or which you have already obtained so that you don't involve them in unnecessary work.

If you don't already know through your personal acquaintance with the source, you must also ask: if material can be loaned; for details of fees; for copyright clearance; what acknowledgement is required.

If you are not always at your company's offices, you must also state where you can be contacted for queries, or where messages can be left for you.

VISITING SOURCES
Unless it is strictly not allowed, or unless your order is really very small and specific (ie less than about 10 pictures) and their archivist will research for you, you should always offer to visit a source. When you are there, try to get the hang of their filing arrangements as quickly as possible, so that staff don't have to dance attendance on you more than necessary; do not rearrange or alter the position of pictures and tidy up when you leave. Always make good captioning notes as you go along, especially at museums where you are ordering copies (photographers do not usually supply more than the minimum information necessary to identify the picture, and taking notes at the time can be a great time-saver in the long run). Don't take too many pictures. To take a great number suggests either that you are not sure what is required, or that you are not competent at making decisions; either way, it will make a bad impression on the staff, apart from the fact that you will be depriving them of useful material and involving them in additional checking and re-filing. Many sources will add an additional 'handling' fee when large numbers of pictures are taken and not ultimately used, even though it was you and not they who did the research — for don't forget, it is still they who have to check your pictures back and replace them in their files! Make notes for your own future reference on their procedure, and jot down the names of the individuals who helped you.

RECEIVING PICTURES
Adequate arrangements must be made for storing pictures as they come in. Not only must they be protected from damage and straightforward loss, but also from theft — especially in the case of original engravings which have a real monetary value.

As pictures arrive at your office, it is important that the following procedures are carried out:
1 All *delivery notes* must be checked and filed, and their requirements noted.
2 All *pictures* must be checked for damage, perhaps sustained in the post, and the source informed if any has already taken place prior to your receiving them so that you are not subsequently held liable for it.
3 Note whether pictures are to be kept or returned, and that the source is clearly indicated — if possible, on the back of the picture itself.
4 Make sure the *caption material* is on the picture itself or accompanies it. NEVER write on any item which has to be returned.
5 Check off your picture list.
6 File the material with other items on the same project, in an order convenient for quick reference.

SELECTION DAY
This is generally a date some ten days before design or deadline date. It should allow time for further material to be collected — either because some of your choices are unsatisfactory, or because new

needs have become apparent due to such factors as the arrival of the author's final manuscript which perhaps embodies some changes. Everyone who is likely to have a say in the project, or whose opinion is necessary for approval or rejection of illustration material, should be present at this meeting.

RETURNING PRELIMINARY REJECTS

It is most important that unwanted pictures should be returned at the earliest possible date. Not only is this considerate towards the source who loaned the material on approval, but there may be financial considerations involved if holding fees are involved — and an extra ten days can make a substantial difference.

Returned pictures should be: checked against delivery notes; carefully packed for postage; accompanied by a letter or form, which states that the enclosed pictures have not been selected for this project, but that the remiaining pictures (state how many) have been retained for final selection on such-and-such a date. A printed form is generally siutable for this purpose, except to non-commercial sources where a personalised letter is more polite.

Material you have bought, such as prints from museums, should be filed in the company's archives if they have them, for possible use in other projects. So long as it is properly labelled, there should be no problem about clearing permission with the source for use on another occasion.

RETURNING USED MATERIAL

This is not always the responsibility of the researcher. But if it is, these pictures too should be returned at the earliest possible date, and be accompanied by a clear indication as to how many items have been used, for what purpose, and what form of payment procedure is adopted by the company. Wherever possible, send the source a copy of the publication containing their material (many sources insist on this in every case, and some even require two copies!).

EMPLOYING A RESEARCHER

A new researcher inevitably causes slight worries for the employer — either fears whether a deadline date will be met, or doubts as to the quality of the research. A good employer will be familiar with the nature of the research programme, and should not only supply all the necessary briefing information, but also make quite clear how much of the programme is to be the researcher's responsibility.

Fees are generally paid in addition to any expenses such as travelling, print fees, external telephone bills, postage etc. The employer will of course want a detailed statement of such expenses, with receipts wherever possible.

The British National Union of Journalists is now considering freelance researchers for membership, and is in the course of preparing a scale of recommended fees. In the meantime, fees vary as much as any part of the picture research business. A researcher can be employed full time or contracted by the hour, the day, week, month or quarter. He can also be employed for the individual project, by the picture budget (10% or so of the total) or by the number of pictures eventually used. (Say, £1 per picture, on a project requiring 100 pictures.)

These last two methods are highly unsatisfactory, as they work against the researcher's skill and ability — except perhaps the ability to find cheap sources, regardless of quality. We strongly discourage researchers from accepting any such arrangement. The only fair way of allotting fees is in relation to the amount of work done by the researcher, as with any other profession. If the work turns out badly, that researcher will not get another assignment; if it turns out well, the researcher will be called in again. There is no reason for researchers to work on terms which do not recognise time spent on the one hand, skill and judgment on the other.

Whatever is arranged, it must be clearly agreed before the project is commenced; the researcher must be clear how much will be paid, when and how. Contract and full-time work will be paid by the usual salary system; project and hourly rates are usually paid on completion.

An advance is customarily offered to freelance researchers; this helps to pay for on-the-job expenses, and can also be used as the first payment to a new researcher and an opportunity for checking progress. It is a sensible practice to pay such advances on receipt of the picture list: this gives the editor some idea of the way the research programme is going. As pictures arrive, the list can be checked and the employer can make sure the programme is going ahead satisfactorily.

The employer should: brief the researcher as fully as possible; provide picture storing facilities; provide mail and message receiving facilities when the researcher is away from the office; introduce the researcher to the rest of the creative team; keep in continual touch.

TWO WORDS OF WARNING

To employers — do not be tempted to use researchers simply because they ask low fees. While it is true that the highest-paid researcher is not necessarily the best, this is more likely to be the case than the reverse, and this is an instance where 'the best is the cheapest in the end'. Skill and experience are worth paying for; a capable professional researcher will not only do the job more quickly — but will do a better job, wheedling pictures from 'difficult' sources, turning up fresh material which will enhance the publication.

Incompetent researchers, on the other hand, make a bad impression on sources, who will want to get rid of them as quickly as possible, and will be reluctant to offer them more than minimal assistance or lend them valuable or unusual material.

To researchers — do not be tempted to take on an assignment unless the fee is a fair and realistic one, and unless your employer is prepared to launch you with a proper brief and provide suitable facilities. If he is shirking his responsibilities or simply shifting their burden onto your shoulders, you will only be letting yourself in for frustration and probable disappointment if you accept the assignment.

COMMISSIONING A PHOTOGRAPHER

This is generally a happy business, especially on big expensive projects. More often, though, it is a question of the odd single picture in a museum, or a photograph of a single place.

Finding a photographer. This is usually a matter of recommendation, and most museums and galleries are prepared to do this whether or not they have a photographic staff of their own. A further guarantee of professional competence is to use a member of a recognised body, such as the National Union of Journalists in Britain; chapter 11 lists some useful books which contain names of such photographers. Another way is to approach a town hall, public library or local Chamber of Commerce for their advice on local professional photographers.

Overseas sources tend to be more complicated for photographic orders. The larger museums and galleries can generally provide their own material, while smaller ones may suggest a local photographer. But occasionally it is left entirely to you. If you don't happen to know anyone on the spot (this is something else you should start to compile notes about), your best chance is to approach the embassy of the country concerned, and consult their commercial attaché. Another method is to go to one of your commercial sources in your own country, and ask them to commission an overseas contact on your behalf — most photographic agencies, particularly the news-oriented ones, have regular contacts throughout the world and are happy to do this.

When ordering photographs be sure to send a copy of the source's permission-to-photograph with your order, and be as precise as you can as to what you want, especially if angles, colour or background are relevant. Fees should be settled in advance. There may be subsequent problems of additional expense unless the position is made clear from the start. Get to know the photographers who habitually work in the important museums — what days they work there, what length of notice they require, what is the average delay and the minimum time they need. They are usually most helpful, but will be even more so if they feel you understand their problems. For instance, they cannot

always get hold of the item you want photographed very quickly, and this is something you should check with the source before you commission the photograph. Then you will be less likely to expect the impossible.

5 COPYRIGHT

These notes are for general guidance only, and should not be taken as constituting any definitive statement of the legal situation, which is a highly complicated one.

A picture is out of copyright and may be freely used fifty years after the end of the year in which the copyright-holder died. The copyright-holder is normally the artist or photographer, but where the picture was published in a book or magazine, it may be the publisher. In the case of anonymous material, copyright expires fifty years from the end of the year in which it was published.

USE OF MATERIAL IN COPYRIGHT

If you want to use a picture which is still in copyright, you *must* ask the copyright-holder for permission; he may or may not charge a fee, and he is entitled to charge whatever fee he thinks fit. In the case of pictures in public collections, or held by agencies, it may be that some special arrangement has been made whereby the institution negotiates copyright permission, so check first with the librarian, agent or equivalent.

If you have difficulty in tracing the copyright-holder, your wisest course is probably to go ahead and publish regardless. Should the copyright-holder then appear and challenge your action, he will probably be willing to accept the normal reproduction fee, so it will cost you no more than if you had obtained permission in the normal manner. Should he demand an excessive fee, you should refuse to pay it: he may take you to Court, but the Court will not be likely to award him a large payment provided you can prove that you made every reasonable effort to trace the copyright-holder. This is important: so do not be tempted to use material until you have made such efforts, and preserve documentary evidence of the steps you have taken. In some cases it may be worthwhile inserting an advertisement in an appropriate journal, as a sign of good faith, asking the copyright-holder to get in touch with you.

USE OF MATERIAL OUT OF COPYRIGHT

A peculiar situation arises when out-of-copyright material is obtained from a picture source which nevertheless owns the material. Strictly speaking, no question of copyright as such arises in such cases. The source cannot claim to own the copyright, they only own the material itself; what you are doing is borrowing that material and paying for their trouble.

If the material is not exclusive to that source — for instance, if you use an engraving from Source A which you could equally well have got from Source B — you can be dishonest and claim that you used someone else's picture. It would be hard (but not necessarily impossible) for Source A to prove otherwise, but you would not find them very willing to do business with you again.

USE OF MATERIAL FOR REFERENCE

Even when a picture is not used for direct reproduction, but only as a reference for new artwork by an artist, copyright still applies so long as the original picture can be recognised in the new drawing. This is true even when only a part of the original is used, or when the picture is used only as part of the new artwork.

The only really safe course is to obtain permission to use the picture as reference. The fee for this is generally low (half the normal reproduction fee or less) and this avoids all risk of potentially costly legal action.

COPYRIGHT OF COMMISSIONED PHOTOGRAPHS

A rather complicated situation exists where a photograph is specially ordered by a client. If there is a negative, this remains the property of the photographer, NOT the client who commissions the photograph. The photographer may, if he chooses, sell the negative to the client, but he is entitled to — and usually will — charge an additional fee for this.

If there is no negative — ie if the photograph is a transparency — this becomes the client's outright property, the fee paid being deemed to cover this.

Unless otherwise agreed, the copyright of the photograph belongs to the client who commissioned it. In other words, the photographer is not legally permitted to make any further prints from his own negative, unless he has obtained permission from the client who commissioned it in the first place. While admittedly it might be difficult in practice to prove that a photographer was so doing, you would be legally entitled, if you found that he was selling or even simply making prints from a negative you asked him to take, to take legal proceedings against him.

6 RATES

The question of rates is one of the most confused in the whole field of picture research. Almost every source charges some kind of fee for the reproduction of its pictures, but every picture researcher quickly learns that not only do the rates themselves vary enormously, but also the ways in which they are fixed are no less variable.

There are two points to get clear from the start: first, when you pay to reproduce a picture, you are really paying not for the picture itself, but for the service which enables you to get hold of that picture. You are paying for the trouble spent in taking the photograph or hunting up the old engraving; you are paying for the work of cleaning, mounting, identifying, labelling, filing, cataloguing; you are paying for the facilities provided by the source to help you in your research — the reference books, the photostat equipment, the files and catalogues; you are paying for postage, handling, packaging; you are paying for the necessary paperwork — the checking out and in again, the billing and the chasing. All these factors apply just the same whether the picture itself is valuable or not.

The second point is that the reproduction fee bears no direct relation to the work done or the services provided. A picture source has to go to the same trouble and expense to lend a picture to an advertising agency as to a book publisher, to a New York publisher as to a London publisher; yet the fees charged will vary very markedly. This is because fees are not assessed, as in most fields of human activity, by the actual work done, but with regard to the size and nature of the market for whom it is done — rather as if a road-builder got paid twice as much if his road leads to Buckingham Palace as if it led to a housing estate!

HOW RATES ARE FIXED

Rates are fixed with regard to several different factors. The most important are the Size to which the picture is to be reproduced; the Number of Copies of the publication which will be printed; the Number of Countries in which the publication will be published. Some sources will take only one or two of these factors into account, others will take all three.

Then there are complicating factors

1 Colour, which generally means at least twice the black-and-white fee
2 Use in Dummies, which is generally half the normal fee
3 Use on Front Covers, usually an additional 50% or double the normal fee
4 Use for Reference Only — ways of assessing this vary too widely to give any useful indication; but a typical rate in Britain is £3 to £5 for up to 10 pictures on a given subject, which must not be copied exactly

5 Educational Publications — most sources will, rather reluctantly, agree to give a discount of 10—25% for publications which are genuinely educational.

Finally, there are some additional types of fee:

Search Fee or *Handling Fee.* This is generally charged only if a great number of pictures are loaned and only a very few used, or if none at all are used. Black Star of New York have a system of charging a $25 minimum search fee on every order, which is deductible from the final bill but non-returnable if no pictures are used.

Holding Fee. This is charged when pictures are retained by the client beyond a stipulated period. This is most frequently a month, but can be longer; occasionally it is shorter. Most sources are ready to extend this period by arrangement to meet publisher's needs, but the researcher should always inform the source and check that this is agreeable. It should be borne in mind that holding fees are not intended by the sources as an additional form of revenue, but as an inducement to publishers to return pictures as soon as possible so that they are available for other clients. So it is in everyone's interests to return pictures at the earliest possible moment — especially as holding fees, which seem modest enough when expressed in terms of say 10p per picture per week, have a nasty tendency to mount up to very substantial sums!

All these fees are additional to the Print Fee or Transparency Fee. This is what you pay to purchase an actual print or transparency of the picture you want. Some sources (eg the Science Museum, London) never loan material, but insist that you purchase a print; others refuse to permit you to retain any kind of copy and insist that all prints are returned; yet others offer you the option. If you do purchase a print, it becomes your own property; but remember, you are buying only the print — not the right to reproduce it. It is a convenience to physically possess your own artwork, which you can re-touch, mark up and so on as you please; and of course you avoid any question of holding fee. But simply because you possess the print does NOT give you the right to use it as you wish. Print fees are usually modest — little if anything above the standard trade price of making a photocopy.

In addition, some sources will charge you a fee, sometimes referred to as a Negative Fee or Copying Fee, if they have to photograph an item in their collection which they would not normally have copied, or which has never been copied before. Thus the American Museum of Photography charges $5 to copy any picture they do not already have on negative, and the Mary Evans Picture Library charges an additional 50p to copy an item which they would not normally have had copied.

STANDARD RATES
Many publications pay standard rates according to their own scale, and this makes life easier all round. Most sources are generally ready to accept such rates from standard periodicals, which have generally stood the test of time and perhaps been mutually negotiated.

On the other side of the fence, very few sources have a standard rates scale; those that do are generally the larger commercial collections, for whom the trouble of negotiating every single transaction would be intolerable. So in fact only about 20 of the sources listed in this book issue their own rates card (though many more go along with professional scales mentioned below). In view of the many complicating factors we have already considered, this reluctance to set down firm rates in black and white is understandable enough; it is none the less regrettable, for a rates card is a very useful help to the picture researcher who has to keep a weather-eye on the budget limitations of an assignment.

Sources that do have a rates card are generally ready to be flexible in its application. The Mary Evans Picture Library, for example, issues a card which gives general guidance as to the sort of rates it

expects its clients to pay, but is always willing either to accept clients' own standard rates, or to negotiate in the light of special factors. But at least its clients know from the start the sort of money they must expect to pay.

Some non-commercial sources, such as public archives and museums, charge minimal rates, regarding it as right and proper that the public should have free use of what is, after all, public property. But even so there is generally some kind of rate, simply to cover the cost of maintaining the collection and paying the staff who do the research and provide other assistance.

Many other sources belong to professional associations, such as l'Association Nationale des Journalistes, Reporters, Photographes et Cinéastes in France, the ASMP in the United States, or the Council of Photographic News Agencies in Britain. These recommend standard scales which are normally charged by all their members, though here again a certain amount of negotiation is acceptable.

LOSS, DAMAGE & REPLACEMENT

Every source will charge for lost or damaged pictures. At best, this will simply be the cost of making a replacement print of a black-and-white picture which the source has on neg (ie has already photographed); but in the case of a transparency, of which the original has been sent out, things aren't so simple. To replace a photograph of, say, the sun setting behind the Taj Mahal, would cost hundreds of pounds; so, not surprisingly, loss fees for colour transparencies are very, very high. From £100 to £200 is normal, and they can be a lot costlier than that.

Similarly with original engravings, particularly if they happen to be rare. In such cases you must remember that you are not paying simply for the material loss of the picture; you are paying for the loss of business which loss of the picture entails. A source may have hunted for years to find a picture which costs next to nothing in itself; one London library is very proud of a picture of a domestic servant black-leading a grate, which is a simple drawing from a book which was purchased for less than £1 — but is none the less a very rare and therefore valuable item. If you deprive a library of such a picture, you must expect to reimburse them in proportion.

REPRESENTATIVE RATES

The following table shows, very generally, the sort of rate you can expect to pay for a single picture, reproduced in an average book or journal. Rate structures vary so widely that only the most approximate figures are possible, but these have been compiled from a number of different sources, and may be taken as representative.

The table clearly illustrates the point made earlier, that the same picture and the same research effort can earn widely differing financial rewards. Another point which emerges clearly enough is that British publishers expect to pay the lowest rates anywhere. In a straight supply-and-demand market, this could be taken as showing that British publishers have successfully managed to secure the brightest bargain, a splendid example of British acumen and what have you. But looked at another way, it could imply that British publishers are starving the goose whose golden eggs could be so useful to them.

For the consequence of paying low rates is that British picture sources are impoverished compared with their opposite numbers in other countries. This means that they are at a disadvantage when competing in world markets; they can neither obtain the material nor provide the service they would wish.

Two consequences follow: first, British sources find it difficult to build up the sort of collections that are needed to meet their clients' needs — which means that British publishers have to go abroad, paying in the long run even more for the pictures they must have. And the second consequence is that the finest material is steadily flowing out of the country — and largely across the Atlantic in a westerly direction. The Gernsheim Collection, probably the world's finest collection of historic photographs,

was once located in England and readily accessible to British publishers; it is now in faraway Texas. Maybe from a world-oriented viewpoint there is no harm in this; certainly the pictures are being excellently cared for in Texas where there are ample funds to provide superb facilities just as there were to acquire the collection in the first place. But the simple fact remains that British publishers have lost easy access to what was one of their finest native sources of illustration material. Today, if they want to use one of those pictures, they have to go to a sight more trouble and expense than in the days when Helmut Gernsheim lived on their doorstep.

It would be unrealistic to propose that British publishers should forthwith hand out double fees for their illustration material. They too have their economic problems, and picture fees form only part of a larger situation. But we would suggest that they should consider the matter in perspective, and appreciate that success in obtaining pictures comprises more than screwing suppliers down to the lowest possible rate. If British publishers want to be able to call on the services of picture sources comparable to those in other countries, they must expect to pay for those services, not as they pay a grocer or an ironmonger, but as they pay a lawyer, a doctor, or any other professional consultant.

	HISTORICAL (photographs or prints)			MODERN (photographs)		
	UK (£)	rest of Europe (£)	North America ($)	UK (£)	rest of Europe (£)	North America ($)
Book or magazine one country only less than ½ page black-and-white	4–6	4–13	25+	4–15	5–15	35–65
Ditto larger size	6–10	6–28		6–20	7–25	60–100
Ditto world rights	10–12	21–28	50	12–34		
Television, single flash	5	10–25	200	5	10–25	200
Colour	x 2–2½	x 2–3	x 2–3	x 2–3	x 3	x 2½
Jackets & covers	usually x 2 (ie double normal rate)					
Dummies	usually x ½ (ie half normal rate)					

Advertising & publicity — no fixed rates, always negotiated

POSTSCRIPT: SOME SUGGESTIONS FOR RESEARCHERS

Always establish rates at the earliest possible stage of the assignment. Ask if the source has its own rates card; if it hasn't, then get a clear idea of what rate will be charged, if possible in writing. Otherwise you run the risk of putting your employer in an embarrassing position, should he find,

when he has sent the book to the printer, that the source expects a far higher fee than he was prepared to pay.

Try to keep notes — wherever possible in the form of rates cards — as to what rates are charged by the sources you use. Then you will know where to pay your first calls when on a low-budget assignment. Remember, though, that rates increase just like any other costs; don't expect them to remain static while postage and other costs rise!

Take good care of the pictures in your possession — the cost of loss can be staggering. Make sure you are covered by insurance if you are working from home, or that your employer's office is similarly protected. And pack pictures well when sending them to the printer or returning them to the source — a damaged transparency will cost you as much as a lost one.

Finally, don't expect the rates of a commercial source to match those of a public and probably subsidised collection. When you use a commercial source you are paying for the additional service you get — the promptness of their reply, their help in your research, the ease of access and convenience, which are all saving you money in the long run.

7 CREDITS

Picture credits are a nuisance to the publisher, to the printer and to the researcher — but they are of very great importance to the picture source itself. How important they are rated is indicated by the fees charged by Alinari of Italy; a picture *accompanied* by a credit is charged L2000; the same picture, when the credit is printed at the back of the book, is charged L3000; and the same picture with no credit line at all, L5000!

Why is a picture source willing to reduce its rates so substantially simply to make sure of a credit line? The simple answer is that credits are far and away the most effective promotion that a picture source can obtain. They inform anyone who is interested which source possesses that particular picture, with the implication that it possesses others of the same type. Credits are to a picture archive what the brand-name of his product is to a manufacturer or the label inside the neck of a garment to a dressmaker — public evidence, for good or ill, of the supplier's capability.

It might be asked why a publisher should provide a vehicle for the advertising of picture sources; but in fact credits offer a mutual advantage. They are in fact just about the most important clues a researcher can get in the endless quest for new sources. Second to personally visiting the picture sources themselves, credit-spotting is the finest possible way of familiarising yourself with picture sources and — because the credit line accompanies the actual picture — getting to know what sort of material that source possesses. A novice researcher can hardly spend time better than by leafing through illustrated books, noting which source supplied which picture; while more experienced researchers could make a party game out of guessing which illustration in a publication was supplied by whom!

So bear in mind that picture sources take credits very seriously indeed, and that the provision of them is implicit in every transaction, even where it is not explicitly written into the contract. It is up to the publisher where such credit lines are placed; the alternatives, in order of preference, are

1 alongside the picture itself
2 at the end of the caption accompanying the picture
3 on the same page or spread, in the margin or the gutter
4 en bloc at the beginning or end of the book.

Whenever the credit line is not physically adjacent to the picture, it must be made quite clear which credit is intended for which picture.

It is important for the researcher to keep a record of every picture and its source, so that there is

no possibility of error; and that the correct form of wording is obtained from the supplier. In this respect, the wishes of the source should be followed as long as they are not too demanding. This is particularly true of sources who supply material free, such as certain public collections and professional bodies, the publicity departments of manufacturers, tourist organisations and suchlike, where the picture credit is the only 'payment' made.

When a picture is obtained from an agency, it is often customary for the credit line to contain both the agency's name and that of the individual photographer. Here are some typical uses of 'double' credits:

CAMERA PRESS LONDON / JOHN BLUMER
(agency and individual photographer)

MUSEE CARNAVALET / BULLOZ
(museum and agency owning transparency)

SAMUEL H KRESS COLLECTION / PORTLAND ART MUSEUM
(individual collection and museum which houses it)

PHOTO MEYER / KUNSTHISTORISCHES MUSEUM, VIENNA
(individual photographer and museum owning work of art)

8 TYPES OF PICTURE SOURCE
—AND HOW TO MAKE BEST USE OF THEM

Most pictures can be obtained, not simply from more than one source, but from more than one *type* of source. Knowing when to use which is a very important part of picture research.

Your decision will depend on several factors. Primarily, your *budget* will exercise an overall limiting factor — if money's tight, you will be restricted in your choice. Then comes *time* — again, if time is limited, that will prevent you spending too long in hopes of running down elusive items. Related to these two factors are convenience of location and ease of access to the available material. Finally, a congenial atmosphere and a helpful staff are not to be seen simply as the reward for making personal visits; they can lead to valuable personal relationships which can result in greater co-operation and special privileges. Many a researcher who has won her way to the heart of a Curator has found herself granted access to material denied to her colleagues!

The most important stage of a research programme is the first: you must get to know what your project is all about, become a temporary expert in your subject. Then your needs must be matched to the sources which are most likely to meet those needs; and this is where your past efforts in getting to know sources will pay off. Whenever you visit a source, try to resist the temptation to dip quickly in and out; try to allow yourself time to get to know the source on a wider basis. Telephone requests and written letters will generally produce good enough short-term results, but personal visits will give you a deeper awareness of what a source has to offer.

What kind of information is helpful? Frankly, you can't know too much. Not just the scope and calibre of the material the source contains, but the way it is filed and catalogued; the delay you must expect before your photo-orders are supplied; which archivists will help you, which will leave you in peace, which will even prove obstructive. Sometimes patience and tact are called for. There are sources which have suffered from abuses of their time and material — who are smarting from researchers who have departed leaving piles of rejects behind them, or who have muddled their neatly arranged files. Sometimes, again, it is not the researcher who has been at fault but the company which employs her;

some companies have a bad reputation in matters of payment, or for losing pictures or damaging them. It is prudent to make a discreet check of your employer's record in such matters before you proceed too far with your project. In particular, find out how long your employer intends to keep the material you supply, and make sure that the source is aware of this intention and is agreeable. As go-between between your employer and your sources, it is your job to smooth out the problems; your relationship with your source is by no means over when you have chosen your pictures. Besides, one day you will want to go back there – and they will remember you!

These considerations are true of all kinds of source, but they will all tend to affect your choice. Leaving aside any personal considerations, there are a number of objective factors which you will take into account. In the following table, we have tabulated them against the three main types of source; stars represent plus factors – the more stars, the better.

	Public	General commercial	Specialist commercial
COST	***	*	**
QUALITY OF MATERIAL	***	**	***
TIME	*	***	**
EASE OF ACCESS	*	***	**
EXPERT KNOWLEDGE	**	*	***
CONVENIENCE FOR COMPLEX PROJECTS	**	***	*
PERSONAL	*	***	***
BACK-UP SERVICES	*	***	*

Rough-and-ready though it is, the table shows that, other things being equal (which of course they never are) a general commercial source is your best first bet. Broadly speaking, where cost is the first consideration, choose a public source; where quality of material comes first, choose a public source or specialist commercial source; where time and/or convenience come first, choose a general commercial source.

This is not to say, of course, that these qualities are possessed exclusively by particular types of source. Many specialist sources are fast and efficient, many public collections are genuinely helpful, many general collections possess top-quality material. In the end, it comes back to personal familiarity with individual sources.

In the notes which follow, we go into slightly more detail into what you can expect to find when you call on the services of the various types of source. Here again, the descriptions are general and should not be taken as necessarily applying to every source in that category; for in the end, as you will discover, no two sources are alike.

PUBLIC COLLECTIONS
There are three main categories of public collection

1 NATIONAL museums, archives and libraries
2 LOCAL museums, archives and libraries

3 PRIVATE museums, collections, libraries and other institutions open to the public whether on a free or restricted basis

Much of the world's finest historical material is to be found in National and Private archives all over the world. Almost every country has its own national archives, and many have regional and local collections too. Though what they do possess is definitive within its limits, it tends to be somewhat 'establishment-oriented' in character: it is rare to find a national archive collecting — for instance — political ephemera or visual documentation of everyday life.

Private archives naturally reflect the interests of their creators. They are less comprehensive in scope than the national collections, but make up for this by their dedication within their chosen field. Since in many cases they were formed by some wealthy person or family, they are just as likely as the national collections to possess real treasures, to be well housed and indexed, and to be staffed by experts.

Only rarely can you borrow original material from these sources; instead it's a matter of obtaining copies. To some extent, most collections have already made copies of much of their most popular material, which of course makes your job easier. Otherwise, you have to discover what copying procedure is used by each particular collection. Sometimes they have their own photographic department, sometimes they leave it to you. Most often you have a choice. The collection's own photographic department is apt to be less costly but slow, while employing a photographer will cost more but be faster. So you have to balance cost against time.

The photographic departments of most big collections seem to be overworked and understaffed: you will more often than not have to wait weeks for the prints you order, and you cannot expect much personal attention as to size, type of paper and so on. However, recognising this situation and realising that many researchers cannot afford to wait so long, many collections have arrangements whereby certain freelance photographers are granted facilities to photograph within the collection. Such photographers are often very knowledgeable about the collection, and while you have to make your own financial arrangements with them, their knowledge can be very useful.

Many of the private archives are valuable chiefly for reference only, particularly when they comprise a collection of photographs of material from many different sources. Where prints are sold, it is usual for the researcher to clear copyright with the original owners; nevertheless, using such sources can save much time, especially when the original is from an overseas source.

Time, as we have seen, is the bogey of public collections. Hours spent exploring catalogues will be wasted if you find that pictures cannot be supplied in time to meet your deadline. Again, unless it is only one or two specific illustrations you need, you can spend an inordinate amount of time floundering through artist indices, catalogues of special collections and the like — and while staff are often willing to be helpful, there is a limit to the amount of time they can give you.

PROCEDURE HINTS

1 Check out the photographic procedure before investing time in research — make sure there is time (with a little margin for error!) to get your prints. Make sure, too, that the prints supplied will be of suitable quality for your needs; microfilm print-outs, for example, are NOT suitable for reproduction.
2 Learn how to use the catalogues. If you have spare time, go to the collection on practice visits. Get used to using catalogues which are as often as not arranged by anything rather than subject-matter — by artist, by individual collection, by date.
3 Get hold of printed catalogues, lists of prints and transparencies already available and so forth. A good collection of these at your home or office can save you a great deal of time and trouble.
4 Get to know which photographers are approved by, or familiar with, specific collections — and get to know their collections of material already photographed. Again, this can be a valuable time-saver.

5 Always make your own caption notes of any picture you order. This can save a lot of time when pictures are supplied by a museum photographer, or a commissioned photographer, as in such cases they will generally be supplied with no caption at all.

COMMERCIAL COLLECTIONS — HISTORICAL

Commercial sources of historical material are available in some countries — chiefly Europe and North America. They are relatively inexpensive compared with modern photographic archives; compared with the public collections they are more expensive, but this can often be outweighed by the time you will save. Being geared to commercial needs, they are usually arranged in the most convenient manner — by subject-matter rather than by individual artist, for instance — so that research time is saved; access is generally easier; staff are anxious to assist; and photographic services are very much faster.

Most commercial historical collections are general in scope — their subject index covers every aspect of visual documentation. There are also a number of specialised sources, with material relating to theatre, science, medicine and so on; and a certain number of such specialist collections are tacked onto larger modern collections. Whether general or specialist, such collections are usually run by people who, in spite of their commercial interest, love their material, and whose expertise rivals that of museum curators. They will usually take a personal interest in your research problems and give you all the help they reasonably can.

While public collections are often static, commercial collections are generally expanding and adding new material all the time; it pays to revisit them periodically to keep yourself up-to-date with their progress. Again, such collections often lend out their original material; so a second visit may reveal material which was away on loan the first time.

However, it is becoming rarer for even this type of source to lend out original material, as this becomes scarcer and more valuable. The trend is towards supplying photocopies of the material they hold; some collections confine their photocopied material to pictures of which they possess the originals, others will also have photocopies of material from museums and other such sources, for which special copyright arrangements may have to be made.

Most such sources charge a holding fee if material is kept long without being used, or if a quantity of material is borrowed and only a small proportion used. Often, though, special arrangements can be made with the source if you know your employer will need to keep the pictures for an exceptional length of time: it is far better to discuss this at the outset than leave it till the date for returning the pictures without fee is already past. Most sources are flexible in this respect, but they like to be treated with consideration.

Search or research fees are usually charged according to circumstances: if the source does your work for you, you must expect to pay for their trouble. Again, this will be affected by the quantity of material which is eventually used; if you borrow a substantial amount of material (which means that none of their other customers can have it) you must expect to reimburse the source either by using a fair number of pictures or by compensating them for depriving them of their material.

Time is not usually a problem with this type of source: often you can take the chosen material away with you if you make a personal visit, or it will be sent to you in a matter of a few days, even a few hours. In some cases, sources can accept visits immediately or very soon after your request to visit them; others have a waiting-list for appointments, but this does not necessarily mean that they will be slow in sending material ordered in writing or by phone.

PROCEDURE HINTS

1 Whenever possible, send your requests in writing in the first instance, particularly when your employer is not known to the source. Later, when you know them and they know you, you can

expect to obtain your material via a phone call. But they do like to know who they are dealing with!

2 If possible, do not ask for more than 10 pictures without offering to visit, unless you are sending a list of very specific individual subjects. Do not expect a source to be pleased at being asked to supply, say, 'anything you have on social conditions in the 16th century'.

3 Before visiting the source, study previous works on the subject you are researching, so that you will be able to recognise unusual material when you see it.

4 Never send blanket requests; try always to send a list of the type of things you hope to be able to illustrate, and include alternatives wherever possible.

5 Remember that commercial sources are not philanthropic institutions – they need money to exist, to add material, to give you the service you want. Do not try to abuse their goodwill or generosity – it will only be a short-term gain.

COMMERCIAL COLLECTIONS – MODERN GENERAL

In almost every country there are commercial collections of photographs on contemporary subjects. Usually their function is to act as a source of supply for all the variegated needs of modern society – books and magazines, television and publicity, travel agents and greetings card manufacturers, packaging and promotion. It will range from specific news coverage of current events to stock pictures of kittens for jigsaws and chocolate boxes.

While some general modern commercial collections cater for all these markets, most are more limited – some are definitely news-oriented, others specialise in 'feature material', others in stock shots of places or everyday life and so forth. It is important to get to know what area is covered by each of the more important sources. Again, while essentially up-to-date in their material, some will have been created 40 or 50 years ago, and may have kept their original material which has now become of historic importance. This is particularly worth knowing about (and incidentally, if they themselves do not seem interested in such material, do your best to encourage them to recognise its value!)

The rates charged by such collections are usually in line with established rates for photographers in that country, but of course these rates too vary widely from one country to another. This can make a difference when you want material from other countries; the big agencies often act as agents for overseas material, and will lend material at the rates in their own country, not at those of the country of origin.

Photographic agencies generally charge holding fees after a fairly short period, as their transparencies are often even more exclusive than a museum's print. There is a growing trend towards making duplicate transparencies, but this is an expensive process so that most collections comprise almost entirely one-off material. You will be well advised to get your employer to give you signed agreements accepting responsibility for any material you borrow; whatever the legal value of such a document, it will encourage him to take better care of the material while it is in his possession.

General sources of the type we have been describing save time and trouble, providing quick and generally satisfactory answers to many picture problems. Being in a highly competitive business, they are continually adding to their material and keeping their general stock up-to-date. In addition, there is a good deal of 'take-over' activity in this field, agencies or individual photographers joining forces continually – a step which makes the researcher's task progressively easier.

Material which has appeared in periodicals is usually in the collection of this type of source. Unless an actual credit appears in the journal, it is best to consult the journal in the first instance. Remember that the same material will be handled by separate agents in different countries; if you write from abroad to *Time-Life, Paris-Match* or the *Sunday Times,* they will refer you to the appropriate agent in your own country.

36

COMMERCIAL COLLECTIONS — MODERN SPECIALIST

With the wealth of material that is available and the size of the demand, it is not surprising that alongside the general sources there are specialist sources of all shapes and sizes. Some are agencies for groups of photographers, others are founded on the work of a single photographer or studio; yet others are commercial companies with their own photographers.

Such sources vary widely in their accessibility and efficiency; at their best they can be first-class, but there are others where only a really determined effort will winkle out the required material, and only the quality or rarity of the material can justify the effort involved in obtaining it. Bear in mind that the staffs of these specialist collections are usually dedicated people who take their chosen field very seriously; if you approach them in the same spirit, you are most likely to win their sympathy and their co-operation.

NATURAL HISTORY

Most specialist agencies in this field are fairly general in scope, covering all aspects of natural history, ecology, conservation and the like. They are often large agencies handling the work of many excellent photographers, and tend to be international in scope. At the same time there are collections formed by individuals who have made a speciality of a single aspect of even of a single species; more often than not, however, such photographers have made arrangements with an agency to handle their material.

Note that some such agencies file their material alphabetically under the *latin* name. If you can adopt this practice when applying for material, you will save time both for yourself and for the staff of the collection.

FINE ARTS

This class of source can be a great time-saver to the researcher. Some will even send a selection of material on a given theme, though the more usual practice is to request a specific item by title and artist's name. From this it follows that it is well worth building up a collection of their catalogues, through which you can conveniently browse when looking for material on a particular subject or theme.

There are good Fine Arts sources in America, France, Germany, Italy and Spain; there are no comprehensive collections in Britain, where it is necessary to approach a great number of individual sources in hope of finding what you are after. A certain number of institutes exist in London which provide useful reference sources, but one of the most important of these asked us not to include them in this book because they did not want picture researchers making use of their facilities!

NEWS AGENCIES

These are basically for the use of the press, and are organised accordingly — immediate availability of material, rapid copying facilities, emphasis on topical and up-to-the-minute material. It is well to bear this in mind when approaching them; they will respond readily to a practical and professional approach, but will not take kindly to vague, non-specific requests.

The current news of today is of course the history of tomorrow, and the collections of many of these sources have in the course of time become important historical archives. Sometimes they themselves are unaware of this process, and are reluctant to deal in their older material — a reluctance increased by the fact that in many cases the original material is in the form of glass plates.

Procedures vary widely in this field. Generally speaking, filing systems are excellent and prints are supplied more rapidly than from any other type of source. But sometimes captions are inadequate, and occasionally your only reference is to a negative, from which you must select your print.

Procedure hints
1 Where prints are not loaned but sold, remember they will need a written order from you, so take stationery with you when you visit them.

2 Always phone before visiting.
3 As the subject-matter is current events, and no one source could possibly cover every event which currently takes place, you will inevitably have to approach more than one before finding what you want except in the case of a Coronation or some such event of universal appeal. So it is worth making a list of such sources, with phone numbers, for quick easy consultation.

SPORTS

These sources are similar to news agencies but tend to be more widely scattered. They generally tend to have a larger proportion of colour material. Naturally, the general news agencies possess much sporting material, but the specialist sports sources are likely to give coverage in greater depth, and are often the suppliers of the big news agencies.

AERIAL PHOTOGRAPHY

These are generally well-established sources, having taken off with the first regular flights after World War One. They are usually well catalogued under localities, but you will do well to arm yourself with map grid references as these are sometimes required.

PHOTOGRAPHERS AND PHOTOGRAPHIC AGENCIES

Nearly every photographer is happy to sell the use of his photographs, very few are happy to see you unannounced at their studio. Most of them find an agent to handle their work for them.

Such agents usually handle several photographers, and many of them appear in our 'General' category. The agents will also arrange commissioning. The market is a very competitive one, and a certain degree of bargaining is possible, particularly if you plan to use a quantity of material. But remember, though photographer's rates may seem high, so are their overheads.

If you want a photographer to take a certain item in a museum or library, the first step is to ask the curator if there is anyone he can recommend: if there is, it is likely to be someone who is familiar with the collection and its material — and who indeed may already have photographed that particular item. If the curator cannot help, another way is to consult the appropriate reference books, such as (in Britain) the National Union of Journalists Freelance Journal; yet another is to approach a body such as the local Chamber of Commerce. In general, such photographers have professional qualifications and their technical ability is as a rule perfectly adequate.

MISCELLANEOUS SOURCES

INDUSTRY AND TRADE

Many large old-established companies possess some historical material relating to their activities, and sometimes even to the industry as a whole. Their archives or public relations files often contain pictorial material, which is generally available to the public at no or a very moderate cost. Apply to the Press Officer.

GEOGRAPHY AND TRAVEL

Most foreign countries who wish to profit from tourism keep picture material at their Embassy or their local tourist offices. This is generally available at no or a very moderate cost.

Airline companies, petroleum companies and other international concerns are also good sources of travel material. Apply to the Press Officer or Public Relations Officer.

Local libraries often have material on their own locality, often the work of a single local photographer or collector. For more recent material, try local newspapers.

RELIGIOUS GROUPS AND CHARITIES

These are often organised on the scale of a big business, with their own reference libraries and a Press Officer who is generally the best initial contact. Bear in mind that their material is intended to support their viewpoint, and is made available to you in good faith.

STATELY HOMES, CHATEAUX

The largest establishments in this category are often on the scale of small museums, and have their own curator and library staff. In such cases, there is no difficulty about making your approach.

For smaller places, you will have to make your approach directly to the family. In such cases, tact is of the greatest importance. Make sure you enclose a letter of authority from your employer, and when you write, remember that you are asking a favour, not claiming a right. The same applies when approaching the family of a deceased prominent personage. Living personalities can generally be traced through reference works such as the British 'Who's Who'.

UNIVERSITIES

Most universities possess libraries and archives. Sometimes these are of universal scope — eg the Bodleian Library at Oxford; others are more limited. Nearly all will be likely to have special collections of material relating to prominent men and women who attended the university.

SOCIETIES

Societies and professional bodies generally have a library of some sort, though rarely a picture library as such. If you are a member, access is generally easy enough; if not, get in touch with the Secretary or the Librarian. Most societies welcome outside interest, but only when it is serious in character and more likely to aid their purpose than harm it.

9 USEFUL BOOKS

To own, or at least have easy access to, a selection of reference books can save an enormous amount of footwork and telephone-time. Every researcher will build up a personal reference shelf according to taste and needs; here is a selection which have been found consistently useful by many professional researchers.

OTHER GUIDES TO SOURCES

No book lists every picture source in the world — or even attempts to. The only other guides which are at all up-to-date are:

REPERTOIRE DES COLLECTIONS PHOTOGRAPHIQUES EN FRANCE (4th edition 1972)
Published by Editions de la Documentation Francaise, 29—31 quai Voltaire, 75340 Paris, France

A directory of more than 700 photographic archives in France, with description of material held. LIsted alphabetically, but with geographical and subject indexes.

PICTURE SOURCES 2 (2nd edition 1963)
Published by Special Libraries Association, 235 Park Avenue South, New York, NY 100003, USA

Guide to 700 sources, mainly American but with some international sources. Subject index, description of availability and indication of scope of material. The 3rd edition is scheduled for publication in 1974.

OTHER ADDRESS BOOKS

NATIONAL UNION OF JOURNALISTS FREELANCE DIRECTORY (annual)
published by the NUJ, and edited for them by Hollis Press
Order from NUJ (attention Mr Jim Nash), Acorn House, 314 Grays Inn Road, London WC1X 8DP, England

A directory listing all members who wish to be included; these include not only reporters, writers and illustrators, but also photographers who are available for commissioning. There is an area directory to guide the researcher to a photographer located near to the museum or site to be photographed.

INSTITUTE OF INCORPORATED PHOTOGRAPHERS (annual)
published by the IIP, Amwell End, Ware, Hertfordshire SG12 9HN, England

Many hundreds of member photographers. Cross-references by subject. Mostly British, but a substantial number of overseas members.

WRITERS AND ARTISTS YEARBOOK (annual)
published by A & C Black, 4, 5 & 6 Soho Square, London W1V 6AD, England

Directory of journals and publishers in Britain, Commonwealth and the United States. Useful subject guide to magazines. A brief list of picture sources. Full guide to syndicates, press and news agencies.

LITERARY MARKET PLACE (revised annually)
published by R R Bowker Co, 1180 Avenue of the Americas, New York, NY 100036, USA

Business directory of American publishing, listing publishers, journals and photographers.
Bowker's also publish **INTERNATIONAL LITERARY MARKET PLACE** which is available in a European edition; this gives detailed information about 1700 publishers in 26 European countries, including Britain.
(Note: Bowker's catalogue of reference books in print is worth getting hold of, as these include many directories of a highly specialised nature which could be valuable reference for specialist research — eg American Art Directory, Photographic literature, Guide to reference material and World guide to libraries.)

INTERNATIONAL DIRECTORY OF ARTS (2 volumes)
(the 1970 edition was the 10th since publication began in 1949)
published by Deutsche Zentraldruckerei AG, 1 Berlin 61, Dessauerstrasse 6—7, Germany

Basically German text, but with introductory notes in 4 other languages to enable foreigners to find their way about the guide. It lists addresses of museums, universities, artists, collectors, dealers, galleries and art publishers.

THE WORLD OF LEARNING (2 volumes) (bi-annual)
published by Europa Publications, 18 Bedford Square, London WC1B 3JN, England

An international guide to the academic world. Lists (by country) academies, learned societies, research institutes, libraries and archives, museums and universities.

THE LIBRARIES, MUSEUMS AND ART GALLERIES YEARBOOK (annual)
published by James Clarke & Co, 7 All Saints Passage, Cambridge, England

Directory to public and special libraries, museums and art galleries of the United Kingdom and Eire. Subject index to special collections in these establishments.

MUSEUMS AND GALLERIES IN GREAT BRITAIN AND IRELAND (annual)
HISTORIC HOUSES, CASTLES AND GARDENS IN GREAT BRITAIN AND IRELAND (annual)
published by Index Publishers, Oldhill, London Road, Dunstable, Bedfordshire, England

Both are relatively inexpensive large-format paperbacks, listing the establishments their titles indicate. Alphabetical and subject indexes and details of opening hours.

PHOTOCOPIES FROM ABROAD
published by Federation Internationale de Documentation, 7 Hofweg, Den Haag, Netherlands

Microfilming is being ever more widely used, and though not generally suited for reproduction techniques, the directory of photocopying and microcopying services can be useful. It is a slim booklet which lists museums and libraries in 38 countries which offer comprehensive photocopy and microfilm services.

ASLIB DIRECTORY OF INFORMATION SOURCES
published by Association of Special Libraries and Information Bureaux, 3 Belgrave Square, London SW1, England
Covers Medicine, the Social Sciences and the Humanities. Last edition 1970.

BASIC REFERENCE BOOKS

An atlas: choose the one with the most names. It would be hard to beat The Times atlas of the world. A biographical dictionary: for most purposes, the wonderful Webster's Biographical Dictionary is unbeatable — beautifully legible, giving just the basic facts about its subjects, and not too bulky. For British people, the concise DNB (Dictionary of National Biography) is indispensable. Extraordinarily enough, there seems to be no equivalent in any other language! If you do much historical research, Burke's or Debrett's Peerages are worth acquiring — you can get hold of secondhand copies without too much expense. Similarly with Who's Who.
A dictionary of dates: it's worth scouring secondhand bookshops for a copy of *Haydn's Dictionary of Dates,* which was published regularly during the last decades of the 19th century. It remains better than anything published since, though there are quite useful books of the type obtainable today.

BOOKS TO BE FAMILIAR WITH IN LIBRARIES
ALA PORTRAIT INDEX (2 volumes)
published by Burt Franklin, 235 East 44th Street, New York, NY 10017, USA

First published in 1906, compiled by William Coolidge Lane and Nina Browne. This is a dictionary of internationally famous personalities with accurate references to engraved or printed portraits and the publications where they appeared. If a person is not included in the index, it does not necessarily follow that no portrait exists — but it makes it extremely unlikely.

CATALOGUE OF COLOUR REPRODUCTIONS OF PAINTINGS (2 volumes)
VOLUME ONE: PRIOR TO 1860 VOLUME TWO: 1860 to 1961
published by UNESCO, Paris

Thousands of black and white reproductions, approximately 5 cm square, of great works of art, with reference to their sources and to the publishers and printers of colour reproductions. Listed by artist, this is a very useful visual reference tool.

BRITISH BOOKS IN PRINT
published by Whitaker

A useful indication of what books are being published on any subject. There is a form of subject guide.

SOURCES OF ILLUSTRATION
published by Adams & Dart, Bath, England (1971)

Compiled by Hilary and Mary Evans, this is a basic introduction to non-photographic illustration, with notes on techniques and reproduction and a great many illustrations showing the type of illustrations produced at various periods. Specifically designed for the picture researcher rather than the specialist reader.

Two useful pictorial references for Natural History:
LAROUSSE ENCYCLOPEDIA OF ANIMAL LIFE (published in France originally, but available in an English-language edition from Hamlyn (1972))
LIVING WORLD OF ANIMALS (published by Reader's Digest)

PICTURE SEARCHING — TECHNIQUES AND TOOLS
published by Special Libraries Association, 235 Park Avenue South, New York, NY 100003, USA

Compiled by Renata Shaw, a bibliographic specialist, this is an illustrated bibliography of picture research, designed to guide the researcher through the available reference material.

CATALOGUES AND OTHER PUBLICATIONS
Many of the sources listed in our handbook offer catalogues to their collections. We have mentioned wherever this is the case, and it is well worth while making a collection of such catalogues in your field. Most commercial subject lists are free; those that have to be paid for, like that of Giraudon, are well worth the investment. Here are some of the sources whose catalogues are of special interest: GIRAUDON; BETTMANN ARCHIVE; BULLOZ; LIBRARY OF CONGRESS; NATIONAL POR-TRAIT GALLERY, LONDON; VICTORIA & ALBERT MUSEUM (PHOTOGRAPHS).

You will also find that many of the publications put out by various establishments are a useful guide to their resources. This is true of most museums, and in Britain a visit to a branch of Her Majesty's Stationery Office discloses many excellent publications valuable both as reference books and as guides to the visual material available at the Science Museum, the Victoria & Albert, and so forth.

USING LIBRARIES
Using libraries is an art in itself, and one which is well worth developing. An idle afternoon spent browsing round your local library (find the nearest one with a good reference section) can pay off handsomely on some subsequent occasion when you are pressed for time. The staff will often help by letting you study published lists of reference books available at their branches. Note, too, where are the nearest runs of journals such as *Punch* or the *Illustrated London News* in Britain, *Harper's Weekly* or *Scientific American* in the United States, *L'Illustration* in France and its equivalents in other countries.

S. Thomas de aqui
no doctor

Thomas de aqno ordinis pdicatoz doctor. alberti magni discipulus er in
signi comitū familia. in cōfinibus apulie z sicilie originē durit. Cū motus
regni sicilie varij essent. doctrine ac religionis viā tranisse videt. Quo iu tpe Cō
radus er gente sucua trupatoz aqnū vastas. Thomā parētes ei² genere nobiles.
et in oppido primarij prīa. psugi. cassinēsis cenobij nonachis comendatū reliq
rūt alendū. vbi lrīs ac religioni operā dare cepit. Eius em pr landulfus noie. mr
theodora e neapoli originē habuit. Qui z in ipis infantie rudimētis dei gra pre
ditus deinde ordinē diui dnīci ingressus religiosissimā psectissimā vitā vlqȝ in
sinē exegit. Ubi etiā pter doctrinā maximā ad eā peruenit doctrine excellentiam
vt nemini phie z theologie scia secudus habeat. Coloniā ei pgens tantū profe
cit vt post aliqs annos apud pisius primū in doctrina locum teneret. Ubi qtuor
libzos in sentētias edidit. inde angelicus doctor appellatus. romā deinde ab vr
bano accersitus spretis dignitatib⁹ q̄ vltro offerebantur. totū z iectioni et scripti
oni dedit. Et eius rogatu multa cōscripsit. Reliquit post summā theologie i tres
ptes diuisam i qstiones distinctā. Summā z gentiles. Cathenā aurea. In qtuor euāgelia. Cōmentaria in
bibliā. Et Aresto. libzos z plima alia. Totam qz naturalē philosophiā ac mozalē cōmentationibus erpo
siut. Declarauit z Job. Cōposuit z officiū de rp̄i cozpe. Quo i opere plime figure ve. testa. cōtinentur.
Qui etiā miraculoz gloria nōatissimus euasit. tandē iterato romā vocatus vt ad pciliū lugdunēse p Gre
goriū. r. celebzandum accederet pperas. cū apud cassinū mōtem fuisset infirmitate cozre pt⁹ Anno domini
1274. sanctissime migrauit ad dnm. Nonis marcij. Quē postmodū toannes. 22. pōtifer. pter crebza mi
racula in sanctozum confessozum z doctozum numero aggregare voluit. Apud auinionē. rv. kal. augusti
Anno. M. cccrriij. a transitu eius er mūdo quinquagesimo.

Carolus rer

Arolus ludouici regis frācoz frater manfredo rege interfecto a clemēte pa
pa sicilie rer declaratus. regnauit annis. 7. atqz ita paulopost sicilie z apu
lie regna in suā prātem redegit. In quibus cōpositis rebus euestigio viterbiuz
cū vniuerso exércitu ad pontifice venit. vbi audiens conradinū adolescentē cōu
radi sucui nepote in ytalia a gibellinis z guelphos fuisse vocatū. In etruriam.
gibellinos domitos illico venit. ibiqz magna de hostibus strage edita. cōradi
nū cepit z capitali sentētia pūniuit. Inde in regno confirmatus pacem cum pi
sani z iuijt. Et cū eis in aphricā i ludouici regis germani sbsidiū traiecet. Ibiqz
ludouico sre er peste mozto inuēto cū Tunici rege pace hac lege cōposuit. vt p
petuo annis singulis sibi suisqz successozibus tributū aliquot pēderet. inde i re
gnū rediit. vbi petro aragonēsi siciliā se sbdidisse reperit. dēiqz z ipse carolus mozit. z neapoli sepelitur.
Huic ideo hierosolimoz regnū declaratum fuit. qz maria antiochie principis filia cui id regnū debebatur
(qd hugo eius nepos occupauerat) illud carolo huic regi deuouerat.

Ecta flagellantiū in ytalia oztum habuit. Et inde in
Alemāniam z gallia. pgressa bifarie. qui se nodosis
flagellis in qbus aculei inserti erant flagellabant ad oste
tatione. Er qua secta multi graues errores pullulabant.
in plerisqz locis circa fidem. z sacrameta ecclie. Que po
stremo in pte igne z gladio exterminata fuit.

Erunt theologi hāc ozationem a summis viris lau
datam hac tempestate. Benedictum sit dulce nome
domini nostri ihesu christi. z gloziosissime virginis ma
rie matris eius internum et vltra amen. Nos cum pzole
pia benedicat virgo maria amen. Et q̄ hec legerit vel ora
uerit de singulis iterationibus auctozitate Clementis pa
pe ob petitōnem ludouici sancti regis francie tres annos
indulgentiarum habebit.

Ppilippus rer

Hilippus sancti ludouici regis filius patre germano in affrica defunctis.
ibidem regiū munus suscipiens regnauit annis quindecim. Uir certe vite
sanctimonia patri persimilis. qui vitande contagionis causa pmotus. dimissa
aphrica. in ytaliam adnauigauit. pacem inter genuéses z venetos ad quinquē
niū composuit. Adulta quoqz z laudabilia pzo fide christi tum domi tū fozis er
egit pietatis opera. Et iter cetera memozatu digna beate marie magdalene coz
pus massilie iam diu a beato maximiano in villa sui nominis cōditum. oznatio
re sepulcro. z maiore sacello exoznauit. Eiusqz caput seozsum in theca argētea re
cludens. Alia quoqz cōsimilia z multo maioza confecit opera.

WOODCUT
A page from the *Nuremberg Chronicle*, 1484

WOOD
ENGRAVING
Pittsburg Landing
during the American
Civil War; from the
Century Magazine,
1887

Easington the Seat of Nathaniel Stevens Esq.

LINE
ENGRAVING,
COPPER
View of Easington,
Gloucestershire,
drawn and engraved
by Jan Kip, 1712

LINE ENGRAVING, STEEL
The River Wharfe at Bolton, published by Rock & Co (circa 1850s)

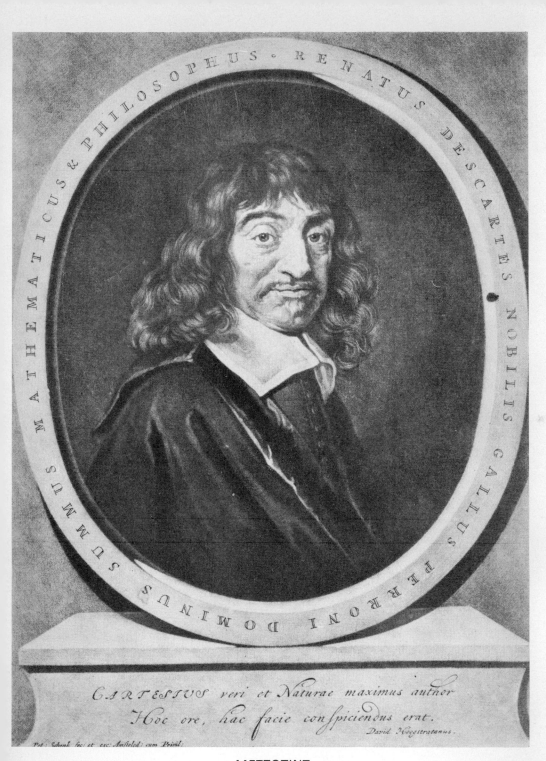

MATHEMATICUS & PHILOSOPHUS · RENATUS DESCARTES NOBILIS GALLUS PERRONI DOMINUS SUMMUS

CARTESIUS veri et Naturae maximus author
Hoc ore, hac facie conspiciendus erat.

David Hoogstratanus.

Pet: Schenk fec: et exc: Amstelod: cum Privil:

MEZZOTINT
Portrait of René Descartes, engraved by Pieter Schenck after Frans Hals (late seventeenth century)

ETCHING
La Place de la Concorde, with mad Fantasy on the Sky, by Charles Méryon (circa 1850)

AQUATINT
Portrait of Richard Badham Thornhill, engraved by Medland from a painting by Bell, 1804

LITHOGRAPH

A Hot Day in the Battery, scene from the Indian Mutiny, by G. F. Atkinson (circa 1858)

PART TWO

DIRECTORY OF SOURCES

A: GENERAL

G1 Public Collections, Historic and Modern

G2 Commercial Historical

G3 Commercial Modern

This type of source is likely to possess the finest historical material from the quality point of view, and often as regards quantity also. On the other hand, it is less likely to possess more fugitive categories of material. State archives tend to be concerned with state affairs, and while the Bibliothèque Nationale no doubt has a magnificent choice of pictures of Marie Antoinette losing her head, one would be far less likely to find there a picture of a servant girl of the period sweeping a floor. So patronise the public collections for the cornerstones of history; then for your 'filling-in' material turn to the commercial historical sources listed in section 2.

BRITAIN and EIRE

AUSTRALIAN NEWS & INFORMATION BUREAU, LONDON

Modern photographs of Australian subjects

Address	Canberra House, Maltravers Street, Strand, London WC2R 3EH, England
Phone	(01) 836 2435
Apply to	Pictorial Librarian.
Credit	Australian Information Services.
Material	Photographs of all aspects of Australian life, including history and natural history. Extremely helpful staff who can supply most black and white needs immediately, obtain colour material, and advise on other sources. Period — early Australian history to present. Number — 60,000.
Availability	Research by staff. Requests by writing, phone or visit. Appointment preferred. Hours — Monday to Friday, 9 to 5.
Procedure	Material loaned. No fees.

BODLEIAN LIBRARY/Department of Western Manuscripts

Manuscripts, Western and oriental: early Mexican pictures

Address	Department of Western Manuscripts, Bodleian Library, Oxford, OX1 3BG, England
Phone	(0865) 44675 extension 305
Telex	83656
Apply to	for colour filmstrips: Miss E Arkell for black and white photos: Keeper of Western MSS (exact references must be given on official photographic orders) enquiries about European illustrated manuscripts, *write* to Dr W O Hassall
Credits	Include exact reference to original ms (eg 'Ms Ashmole 1504 f.–') or filmstrip (eg 'Bodleian Library coloured filmstrip roll 156b')
Material	The Bodleian possesses one of the world's finest collections of manuscripts — English, European, and Oriental. Access to these originals is necessarily restricted to researchers with the very highest credentials and who can establish a case for such access; this must be established after verbal discussion and confirmed in writing. However, a very large proportion of the most significant manuscripts have already been photographed in colour, and transparencies of these are readily available at a moderate price. The *Colour Transparencies catalogue* (free on request) is therefore an essential first step. It gives detailed lists of many hundreds of strips of transparencies, normally supplied in sets and generally with an accompanying handlist giving detailed information.
Availability	Much material can be obtained by catalogue and order form. Researchers who wish for personal access to the library must have a Reader's Ticket, which must be obtained in advance and for which a recommendation by a person of recognised standing is necessary. An application form for a Reader's Ticket can be obtained by writing to the *Bodley's Librarian*. Requests by writing, phone (before 4pm) or visit. Written authorisation required in first instance. Appointments should be made if a particular individual is needed, to ensure his/her presence at any given time. Hours — the library is open Monday to Friday, 9am to 10pm in term, to 7pm in vacation; Saturday 9 to 1. For best service researchers are advised to call between 10 and 10.30am, 2.30 and 3.30pm. The Library is closed in the week containing the August and September bank holiday, at the Encaenia, and between Xmas Eve and New Year.
Procedure	Material not loaned, copies made. Fees: reproduction, sometimes service (payable to Bodleian)

Photostat service and photocopy (payable to University Printer)
Many specific catalogues available. Pricelist of transparencies free on request. Detailed handlists of individual filmstrips are available at 25p, or free if the filmstrip is purchased.

BRITISH MUSEUM

This vast national archive is so complex in its scope and in its arrangements that we felt it would be more useful to readers to abandon our normal format and adopt an individual approach suited to the establishment itself.

General notes on using the facilities

The museum comprises a number of departments each of which has its own procedural methods as well its own material. But one thing is common to all: collecting and maintaining the collection is the primary function of the museum, making that material accessible to the researcher is only secondary. This general principle lies behind much of the advice which follows.

Two basic rules follow at once: first, allow time for your work — do not expect a service geared to commercial requirements; and second, arm yourself before your visit with as much information as you can, and be sure you have a clear idea of what you are looking for.

Application for help will meet with every co-operation from the staff, so long as these rules are followed. They will be impatient only when it becomes apparent that the researcher has failed to study the subject or obtain a proper briefing, and that the museum staff are in fact being asked to do the research.

In all departments, telephone requests will be answered helpfully if they are specific and simple: more complicated requests should be submitted in writing to the head of the appropriate department. An appointment will then be arranged for your visit, and an assistant will give you the necessary guidance to start your research.

Some specific suggestions:

1 Use the Reading Room for information-gathering, before applying to any special department.
2 Carry a good supply of pencils and paper with you. Some departments insist that only pencils may be used.
3 All departments tend to be completely full at peak hours of the day; it is advisable to go early to be sure you have a seat, and in some departments you will be admitted only if there is a vacant seat.
4 Consideration, both as regards your fellow-researchers and when handling the material, will encourage staff to be co-operative.

THE READING ROOM
Hours: Monday, Friday, Saturday — 9 to 5 (last orders for books 4.15).
Tuesday, Wednesday, Thursday — 9 to 9 (last orders 8pm).

Admission is by ticket (short or long term). Start by writing to the Director of the department for an application form. Allow several days for reply. Your ticket will admit you also to the Newspaper Library (see Section 1) and the State Paper and Map Room.

Using the Reading Room. Choose a seat, leave something there to show that it is occupied, note its number (you will need this). Then find the index you want — these are shown on the plan of the room in the leaflet 'Notes for Readers' which is available at the entrance.

There are two main indexes, the *General Catalogue* and the *Subject Index*. At the desks you will find slips of paper for ordering books: you must provide your name, your seat number, and the information from the index. The General Catalogue gives complete information; the Subject Index is not so accurate and should be cross-checked. Place the completed slip in the tray at the Applications for Books desk. You may order up to twelve books at a time.

You may have to wait some time for your books to arrive (some are stored at Woolwich and will take over 24 hours, but these are exceptional! — a list of shelf marks is available for you to make sure yours is not one of them.) Books destroyed in the war are marked 'D' in the general catalogue.

While waiting for your books, you may use the reference books on the open shelves. Books may be taken to your seat, but you must replace them yourself.

If you are too busy to wait for your books, put no seat number on the slip but write 'RESERVE' and a date when you can return. Return the day *after* that date, or later that day, and the books will be waiting at the Reserved Books Desk. Before you leave the slips, note the books you have ordered, as this information will be required when you collect your books, together with your new seat number. Reserved books will be kept for 48 hours from the date you specify.

You may leave books on your seat for up to 1 hour, for lunch etc, but if leaving for longer return them to the Reserved Books desk; otherwise staff will clear desks unoccupied for prolonged periods.

When you have finished with a book, return it to the Centre Desk and obtain your slip in return. If you want to reserve it for the following day, complete the small yellow slip near the Centre Desk and hand the book in there. You can subsequently collect it from the Reserved Books desk.

Occasionally you will order a book which necessitates a move to the North Library. In this case, you must not carry any book through, it must be transferred by the Central Desk. First find a free place in the North Library; then give the seat number to the Centre Desk with your books. They will complete the transfer. The North Library will also reserve books for 48 hours.

Photography from books is carried out in the same way as for prints and drawings, see note at the end of the notes on the that department.

The MAP ROOM is open Monday to Saturday, 9.30 to 4.30. Regulations for use are available in the Reading Room.

The STATE PAPERS ROOM is open Monday, Friday and Saturday, 9.30 to 4.45, and Tuesday, Wednesday and Thursday, 9.30 to 8.45. The British state papers are housed at Bloomsbury, some others may be stored elsewhere; the staff will inform you of the arrangements.

DEPARTMENT OF MANUSCRIPTS
Hours: Monday to Saturday, 10 to 4.45.

Admission is by ticket. Start by writing to the Director of the department for an application form.

Using the department. Choose a seat and ensure it is clearly occupied. Then consult the indexes, which are in large books along the left-hand wall of the main room. Most have got subject indexes; the 'Kings' and 'Royal' are the nicest, while those which, like the Cotton MS, are in Latin, can be irritating; it can be worth taking a Latin dictionary with you.

The indexes must not be taken to your seat, but studied at the counter near their place on the shelf, and returned after use. The staff in this department are particularly busy and can give little help in your research; however, a useful book for beginners which you can take to your seat is EARLY DRAWINGS AND ILLUMINATIONS, by Jenner and Birch (shelf no SR 19, on the top wall, left-hand side, of the Student's Room). This is a subject index to most of the illuminated Manuscripts in the collections. It is not up-to-date, the references are neither wholly accurate nor complete, but it gives useful subject advice and provides shelf marks which touch on your subject.

British Museum (continued)

Make as full notes as you can of items which seem interesting — shelf mark, captioning information, folio number (verso or recto). With this information, try to trace your manuscript in the card index at the top end of the room; this lists all manuscript pages which have been photographed. If you find it, add all possible information, including negative, ektachrome and 35mm transparency numbers. At the bottom of the card there will probably be a 'Print Reference Number' which will guide you to a black and white print in the PRINTS FROM MS NEGATIVES albums — large off-white books stored on the shelf under the card index boxes. If there is no print reference number, apply to the enquiry desk in the Students Room with your 35mm number, and ask to be shown the transparency if available. These are stored in the inner room, which also has a subject index to photographs (incomplete).

If you find no trace of your manuscript in these files, you will have to apply to see the original; do this only if it is really necessary, partly because all handling however careful tends to damage the manuscript, and partly because now you will have to find a new seat, in the inner room this time, which is specially reserved for such items. While waiting for your manuscript to arrive, study the stringent regulations. If you decide this is a good time for a coffee break, tell the staff, for they will not leave a manuscript at an unattended seat.

When your manuscript arrives, note any information pencilled on the front or title page, as these will refer you to publications which could give you additional information about the manuscript.

If you have to leave the room for any reason, reserve the manuscript at the enquiry desk. When you have finished, return the manuscript to the desk and obtain your slip.

Photography of manuscripts is only by Museum Staff. 35mm transparencies of the most popular items can be ordered from a list available near the enquiry desk.

DEPARTMENT OF PRINTS AND DRAWINGS
Hours: Monday to Friday: 10am — 1pm; 2.15 — 4pm.
 Saturday 10am — 12.30pm.

1 ADMISSION
Application to study the collections is made by completing form B M Students 8A which asks applicants to state their occupation and the purpose for which they request admission. The applicant must obtain a signed recommendation (space for which is provided on the form) from a person of recognised position who can be identified from the ordinary sources of reference and who is not related to the applicant. Applicants must be eighteen years of age or over.

Tickets of admission are valid for one year.

2 COLLECTIONS
The Department of Prints and Drawings illustrates the history of Graphic Art in Europe from the fifteenth century to the present day. It does not include oil-paintings or miniatures, and the staff of the Department do not reckon to answer enquiries on these subjects.

The main collections are arranged under the names of the artists by Schools eg British, Dutch and Flemish, French, German, Italian.

There are, besides, subsidiary collections of Sketchbooks, Albums, Books of prints, Historical material (British and Foreign), Topographical prints, Engraved Portraits (British and Foreign), Fans, Trade Cards, Playing Cards, Book-plates and Satirical prints.

3 PUBLICATIONS
The following is a list of books that should be consulted. In addition to the official catalogues, there are others, mainly collections later acquired by the Department, as well as the standard oeuvre catalogues (eg Bartsch, Hollstein, Lehrs etc) in which the Museum's holdings are indicated.

Frederick Crace:	*Catalogue of his Collections of London Views and Plans* 1878, 2 vols
J C Robinson:	*The Malcolm Collection* 1876
A J Finberg:	*Inventory of the Turner Bequest* 1909, 2 vols
A E Popham:	*The Phillipps Fenwick Collection* 1935
J W Archer:	*Catalogue of his Drawings of Old London*
A M Hind:	*Early Italian Engravings* 1910, 2 vols
W H Willshire:	*Early German and Flemish Prints* 1873–83, 2 vols
Campbell Dodgson:	*Early German and Flemish Woodcuts* 1903–11, 2 vols
Freeman O'Donoghue and H M Hake:	*Engraved British Portraits* 1905–25, 6 vols
F G Stephens and M D George:	*Political and Personal Satires* 1870 etc, 12 vols
A E Popham and P Pouncey:	*Italian Drawings, The Fourteenth and Fifteenth Centuries* 1950, 2 vols
Johannes Wilde:	*Italian Drawings. Michelangelo and his studio* 1953
P Pouncey and J A Gere:	*Italian Drawings. Raphael and his Circle* 1962, 2 vols
A E Popham:	*Italian Drawings. Artists working in Parma in the sixteenth century* 1967, 2 vols
A H Hind and A E Popham:	*Dutch and Flemish Drawings* 1915–32, 5 vols
A M Hind:	*Catalogue of an Exhibition of the Drawings of Claude Lorraine* 1926
Edward Croft-Murray and P Hulton:	*Catalogue of British Drawings XVI and XVII centuries* 1960, 2 vols
Laurence Binyon:	*Catalogue of Drawings by British Artists* 1898–1907, 4 vols
W H Willshire:	*Playing and other Cards* 1876
Sir Lionel Cust:	*The Schreiber Collection of Fans and Fan-leaves* 1893
Freeman O'Donoghue:	*The Schreiber Collection of Playing Cards* 1901
E R J Gambier Howe:	*Catalogue of Book plates bequeathed to the British Museum by Sir A W Franks* 1903–4

4 USING THE DEPARTMENT

Visitors to the Department should as far as possible undertake their own research. They can consult the Index of Artists represented in the collection, in which artist's work is broken down into categories (eg 'drawing by', 'etchings and/or engravings by', 'prints after' etc), and also the card index of the Departmental Library. The library includes all the existing catalogues of sections of the collection.

The visitor fills in a slip with details of the material or book required, which is then brought by one of the staff.

5 ENQUIRIES BY POST

When making enquiries by letter, writers are asked whenever possible, to consult the published catalogues and to provide an exact reference. While every facility is given for studying the collection, they cannot engage in correspondence involving lengthy research. (Schoolchildren with 'projects' should find all the information that they require in the reference section of a public library). Enquiries involving consultation of material or research of any kind cannot be dealt with on the telephone.

6 PHOTOGRAPHY

Photographs, 35mm trasnparencies and ektachromes are obtainable from the photographic section of the Museum. Applications must be made by letter or by completing a photographic form. Each item

must be identified by the Departmental reference number or by giving a catalogue reference. Outside photographers are permitted to photograph in the Department at the discretion of the Keeper or his representative.

The cost of photographs can be reduced by ordering prints from the large stock of negatives already held by the Department, of which there is a card index that can be consulted by visitors. A list of 35mm transparencies of which the Department holds master copies can be sent on request.

7 EXHIBITION GALLERY

The Exhibition Gallery adjoining the Students' Room is open from 10am – 5pm Mondays to Saturdays; Sundays 2.30 – 6pm. In it are held temporary exhibitions drawn from collections of the Department, usually illustrating a particular theme.

CENTRAL OFFICE OF INFORMATION, PHOTOGRAPHS LIBRARY

Historical and modern pictures depicting British way of life and that of British dependencies

Address	Hercules Road, London SE1 7DU, England
Phone	(01) 928 2345 extension 707/8
Material	The COI is a government institution which in effect acts as an official press or public relations office for the nation. In the course of these activities it has created a library of illustrative material, derived from official and commercial agency sources, which gathers together a wide range of items depicting the British way of life both at home and in United Kingdom dependencies. These facilities are available to the general public as with any other type of source. Number – 200,000 black and white, 40,000 colour.
Availability	Research by staff or researcher. Material cannot be sent out on approval or loan, but the librarian will make selections to specific briefs, provided the customer is willing to accept selections so made. Visitors are welcome to make their own selection. Requests by writing, phone or visit. Appointment preferred. Hours – Monday to Friday, 10 to 4.
Procedure	Material copied if black and white, colour transparencies loaned. Fees: reproduction (normal commercial rates).
Notes	Since all prints must be purchased, it is advisable to state, if ordering by letter, roughly how many prints are required on any given subject. Prints of official subjects can be supplied within a few days (24 hours for press enquiries).

COMMONWEALTH SOCIETY LIBRARY, ROYAL

History of the British Commonwealth

Address	Northumberland Avenue, London WC2, England
Phone	(01) 892 2398
Apply to	Mr D H Simpson, Librarian.
Material	Photographs, prints and engravings (chiefly in books), a few original paintings and drawings, some manuscripts, relating to the history of the British Commonwealth and the countries which compose it. The collection of some 400,000 books contains a great many illustrated items. The photographic collection is partly in albums, partly in separate prints: these total some 23,000 items. The collection is well indexed and the staff will give every assistance, particularly to personal visitors. Period — 16th century to present.
Availability	Research by staff or researcher. Requests by writing or phone, but preferably by visit. Appointment desirable, delay 2 days. Hours — Monday to Saturday, 10 to 5.30.
Procedure	Material not loaned, copies made. Fees: reproduction.

EDINBURGH CORPORATION, LIBRARIES AND MUSEUMS DEPARTMENT

Edinburgh and Scotland in general

Address	George IV Bridge, Edinburgh EH1 1EG, Scotland
Phone	(031) 225 5584
Apply to	City Librarian.
Credit	'By courtesy of Edinburgh Public Libraries'.
Material	All types of material relating to Edinburgh and Scotland, plus a fine art collection. There are three basic collections: 1 The Scottish Library. Some 65,000 books and prints covering all aspects of Scottish life and history. All standard books are held, plus Scottish family histories in a special collection. There is a map collection. The photographic collection includes the Grant collection of life in the Highlands and Islands, and the Thomas Keith and D O Hill collections.

Edinburgh Corporation (continued)

2 The Edinburgh Room. Some 18,000 prints and illustrations of Edinburgh, comprising views and scenes of daily life. Photographs from 1840s to present. Also books, maps, plans, old newspapers (from 1710 to the present).
3 The Fine Art Library. (not limited to Scottish material). Prints and transparencies on all aspects of the fine arts except music, with an extensive reference section.

Availability Research by staff.
 Requests by writing, phone or visit.
 Appointment preferred if enquiry is complicated.
 Hours — Monday to Friday 9 to 9, Saturday 9 to 1.

Procedure Material not loaned, copies made. (Photocopying service available)
 Fees: Reproduction.
 Leaflets describing the resources and services of each of the three divisions described above are available on request.
 Photostat service.

Notes Each of the Library's publications carries the words 'The Staff are always willing to help' and from personal experience the editors can confirm that this is true. This must surely be one of the most helpful as well as one of the best organised public collections listed in this Handbook.

HER MAJESTY'S STATIONERY OFFICE

All material covered by Crown Copyright

Address Copyright Section, Atlantic House, High Holborn, London EC1P 1BN, England

Phone (01) 248 9876

Apply to The Controller.

Material Photographs: English and Scottish Crown Regalia, Royal Gold Plate in the Jewel House, Robes of the Orders of Chivalry, Orders of Chivalry.
 Crown Copyright also relates to material from HMSO publications (unless specifically acknowledged to another source and HM Government publications). It also governs certain national museums and government offices and in cases of any doubt, application should be made to the Controller.

Availability Research by researcher.
 Requests by writing or visit.
 Appointment required.
 Special acknowledgements required:
 UK and Commonwealth: 'Crown Copyright, reproduced by permission of the Controller of Her Britannic Majesty's Stationery Office'.
 Others: 'British Crown Copyright, reproduced by permission of the Controller of Her Britannic Majesty's Stationery Office'.
 Advertising: Not permitted for Crown Regalia Items.

Her Majesty's Stationery Office (continued)

Procedure Requests must be in writing with precise details of items required and purpose of publication.
Hours — weekdays, 9 to 4.
Some material loaned, others copied.
Fees: reproduction and hire.

Notes Supply of pictures does *not* authorise publication. Ordnance Survey maps are covered by a different department and applications should be made to: The O.S. Office, Romsey Road, Marybush, Southampton SO9 4DH.

INDIA OFFICE LIBRARY AND RECORDS

History of India and South-East Asia

Address Orbit House, 1—7 Blackfriars Road, London SE1, England

Phone (01) 928 9531

Apply to Prints and drawings section.

Material Photographs, prints and drawings, original paintings of all aspects of life and events in India and South-East Asia from about 1700 to the present. There are special collections of drawings by British and native artists, natural history drawings, photos from an archaeological survey of India and 350 separate photographic collections. Expert and helpful staff.

Availability Research by staff or researcher.
Requests by writing, phone or visit.
Appointment necessary, delay 7 days.
Hours — Monday to Friday, 2 to 5.

Procedure Material not loaned, copies made.
Fees: none at present, but may be introduced.
Substantial (and correspondingly costly) catalogues of some material are available, published by Her Majesty's Stationery Office.
Photostat service.

IRELAND, NATIONAL LIBRARY OF

Ireland and Irish affairs, 1700 to 1930

Address Kildare Street, Dublin 2, Eire

Phone (0001) 65521

Ireland (continued)

Apply to The Director.

Material Photographs, prints and engravings, original paintings and drawings covering people, places and events of Irish interest. The director and his staff are always most helpful with enquiries, but requests should preferably be as specific as possible.
Period — 1700 to 1930.
Number — 7000 engravings, 40,000 photographs.

Availability Research by staff.
Requests by writing, phone or visit.
Written authorisation required in first instance.
Appointment preferred.
Hours — Monday to Friday, 10 to 5.

Procedure Material not loaned, copies made.
Fees: reproduction.
Photostat service.
Catalogues: Irish topography, Irish portraits.

LONDON MUSEUM, THE

History of London

Address Kensington Palace, London W8, England

Phone (01) 937 9816

Apply to either: The Librarian, or Curator of Prints and Drawings, or Photographic Department.

Material Photographs, prints and engravings, original paintings and drawings, costumes and other ephemera relating to the history of London, with a strong emphasis on daily life.
Period — earliest times to present.
Number — 20,000.

Availability Research by researcher.
Requests by writing, phone or visit.
Appointment preferred.
Hours — Monday to Friday 10 to 5, Library and Photographic Department also open Saturday 10 to 5.

Procedure Material not loaned, copies made.
Fees: reproduction, search, service/handling.
Many catalogues available; list supplied on request.

Notes Photographs of objects and works of art, including photographs of prints and drawings, are held by the Photographic Department. The Print Room houses only the *original* prints and drawings.

NOTTINGHAM UNIVERSITY LIBRARY, MANUSCRIPTS DEPARTMENT

Specialist areas of history, literature and natural history

Address University Park, Nottingham, NG7 2RD, England

Phone (0602) 56101

Apply to Keeper of the Manuscripts.

Material Photographs, prints and engravings, original paintings and drawings, illuminated
 manuscripts, maps, documents and other material relating to the following fields:
 Historical — particularly 16th to 18th centuries.
 Literary — special D H Lawrence collection.
 Natural history — particularly 17th century.
 The staff are very helpful, and a visit is well worthwhile. The collections are well
 arranged, and easily accessible for the researcher.

Availability Research preferably done by researcher.
 Requests by writing, phone or visit.
 Written authorisation required in first instance.
 Appointment preferred, if possible 7 days ahead.
 Hours — Monday to Friday, 9 to 5.

Procedure Material not loaned, copies made.
 Fees: reproduction, search, handling.
 Photostat service.

SAINT ANDREWS UNIVERSITY LIBRARY

History, chiefly Scotland and St Andrews area

Address South Street, St Andrews, Fife, Scotland

Phone Saint Andrews 4333

Telex 76213

Material Photographs, prints and engravings, original paintings and drawings on general
 subjects, with the emphasis on Scottish scenes and events and particularly the St
 Andrews district. The archives of Valentine & Sons view postcard business are one of
 the special collections, and there are local photographs of the region dating from
 1839!
 Period — middle ages to present.
 Number — over 100,000.

Saint Andrews (continued)

Availability Research by staff or researcher.
 Requests by writing, phone or visit.
 Appointment necessary.
 Hours — Mon, Wed, Fri, 9 to 5.
 Tue, Thur, Sat, 9 to 1.

Procedure Material not loaned, copies made.
 Fees: reproduction.
 Catalogue in preparation.

VICTORIA & ALBERT MUSEUM

General historical, emphasis on cultural subjects

Address South Kensington, London SW7 2RL, England

Phone (01) 589 6371; (ask for appropriate department)

Apply to Individual departments as indicated below.

Material As one of the world's major collections of historical cultural material, the Victoria &
 Albert is necessarily divided into several separate sections. The majority of these are
 concerned with their own museum-type collections; photographs of specific items
 may be available from the museum's own *photographic service,* or arrangements may
 be made to take your own photographs.

 The departments most likely to be of interest to the Picture Researcher are the
 following:

 *DEPARTMENT OF PRINTS AND DRAWINGS. Besides a fine collection of Fine Art
 engravings and Reproductive engravings, many by the greatest masters, there are
 prints under many headings including: portraits; topography; social history; religious
 and pagan symbolism; costume; games, toys and pastimes; architectural drawings;
 posters; design subjects such as wallpapers, textiles, ceramics and metalwork.*
 *These headings give only the most superficial indication of the scope; the Print
 Room, through which all applications to see material must be made, houses detailed
 subject catalogues as well as indexes by name or artist and/or engraver. The museum's
 Handbook to the Department of Prints and Drawings and Paintings gives a fuller idea
 of the range of material available, and several other of the museum's publications
 contain illustrations drawn from specific categories. Many thousands have already
 been photographed, so it is worth while asking the Print Room staff is this is the case
 in respect of any item in which you are interested. If it is, then they will give you the
 negative number and you can obtain prints from the Photographic Section.
 Otherwise, you must either request the Museum to photograph it for you, or make
 your own arrangements.*

 THEATRE SECTION. This is in fact a department of the Department of Prints and
 Drawings, and access is again via the Print Room. The material itself is however

separately housed and catalogued. The nucleus is the Enthoven Collection, which has been supplemented by the Harry Beard collection and other subsequent acquisitions: at present, however, these are still separately catalogued and the collections not integrated.

Between them, the theatrical collections cover every aspect of theatrical history, comprising photographs, prints, playbills, posters, programmes, press cuttings, postcards, set and costume designs. Most of the material is filed under the name of the theatre or other place of performance, and arranged chronologically.

Period — earliest times to present.

Number — over 1 million.

LIBRARY PHOTOGRAPH COLLECTION. This is a general collection of early photographs, mainly 19th century. It contains some of the finest existing early material, including: Hill and Adamson calotypes, Fox Talbot, Daguerrotypes etc; Fenton's Crimea photographs; Julia Margaret Cameron and other notable Victorian photographers; Muybridge; many photographs of Victorian daily life; portraits and cartes-de-visite; early topographical photographs.

The catalogue, available free on request, is an invaluable guide.

Period — 1840 to 1918.

Number — 300,000.

Availability Research by researcher. (Items are located in catalogues in Print Room, a form is completed for each item, and staff bring you the items for inspection.)
Requests by writing, phone or visit.
Hours — Monday to Friday, 10 to 4.50; only limited access on Saturday. Closed week beginning last Monday in September.

Procedure Material not loaned, copies made.
Fees: reproduction (not necessarily charged if you do your own photography).

WALES, NATIONAL LIBRARY OF
LLYFRGELL GENEDLAETHOL CYMRU

All aspects of Wales and Welsh life

Address Aberystwyth, Cardiganshire, Wales

Phone (0970) 3816/3817

Telex 35165

Apply The Librarian.

Material Photographs, prints and engravings, original paintings and drawings of all aspects of Welsh life and Wales in general. The prints and drawings are mainly topographical but there are also engraved portraits and a Welsh costume collection. Special collections include:

 1 Thomas Rowlandson drawings of a tour in Wales 1794.
 2 Watercolours, drawings and sketches by John Warwick Smith, John Ingeleby and Moses Griffith.
 3 Collection of some 3,000 glass negatives of portraits, landscapes and architectural subjects taken by John Thomas from 1865—1895.
Number — 45,000
Period — 1740 to present day.

Availability Research by client who must first obtain a Reader's Ticket.
Appointment preferred for visits.
Application by writing, telephone or visit.
Hours — Monday to Friday, 9.30 to 6; Saturday, 9.30 to 5.

Procedure Material not loaned, copies made.
Photographic service — application form.
Fees: print fees only.
Credit: 'from the original in the National Library of Wales'.

Notes This valuable national collection is well worth visiting although very small specific written requests will be given every possible attention.

EUROPE

ANTWERP: STADSARCHIEF

History of Antwerp and neighbourhood

Address	Venusstraat 11, 2000 Antwerp, Belgium
Phone	(03) 31 11 55
Material	Photographs, prints and engravings, original works of art, medals, seals, plans etc relating to the history of Antwerp and neighbourhood. Period — 1124 to present.
Availability	Research by staff or researcher. Requests by writing, phone or visit. Hours — Monday to Friday, 8.30 to 4.30.
Procedure	Some material loaned, others copied. Fees: reproduction, sometimes search. Photostat service.

AUGSBURG STAATS—UND STADTBIBLIOTHEK

General history, chiefly European

Address	Schaezlerstrasse 25, 89 Augsburg, West Germany
Phone	(0821) 324 2739
Material	Historical material of general European interest, particularly relating to region. One of many West German civic archives who generally give good service and are helpful with small and specific requests. Specialising in portraits. Period — 1450 to 1800. Number — 20,000.
Availability	Research by staff or researcher. Requests by writing or visit, not phone. Appointment preferred. Hours — Monday, 3 to 5; Tuesday to Friday, 10 to 12.30, 3 to 5; Saturday, 9 to 12.30.
Procedure	Some material loaned, others copied. Fees: reproduction (sometimes). Photostat service.

BIBLIOTHEQUE NATIONALE

General historical and cultural

Address 58 rue de Richelieu, 75084 Paris, France

Phone 742 02 51

Material The Bibliothèque Nationale, the largest collection of its kind in France and one of
 the world's richest and most important sources for illustrations of all kinds,
 comprises a number of separate departments.

 1 SERVICE PHOTOGRAPHIQUE. This is a collection of photographs taken from
 their own material. It covers a wide range of subjects including posters, maps,
 engravings, book illustrations and title-pages, manuscripts, medals, coins, works of art
 from antiquity to the renaissance, illustrations from newspapers and journals, theatre
 arts and so on — in short, a general collection of diverse historical and cultural items.
 Number — 140,000 black and white, 10,000 colour.

 2 CABINET DES ESTAMPES. Engravings and photographs, again covering all
 subjects, including reportage photographs collected from many press agencies within
 a collection named 'Monde et Camera', from the period 1907 to 1945. Inevitably
 there is a degree of overlap between this section and the Service Photographique;
 familiarity with the collections is essential for efficient research. The material is
 classified under general headings — Portraits, History, Topography, Costume,
 Customs (Moeurs), Trades (Métiers), Science and Technology, etc.
 Number — 1½ million.

 3 RESERVE DU DEPARTEMENT DES IMPRIMES. Photographs of pages, illustra-
 tions and bindings from rare books in the Library.
 Number — 12,000 black and white, 275 colour.

 4 CABINET DES MANUSCRITS. Photographs of Western and Oriental manuscripts,
 medieval paintings.
 Number — 40,000 black and white, 2500 colour.

Availability A Reader's Ticket is necessary for personal research. There are three types: a
 'Laissez-passer' available for two days only; a 'Carte exceptionelle' for a limited
 number of visits relating to a specific search; and a 'Carte Régulier' available for 1
 year. All can be obtained by applying in person at the 'service d'accueil et
 d'orientation des lecteurs'. For all types of ticket, you must present a passport or
 other proof of identity containing a photograph, and provide specific information
 about the purpose of your research. For the 'Carte exceptionelle' or 'Carte Régulier'
 you must provide two passport photographs; and for the 'Carte Régulier' you must
 also produce a letter of authorisation from your employer and, if a foreigner, a letter
 of introduction from the cultural service of your embassy or from a French
 university professor or scientific establishment. Both types of 'carte' cost 3 francs.

Photography The Bibliothèque prefers to do its own photography, and for rare or valuable material insists on this. In other cases, however, permission may be granted for researchers to employ approved photographers to carry out commissions.

DEUTSCHE FOTOTHEK DRESDEN

(Zentrales Institut für Bilddokumente der Wissenschaft, Forschung und Lehre bei der Deutschen Staatsbibliothek Berlin)

History of art and culture, some geography and biology

Address 801 Dresden, Augustusstrasse 2, East Germany

Phone 41413

Apply to Hans-Heinrich Richter, Director.

Material Photos in colour and black and white of fine and applied art, general European history, photographs of prints and engravings. Comprises the photo collection of the Academy of Fine Arts of the GDR, section of Formative Arts. Also geographical and biological subjects.
Period — historical, and 1864 to present.
Number — 350,000.

Availability Research by staff or researcher.
Requests by writing, phone or visit.
Appointment preferred, maximum delay 10 days.
Hours — Monday to Friday, 9 to 3.

Procedure Colour items loaned, black and white items copied.
Fees: reproduction, search, holding after 28 days.
Catalogue of recent acquisitions sent on request.

DOCUMENTATION FRANÇAISE

General documentation, historical and modern; chiefly France and her overseas territories, also some foreign; emphasis on economic and social subjects

Address 31 quai Voltaire, 75 340 Paris, France
(visits: 4th floor, bureau 461)

Phone 222 70 00, extensions 319 or 398

Apply to Photothèque générale (general black and white); photothèque sur l'Afrique et l'Outre-Mer (black and white); diathèque (colour).

Material — This is an admirable government institution of a kind which should exist in every country. Created to provide a public source of readily available visual documentation, it is both an important source in itself and at the same time a departure point for contacting further sources (see notes on Procedure below).

The scope is comprehensive, taking in the history of France and to some extent of the rest of the world; all aspects of French geography, economy, industry, daily life and so on. The main emphasis, particularly in the colour collection, is on economic and social life. There are important special collections relating to the two World Wars and to French institutions. The Photothèque sur l'Afrique et l'Outre-Mer performs the same function for French overseas territories past and present.
Period — historical and present, but chiefly 20th century.
Number — about 150,000 but continually growing.

Availability — Not to be used for commercial or publicity purposes.
Research by researcher.
Requests by writing, phone or visit.
Hours — Monday to Friday, 2.30 to 6.

Procedure — There are two separate divisions — the Photothèques (black and white) and the Diathèque (colour).
Within each of these, the material falls into two distinct categories:

1 Material owned by the library. If black and white, up to 30 items may be borrowed and used without payment. Borrowing period is normally 15 days, or 2 months for book publication. If colour, copies may be purchased if available, and used after permission has been obtained.

2 Material not owned by the library. These items are kept for reference purposes, being the property of other sources throughout France. They may not be borrowed. Instead, when you find a picture you want to use, the staff will tell you where to go for a print or copy and for permission to use it; you then negotiate with the source directly without further reference to Documentation Française.

EDITURA ENCICLOPEDICA ROMANA

Special Romanian archive on all aspects of Romania

Address — Calea Victoriei 126, Bucharest, Romania

Phone — 50 42 15

Material — Colour transparencies on all aspects of Romania from antiquity to present, including fine art.
Number — 10,000.

Availability — Research by staff.
Application by phone, writing or visit.
Hours — Monday to Saturday, 7 to 3.

Editura Enciclopedica Romana (continued)

Procedure Material loaned.
 Photographic service.
 Commissions undertaken.
 Fees: reproduction.

Notes Allow time and this source will prove rewarding.

HUNGARY: NATIONAL SZECHENYI LIBRARY

Hungarian history and culture

Address 1827 Budapest, Museum Krt 14/16, Hungary

Phone 134 400

Telex 22 42 26

Material A comprehensive national archive containing unique historical material relating to all aspects of Hungarian history, life and culture. Several million items comprising photographs, prints and engravings, illuminated manuscripts, playbills and ephemera such as posters and postcards. The main collections are:

 1 Manuscript collection — transparencies exist for the more interesting originals.
 2 Ancient book collection — including historical prints, engravings relating to Hungary, foreign prints acquired in 16th century etc.
 3 Graphics and small prints collection — posters from 1885, picture postcards, engravings on all subjects.
 4 Theatre history collection — including engravings, stage and costume designs, photographs.

Availability Research by researcher.
 Requests by writing or visit, not phone.
 Written authorisation required.
 Appointment preferred, 2 days delay.
 Hours — Monday to Friday, 8.30 to 5, Saturday 8.30 to 1.

Procedure Some material loaned, others copied.
 Fees: reproduction, other fees sometimes for private individuals and commercial users.
 Photostat service.

NORDISKA MUSEET

Cultural history of Sweden, 16th century to present

Address	115 21 Stockholm, Sweden
Phone	(08) 63 05 00
Apply to	Picture Department.
Material	Photographs, prints and engravings, original paintings and drawings relating to Sweden's cultural history, including portraits. Period — 16th century to present. Number — 1½ million.
Availibility	Research by staff or researcher. Requests by writing, phone or visit. Appointment preferred. Hours — Monday to Friday, 8 to 4.40 for phone calls. Museum opening hours Tuesday to Friday, 10 to 12, 2 to 4, for personal visits to archives.
Procedure	Most material not available on loan, copies made. Reproduction, service/handling fee. (Reduced fees for scientific or teaching purposes.) Photostat service.

OSLO: UNIVERSITETSBIBLIOTEKET
(Royal University Library)

Norwegian history, life and culture

Address	Drammensveien 42, Oslo 2, Norway
Phone	56 49 80
Telex	6078 ub o
Apply to	Billedsamlingen (Picture Department).
Material	General material relating to Norwegian history, life and culture; mainly portraits and topography. There is a specialist collection on Drama, which is of course of special interest as regards Ibsen, Bjornson and the like. Period — circa 1600 to present. Number — 100,000.

Oslo: Universitetsbiblioteket (continued)

Availability	Research by staff. Requests by writing, phone or visit. Appointment preferred. Hours — Monday to Friday, 8.30 to 3.
Procedure	Material copied. No fees, only copying and handling. Photostat service.

ÖSTERREICHISCHE NATIONALBIBLIOTHEK: BILDARCHIV UND PORTRAT-SAMMLUNG

(Austrian National Library: Picture archive and portrait collection)

History of Austria and particularly the Hapsburg empire

Address	*A-1014 Wien 1, Josefplatz 1, Austria*
Phone	*52 23 08, 52 71 92, 52 16 84/5/6*
Apply to	*The Direktor, Dr Walter Wieser — for all enquiries.*
Material	*This is one of the most comprehensive national collections in the world, containing millions of pictures relating to Austrian history which — for a period of many centuries — implies the entire history of Europe. Political, social and cultural themes are covered in depth with photographs, prints and engravings, original paintings and drawings, etc.*
Availability	*Research by staff or researcher.* *Requests by writing or visit.* *Written authorisation required.*
Procedure	*Transparencies loaned, black and white material copied.* *Fees: reproduction.* *The Library will arrange for the items you order to be copied; you will receive a bill for the copying from their regular photographers, ALPENLAND, who should be paid independently of the reproduction fee payable to the Library itself.* *Photographs arrive well captioned, but of course in German, handwritten.*

PORTUGAL: BIBLIOTECA NACIONAL

Portuguese history and culture

Address Campo Grande 83, Lisboa 5, Portugal

Phone 76 77 86

Material General historical and documentary material relating to Portuguese history and
 culture from the 16th to the 20th century. Special collection of religious prints.
 Number — 13,000.

Availability Personal access by reader's ticket only.
 Research by staff or researcher.
 Requests by writing or visit, not by phone.
 Written authorisation required in first instance.
 Hours — Monday to Friday 10 to 5.30, Saturday 10 to 1.

Procedure Material not loaned, copies made.
 Catalogues available.
 Photostat service.

RHEINISCHES BILDARCHIV

German history and culture from 1890, especially Rhineland

Address 5 Köln 1, Zeughausstrasse 1—3, West Germany

Phone 2212354 or 2212357

Material A very fine photographic collection illustrating German political and cultural history
 over the last century, with special emphasis on Cologne and the Rhineland.
 Period — circa 1890 to present.
 Number — 200,000.

Availability Research by staff and researcher.
 Requests by writing, phone or visit.
 Written authorisation required.
 Appointment necessary, delay 10 to 20 days.

Procedure Material copied.
 Fees: reproduction, service/handling.

SCHWEIZERISCHE LANDESBIBLIOTHEK BILDERSAMMLUNG
(Swiss National Library, Illustrations Collections)

Switzerland, past and present

Address	Hallwylstrasse 15, CH 3003 Bern, Switzerland
Phone	(031) 61 71 11
Telex	32526 slbbe ch
Material	Photographs, prints and engravings and posters, covering all aspects of Swiss history, life, geography and culture. Period – 1550 to present. Number – 150,000.
Availability	Research by staff or researcher. Requests by writing, phone or visit. Appointment preferred. Hours – Monday to Friday, 8 to 12, 2 to 6.
Procedure	Some material loaned, others copied. Fees: reproduction. Transparencies may be purchased. Photostat service.

VATICANO, BIBLIOTECA APOSTOLICA

Manuscripts and early printed material relating to Holy See but frequently containing general material

Address	Città del Vaticano, Roma, Italy
Material	Unique collection of early manuscripts and printed items, largely relating to Holy See and Catholic Church, but including general items such as Marco Polo's Travels, as published in 1486. The catalogue is clearly essential.
Availability	For serious purposes only. Research by staff. Requests by writing or visit. Written authorisation required. Appointment preferred. Hours – Monday to Saturday, 9 to 12.
Procedure	Material not loaned, copies made. Catalogues available (in Italian). Photostat service.

USA and CANADA

BANCROFT LIBRARY, UNIVERSITY OF CALIFORNIA

History of western North America

Address	University of California, Berkeley, California 94720, USA
Phone	(415) 642 3781
Apply to	John Barr Tomkins, Curator, Pictorial Collections.
Credit	Unique items: 'Reproduced by permission of The Director, the Bancroft Library, University of California, Berkeley' Non-unique items: 'Courtesy, The Bancroft Library, University of California, Berkeley.'
Material	Photographs, prints and engravings, original paintings and drawings relating to history of western North America. Specialities: early Californian mining; marine bridge construction; railroads; San Francisco. Period — 15th century to present. Number — over 1 million; only 65,000 indexed to date.
Availability	For genuine research and serious publications, *not* commercial. Research mostly done by staff, but researchers can consult indexes. Requests by writing, phone or visit. Written authorisation required. Appointment necessary, delay 2 days. Hours — Monday to Friday 9 to 5, Saturday 1 to 5.
Procedure	Material not loaned, copies made. Handling fees are included in copying charges. Reproduction rates in line with commercial fees, should be discussed at time of negotiation.
Notes	This is primarily a research library, not a commercial source. However, the curator and his staff are willing to assist serious researchers as far as possible. Requests should be specific, not comprehensive. The collection's indexes should first be consulted; otherwise, submit requests to the curator.

CANADA, PUBLIC ARCHIVES OF

Canadian history

Address	395 Wellington Street, Ottawa, K1A ON3, Ontario, Canada

Phone 996 6011

Apply to Chief, Picture Division.

Material Photographs, prints and engravings, original paintings and drawings relating to all aspects of Canadian history, with emphasis on governmental material. Includes pictures of people, places, historical events etc. There is also a Map Division.
Period — 1600 to present.
Number — 3 million.

Availability Research by staff or researcher.
Requests by writing, phone or visit.
Appointment preferred if staff assistance required.
Hours — Monday to Friday, 8.45 to 4.

Procedure Material not loaned, copies made. Transparencies sold.
No fees.
Catalogues available on varied subjects at varied costs.

Notes The staff are most co-operative with serious requests; however, as with all such collections, researchers are advised to be as specific in their requests as possible.

CONGRESS, LIBRARY OF (USA)

General, emphasis on all aspects of Americana

Address 10 First Street S.E., Washington, DC 20540, USA

Phone (202) 426 6394

Apply to Head, Reference Section, Prints and Photographs Division.

Material This is a vast collection covering all aspects of Americana — history, geography, people, daily life etc. Broadly speaking, the material comprises:

1 Historical prints. Lithographs, engravings and reproductions of paintings of life in America from the 17th century to the present. Historical events, presidents and other portraits, political cartoons, views, scenes of industry, agriculture, transport and daily life.

2 Historic American Building Survey. Measured drawings and photographs of early American homes, farms, public buildings etc erected before 1870.

3 Civil War photographs by Brady and others.

4 Detroit Photographic Company collection. Photos of cities, buildings and life in the US about 1890–1910. Also navy ships of the period.

5 Farm Security Administration and Office of War Information collections. Photographs, 1935–1943, chiefly of the US, the land, people, housing, agriculture, industry, migrant labour, war production.

6 Geographic files. Cities and buildings about 1900 to 1920.

7 Portraits. Photographs, steel engravings and reproductions of paintings.

8 General collections. Groups of pictures catalogued either by subject, place, period, person, photographer or artist. Not limited to USA. Brief descriptions of these collections (which number over 800) are to be found in the catalogue mentioned below.

9 Fine print collection. Original etchings, engravings, lithographs and other prints by artists of all periods and nationalities.

Overall period covered – 15th century to present.
Total number – 20 million.

Availability
Research by researcher.
Requests by writing, phone or visit.
Appointment preferred.
Hours – Monday to Friday, 8 to 5.

The Library has supplied the following information:
'The Prints and Photographs Division of the Library of Congress has a small reference staff. This limits service to readers and makes it desirable for picture searchers to visit the collections in person. Readers may consult vertical files and card indexes and request items from the staff. If a personal visit is impossible to arrange, there are several free-lance picture researchers who are thoroughly acquainted with the picture holdings, and who may be contacted.

If a reader finds a picture credited to the Library of Congress in a published book and wishes to order the same picture, he should send a photocopy with all the pertinent bibliographical information to the Head of the Reference Section. Orders accompanied by payment will be searched and processed provided they do not exceed 6 pictures.'

Procedure
Material not loaned, copies made.
Reproduction fee, sometimes Permission fee for restricted collections.
Photostat service.
Catalogues: An excellent Guide to the Special Collections of Prints and Photographs in the Library of Congress is available, price $2 – this is essential for every researcher wishing to make effective use of the collection. Also available are a leaflet about the Historic American Buildings Survey, a list of Publications in Print, and picture lists on selected aspects of Americana which may be obtained on request, specifying the field in which you are interested. Please be as specific as you can.

DENVER PUBLIC LIBRARY, WESTERN HISTORY DEPARTMENT

History of western United States

Address 1357 Broadway, Denver, Colorado 80203, USA

Phone (303) 753 5152

Apply to James H Davis, Picture Librarian.

Material Photographs, prints and engravings, original paintings and drawings, advertising
 matter, relating to history of the American west, particularly Mississippi and Rocky
 Mountain areas. Specialising in discovery and settlement of western USA, mining,
 railroads, Indians, early Spanish.
 Period — 1540 to present.
 Number — 250,000.

Availability Research by staff or researcher.
 Requests by writing, phone or visit.
 Appointment preferred.
 Hours — Monday to Thursday, 10 to 9.

Procedure Material not loaned, copies made.
 Fees: reproduction, handling.
 Catalogues issued for David F Barry photo collection of Indians etc.
 Photostat service.

McCORD MUSEUM, NOTMAN PHOTOGRAPH ARCHIVES

Photographs, Canada and Canadian life 1847 to 1940s

Address 690 Sherbrooke Street West, Montreal, Canada

Phone (514) 392 4781

Apply to Stanley G Triggs, Curator of Photography.

Credit 'Notman Photographic Archives.'

Material Enormous collection of photographs relating to Canadian life and history from 1847
 to the 1940s. Largely based on the work of the firm of William Notman carried out
 between 1856 and 1936. Two main sections are portraits (comprehensive collection
 including virtually every notable of the period) and views (places and scenes from
 everyday life).
 Number — 400,000 black and white, plus written records.

McCord Museum (continued)

Availability	Research usually by staff, by researcher only in special cases. Requests by writing, phone or visit. Written authorisation required in first instance. Appointment necessary. Hours — Monday to Friday, 2 to 5.
Procedure	Material sometimes loaned, usually copied. Fees: reproduction, service. Catalogues available. Photostat service.

MANITOBA, PROVINCIAL ARCHIVES OF

Canadian North West and Manitoba from 1800 to present

Address	The Provincial Library & Archives Building, 200 Vaughan Street, Winnipeg R3C IT5, Manitoba, Canada
Material	Photographs, prints and engravings, original paintings and drawings, and maps, relating to Manitoba, the Canadian North West, Red River Settlement etc. An important section of the collection is the work of L B Foote, a professional photographer spanning the period 1890 to 1945. Period — 1800 to present. Number — 60,000.
Availability	Research by staff or researcher. Requests by writing, phone or visit. Hours — Monday to Friday, 9 to 5.
Procedure	Material not loaned, copies made. Fees: reproduction. Photostat service.

NATIONAL ARCHIVES AND RECORDS SERVICE (USA)

American history and national affairs, past and present

Address	8th & Pennsylvania Avenue, Washington DC 20408, USA
Phone	(202) 962 2513
Credit	Original source and National Archives, including photograph number wherever possible, eg 'US Signal Corps Photo No.B—100 (Brady Collection) in the National Archives.'

National Archives and Records Service (continued)

Apply to James W Moore, Division Director.

Material The US National Archives is the final repository for the permanent records of the US government, corresponding to the British Public Records Office and the French Archives Nationales. As such, they include many special collections of unique visual material as well as verbal records. Every department of government has its own picture collection, making more than 100 files of which some have only a few items (eg William S Soule's Indian photographs (1868–74) – 18 items) while others are vast (eg Department of the Navy, 1798–1958, – 786,872 items covering every aspect of US naval affairs).
In short, the collection includes photographs, prints and engravings, original paintings and drawings, and posters, covering every aspect of American history and state affairs, internal and external.
Period – 1750s to present.
Number – 5 million.

Availability Research passes are essential for personal access. These are obtained from the Division Director named above.
Research by researcher or staff.
Requests by writing, phone or visit.
Written authorisation required in first instance.
Hours – Monday to Friday, 8.45 to 5.15.

Procedure Material not loaned, copies made.
Fees: reproduction.
Photostat service.
Catalogues: There is no central catalogue for the whole collection. Each file is carefully arranged, and the larger ones have card indexes.
A number of Select Picture Lists are published. These include: The Revolutionary War; Indians in the United States; Negro Art from the Harmon Foundation; Contemporary African Art from the Harmon Foundation; The American West 1848–1912; US Navy Ships 1775–1941.
These are obtainable free on request. Researchers should also try to obtain the very helpful 'Still Pictures in the Audiovisual Archives Division of the National Archives', by Mayfield S Bray, which constitutes an outline catalogue of the archives as a whole and is an admirable guide to the collection. There are also similar introductions to some specific fields, including Indian and Black History.

NEW BRUNSWICK MUSEUM

Canada, past and present

Address 277 Douglas Avenue, Saint John, New Brunswick, Canada

Phone 693 1196

Apply to Mr L K Ingersoll, Curator of Canadian History.

Credit If from Webster Collection, add 'Webster Collection of Pictorial Canadiana' to name of museum.

Material Photographs, prints and engravings, original paintings and drawings depicting all aspects of Canadian history and life.
Period — 1600 to present.
Number — 12,000.

Availability Research by staff or researcher.
Requests by writing, phone or visit.
Written authorisation required in first instance.
Appointment preferred.
Hours — Monday to Friday, 8.45 to 5.

Procedure Some material loaned, others copied (outside photographers available).
No fees, copying charges only.
Catalogue available for Webster Collection, 3 vols, $10.00.

NEW YORK PUBLIC LIBRARY

General, with several specialist collections

Address (general) Fifth Avenue at 42nd Street, New York City, NY 10018, USA; (performing arts) Lincoln Center, 111 Amsterdam Avenue, New York City, NY 10023, USA

Phone (general) (212) 790 6254; (performing arts) (212) 799 2200

Material As one of the largest library complexes in the world, this source contains a vast amount of visual material which is not easy to describe in summary form and impossible to describe in detail. You are advised to write for their free leaflet 'Guide to the Research Libraries' which gives a brief account of the overall collection. We have picked out the following special collections as likely to be of greatest interest to researchers, but we must emphasise that they do not constitute anything like the total resources of the collection.

GENERAL
Map Division. (some also in Rare Book division)
Manuscript Division. Strong emphasis on United States and New York city history.
Prints Division. Original prints from 15th to 20th century, portraits, bookplates, book illustrations etc, with material relating to the techniques of printmaking as well as original prints.

PERFORMING ARTS
Dance Collection. Books, manuscripts, periodicals, films, photographs, original designs and drawings, scrapbooks, programmes, clippings, playbills, posters, letters etc relating to all aspects of all types of dance, ancient and modern, social and ethnic.

Music Division. Books, scores, libretti, sheet music, periodicals, manuscripts, portraits, programmes, clippings and scrapbooks covering all aspects of music. Special collections on opera in 18th and 19th centuries.

Theatre Collection. Photographs, prints and engravings, original paintings and drawings, scene designs, caricatures etc relating to all aspects of theatre arts and stage entertainment including film, radio, tv, vaudeville, circus, puppets, magic. Many individual collections have been presented by photographers, theatrical personalities, producing groups etc.

In short, the Library claims to have specialised collections in all fields of knowledge except law and medicine.

The total number of items is many million — there are 287,000 maps, 125,000 fine prints, countless items of ephemera.

Availability	Research by staff or researcher. Requests by writing, phone or visit. Hours — Monday to Saturday, 10 to 6; (also some evenings).
Procedure	Some material loaned, but more generally copied. Fees: reproduction, service. Photostat service.
Notes	The collections are well organised and catalogued, and access is made as easy as possible considering the vast bulk of the material. While the staff are willing to be helpful, it is only natural that they prefer requests to be as specific as possible when coming from overseas.

ONTARIO, ARCHIVES OF

History of Ontario (Canada), its life, culture and activities

Address	Parliament Buildings, Toronto M7A 1C7, Ontario, Canada
Phone	(416) 965 4030 or 4039 or 5329
Apply to	Margaret Van Every, Picture Archivist.
Material	Photographs, prints and engravings, original paintings and drawings, posters and architectural measured drawings of all aspects of the history and daily life of the province of Ontario. Special collections cover such aspects as Indians: mining: lumbering: the fur trade. Also the collections of early photographers in the region. Well organised and efficient. Period — 1790s to 1960s, but mainly 1850–1920. Number — 35,000.
Availability	Research by staff or researcher. Requests by writing, phone or visit. Hours — Monday to Friday, 8.30 to 5.

Ontario, Archives of (continued)

Procedure Material not loaned, copies made.
 No fees beyond material costs.
 Photostat service.

TORONTO, METROPOLITAN CENTRAL LIBRARY

Canadian history

Address 214 College Street, Toronto M5T 1R3, Ontario, Canada

Phone 924 9511

Telex 06 22232

Material Photographs, prints and engravings, original paintings and drawings relating to
 Canadian history.
 Period — 17th century to present.
 Number — 10,000.

Availability Research by researcher.
 Requests by writing, phone or visit.
 Hours — Monday to Friday, 9 to 9, Saturday 9 to 5.

Procedure Material not loaned, copies made.
 No fees.
 Catalogues available: Landmarks of Canada ($15); Toronto & Early Canada ($2.50).

WILLIAMSBURG, COLONIAL

Colonial life in 18th century New England

Address Audiovisual Library, Colonial Williamsburg Foundation, Drawer C, Williamsburg,
 Virginia 23185, USA

Phone 229 1000

Apply to Chief Librarian.

Material This collection is unique in that it relates to a painstaking 'living' reconstruction of
 Williamsburg as it was during the Colonial period. Much of the material issued by the
 Foundation is based on this reconstruction; though it cannot of course replace
 authentic material, it is nevertheless faithful to the original and of unique educational
 value. Naturally, the Library also possesses contemporary source material, covering

architecture, daily life, events and so forth, to which access may be had via the Chief Librarian. Due to the unique character of the collection, specific approach should be made to the Chief Librarian in the first instance.

Availability For educational purposes only.
Research by staff.
Requests by writing, phone or visit.
Written authorisation required in first instance.
Hours — Monday to Friday, 8.30 to 5.

Procedure Some material loaned, others copied.
Fees: reproduction, sometimes search, handling, holding.
Catalogue of published audiovisual material available.
Photostat service.

BEYOND EUROPE
(except USA and Canada)

ALEXANDER TURNBULL LIBRARY

National collection relating to New Zealand and Pacific, with some special fields

Address National Library of New Zealand, 42.44 The Terrace, Wellington 1, New Zealand
(postal) PO Box 8016, Wellington 1, New Zealand

Phone Wellington 48 617

Material The Library comprises a number of distinct collections:
1 English literature, particularly 17th and 18th centuries; rare books; history of printing; some illuminated manuscripts; complete set of de Bry; illustrated books of 1860s.
2 New Zealand and Pacific collection, comprehensive coverage of all aspects of New Zealand and its surroundings, including history, exploration, ethnography, topography etc.
3 Art collection, approximately 20,000 items, particularly from the 1840 to 1890 period but also earlier and later material.
4 The National Photograph collection, containing about 130,000 photographs covering every aspect of New Zealand topography, daily life and history.
Period — 1150 to present.
Number — 20,000 prints and drawings, 130,000 photographs.

Availability Research by staff and/or researcher.
Requests by writing, phone or visit.
Written authorisation required.
Appointment preferred.
Hours — Monday to Friday, 9 to 5, Saturday, 9 to 12.

Procedure Black and white not loaned, copies made; colour transparencies loaned.
Fees: reproduction, sometimes others.
Photostat service.

AUSTRALIA, NATIONAL LIBRARY OF

General Australian material

Address Parkes Place, Canberra, ACT 2600, Australia

Phone 621395

Telex 62100

Apply to Keeper, Pictorial Section.

Material Photographs, prints and engravings, original paintings and drawings, relating to
 Australia, New Zealand, South West Pacific.
 Period — 1770 to present.
 Number — 105,000.

Availability Research by staff or researcher.
 Requests by writing, phone or visit.
 Hours — Monday to Friday, 8.30 to 4.50.

Procedure Material not loaned, copies made.
 Fees: reproduction.
 Catalogues available.
 Photostat service.

Notes Researchers in UK can obtain material via Australian News & Information Bureau.

RHODESIA, NATIONAL ARCHIVES OF

Rhodesia and neighbouring territories, past and present

Address Postbox 7729, Causeway, Salisbury, Rhodesia

Phone 29101

Apply to The Director.

Material Photographs, prints and engravings, original paintings and drawings relating to the
 history of Rhodesia and also covering Botswana, Zambia and Malawi. The collection
 is particularly strong on the period 1890 to 1920.
 Period — 1870 to present.
 Number — circa 15,000 photographs, plus other items.

Availability Research by staff or researcher.
 Requests by writing or visit, preferably not by phone.
 Hours — Monday to Friday, 7.45 to 4.30. Saturday, 8 to 12.

Procedure Material not loaned, copies made. (Black and white or sepia-toned only.)
 Fees: reproduction, service/handling.
 Photostat service.

Notes For those unable to visit the collection, detailed lists are supplied *on specific topics*
 eg railways, Matabele rebellion etc but not on general themes such as Rhodesian
 history.
 Payment in advance is required, on invoice from the collection.

SRI LANKA NATIONAL ARCHIVES

General material, relating to Sri Lanka (Ceylon)

Address PO Box 1414, 7 Reid Avenue, Colombo 7, Sri Lanka

Phone 94523 or 94419

Material Photographs, prints, original drawings and a few other items of a general nature relating to the history of Sri Lanka. Special collection relates to Buddhist art and monuments in Asia.

Availability Research by staff or researcher.
Requests by writing, phone or visit.
Written authorisation preferred.
Appointment preferred.
Hours — 8 to 3.30 every day except Saturday afternoon and Sunday.

Procedure Material not loaned, copies made.
Photographic department.
Photostat service.
Copyright must be cleared by client on some items.
Fees: reproduction and handling (postage) charges.

G2 COMMERCIAL HISTORICAL

This type of source tends to be more geared to the needs of the researcher than are the state archives and other public collections. For instance, at libraries like the Granger Collection in New York or the Mary Evans Picture Library in London, you can browse on your own among the picture files, instead of having to fill in a request form and wait till someone brings you a picture which you have chosen from a words-only catalogue description.

Access apart, commercial historical sources provide a valuable complement to the 'establishment' archive in that they tend to take a less dogmatic approach to their material. If you get (as you should) Dr Bettmann's *Bettmann Portable Archive,* you will see how it is possible to 'enjoy' pictures while respecting them; this is reflected in this type of archive where the more humanist approach pays off in a wider range of material — where the face of Pope Pius in a tonic wine advertisement is seen as a viable alternative to his official portrait, and where portraits of courtesans and con-men rub shoulders with bewigged statesmen and bemedalled generals.

BRITAIN

BRITISH HISTORY ILLUSTRATED

British history, AD 1000 to present

Address	55 Neal Street, London WC2H 9PJ, England
Phone	(01) 836 3814
Apply to	Carina Dvorak
Material	Photographs, prints, etc, illustrating British history; access to large collection of World War II photographs. Period — AD 1000 to present. Number — 10,000.
Availability	Research by staff. Requests by writing, phone or visit. Written authorisation required. Appointment preferred, 2 days delay. Hours — Monday to Friday, 10 to 5.30.
Procedure	Material copied. Photostat service. Fees: reproduction, search/handling.

DAVIS, William Gordon

General, historical and contemporary

Address 10 Becmead Avenue, London SW16, England

Phone (01) 769 4176

Material A small modern library which also comprises a large collection of 19th century photographs,reproductions and historical material. Fees are low and loaning material is generous.
Period — Historical and 1956 to 1973.
Number — 40,000.

Availability Research by staff.
Requests by writing or phone or visit.
Appointment preferred.
Hours — Monday to Friday, 8 to 8.

Procedure Some material loaned, others copied.
Fees: reproduction (modest), sometimes others.
Commissions.

EVANS, Mary, PICTURE LIBRARY

General historical, mostly before 1914, some later non-photographic material

Address Samuel Smiles House, 11 Granville Park, London SE13 7DY, England

Phone (01) 852 5040 (in emergency 852 7482)

Material General historical collection of prints and engravings, plus some photographs and ephemera. Mainly black and white but also colour collection. Emphasis on social conditions, history of technology etc. Special collections of 19th century science and technology, late 19th century children's books. Personal visits well worthwhile as material is readily accessible for research and the choice is very wide. Runs of several English and foreign periodicals may be consulted. Prompt and efficient postal service, usually within 24 hours.
Period — antiquity to recent past.
Number — 1 million.

Evans, Mary, Picture Library (continued)

Availability Research by staff or researcher.
Requests by writing, phone or visit.
Appointment preferred.
Hours — Monday to Friday, 9 to 6, other times by arrangement.

Procedure Material loaned or copied.
Fees: reproduction, sometimes search, service if none used, holding fee after 1 month.
Photostat service.
Descriptive brochure available on request.

Notes Association with similar collections in New York and Berlin gives useful access to American and German material at British rates.

FREEMAN, John & COMPANY

General fine art and engravings

Address 74 Newman Street, London W1P 0AD, England

Phone (01) 636 4148 or 636 4537

Material Photographs of prints, engravings, drawings, paintings and photographs on all subjects dating from early times to 1910.
They also have special collections of:
1 Wallace Collection for which they act as special photographers.
2 Early Victorian photographs of London.
3 Shuttleworth collection of aeroplanes.
Number — 14,000 indexed, 150,000 others.

Availability Research by researcher or staff.
Requests by writing, phone or visit.
Written authorisation required.
Appointments preferred for visits.
Hours — Monday to Friday, 8 to 6.30.

Procedure Some material loaned, others copied.
Copyright depends on original ownership; staff will advise who clears copyright.
Fees: reproduction, service, search etc depending on circumstances.

Notes Freeman & Co have spent many years photographing in museums and galleries and private houses of the UK. The material in their collection is based on their stock photographs and although not always well captioned, is of excellent quality.

HISTORICAL PICTURE SERVICE

General historical

Address	86 Park Road, Brentwood, Essex CM14 4TT, England
Phone	(0277) 21743
Apply to	Peter Newark.
Material	Photographs, prints and engravings, original paintings and drawings covering all aspects of history. Special collections on Old London, Boxing and Bridges (to 1900). Period — pre-history to 1920. Number — 100,000.
Availability	Professional use only. Research by staff. Requests by writing or phone, no visits. Written authorisation required. Hours — Monday to Friday, 9 to 5.
Procedure	Material loaned. Fees: reproduction, holding after 1 month.

HISTORICAL RESEARCH UNIT

European military history

Address	27 Emperor's Gate, London SW7, England
Phone	(01) 373 2377
Cables	Histsearch London
Apply to	Andrew Mollo.
Material	The Historical Research Unit was formed by four members of the Mollo family to exploit commercially their unique and very extensive collections of militaria and objets d'art. The collection covers most countries and periods, with prints, photos and paintings, weapons, medals and decorations, Russian antiques including pieces by Fabergé, Tomir etc. There are three special categories: 1 Imperial Russian history up to 1917. 2 German Empire 1871–1945. 3 British military history 1650 to 1973.

Historical Research Unit (continued)

Availability	Research by staff or researcher. Requests by writing, phone or visit. Written authorisation required. Appointment necessary. Hours — 24 hours a day, 7 days a week.
Procedure	Some material loaned, but mostly copied. Fees: reproduction, sometimes search and service.

MANSELL COLLECTION

General world history, including fine and applied arts

Address	42 Linden Gardens, London W2 4ER, England
Phone	(01) 229 5475
Material	Photographs, prints and engravings covering all matters of historical interest from pre-history to the 1940s. Material is filed under subject headings. There are specially fine portrait and topographical collections, also the following special collections: 1 Helmut Guttman, portraits and historical subjects. 2 Dorien Leigh, portraits and topography. 3 E O Hoppé, portraits and topography. 4 Alinari, Anderson and Brogi; the collection acts as sole agents in the UK for these collections, comprising photographs in colour and black and white of works of fine and applied art, filed under subject unless the subject is not clearly defined, when it is filed under object (eg sculpture, friezes etc). Number — 2 million.
Availability	For commercial and professional use only. Research by staff. Requests by writing. Written authorisation required in first instance. Visits by appointment *only*, delay 1 to 2 weeks under normal conditions. Hours — Mondays to Fridays, 9 to 6.
Procedure	Material loaned. Fees: reproduction, search fee if none used, hire fee for colour after 2 weeks approval. Postage charged outside Europe.

RADIO TIMES HULTON PICTURE LIBRARY

General to 1957

Address	35 Marylebone High Street, London W1M 4AA, England
Phone	(01) 580 5577
Telex	22182
Apply to	The Librarian.
Material	Photographs, prints and engravings, original paintings and drawings covering all aspects of history, social life, events, places, natural history, technology etc, and specialising in theatre, ballet and British royalty. There are a number of specialist collections within the Library, including: 1 Rischgitz collection (historical prints and portraits, maps and photographs). 2 Topical Press (events, personalities, sport, 1903–1956). 3 Picture Post library (1938–1957). 4 Sasha London Theatre Collection (1923–1940). 5 Gordon Anthony & Derrick de Marney Theatre Collection (circa 1935–1955). 6 Baron ballet and portrait collection (1935–1956). 7 Downey court portraits (1870–1920). 8 Herbert Felton collection of British and foreign topography (1920s–1940s). 9 Studio Lisa collection of informal portraits of British royalty (1936–1954). Period (Library as a whole) — antiquity to present. Number — 6 million.
Availability	For commercial and professional use only. Research by staff. Requests by writing, phone or visit. Written authorisation required in first instance. Appointment essential, delay (normally) 3 to 5 days. Hours — Monday to Friday, 9.30 to 5.30.
Procedure	Material loaned or copied. Fees: reproduction, service. Photostat service.
Notes	Since the Library's own picture researchers do the research, detailed and specific information about your needs should be provided. You should also note the name of the staff picture researcher on your project, in case you subsequently require further material.

RAINFORTH COLLECTION

Historical portraits to 1900

Address	Mulberry Cottage, Park Road, Toddington, Dunstable, Bedfordshire, England
Phone	052 55 2687
Material	Historical portraits, (prints and photographs). Period — ancient times to about 1900. Number — 5000.
Availability	Research by staff. Requests by writing, phone or visit. Written authorisation required. Appointment necessary. Hours — daily except Wednesday, 9.30 to 6.
Procedure	Material sometimes loaned, usually copied. Fees: reproduction, holding after 2 months.

WESTERN AMERICANA PICTURE LIBRARY

History of American West

Address	86 Park Road, Brentwood, Essex CM14 4TT, England
Phone	(0277) 217643
Apply to	Peter Newark.
Material	Photographs, prints and engravings, original paintings and drawings covering all aspects of the American West — cowboys, Indians, railroads, steamboats, bandits, lawmen etc. Special collections on famous gangsters, the FBI, the old South, slavery. Also general American history. Number — 50,000.
Availability	Professional use only. Research by staff. Requests by writing or phone, no visits. Written authorisation required. Hours — Monday to Friday, 9 to 5.
Procedure	Material loaned. Fees: reproduction, holding after 1 month.

EUROPE

ARCHIV FÜR KUNST UND GESCHICHTE

Art and culture, antiquity to 1930s

Address	Prinz Friedrich-Leopold Strasse 34, D-1 Berlin 38, West Germany
Phone	(0311) 803 70 92
Material	Photographs, prints and engravings of art and other cultural subjects, including literature and music. Portraits and art history as well as reproductions. A very helpful agency who send generous loans of material in response to written requests. Period — Roman Empire to about 1930. Number — 250,000.
Availability	Research by staff. Requests by writing, phone or personal visit. Written authorisation required. Appointment required. Hours — Monday to Friday, 9 to 1, 3 to 6.
Procedure	Material loaned or copied. Fees: reproduction, sometimes search, holding after arranged time-limit. Postage charged. Commissions.

BERLIN, STAATSBIBLIOTHEK BILDARCHIV

General to 1945

Address	1 Berlin 30, Stauffenbergstrasse 11–13, West Germany (postal) 1 Berlin 30, Postfach 1407, West Germany
Phone	266 2425-8 (archive) or 261 3922 (Dr Klemig)
Telex	0183160 staab d
Apply to	Dr Roland Klemig.
Material	A vast and splendidly comprehensive historical collection, which covers all subjects and all periods while at the same time offering particularly rich material in certain specific fields. These include Prussian culture throughout history, archeology, World War II in colour, posters, fashion, musical instruments, French 19th century caricaturists. The general material covers every conceivable subject, and the friendly

89

and expert staff welcome inquiries whether general or specific. Both the organisation and the service are efficient, while the fees are moderate.
Period — antiquity to 1945.
Number — over 3½ million.

Availability	Research by staff or researcher. Requests by writing, phone or visit. Written authorisation required in first instance. Appointment preferred. Hours — Monday to Friday, 9 to 6.
Procedure	Material loaned. Fees: reproduction, holding after 2 to 6 months. Catalogues of transparencies and early history available.
Notes	The Bildarchiv is able to obtain additional picture material from the museums, libraries and archives of Berlin and elsewhere in Germany, on commission.

EDISTUDIO

General photographs, especially history, geography and culture of Spain and Latin America

Address	Mallorca 53, Barcelona 15, Spain
Phone	321 24 00
Telex	SAEDI 53132
Material	Colour transparencies covering geography, history, art and architecture of Spain and Europe as well as Latin America. Material also includes sport, zoology, botany, medicine and industry. A good and helpful source, particularly on art and history. Number — 100,000.
Availability	Research by staff. Requests by writing or visit, not phone. Hours — Monday to Friday, 8 to 6.
Procedure	Material loaned or copied. Fees: reproduction, holding. Photostat service.

GERSTENBERG, ARCHIV

General historical to 1950

Address	6 Frankfurt am Main 90, Post Box 900464, Grempstrasse 19, Germany.
Phone	776456
Material	Photographs, prints and engravings, original paintings and drawings covering all aspects of history, including social history, ethnology, costume and uniforms, etc. The emphasis is naturally on Germany, but the collection is international in scope. Period — prehistory to about 1950. Number — 1 million.
Availability	Research by staff. Requests by writing, phone or visit. Appointment necessary, delay 3 days. Hours — Monday to Friday, 11 to 7.
Procedure	Some material loaned, others copied, Fees: single fee including reproduction, service and any other charges.
Notes	Requests should specify nature of use and depth of coverage required.

IBA (INTERNATIONALE BILDERAGENTUR)

General, from antiquity to present

Address	Zürcherstrasse 54, CH-8102 Oberengstringen, Switzerland
Phone	(01) 79 20 60
Apply to	Frau Magda Müller.
Material	Photographs, prints and engravings covering history, geography, portraits; special emphasis on World Wars I and II, and the years between; also portraits of writers, philosophers and scientists. Period — antiquity to present. Number — 300,000.
Availability	Research by staff or researcher. Requests by writing, phone or visit. Appointment necessary, delay 3 to 5 days. Hours — Monday to Friday, 8 to 6.

Procedure Some material loaned, others copied.
 Fees: reproduction, sometimes search, service and holding.

MORO, ROME

General historical and cultural from 1820, especially Italian

Address vicolo Moroni 18, 00153 Roma, Italy

Phone 5807834

Material Photographs, prints and engravings, original paintings and drawings, printed ephemera
 of all kinds, leaflets, newspapers and various other propaganda items, covering a wide
 range of political and cultural trends and movements over the last 150 years — eg
 Italian Risorgimento and unification, the Industrial Revolution, the growth of
 fascism, the papacy, erotica, communism, women's liberation . . . Signora Moro has
 gathered (and is still gathering) a unique collection of material much of which has
 never been reproduced even in Italy, with emphasis on the popular iconography of
 the period rather than the establishment record. Particularly rich in postcards.
 Period — 1820 to present.
 Number — vast.

Availability Research by staff.
 Requests by writing; if necessary by phone, but confirm in writing; no visits.
 Written authorisation required in first instance.
 Hours — daily 8 to 9am, 2 to 4pm for certain, possibly other times.

Procedure Material not loaned, copies made.
 Fees: reproduction, others according to circumstances.
 Photostat service.

Notes Commissions undertaken: as an accredited journalist and experienced in this field,
 Giovanna Moro can quickly obtain material from Italian museums and collections
 both public and private.
 It is essential that requests are as detailed as possible and give full details as to use.
 Rates are not cheap, but are related to the rarity of the item and other circumstances.

ROGER-VIOLLET

General, all subjects, all periods

Address	6 rue de Seine, 75006 Paris, France
Phone	033 32 90
Material	An enormous and comprehensive collection of photographs, prints and engravings, efficiently housed in thousands of box files in a picturesque corner of the Quartier Latin. Their own summary of their scope is: 'History — geography — animals — flowers — plants — paintings — architecture — music — show business — sculpture — art of all kinds — archeology — museums — costumes — crafts — furniture — religion — science — landscapes — sport — everyday life — planes — ships — engravings of all periods.' The staff are knowledgeable and helpful, and the service is very good. Period — earliest times to present. Number — 10 million.
Availability	For journalists and publishers only. Research by staff or researcher. Requests — preferably by visit; if by writing or phone, only if very definite. Written authorisation required in first instance. Hours — Monday to Saturday, 9 to 12.30, 2 to 6.30.
Procedure	Material loaned or copied. Fees: reproduction, holding after 21 days, search and service if no order. Photostat service.

SNARK INTERNATIONAL

General historical and cultural, international scope

Address	8 rue Saint-Marc, 75002 Paris, France
Phone	231 37 26 or 508 56 74
Apply to	Denise Fastout.
Material	An important collection of photographs, including photos of works of art, relating to the political, social and cultural history of all countries. Though the collection as a whole is described as documenting 'contemporary history' of all periods, this can be taken as covering such diverse subjects as painting, sculpture, music, dance, cinema or scientific experiment. Period — earliest times to 1945. Number — 25,000 black and white, 4000 colour.

Snark International (continued)

Availability Research by staff or researcher.
 Requests by writing, phone or visit.
 Written authorisation required.
 Appointment preferred — 2 days delay.
 Hours — Monday to Friday, 9 to 1, 2.30 to 5.30.

Procedure Material loaned or copied.
 Fees: reproduction, sometimes others.
 Partial catalogue available.

TOMSICH, Gustavo

General historical to 1945, various special fields

Address Viale di Villa Massimo 37, 00161 Roma, Italy

Phone 851 704

Material Photographs, prints and engravings, original paintings and drawings, but chiefly
 colour transparencies, covering a wide range of subject-matter including natural
 sciences, history, arts, handicrafts, geography. There is a special collection of 15,000
 colour transparencies of botanical subjects.
 Period — prehistory to 1945.
 Number — 135,000.

Availability Research by staff or researcher.
 Requests by writing or visit, not phone.
 Appointment necessary, 1 to 3 days delay.
 Hours — Monday to Friday, 8 to 12.

Procedure Some material loaned, others copied.
 Fees: reproduction, search, service/handling, holding after 15 days.
 Free catalogue available.
 Photostat service.
 Commissions.

USA, CANADA and S. AMERICA

BETTMANN ARCHIVE

General, prehistory to 1950s

Address	136 East 57th Street, New York, NY 10022, USA
Phone	(212) 758 0362
Material	A big, comprehensive collection of historical material, covering all aspects of history, culture, daily life, science, sport, etc. Special collection of movie stills from 1920s to 1970s, much historical and current exclusive news coverage. The staff are knowledgeable and helpful. Period — prehistory to 1950s. Number — 2 million.
Availability	Research by staff. Requests by writing, phone or visit. Written authorisation required. Appointment preferred, no delay. Hours — Monday to Friday, 9 to 5.
Procedure	Material loaned. Fees: reproduction, holding, sometimes search. Catalogue: the Bettmann Portable Archive is not exactly a catalogue, but a splendid sampler containing 3669 pictures, much entertainment, some wise and lucid thoughts on the picture business from Dr Otto Bettmann who knows and understands the trade as well as anyone alive, and a book which every researcher should have on the shelf. ($19.50 plus postage).

BROWN BROTHERS

General historical and modern

Address	Sterling, Pennsylvania 18463, USA
Phone	(717) 689 9688
Material	One of America's biggest commercial archives, this contains a vast assortment of material on every subject, general or specific. There is a big news collection, particularly of the early 20th century, and they have superb early photographic material on American daily life in the late 19th and early 20th centuries. Period — prehistory to present. Number — several million.

95

Brown Brothers (continued)

Availability	Research by staff.
	Requests by writing or phone, no visits.
	Written authorisation required in first instance.
Procedure	Material not loaned, copies made.
	Fees: reproduction, sometimes search, service and holding.

CULVER PICTURES

General, specialising in entertainment

Address	660 First Avenue, New York, NY 10016, USA
Phone	212 MU4 5054
Material	A large collection of historical material with a special emphasis on the entertainments world. Photographs, prints and engravings, some original paintings. Includes movie stills, scenes from theatre and opera and so on.
	Period — cavemen to 1960.
	Number — 7½ million.
Availability	Research by staff or researcher.
	Requests by writing, phone or visit.
	Written authorisation required in first instance.
	Appointment preferred, delay 2 or 3 days.
	Hours — Monday to Friday, 9 to 5.
Procedure	Material loaned.
	Fees: reproduction; search. service and holding according to circumstances.
	Catalogue available.

CUSHING, Charles Phelps

General historical, with special fields

Address	51 East 42nd Street, New York, NY 10017, USA
Phone	212 MU7 3482
Material	A somewhat diverse collection of historical material, with special fields including: Early Americana, especially Ozarks (photos); early Russian history; Chinese history up to recent past; Europe before World War I; Japan up to and including Pearl Harbour; World Wars I and II; material comprises photos, prints and engravings, original drawings.
	Number — over 500,000.

Cushing, Charles Phelps (continued)

Availability Not available for advertising.
 Research by staff or researcher.
 Requests by writing, phone or visit.
 Written authorisation required in first instance.
 Appointment preferred.
 Hours — Monday to Friday, 10 to 3.30.

Procedure Material loaned.
 Fees: reproduction, search, service/handling, holding.

GRANGER COLLECTION

General history, from prehistory to recent past

Address 1841 Broadway, New York, NY 10023, USA

Phone (212) 586 09 1

Cables Illustrate, New York

Apply to William Glover, Director.

Material Photographs, prints and engravings, original paintings and drawings covering all
 aspects of history, with a natural emphasis on America but worldwide in coverage.
 William Glover takes a personal interest in requests and knows his collection
 intimately. Specialities: cartoons, slavery and negroes, graphic design, opera.
 Period — prehistory to recent past.
 Number — over 3 million.

Availability Research by staff or researcher.
 Requests by writing, phone or visit.
 Appointment preferred.
 Hours — Monday to Friday, 10 to 5.

Procedure Material loaned or copied.
 Fees: reproduction, sometimes search, service/handling, holding.
 Photostat service.
 Catalogue available, free on request. Also catalogue of silent cinema stills
 (purchaseable).
 Commissions.

HISTORICAL PICTURES SERVICE

General historical, prehistory to 1930s

Address	The Stevens Building — Suite 1700-02, 17 North State Street, Chicago, Illinois 60602, USA
Phone	(312) 346 0599
Apply to	Joseph Karzen, Director.
Material	Photographs, prints, engravings, cartoon caricatures and maps covering every aspect of man's development from antiquity to the present. While specialising in history, its scope encompasses materials in politics, diplomacy, military affairs, aesthetics, social life, science, economics and technology. Number — over 2 million.
Availability	Research by staff. Requests by writing, phone or visit. Written authorisation required in first instance. Appointment preferred. Hours — Monday to Friday, 9 to 5.
Procedure	Material loaned or copied. Fees: reproduction; others only when unusual trouble is involved. Photostat service.

INTER-PRENSA S.R.L.

General, Argentina, historical and modern

Address	Florida 229, Buenos Aires, Argentina
Phone	33 3808 and 33 9109
Cables	Interprensa Baires
Material	Photographs, prints and engravings, original paintings and drawings relating to all aspects of Argentinian history, culture and social life in the 20th century. The service is geared primarily to magazine and newspaper publishing.
Availability	Research by staff. Requests by writing, phone or visit. Appointment necessary. Hours — Monday to Friday, 9 to 6.

Inter-Prensa S.R.L. (continued)

Procedure Material loaned or copied.
Fees: reproduction, search, service/handling, holding.
Photostat service.
Commissions.

KEAN ARCHIVES

General historical, especially American

Address 1320 Locust Street, Philadelphia, PA 19107, USA

Phone 215 Pennypacker 5 1812 and 5 2716

Apply to Manuel Kean.

Material A large and authoritative historical collection, efficiently organised and expertly catalogued. Scope is comprehensive, but specialities include American popular music of all periods, American Civil War, Bible history and theatre.
Period — prehistory to about 1890.
Number — 3½ million.

Availability Research by staff or researcher.
Requests by writing, phone or visit.
Appointment preferred.
Hours — Monday to Friday, 10 to 5.

Procedure Material loaned or copied.
Fees: reproduction, sometimes research, holding after 30 days.
Photostat service.

MERCURY ARCHIVES

General historical

Address 1574 Crossroads of the world, Hollywood, Los Angeles, California 90028, USA

Phone (213) 466 1441

Apply to Edythe Carroll.

Material General historical items, prints and engravings, covering scenes, events, objects under every conceivable heading.
Period — 1500 to 1900.
Number — over 3 million.

Availability Research by staff.
 Requests by writing, phone or visit.
 Appointment necessary.
 Hours — Monday to Saturday, 9.30 to 3.30.

Procedure Material loaned.
 Fees: reproduction, search, sometimes service.

SEIDMAN, Sy

Americana, mostly historical

Address 4 West 22nd Street, New York, NY 10010, USA

Phone (212) 924 3180

Material Photographs, prints and engravings, original paintings and drawings covering many aspects of American social history. The collection is rich in popular culture and ephemera, and the scope and system are best illustrated by such headings in his subject-list as 'Etiquette in the 1880s', 'Famous American Mothers', 'Presidential Campaign material' etc. The picture collection is complemented by one of actual items such as early household equipment.
Period — throughout American history.
Number — several thousand.

Availability Research by staff or researcher.
 Requests by writing, phone or visit.
 Written authorisation required in first instance.
 Appointment preferred.
 Hours — Monday to Friday, 10 to 4.

Procedure Some material loaned, others copied.
 Fees: reproduction, service/handling, holding.
 Subject catalogue available.

This is both the biggest and the most varied section of our directory; it includes all those sources, apart from specifically press agencies, which offer a wide range of contemporary material. It is almost true to say that any of these sources *may* have a photo of anything from Toscanini at rehearsal to a pin-up nude for a calendar; but it is also true to say that the chances are you will have to phone one source after another before you find just the item you are looking for...

BRITAIN and EIRE

ALDUS BOOKS

General, various specific subjects

Address	Aldus House, Conway Street, Fitzroy Square, London W1P 6BS, England
Phone	(01) 387 2811
Apply to	David Paramor, Archivist.
Material	Primarily material used in books published by Aldus, which cover a wide range of cultural and sociological fields, some of general interest and others highly specialised. Period — antiquity to present. Number — about 5000.
Availability	Research by staff. Requests by writing or phone. The material is filed spread by spread under book titles. There is no subject index, so reference must be made directly to the published book. There are no facilities to consult books on the premises; researchers are expected to either purchase books or consult them in libraries, then give Aldus specific requests. Such orders will be handled by return of post. Illustrated book lists sent gratis on request.
Procedure	Material loaned. Fees: reproduction, service, holding.

ANDREW, K M

Modern photographs, Scotland and Scottish life

Address	15 Station Road, Monkton, Prestwick, Ayrshire KA9 2RH, Scotland

Andrew, K M (continued)

Phone 0292 77503

Material Colour and black and white photographs covering all aspects of Scottish scenery, topography, architecture, history, natural history and so on. There is a special collection of mountain photographs, as Mr Andrew has personally climbed every Scottish mountain over 2,500 ft!
Period — 1955 to present.
Number — 20,000 colour, 20,000 black and white.

Availability Research by staff.
Requests by writing, phone or visit.
Appointment necessary.

Procedure Some material loaned, others copied.
Fees: reproduction.
Commissions.

ASSOCIATED FREELANCE ARTISTS

Modern photographs, chiefly natural history and geography

Address 19 Russell Street, London WC2, England

Phone (01) 836 2507

Material Though primarily an illustrators' agency, AFA also represent some good photographers, working particularly in the fields of natural history and geography, but covering a wider range of subject-matter in addition.
Period — present only.

Availability Research by staff.
Requests by writing, phone or visit.
Appointment preferred.
Hours — Monday to Friday, 10 to 6.

Procedure Material loaned or copied.
Fees: reproduction, sometimes search and holding.
Commissions.

BARNABY'S PICTURE LIBRARY
(incorporating the MUSTOGRAPH AGENCY)

General, chiefly recent and modern photographic

Address 19 Rathbone Street, London W1P 1AF, England

Phone (01) 636 6128 or 6129

Material	General stock, chiefly photographs but some prints and engravings. Barnaby's Library has special collections on Hitler, women's suffrage, Victorian photos, London history. The Mustograph Agency, representing the work of some 350 individual photographers, has a wide range of subject photos from 1900 to the present, ranging over a diversity of material from follies to trams, from hiking to mud. Very strong on British topography. A useful complement to news-oriented agencies, in fact. Period — antiquity to present, but chiefly 20th century. Number — 2 million.
Availability	Research by staff or researcher. Requests by writing, phone or visit. Written authorisation required in first instance. Hours — Monday to Friday, 9.30 to 6.
Procedure	Material loaned or copied. Fees: reproduction, search, service, holding after 30 days. Brief subject lists available. Commissions.

BERNSEN'S INTERNATIONAL PRESS SERVICE (BIPS)

General modern feature photographs

Address	25 Garrick Street, London WC2E 9BG, England
Phone	(01) 240 1401
Apply to	Mr Onno T Bernsen or Miss Kim Ross.
Material	Modern general press and feature material, also comprising such subjects as medicine, science, transport, architecture and so on. Photo features and illustrated articles as well as single pictures. Period — 1946 to present.
Availability	Research by staff or researcher. Requests by writing, phone or visit. Written authorisation required. Appointment preferred. Hours — Monday to Friday, 9 to 6, Saturday, 9 to 12.
Procedure	Material sometimes loaned, usually copied. Fees: reproduction, search, service/handling, holding. Commissions.
Notes	Branches in New York, Stockholm, Antwerp (for Benelux), Paris, Hamburg, Milan.

BLACK STAR (LONDON)

General modern feature photographs

Address	Cliffords Inn, Fetter Lane, London EC4A 1DA, England
Phone	(01) 405 3103
Apply to	Mrs Boreham.
Material	General collection of photographs covering all subjects, and including an 'enormous amount of glamour'. Period — 1935 to present. Number — over 2 million.
Availability	Research by staff or researcher. Requests preferably by phone; written if lengthy or detailed, visits by appointment. Written authorisation required in first instance. Hours — Monday to Friday, 10 to 1.30, 3 to 6.
Procedure	Material loaned or copied. Fees: reproduction, search, service/handling, holding. Photostat service. Commissions.

CALLANAN, FIONNBAR

Modern photographs, Irish life and sport

Address	17 Park Avenue, Sandymount, Dublin 4, Eire
Phone	(0001) 692274
Material	Good quality photographs in black and white and colour of Irish subjects, particularly sports (speciality athletics) and Irish features. Period — contemporary. Number — 40,000.
Availability	Research by staff. Requests by writing, phone or visit. Appointment necessary. Hours — Monday to Saturday, 10 to 10.
Procedure	Some material loaned, others copied. Fees: reproduction, sometimes holding. Photostat service. Commissions.

CAMERA CLIX

General modern commercial photographs

Address 6 Portman Mews South, London W1, England

Phone (01) 493 5127

Apply to R A Attwood, G J Attwood, Miss M Brown.

Material Extensive stock of material suitable for advertising, greetings cards, calendars etc — cover girls (glamour, beach, pin-ups, nudes), children, animals, children with animals, Christmas still life, family scenes, views etc. Also Old Masters.

Availability Research by staff or researcher.
Requests by writing, phone or visit.
Appointment preferred.
Hours — Monday to Friday, 10 to 5.

Procedure Material loaned or copied.
Fees: reproduction, holding.
Catalogue available.

CAMERA PRESS

General modern news and feature photographs

Address Russell Court, Coram Street, London WC1, England

Phone (01) 837 4488 or 9393 or 0606 or 1300

Telex 21654

Material Large collection of diverse material giving worldwide coverage of almost any subject in black and white or colour. Big portrait file, and special department of material from/for women's magazines. They represent many 'big name' photographers of the calibre of Karsh, Beaton and Parkinson, and also many international publications.

Availability Research by staff or researcher.
Requests by writing, phone or visit.
Written authorisation required in first instance.
Appointment preferred, no delay.
Hours — Monday to Friday, 9.30 to 6.

Camera Press (continued)

Procedure	Material loaned or copied.
	Fees: reproduction, sometimes others according to circumstances.
	Photostat service.
	Commissions.

CASH, J Allan

Modern photographs, especially geographical, worldwide scope

Address	8—10 Parkway, London NW1 7AE, England
Phone	(01) 485 8212 or 7211
Material	Photographs, colour and black and white, giving world coverage of geography, natural history, social and economics, yachting, space travel.
	Period — mostly contemporary, but some 1935—9.
	Number — 500,000.
Availability	Research by staff or researcher.
	Requests by writing, phone or visit.
	Appointment preferred.
	Hours — Monday to Friday, 9 to 5.15 (visits 10 — 4).
Procedure	Material loaned or copied.
	Fees: reproduction, search, service/handling, holding (after 30 days).
	Catalogue available.
	Commissions.

CENTRAL PRESS PHOTOS

News and feature photographs, 1914 to present

Address	6—7 Gough Square, London EC4 A3D, England
Phone	(01) 353 6600
Material	A good general news and feature photo agency, catering mainly for press requirements. Helpful service.
	Period — 1914 to present.
	Number — over 1 million.
Availability	Research by staff.
	Requests by writing, phone or visit.
	Appointment preferred.
	Hours — Monday to Friday, 9 to 6.

Central Press Photos (continued)

Procedure	Material not loaned, copies made. Fees: reproduction, search, service. Commissions.

COLORIFIC

General modern colour photographs

Address	16 Spring Street, London W2, England
Phone	(01) 723 5031
Material	General collection of colour photographs, speciality North America and Africa. Includes photographic copies of paintings. Number — 100,000.
Availability	Research by staff or researcher. Requests by writing, phone or personal visit. Written authorisation required in first instance. Appointment preferred. Hours — Monday to Friday, 9.30 to 5.30.
Procedure	Material loaned or copied. Fees: reproduction, search, service and holding. Free catalogue available. Commissions.

FEATURES INTERNATIONAL

General modern feature photographs

Address	1 Gough Square, Fleet Street, London EC4A 3DE, England
Phone	(01) 583 0527
Telex	28905
Material	Features agency specialising in sets of photos on a news or human interest story. Very wide range of subjects, including natural history, domestic or travel material. Small collection of c 1900 photos of Malta, Ceylon, Singapore, and of World War I. Can obtain material very quickly from contacts in Hongkong, South Africa, Germany and Spain.

Features International (continued)

Availability Research by staff or researcher.
Requests by writing, phone or visit.
Appointment preferred.
Hours — Monday to Friday, 10 to 6.

Procedure Material loaned.
Fees: reproduction, search, holding.
Commissions.

FOX PHOTOS

General modern news and feature photographs, international scope

Address 69—71 Farringdon Road, London EC1, England

Phone (01) 405 6851

Cable Foxphotopic London EC1

Apply to Photographic Library.

Material A good news agency source of modern news and feature material of broad scope.
Efficient service, personal visits (by appointment) most effective method.
Period — World War II to present.
Number — 2 million black and white, 50,000 colour.

Availability Research by staff.
Requests by writing, phone or visit.
Written authorisation required in first instance.
Appointment preferred.
Hours — Monday to Friday, 9 to 5.30.

Procedure Material loaned or copied.
Fees: reproduction, search, handling and holding.
Commissions.

GRANT, Henry

General modern photographs, especially education and social services

Address	34 Powis Gardens, London NW11, England
Phone	(01) 455 1710
Material	Contemporary photographs on many subjects, including scenes of everyday life. Specialising in education and social services, particularly in Britain. Period — 1950 to present. Number — 60,000 black and white, 5000 colour.
Availability	Not available for advertising. Research by staff or researcher. Requests by writing, phone or visit. Written authorisation required in first instance. Appointment necessary. Hours — Monday to Friday, 9 to 6.30.
Procedure	Some material loaned, others copied. Fees: reproduction, search, service/handling, holding. Brief subject list available on request. Commissions undertaken, particularly in fields of education and social services.

GREEN, Ray

Modern photographs of life (especially working-class) and sport in Northern England

Address	18 Cringle Drive, Cheadle, Cheshire, England
Phone	(061) 428 4053
Material	Colour transparencies of sports and scenes of daily life in Northern England, with emphasis on social and sociological aspects and industry; also some black and white. Number — 10,000. Period — 1950s to present.
Availability	Research by staff. Requests by writing, phone or visit. Appointment necessary. Hours — Monday to Friday, 10 to 6.
Procedure	Some material loaned, others copied. Fees: reproduction, sometimes search, holding. Commissions.

GRIGGS, Susan, Agency

General modern photographs

Address	17 Victoria Grove, London W8, England
Phone	(01) 584 6738
Cables	Susanpix London W8
Apply to	Mrs Anne McInroy (Syndication Manager) or Jennifer Allsopp.
Material	Modern photographs covering worldwide travel, people, features, animals, decoration, food, pretty girls, mood shots etc. Period – 1960 to present. Number – 80,000.
Availability	Research by staff or researcher. Requests by writing, phone or visit. Appointment necessary. Hours – Monday to Friday, 10 to 6.
Procedure	Material loaned or copied. Fees: reproduction, search if none used, holding after 30 days. Photostat service. Commissions.

HARDING, Robert, Associates

General modern colour photographs, emphasis on educational material

Address	5 Botts Mews, Chepstow Road, Bayswater, London W2 5AG, England
Phone	(01) 229 2234
Cables	Rohard
Material	A fairly new concern which is building up a good stock of material primarily of educational and documentary value – geographical, architectural, natural history, cultural subjects, etc. The material is well organised for fast easy access. Period – modern. Number – 60,000.
Availability	Research by staff or researcher. Requests by writing, phone or visit. Appointment preferred. Hours – Monday to Friday, 9.30 to 6.

110

Harding, Robert, Associates (continued)

Procedure Material loaned or copied.
Fees: reproduction, sometimes search, service, holding.
Catalogue available.
Photostat service.
Commissions.

HILLELSON, John, Agency

General modern photography, some historical from 1850

Address 145 Fleet Street, London EC4, England

Phone (01) 353 4551

Telex 267357

Apply to The Librarian.

Material Top quality photographs of general subjects, by many first class international photographers. Also a small collection of historical photographs from 1850 on, including London during World War Two.
Period — 1850—1914, 1930 to present.
Number — 40,000.

Availability Research by staff.
Requests by writing, phone or visit.
Written authorisation required in first instance.
Appointment preferred.
Hours — Monday to Friday, 9.30 to 5.30.

Procedure Material loaned.
Fees: reproduction, search, service, holding.
Commissions.

Notes Agents for GAMMA and VIVA of Paris. Associated with MAGNUM (p. 114)

IRONS, Raymond, PICTURE LIBRARY

Modern feature photographs

Address 35 Langbourne Mansions, Holly Lodge Estate, Highgate, London N6, England

Phone (01) 348 1805

Material Photographs covering various types of feature material, including industry, children, glamour, landscapes and animals. Special series on deepsea fishing off Iceland, another on the first year of a child's life with photo for every day of the year.

Availability Research by staff.
 Requests by writing, phone or visit.
 Written authorisation required.
 Appointment necessary.
 Hours — Monday to Friday, 9 to 5.30.

Procedure Material loaned or copied.
 Fees: reproduction, search, service/handling, holding.
 Commissions.

KEYSTONE PRESS AGENCY

General news and feature photographs, 1920 to present

Address Bath House, 52—62 Holborn viaduct, London EC1A 2FE, England

Phone (01) 236 3331

Telex 888258

Apply to Monochrome Librarian or Colour Librarian.

Material A large, efficient news photoagency, with material covering a wide range of subjects relating to daily life, events, places, personalities etc.
 Period — 1920 to present.
 Number — 2 million black and white, 100,000 colour.

Availability Research by staff or researcher.
 Requests by writing, phone or visit.
 Written authorisation required in first instance.
 Hours — Monday to Friday, 9 to 6.

Procedure	Some material loaned, others copied.
	Fees: reproduction, search, service/handling, holding.
	Photostat service.
	Commissions.
Notes	Agents for Keystone offices around the world.

MACDONNELL, Kevin

Prints and ohotographs, various subjects, 1850 to present

Address	10 South Hill Park Gardens, Hampstead, London NW3, England
Phone	(01) 435 0125
Material	Although not a general collection in the full sense of the word, Mr Macdonnell's material covers a wide range of subjects. The most interesting are: Ireland 1916 to 1923; Victorian and Edwardian scenes and subjects; Boer War; World War One; Kent, Sussex, stately homes within 50 miles of London; Churches; Aircraft.
	Period — 1850 to present.
Availability	Research by staff.
	Requests by writing or phone, no visits.
	No fixed hours.
Procedure	Some material loaned, others copied.
	Reproduction fee.
	Commissions.
Notes	Despite the disparate nature of the collection, it includes some very fine material particularly of the Victorian and Edwardian eras, and is well worth any researcher's attention. For example, Mr Macdonnell has produced a book on the work of Muybridge.

MAGNUM PHOTOS

Modern photographs, general international

Address 145 Fleet Street, London EC4, England

Phone (01) 353 4551

Telex 267357

Apply to The Photo Library.

Material Modern photographers' work in all fields, including many of the world's leading photographers. (One researcher comments 'Expensive but worth it.')
Period — 1930s to present.
Number — 30,000.

Availability Research by staff.
Requests by writing, phone or visit.
Written authorisation required in first instance.
Appointment necessary.
Hours — Monday to Friday, 9.30 to 5.30.

Procedure Material loaned.
Fees: reproduction, sometimes search, service/handling, holding.
Commissions.

Notes Offices in Paris and New York.
Associated with John Hillelson agency (p. 111).

MARSHALL CAVENDISH

General, various specific subjects

Address 58 Old Compton Street, London W1V 5PA, England

Phone (01) 734 6710

Apply to Picture Library.

Material Photographs of a wide range of material, including historical prints and paintings, acquired in the course of preparing the company's part-works and other publications. Consequently, though wide in scope, the material falls into certain specific fields:
1 biblical (incl Holy Land topography etc).
2 medical.
3 knitting, crochet and needlework.
4 children
5 adult relationships, including wide range of sociological material.
Number — 25,000.

Marshall Cavendish (continued)

Availability	Research by staff or researcher.
	Requests by writing, phone or visit.
	Appointment preferred, no delay.
	Hours — Monday to Friday, 9.30 to 5.30.
Procedure	Material loaned.
	Fees: reproduction, loan fee.
	Photostat service.

MONITOR INTERNATIONAL

Modern photographs, particularly places and personalities

Address	17—27 Old Street, London EC1, England
Phone	(01) 253 7071 or 6281
Telex	24718
Apply to	R A Collins, Picture Editor.
Material	Modern photographs on general subjects, with a preponderance of well-known personalities and places. Special collection of aerial photographs.
	Period — mid 1950s to present.
	Number — 100,000 black and white, 20,000 colour.
Availability	Research by staff.
	Requests by writing, phone or visit.
	Written authorisation required in first instance.
	Appointment necessary.
	Hours — Monday to Friday, 8.30 to 7.30.
Procedure	Some material loaned, others copied.
	Fees: reproduction, holding.
	Photostat service.
	Commissions undertaken, including aerial photography.

NOVOSTI PRESS AGENCY

Russia, past and present

Address	3 Rosary Gardens, London SW7 4NW, England
Phone	(01) 373 7350
Material	Photographs of all aspects of Russian history, life and culture and contemporary news. A good selection is held in London, other material can be ordered from Russia. The staff are really friendly and helpful and make every effort to co-operate with serious requests.
Availability	Research by staff or researcher. Requests by writing, phone or visit. Written authorisation required in first instance. Appointment necessary. Hours — Monday to Friday, 9 to 3.
Procedure	Material loaned. Fees: reproduction, sometimes search, service/handling and holding. Commissions.

PAF INTERNATIONAL

Modern photographs, general feature material

Address	c/o Crick & Co, 81 Piccadilly, London W1V 0JA, England
Phone	(01) 876 9572
Apply to	Mrs Lucie Maher.
Material	Modern photographs of family life, scenery, animals, cooking, handicrafts.
Availability	Research by staff or researcher. Requests by writing, phone or visit. Appointment necessary. Hours — Monday to Friday, 9.30 to 5.30.
Procedure	Material loaned. Fees: reproduction, holding.

PHOEBUS PICTURE LIBRARY

General, various specific subjects

Address	49/50 Poland Street, London W1A 2LG, England
Phone	(01) 437 0686
Telex	23451
Apply to	Librarian, Mrs Sarie Forster.
Material	Photographs of a wide range of material, including historical prints and paintings, largely accumulated through the preparation of British Printing Corporation part-works and current Phoebus publications. Consequently, though wide in scope, the material falls into certain specific fields:

1 history (particularly Britain and USA).
2 cookery (includes much original material of high quality).
3 antiques.
4 magic and all aspects of occult and supernatural.
5 war and military.
6 natural history.
Some of the material is not Phoebus copyright, in which case half the normal fee is charged and the copyright must be cleared with the copyright owner.
Number — over 20,000.

Availability	Research by staff.
	Requests by writing, phone or visit.
	Appointment preferred, no delay.
	Hours — Monday to Friday, 9.15 to 5.15.
Procedure	Material loaned.
	Fees: reproduction, holding.
	Photostat service.
	Colour material handled by Picturepoint (p. 119)

PICTOR

General modern photographs and historical

Address	Lynwood House, 24/32 Kilburn High Road, London NW6 5XU, England
Phone	(01) 328 1581
Material	General modern photographs in colour, with emphasis on women, scenery and geography, wildlife. Also a collection of historical material in black and white. Number — 500,000.

Pictor (continued)

Availability	Research by staff or researcher. Requests by writing, phone or visit. Appointment preferred. Hours — Monday to Friday, 9 to 5.30.
Procedure	Material loaned. Fees: reproduction, sometimes search and holding. Commissions.
Notes	Agents in Paris and Milan.

PICTORIAL PRESS

General modern photographs

Address	2—3 Salisbury Court, Fleet Street, London EC4Y 8AA, England
Phone	(01) 353 6677 or 4123
Material	General modern photographs in colour or black and white, covering most general subjects but with special emphasis on children, glamour, medical and religious subjects. Also special collections of World War I and World War II, and Russian material. Period — 1930 to present (also World War I collection). Number — 1 million black and white, ½ million colour.
Availability	Research by staff or researcher. Requests by writing, phone or visit. Written authorisation required in first instance. Appointment preferred. Hours — Monday to Friday, 9.30 to 6.
Procedure	Some material loaned, others copied. Fees: reproduction, search, holding, sometimes service. Free subject list available. Photostat service. Commissions.

PICTUREPOINT

General modern photographs

Address	7 Cromwell Place, London SW7 2JN, England
Phone	(01) 589 2489
Material	General photographic collection covering wide range of subjects, and acting as agents for many overseas picture sources. Special collections include Pollution, Photomicrographs and Fine art. Efficient and professional, but at the same time friendly and helpful. Now handle Phoebus colour material. Period — 1954 to present. Number — over 100,000.
Availability	Research by staff or researcher. Requests by writing, phone or visit. Written authorisation required from freelance researchers. Appointment preferred. Hours — Monday to Friday, 9 to 5.30.
Procedure	Material loaned or copied. Fees: reproduction, search, holding after 1 month. Free subject list available. Commissions.

PIXFEATURES

General modern photographs

Address	5 Latimer Road, Barnet, Hertfordshire, England
Phone	(01) 449 9946 or 440 3663
Telex	27538
Material	General modern photographs, emphasis on national affairs and political events. Agents in Britain for Stern magazine (Germany). Period — 1950 to present. Number — 100,000.
Availability	To publishers only. Research by staff. Requests by writing preferably, phone only if urgent. Visits by appointment only, delay 1 to 3 days. Hours — Monday to Friday, 9 to 6.

Pixfeatures (continued)

Procedure Material loaned or copied.
 Fees: reproduction, service, holding after 7 days, sometimes search.
 Photostat service.
 Commissions.

POPPERFOTO

General photographs, chiefly 20th century, some special fields

Address 24 Bride Lane, London EC4Y 8DR, England

Phone (01) 353 9665

Telex 21202

Material The present collection is the result of the amalgamation of a number of separate
 collections largely geared to newspaper requirements; they therefore reflect a general
 emphasis on current affairs and historical events as recorded by Fleet Street
 photographers. There is extensive coverage of topographical subject matter for the
 early 20th century, a particularly interesting collection being Ponting's unique record
 of Scott's Antarctic journeys. The collection incorporates the Conway collection
 which is itself largely based on the archives built up by Odhams Press; this gives
 coverage in depth of events and topical feature material throughout the last four
 decades.
 Period — all dates, but chiefly 20th century
 Number — over 10 million.

Availability Research by staff or researcher.
 Requests by writing, phone or visit.
 Written authorisation required in first instance.
 Hours — Monday to Friday, 9.30 to 6; other times by special arrangement.

Procedure Material loaned.
 Fees: reproduction, holding.
 Photostat service.
 Commissions.

REX FEATURES

General modern photographs

Address	15–16 Gough Square, Fleet Street, London EC4, England
Phone	(01) 353 4685
Telex	24224
Material	Colour and black and white photographs covering a wide range of current subjects, with special emphasis on glamour, personalities and animals. Agents for many overseas agencies. Period – 1953 to present. Number – 250,000 black and white, plus colour collection.
Availability	Research by staff or researcher. Requests by writing, phone or visit. Appointment preferred. Hours – Monday to Friday, 9.30 to 6.
Procedure	Material loaned or copies made. Fees: reproduction, search, service/handling, holding. Commissions.

SPECTRUM COLOUR LIBRARY

Modern photographs, general feature subjects

Address	44 Berners Street, London W1P 3AB, England
Phone	(01) 637 1587 or 2108
Apply to	Keith or Ann Jones.
Material	General modern photographs, including big up-to-date stock on travel, particularly of United Kingdom, Natural History and children. Period – 1960 to present. Number – 1 million colour, 100,000 black and white.
Availability	Research by staff or researcher. Requests by writing, phone or visit. Written authorisation required in first instance. Appointment preferred. Hours – Monday to Friday, 9.30 to 5.30, Saturday and Sunday by arrangement.

Procedure Material loaned or copied.
 Fees: reproduction, search, holding.
 Commissions.

SPORT & GENERAL

General modern photographs, especially sport, royalty and crime

Address 68 Exmouth Market, London EC1, England

Phone (01) 278 1223

Material General modern photographs, comprising a wide range of feature material but with
 special emphasis on sport, royalty and crime. The collection includes Barratts Photo
 Press and the London News Service. Up-to-date material, fast efficient service.
 Period — 1906 to present but mostly post World War II.

Availability Research by staff.
 Requests by writing, phone or visit.
 Written authorisation required.
 Appointment necessary, 1 day delay.
 Hours — Monday to Friday, 9 to 6.

Procedure Some material loaned, others copied.
 Fees: reproduction, search.
 Commissions.

STONE, Tony, Associates

General modern photographs

Address 28 Finchley Road, St John's Wood, London NW8 6ES, England

Phone (01) 586 3322

Cables Stonecolor via Amstelco London 21879

Material Modern photographs of a general character, as exemplified by those of which there
 are specially large collections: flowers, animals, landscapes, vintage cars.
 Number — 100,000.

Availability Research by staff.
 Requests by writing, phone or visit.
 Appointment preferred.
 Hours — Monday to Friday, 9.15 to 5.15.

Stone, Tony, Associates (continued)

Procedure Material loaned.
 Fees: reproduction.

Notes Staff speak most European languages, and do extensive business in Europe and with
 USA.

SYNDICATION INTERNATIONAL

General modern photographs

Address 27 Floral Street, London WC2E 9DP, England

Phone (01) 836 8466

Apply to either colour, black and white or sport libraries, when phoning.

Material Big, well-organised collection of modern photographs drawn from the resources of
 the International Publishing Corporation and many freelance photographers. The
 scope is comprehensive, covering news, sport, entertainment, personalities as well as
 all kinds of general feature material.
 Period — 1903 to present.
 Number — 2 million.

Availability Research by staff or researcher.
 Requests by writing, phone or visit.
 Appointment preferred.
 Hours — Monday to Friday, 9.30 to 5.30.

Procedure Material loaned or copied.
 Fees: reproduction, search, holding.
 Useful brochure available on request.
 Commissions.

TELEGRAPH, DAILY, COLOUR LIBRARY

General modern photographs

Address 6th floor, 81/82 Farringdon Street, London EC4, England

Phone (01) 353 4242 extensions 152 and 155

Apply to Jeremy White, colour librarian.

Material Modern photographs of diverse topical and feature material taken for, though not
 necessarily used in, the newspaper. Well filed and indexed for easy reference. Also
 handles work of many freelance photographers.
 Number — over 1 million.

Availability Research by staff or researcher.
 Requests by writing, phone or visit.
 Written authorisation may be required in exceptional cases.
 Appointment preferred.
 Hours — daily, 9 to 6.

Procedure Material loaned or copied.
 Fees: reproduction, sometimes search, holding after 30 days.
 Photostat service.
 Commissions.

Notes Branch in New York.

TOPHAM PICTURE LIBRARY, JOHN

General collection of black and white photographs, emphasis on agriculture

Address Popperfoto, 24 Bride Lane, London EC4 8DR, England

Phone (01) 353 9665

Material A large collection of black and white photographs with international coverage of a
 variety of subjects. There are special collections of geographical and farming subjects,
 including a huge variety of breeds of farm animals.
 Period — 1928 to present.
 Number — 150,000.
 Harold A Bastin library of Natural History which contains 50,000 negatives of
 animals, birds, insects, plants and marine subjects. Period — c1900.

Topham Picture Library, The John (continued)

Availability	Research by staff. Requests by writing, phone or visit. Visits by appointment only. Written authorisation in the first instance. Hours — Monday to Friday, 9 to 5.
Procedure	Material loaned. Fees: reproduction, search, holding. Photographic service/print fee. Commissions.
Notes	Colour transparencies handled by Camera Press.

TRANSWORLD FEATURE SYNDICATE

Material from international periodicals

Address	52 High Holborn, London WC1, England
Phone	(01) 242 8262 or 9310
Telex	261671
Material	Photographs and art illustrations from a wide range of international periodicals, ranging from the London *Observer* to *McCalls*, from *Jasmin* to *True Confessions*. Agents for Black Star Agency, New York. Subject matter covers geographical subjects, film, television and other international celebrities, cover pictures, glamour, nudes, adventure, sport and general feature material.
Availability	For publication only. Research done by staff or researcher. Requests by writing, phone or visit. Written authorisation required in first instance. Appointment necessary. Hours — Monday to Friday, 10 to 6.
Procedure	Material loaned or copied. Fees: reproduction, search, service, holding. Photostat service. Commissions.

FRANCE

AARONS, Leo

General modern photographs

Address	12 avenue Montaigne, 75008 Paris France
Phone	225 0841
Material	General modern photographs covering scenes of the whole world, people, scenes of everyday life, sport, flowers, fruit etc — in short, general feature material. Period — 1957 to present. Number — over 50,000.
Availability	Research by staff or researcher. Requests by writing, phone or visit. Appointment preferred. Hours — Monday to Friday, 9 to 5.30.
Procedure	Material loaned. Fees: reproduction. Commissions.

AFIP
(Agence Française d'Illustration Photographique)

Modern colour photographs of human interest subjects, worldwide scope

Address	400 rue St Honoré, 75001 Paris, France
Phone	RIC 0711
Material	A wide range of photographic subjects covering the world today, children from all countries, wildlife and domestic animals, documentary features and so forth — in short, everything except current affairs. New pictures are added daily, old pictures are removed from the archive after 5 years. Period — last five years. Number — 50,000 colour.
Availability	Only for publishers and advertising. Research by staff. Requests by writing, phone or visit. Appointment preferred. Hours — Monday to Friday, 10 to 7.

126

Procedure	Material loaned or copied. Fees: reproduction, holding after 30 days. Commissions.

ALMASY, Paul

Modern general photographs, largely geographical and documentary

Address	2 villa des Peupliers, 92200 Neuilly, France
Phone	722 92 95 or 747 97 72
Material	Paul Almasy's archives are based on thirty years of photo-reportage. They cover 119 different countries, the pictures being well cross-indexed by subject-matter in his catalogue. He has also documentation of recent French history, starting with life under the German occupation and continuing to the present. Health, medicine and education throughout the world. Also 2500 portraits of personalities, international but mainly French. Also many general subjects, and 1500 engravings from the 18th and 19th centuries. Period — 1936 to present. Number — 25,000 colour, 300,000 black and white.
Availability	Research by staff or researcher. Requests by writing, phone or visit. Appointment preferred, delay 5 days. Hours — Monday to Friday, 9.30 to 12.30, 2 to 5.30.
Procedure	Material loaned. Fees: reproduction, holding. Excellent catalogue available on request.

CLERGUE, Lucien

Modern photographs, various subjects, emphasis on South of France

Address	17 rue A. Briand, 13632 Arles, France
Phone	91 96 51 06
Material	A highly personal photographer whose work covers a variety of subjects; the treatment tends towards the artistic rather than the purely documentary, and the material includes superb studies of bullfighting, gipsies, the life of the Camargue, Provençal sights and scenes. Other specialities are the work of Picasso, nude studies, portraits of some celebrities including Picasso, Cocteau, famous bullfighters, actors etc. Travel material includes Bangkok, Japan, Tahiti, Delos, Venice. Period — 1953 to present. Number — 30,000.

Clergue, Lucien (continued)

Availability Research by staff.
Requests by writing, phone or visit.
Written authorisation required.
Appointment preferred.
Hours — Monday to Saturday, 9 to 6.

Procedure Some material loaned, others copied.
Fees: reproduction, search, handling, holding.
Catalogues of exhibitions available; they give a good idea of his work.

DOCUMENTATION INTERNATIONALE

Modern photographs — geography, anthropology, culture, especially Communist countries

Address 21 avenue de Gravelle, 94 Charenton, Paris, France

Phone 368 41 00

Material Modern colour photographs covering varied aspects of many countries — scenes, cities, industry, agriculture, flora, daily life, folklore and customs, monuments, cultural objects etc. Particularly good coverage of Russia, Bulgaria, China etc.
Period — 1960 to present.
Number — 50,000.

Availability Research by staff or researcher.
Requests by writing, phone or visit.
Written authorisation required in first instance.
Appointment necessary.
Hours — Monday to Friday, 9 to 8.
BUT NOT DURING JULY, AUGUST AND FIRST 2 WEEKS OF SEPTEMBER.

Procedure Material loaned or copied.
Fees: reproduction, search, service/handling, holding.
Catalogue in preparation.
Commissions.

FREUND, Gisèle

Colour photographs of writers and artists from 1938; travel in Latin America

Address 12 rue Lalande, 75014 Paris, France
 (postal: BP9 75661 Paris Cedex 14, France)

Phone 734 77 49

Material Collection of colour photos of famous writers and artists from many countries, from 1938 to present.
 Geographical material, particularly of Latin America and especially Mexico, including art and architecture.
 Number — 10,000 colour, 30,000 black and white.

Availability Research by staff.
 Requests by writing, phone or visit.
 Written authorisation required.
 Appointment necessary.
 Hours — Monday to Friday, 9.30 to 6.

Procedure Some material loaned, others copied.
 Fees: reproduction.
 Typewritten catalogue available on request.

Notes Represented in England by John Hillelson (p. 111).

GUILLERME

Modern photographs especially of architecture, daily life, industry and crafts

Address 42 avenue Saxe, 75007 Paris, France

Phone 306 20 95

Material A wide ranging collection of photographs covering architectural views, scenes of daily life, industry and crafts, from Europe, North America and North Africa. Also a special collection on the restoration of paintings.
 Period — 1947 to present.
 Number — 20,000.

Availability Research by staff.
 Requests by writing, phone or visit.
 Appointment necessary, delay 8 days.
 No regular hours.

Procedure Some material loaned, others copied.
 Fees: reproduction.

HOLTZ, Michael

Modern photographs, varied subjects

Address	5 square Perronet, 92200 Neuilly-sur-Seine, France
Phone	267 17 29
Telex	PAT 27560F
Material	Modern photographs of personalities (French and international), landscapes, nudes and publicity material, candid photography. Period — 1958 to present. Number — 15,000
Availability	Research by staff. Requests preferably in writing. Phone or visit only if necessary. Written authorisation required. Appointment necessary. Hours — any time.
Procedure	Some material loaned, others copied. Fees: reproduction, service/handling, holding. Photostat service.

LARTIGUE, Jacques-Henri

Unique personal photographic collection, 1903 to present

Address	102 rue de Longchamp, 75116 Paris, France
Phone	727 06 25
Material	One of the great photographers of all time, Lartigue's collection is a unique personal reflection of the first three-quarters of the 20th century. The subject-matter comprises landscapes, personalities and current events, and reflects the photographer's interest in motoring and aviation from the very earliest days; but above all it is the daily life of the time which is most richly covered. Several albums of his work have been published and these may be consulted initially as an indication of the content of the collection. He also has some non-photographic material, including old postcards. Period — 1903 to present. Number — 185,000.
Availability	Research by staff. Requests by writing only. Written authorisation required in first instance.

Lartigue, Jacques-Henri (continued)

Procedure	Some material loaned, others copied. Fees: reproduction, search, service.
Notes	London agent: John Hillelson (p. 111)

MARINIER, Gérard

Modern photographs, geography (especially France) and French daily life

Address	23 rue des Laitières, F94300 Vincennes,France
Phone	328 51 28
Material	Modern photographs of places, comprising chiefly France and Europe, but also including some Africa, India and Canada. Also a wide range of feature subjects, including a number relating to fairs and circuses, marionettes, fireworks etc. (All listed on his subject list.) Period — 1948 to present. Number — 35,000.
Availability	Research by staff. Requests by writing only. Written authorisation required in first instance.
Procedure	Material not loaned, copies made. Fees: reproduction, sometimes others. Commissions.

RAPHO

General photographs, international coverage

Address	8 rue d'Alger, 75001 Paris, France (and see notes below)
Phone	260 30 06
Material	Wide variety of photographs in black and white or colour, whose scope is described as comprising 'human, economic, political, geographic subjects, etc'. With a string of photographers available on a worldwide basis, they have built up a large and diverse stock collection. Period — 1845 to present. Number — ½ million colour, ½ million black and white.

Rapho (continued)

Availability	Research by staff or researcher. Requests by writing, phone or visit. Appointment preferred. Hours — Monday to Friday, 9 to 5.30.
Procedure	Material loaned or copied. Fees: reproduction, sometimes service/handling. Commissions.
Notes	New York office: 59 East 54th Street, New York 22, USA.

RIBIERE, Reportages J et M

General modern photographs, daily life chiefly in France

Address	28 place Rigaud, 66000 Perpignan, France
Phone	(69) 34 51 81
Apply to	Jean Ribière.
Material	Photographs in black and white and colour of a wide range of subject-matter, particularly agriculture, religious art, tourism, street scenes, daily life, folklore etc. Period — 1940 to present. Number — over 60,000.
Availability	Research by staff. Requests by writing, phone or visit. Written authorisation required in first instance. Appointment preferred. Hours — Monday to Friday, 9 to 7.
Procedure	Material loaned or copied. Fees: reproduction, search, service/handling, holding. Comprehensive catalogue sent on request. Photostat service.

SCHWARTZ, Claude

General modern in various specific fields

Address	58 rue Gay-Lussac, 4 Passage des Postes, Paris 5, France
Phone	587 1570 or 633 1791
Material	Colour and black and white general subjects with a special collection of material relating to politics and the arts.
Availability	Research by staff or researcher. Application by writing, phone or visit. Written authorisation required. Hours — weekdays 10 to 8.
Procedure	Fees: reproduction, service and handling.

UNIVERS PRESS

General modern photographs, particularly reportage, some historical

Address	80 boulevard Pasteur, 75015 Paris, France
Phone	783 99 41
Apply to	Raymond Vanker.
Material	This collection consists primarily of the work of M. Vanker, a reporter whose photographs, if not always of the highest quality, have the merit of authentic actuality. Besides his reportage on modern historical events such as the Liberation of Paris, insurrection in Morocco, the Algerian War, etc, the collection includes: 1 Portraits of personalities ranging from Rasputin to Edith Piaf, from Franco to Anastasia. 2 Sporting subjects of every kind. 3 Historical subjects from antiquity to the present. 4 Topographical and tourist subjects from all over the world. Faced with this diversity of subject-matter, we can only suggest that M. Vanker's collection is just the sort of source which so often works out to have an item which all the others for some reason haven't, and a researcher whose field of interests in any way includes those touched on in the above list would do well to ask the proprietor for a copy of the subject list which he was good enough to prepare for this publication.

Univers Press (continued)

Availability	Research by staff. Requests by writing, phone or visit. Written authorisation required in first instance. Appointment preferred. Hours — Monday to Saturday, 9.30 to 9 except Tuesday and Friday, 9.30 to 12.30.
Procedure	Some material loaned, others copied. Fees: reproduction. Photostat service can be arranged.
Notes	This is very much a one-man concern, and approaches to the collections must be made with this in mind. Specific requests are welcome, but there are no facilities for large-scale research.

VIVA PHOTOS

General modern photographs, emphasis on reportage

Address	8 rue St Marc, 75002 Paris, France
Phone	236 3027
Telex	PUBLIO 21 311F / REF 640
Material	General modern photographs produced by the member photographers. International in scope, reportage in all its aspects, portraits of personalities, industry, theatre. Special collections of China 1905—1957 and the archives of William Klein. Period — 1962 to present. Number — over 15,000.
Availability	Research by staff or researcher. Requests by writing, phone or visit. Appointment preferred — 2 days delay. Hours — Monday to Friday, 9.30 to 6.30.
Procedure	Some material loaned, others copied. Fees: reproduction, service, holding. Commissions.
Notes	Agent in London: John Hillelson.

GERMANY and AUSTRIA

ADN ZENTRALBILD

General, 1900 to present

Address	Allgemeiner Deutscher Nachtrichtendienst, Zentralbild, 102 Berlin, Mollstrasse 1, East Germany
Phone	513 4187 (513 4193 after 5 pm)
Material	Photographs, including reproductions of prints, engravings, paintings drawings etc, and photographs of items in GDR museums and galleries. Subjects covered include; industry, agriculture, health, education, urban development, sports and all matters of historic interest. Documentary illustration of the fight of the German working class up to the liberation of fascism and the construction of the GDR.
	As the main GDR news agency, they act as agents for publishers and TV and also have many offices in other countries. The Fleet Street branch is particularly helpful. Period — end of 19th century to present. Number — 4,500,000.
Availability	Research by staff. Requests by writing, phone or visit. Written authorisation (specifying use). Visits (to use their printed lists) by appointment. Hours — weekdays, 9 to 4; for news coverage, 8 to 10.
Procedure	Material loaned. Photographic service. Fees: reproduction, sometimes others.

BAVARIA-VERLAG

General, especially Germany, chiefly modern

Address	Waldpromenade 22, Schliessfach 160, D-8035 Gauting vor München, West Germany
Phone	(0811) 850 12 05
Apply to	Herr Echter, Manager.
Material	Wide range of phogographs covering most aspects of daily life, topography, natural history etc. Also historical pictures of German towns. Excellent service, and good selection sent in response to written requests. Number — over 300,000.

Bavaria-Verlag (continued)

Availability Research by staff.
Requests by writing, phone or visit.
Written authorisation required for reproduction of paintings and for advertising.
Appointment preferred.
Hours — Monday to Friday, 8 to 5.

Procedure Material loaned or copied.
Fees: reproduction, service/handling, holding, sometimes search.
Subject list on request.
Commissions.

DEUTSCHE PRESSE AGENTUR BILDERDIENST

Modern press and general photographs, emphasis on Germany

Address 6 Frankfurt am Main 1, Baselerstrasse 33, Postfach 2649, West Germany

Phone (0611) 23 04 01

Telex 04 13344

Material Modern photographs, news and general coverage, with helpful staff particularly if ample time is available.
Period — 1945 to present.
Number — 3 million black and white, 100,000 colour.

Availability Research by staff or researcher.
Requests by writing, phone or visit.
Written authorisation required.
Appointment preferred.
Hours — Monday to Friday, 9 am to 10 pm, Saturday, 9 am to 9 pm.

Procedure Some material loaned, others copied.
Fees: reproduction, search, service/handling, holding.
Commissions.

LAENDERPRESS

General modern photographs, especially German

Address	4 Düsseldorf 30, Friedrich-Lau-strasse 26, West Germany
Phone	0211 43 15 57
Telex	8584780 1pd
Material	A top quality 'glossy' general agency, which handles much international material besides their own German material. Covers all aspects of daily life and feature subjects. Number — over 1 million.
Availability	Research by staff or researcher. Requests by writing, phone or visit. Appointment preferred. Hours — Monday to Friday, 8.30 to 5.
Procedure	Material loaned. Fees: reproduction, search, service/handling, holding. Commissions.
Notes	Agents for Sunday Times (London), Syndication International (women's magazines), Magnum for Germany, and many other international agencies and individual photographers.

SÜDDEUTSCHER VERLAG, BILDERDIENST

Modern news photographs, European history from 1850

Address	D8000 München 2, Postfach 300, West Germany
Phone	(0811) 218 3301
Telex	München 0523426 or 0524828
Apply to	Herr Ulrich Frodien.
Material	Photographs illustrating European history from 1850 to the present, particularly World War Two. Includes portraits industrial scenes and all related material. Also modern news and features. The collection is outstanding in scope and size, the service is helpful and efficient, and generous selections are sent on request. Period — 1850 to present. Number — 10 million.

Süddeutscher Verlag, Bilderdienst (continued)

Availability Research by staff.
Requests by writing, phone or visit.
Written authorisation required in first instance.
Appointment necessary, delay 3 days.
Hours daily, 8 to 8.

Procedure Material loaned.
Fees: reproduction, search, service/handling, holding.
Commissions.

ULLSTEIN BILDERDIENST

General historical, wide scope

Address 1 Berlin 61, Kochstrasse 50, West Germany

Phone 2591 609 or 610

Telex 0183508 ulsta d or 0184565 ulsta d

Apply to Liselotte Bandelow.

Material A major German source of visual documentation in every field, comprehensive in scope, efficiently run. The emphasis is on historical subjects.
Period – prehistory to present.
Number – over 3 million.

Availability Research by staff.
Requests by writing, phone or visit.
Written authorisation required in first instance.
Appointment necessary, 3 days delay.
Hours – Monday to Friday, 9 to 5.30.

Procedure Material loaned.
Fees: reproduction, search, service/handling, holding.

Notes Requests should be as detailed and as specific as possible.

V-DIA VERLAG HEIDELBERG

General modern photographs

Address	6900 Heidelberg 1, Postfach 1912, Heinrich Fuchs Strasse 95/97, West Germany
Phone	(06 221) 3 70 41
Telegrams	VAUDIA
Apply to	Herr Huhn.
Material	Modern colour photographs covering a wide number of specific subjects, including geography, astronomy, geology, botany, zoology, medicine, industry, art, architecture, folklore and book illustrations (eg Grimm's tales). Number — 8000.
Availability	Research by staff. Requests by writing or visit, not phone. Appointment necessary, delay 10 days. Hours — Monday to Friday, 8 to 4.
Procedure	Transparencies sold. Fees: reproduction. Excellent catalogue available on request.
Notes	This collection is largely educational in character, and specialises in high quality photographs with high information content.

VOTAVA (WIENER PRESSE BILDERDIENST)

Modern press and general photographs, emphasis on Austria

Address	Taborstrasse 7, A 1020 Wien, Austria
Phone	26 12 71 or 26 12 72 or 26 14 064
Telex	74285 votava
Material	Big modern news and general photographic agency, covering all kinds of news, sports, feature, political and social material. Small stock relating to Viennese history. Period — chiefly 1936 to present. Number — 5 million.

Votava (Wiener Presse Bilderdienst) (continued)

Availability Research by staff.
 Requests by writing, phone or visit.
 Appointment preferred.
 Hours — Monday to Friday, 9 to 6; Saturday 9 to 2; Sunday 1 to 6 for sport and emergencies.

Procedure Material copied.
 Fees: reproduction, service/handling, search, holding.
 Photostat service.

ZEFA
(Zentrale Farbbild Agentur GmbH)

General modern colour photographs

Address 4 Düsseldorf (11) Oberkassel, Schanzenstrasse 20, Postfach 755, West Germany

Phone (0211) 57 40 37

Telex 858 4095

Material Modern colour photographs covering a wide range of subject matter — people, daily
 life, industry, trade, geography, natural phenomena, architecture, art, science, natural
 history etc.
 Number — 200,000.

Availability Research by staff or researcher.
 Requests by writing, phone or visit.
 Appointment necessary.
 Hours — Monday to Friday, 8.30 to 5.30.

Procedure Material loaned or copied.
 Fees: reproduction, service, holding.
 Extensive subject list available on request (in English if desired).

REST of EUROPE

ARBEIDERBLADET, billedavdelingen

Modern news photographs of Norway

Address Youngstorget 2 a, Oslo 1, Norway

Phone (02) 33 57 70

Telex 16297

Material Modern photographs of scenes and events in Norway, from 1945 to the present.

Availability Research by staff.
 Requests by writing, phone or visit.
 Hours — Monday to Friday, 8 to 4.

Procedure Material loaned or copied.
 Fees: reproduction.
 Photostat service.

ČESKOSLOVENSKÁ FOTOGRAFIE

Modern photographs of Czechoslovakian subjects

Address Vinohradská 2, Praha 2, Czechoslovakia

Phone Praha 22 02 26

Apply to Alena Šourková, Editor-in-chief.

Material A small but fast-growing collection of contemporary Czechslovakian material. Staff
 helpful with enquiries.
 Period 1960 to present.

Availability Research by staff or researcher.
 Requests by writing, phone or visit.
 Appointment necessary, 7 days delay.
 Hours — daily 9 to 4.

Procedure Some material loaned, others copied.

COMBI PRESS SERVICE

General modern photographs, especially Netherlands and former Dutch possessions

Address	Plantage Parklaan 12, Amsterdam C, Holland
Phone	35 49 51 or 24 67 43
Apply to	Bob van Dam, Manager.
Material	General photographic collection, covering wide range of material, ranging from geographical subjects to erotic sculpture in India. For non-Dutch researchers, chief interest will be in material relating to Holland and former Dutch possessions. Period — 1950 to present. Number — 250,000 black and white, 30,000 colour.
Availability	Research by staff or researcher. Requests by writing or visit, not by phone. Written authorisation required in first instance. Appointment preferred, delay 2 days. Hours — Monday to Friday, 10 to 6.
Procedure	Material loaned for 8 days only; otherwise copies made. Fees: reproduction, handling, holding. Commissions.

ICELANDIC PHOTO & PRESS SERVICE

General modern photographs of Iceland, Greenland and Faroes

Address	PO Box 5211, Reykjavik, Iceland
Phone	85811 (24-hour service 81177)
Cables	Matswib
Credit	Mats Wibe Lund
Apply to	Mats Wibe Lund junior.
Material	Comprehensive coverage in modern photographs of all aspects of life and events in Iceland, Greenland and the Faroe Islands. Geography, everyday life, events, folklore, trade and industry. Also acts as agency for individual photographers in the region, providing a comprehensive service. Period — 1956 to present. Number — 30,000.

Icelandic Photo & Press Service (continued)

Availability	Research by staff or researcher.
	Requests by writing, phone or visit.
	Written authorisation required in first instance.
	Receipt of material should be acknowledged.
	Appointment preferred, delay 1 to 3 days.
	Hours — Monday to Friday, 8.30 to 5.
Procedure	Material loaned or copied.
	Fees: reproduction, holding, sometimes search.
	Commissions.

POULSEN, ASMUNDER

General collection with special emphasis on the Faroes

Address	Lützenstrǿǒ, Tórshavn, Faroe Islands
Phone	12461
Material	General modern photographs with special collections on whale hunting, Faroe Islands. landscapes and other material of general interest.
Availability	Research by staff.
	Requests by writing, phone or visit.
Procedure	Material loaned.
	Fees: reproduction.

PRESSEHUSET

Modern photographs, especially Denmark, Greenland and Faroes

Address	Svend Trøstvej 3, 1912 København V, Denmark
Phone	(01) 213000
Telex	27056
Apply to	Karen Randolph or Erik Betting.
Material	Modern photographic agency, general coverage but special emphasis on subjects related to Denmark, Greenland and Faroe Islands.
	Period — 1940 to present.
	Number — 1 million black and white, 25,000 colour.

Pressehuset (continued)

Availability	Research by staff. Requests by writing, phone or visit. Appointment preferred. Hours — Monday to Friday, 8.30 to 4.30.
Procedure	Material loaned or copied. Fees: reproduction. Photostat service. Stock photo information service mailed out four times a year, free of charge.

SALMER, ARCHIVO FOTOGRAFICO INTERNACIONAL

General modern photographs, especially Spain

Address	Rambla de Cataluña no 54 — 3° 1a, Barcelona 7, Spain
Phone	216 02 22 or 215 75 67
Apply to	Sr Santiago Ortega Alonso or Sr Roberto Castell Esteban.
Material	General modern photographs, main subjects geography — with emphasis on Iberian peninsula — ethnography, monuments (international), all aspects of science, cultural subjects (chiefly Spain, with some from Europe and Latin America). Number — 150,000.
Availability	Research by staff. Requests by writing, phone or visit.
Procedure	Material loaned or copied. Fees: reproduction, holding after 30 days.

TIOFOTO AGENCY

General modern photographs, emphasis on Sweden

Address	Drottninggatan 88C, 111 36 Stockholm, Sweden
Phone	24 54 14
Cables	TIOFOTO, Stockholm
Material	General modern photographs, international but with a natural emphasis on Sweden. One third of the material is geographical; much of the remainder is made up of scenes from daily life, mostly in Sweden. Period — 1950 to present. Number — 800,000.

144

Tiofoto Agency (continued)

Availability Research by staff or researcher.
Requests by writing, phone or visit.
Written authorisation required.
Appointment preferred.
Hours — Monday to Friday, 9 to 4.

Procedure Material loaned or copied.
Fees: reproduction, search, holding.
Well-indexed catalogue available, free of charge.
Photostat service.
Commissions.

USA and CANADA

ALASKA PICTORIAL SERVICE

Modern photographs of Alaska, all aspects

Address	PO Drawer 6144, Anchorage, Alaska 99502, USA
Phone	(907) 344 1370
Apply to	Steve McCutcheon.
Material	Modern photographs covering all aspects of Alaska — scenery, daily life, natural history, industry etc. Period — 1940 to present. Number — 95,000.
Availability	Research by staff. Requests preferably by writing, phone only if essential; personal visitors welcome. Written authorisation required in first instance. Appointment necessary. Hours — Monday to Saturday, 8 to 8, unless out photographing.
Procedure	Material loaned or copied. Fees: reproduction. Commissions.

AUTHENTICATED NEWS INTERNATIONAL

General modern photographs

Address	170 Fifth Avenue, New York, NY 10010, USA
Phone	(212) 243 6995 or 6614
Apply to	Sidney Polinsky, Managing Editor.
Material	Big collection of modern stock photographs covering a wide range of subject-matter from Aeronautics to Zoos, and including a wide range of feature material, photo-news etc. Their news material from the 1920s–1930s could be particularly useful. They co-operate helpfully with all requests, and their material is of high quality. Period — earliest times to present. Number — over 1 million.

146

Authenticated News International (continued)

Availability	Research by staff. Requests by writing, phone or visit. Appointment preferred. Hours — Monday to Friday, 10 to 6.
Procedure	Material loaned or copied. Fees: reproduction, search, service/handling, holding. Leaflet available, brochure in preparation. Commissions.

BLACK STAR (NEW YORK)

General modern feature photographs

Address	450 Park Avenue South, New York, NY 10016, USA
Phone	(212) 679 3288
Cables	Blastarcom New York
Apply to	Howard Chapnick.
Material	General modern photographs on a wide variety of subjects, feature rather than news material. Period — 1935 to present. Number — 1½ million.
Availability	Research by staff or researcher. Requests by writing, phone or visit. Appointment preferred. Hours — Monday to Friday, 9 to 5.
Procedure	Material loaned. Fees: reproduction, search, holding. Commissions.

BRUEMMER, Fred

General modern photographs of Canada, specific material on Arctic

Address	5170 Cumberland Avenue, Montreal, Quebec H4V 2N8, Canada.
Phone	(514) 482 5098

Material	Canada, Greenland, Alaska, Lapland — covering most aspects of wildlife, plants, scenics, people, industry etc.
Availability	Research by staff or researcher. Application by phone, writing, or visit. Appointment necessary — delay up to 5 days. Hours — anytime.
Procedure	Material loaned. Fees: reproduction, holding after 90 days unless special arrangement is made.

CAMERA 5

General modern photographs

Address	27 West 27th Street, New York City, NY, USA
Phone	(212) 683 2534
Apply to	Photo Researcher.
Material	Camera 5 represents 15 photographers working throughout the United States, whose work appears in leading American and international publications. The stock library covers sport, politics, world events, celebrities, personalities and feature material of many kinds. Period — 1965 to present.
Availability	Research by staff or researcher. Requests by writing, phone or visit. Written authorisation required in first instance. Appointment necessary. Hours — Monday to Friday, 9.30 to 5.30, or by arrangement.
Procedure	Material loaned or copied. Fees: reproduction, search, handling, holding. Photostat service. Commissions.

FREELANCE PHOTOGRAPHERS' GUILD

General modern photographs

Address	110 West 32nd Street, New York, NY 10001, USA
Phone	(212) 524 2020
Material	Large, active commercial agency representing many first-class photographers, with photographs on every imaginable subject. Understandably reluctant to send large quantities of material without some assurance of remuneration. Specialities: sport, travel, wildlife. Number — 5 million black and white, 1 million colour.
Availability	Research by staff or researcher. Requests by writing, phone or visit. Written authorisation required in first instance. Appointment preferred. Hours — Monday to Friday, 9 to 5.30.
Procedure	Material loaned or copied. Fees: reproduction, service, holding. Brochure available on request. Commissions.

GLOBE PHOTOS

General modern photographs, especially entertainment personalities

Address	404 Park Avenue South, New York, NY 10016, USA
Phone	212 689 1340
Material	Very large colour library with material on most subjects, but with a special collection on entertainment personalities. Number — 5 million.
Availability	Research by staff or researcher. Requests by writing, phone or visit. Appointment preferred. Hours — Monday to Friday, 9 to 5.30.
Procedure	Material loaned or copied. Fees: reproduction, search, service and holding. Catalogues issued. Commissions.

HACKETT, Gabriel D

General, chiefly modern but some historical

Address	130 West 57th Street, New York, NY 10019, USA
Phone	(212) 265 6842
Material	Wide-ranging collection of material, covering cultural, social and historical subjects. The following are among the collections of special interest: 1 modern artists eg Picasso, Magritte. 2 music over 5 centuries, esp. Bartok and Gershwin. 3 social problems in contemporary New York City. 4 American Indians, historic and contemporary. 5 World wars — concentration camps, resistance, spies. 6 Communist countries of Europe, contemporary. All modern material is Mr Hackett's own or exclusive. Period — 1200 to present. Number — 50,000.
Availability	Research by staff. Requests by writing, phone or visit. Written authorisation required. Appointment necessary, 1 or 2 days delay. Hours — Tuesday to Friday, 2 to 8.
Procedure	Material loaned. Fees: reproduction, service/handling, search, holding after 3 weeks. Commissions. Subject list available on request, also special list of musical items.

LAMBERT, Harold M, STUDIOS

General modern photographs

Address	2801 West Cheltenham Avenue, Philadelphia, Pennsylvania 19150, USA
Phone	(215) 224 1400
Apply to	Raymond W Lambert (Sales).
Material	A large and varied collection of modern stock photographs on all subjects. 300 photographers from all over the world are represented. Period — 1930 to present. Number — 500,000 black and white, 60,000 colour.

150

Harold M Lambert Studios (continued)

Availability	Research by staff or researcher. Requests by writing, phone or visit. Appointment preferred. Hours — Monday to Friday, 9 to 5.
Procedure	Material loaned or copied. Fees: reproduction, service, holding. Free catalogue. Commissions.

MEMORY SHOP

General photographs from 1900

Address	100 Fourth Avenue, New York City, NY 10003, USA
Phone	CTR 3 — 2404
Material	Photographs, general in subject but specialising in film, theatre, sports and politics. Period — 1900 to present.
Availability	No information supplied, except that personal visits are by appointment only.
Procedure	Some material loaned, others copied. Fees: reproduction, search, service/handling, holding.

PHOTO-LIBRARY inc

Modern general pnotographs

Address	404 Park Avenue South, New York, NY 10016, USA
Phone	(212) 689 1340
Apply to	Roy Pinney, President.
Material	A general modern photographic agency, representing 87 photographers covering a wide range of subject-matter. Number — 100,000 colour, 300,000 black and white.
Availability	Research by staff or researcher. Requests by writing, phone or visit. Written authorisation required in first instance. Appointment preferred. Hours — Monday to Friday, 9 to 5.
Procedure	Material loaned or copied. Fees: reproduction, service, holding after 14 days. Commissions.

PHOTO RESEARCHERS inc

General modern photographs, specific fields of permanent interest.

Address	60 East 56th Street, New York, NY 10022, USA
Phone	(212) 753 3420
Cables	FotoSearch
Apply to	General: Mr Van Bucher. Natural history and science: Mrs Jane Kinne.
Material	An unusual photograph agency, in that it covers a wide range of specific fields of permanent interest rather than topical events and feature material. Among the subjects covered are

Natural history Science Geography
Agriculture Industry Sports
Psychology Social studies Politics
Music Religion Entertainment

But personalities, still life and human interest are also included. The material is drawn from the work of 1600 photographers, many highly specialised in their fields.
Period — 1956 to present.
Number — 1 million.

Availability	Research by staff or researcher. Requests by writing, phone or visit. Written authorisation required in first instance. Appointment preferred — 3 days delay. Hours — Monday to Friday, 9.15 to 5.30.
Procedure	Material loaned or copied. Fees: reproduction, search, service/handling, holding after 14 days. Commissions.

RAPHO GUILLUMETTE PICTURES

General modern photographs

Address	59 East 54th Street, New York, NY 10022, USA
Phone	755 0714
Cables	RaphoGuill
Apply to	James Sage, President.
Material	Top quality photographs by many of the world's leading photographers. Subject-matter is general, but particularly strong in human interest, travel, nature, social documentation. Special collections on China and France. Period —1930s to present. Number — over 1 million.
Availability	Research by staff or researcher. Requests by writing, phone or visit. Appointment preferred. Hours — Monday to Friday, 9 to 5.
Procedure	Material loaned. Fees: reproduction, search, service/handling, holding. Commissions.
Notes	Associated with PHOTOFIND (San Francisco), RAPHO (Paris).

ROLOC COLOR SLIDES

General modern photographs, chiefly geographical and ethnographical

Address	PO Box 1715, Washington DC, 20013, USA
Phone	(703) 354 9016
Material	Colour transparencies covering a wide range of subjects by country, scenes, places, daily life etc, with an educational documentary emphasis. Special collection on US space exploration. Natural history, etc. Period — 1940 to present. Number — 35,000.
Availability	Research by staff or researcher. Requests by writing, phone or visit. Appointment preferred. Hours — from 9 am daily (Sunday if necessary!).

Roloc Color Slides (continued)

Procedure Material loaned. Normally copy transparencies are sent in first instance, which may be loaned or bought outright. If top quality is required, original transparencies may be borrowed.
Fees: reproduction.
Catalogues available by separate countries — no charge except postage.

Notes A particularly friendly and helpful source whose detailed lists are a valuable research aid.

SHOSTAL ASSOCIATES

General modern colour photographs

Address 60 East 42nd Street, New York, NY 10017, USA

Phone (212) Mu 7 0696

Cables Shostalpix Newyork

Apply to Walter L Shostal, President.

Credit Shostal and photographer.

Material General modern photographs, colour only, giving almost complete coverage of 'all subjects of general interest' (their own description). Emphasis on material subjects rather than personalities.
Number — over 1 million.

Availability Research by staff or researcher.
Requests by writing, phone or visit.
Appointment preferred.

Procedure Material loaned or copied.
Fees: reproduction, sometimes others.
Photostat service.
Commissions.

SOVFOTO/EASTFOTO

Socialist nations, past and present

Address 25 West 43rd Street, New York, NY 10036, USA

Phone 279 8846

Apply to Harry Lowenkron, photo researcher.
 Liuba Solov, owner/manager.

Material Photographs, prints and engravings covering all 'socialist' countries — which in
 practice means:
 Soviet Union China Albania
 Bulgaria Czechoslovakia GDR (East Germany)
 Hungary Yugoslavia Poland
 Romania Algeria Cuba
 United Arab Republic Vietnam
 The material comprises current news, personalities, geography, daily life, sport,
 national types, industry, technology, medicine, the arts etc.
 Period — historical and current.
 Number — over 750,000.

Availability Research by staff or researcher.
 Requests by writing, phone or visit.
 Appointment necessary.
 Hours — Monday to Friday, 9.30 to 5.30.

Procedure Some material loaned, others copied.
 Fees: reproduction, service, holding.
 Short subject list sent free of charge.

UNDERWOOD & UNDERWOOD NEWS PHOTOS

General photographs, 1850 to present

Address 3 West 46th Street, New York, NY 10036, USA

Phone (212) JU6 5910

Apply to Milton Davidson.

Material General photographic collection, including much historical material.
 Period — 1850 to present.
 Number — over 3 million.

Underwood & Underwood News Photos (continued)

Availability Research by staff or researcher.
Requests by writing, phone or visit.
Appointment necessary, delay 2 or 3 days.
Hours — Monday to Friday, 9.30 to 5.

Procedure Material loaned.
Fees: reproduction, search, sometimes service and holding.

AUSTRALIA, INDIA, JAPAN

AUSTRALIAN PHOTOGRAPHIC AGENCY

General modern photographs of Australian subjects

Address	44 Pitt Street, Sydney, NSW 2000, Australia
Phone	27 7341 or 27 7342
Apply to	The Proprietor, Mr H J R Hickson.
Material	Modern photographs covering all aspects of Australian topography, daily life etc. Special coverage of agriculture, aerial views of cities etc. Period — 1953 to present. Number — over 150,000.
Availability	Research by staff. Requests by writing, phone or visit. Written authorisation required. Appointment preferred, 1 day delay. Hours — Monday to Friday, 8 to 5.
Procedure	Material loaned or copied. Fees: reproduction, service. Photostat service. Commissions.

BANERJEE, J

Modern photographs of India, geographical and social, natural history

Address	65/70 Rohtak Road, New Delhi 5, India
Material	Modern photographs of Indian geography, social life, archeological sites and monuments; also natural history, specialising in entomology. Period — 1955 to present.
Availability	Research by staff or researcher. Requests by writing only. Hours — Monday to Saturday.
Procedure	Material loaned, more usually copied. Fees: reproduction, holding after 1 month, sometimes service charge. Photostat service. Commissions.

FOTO FEATURES

Modern photographs of Indian subjects

Address 2032 Pitleyon Ka Chowk, Johari Bazar, Jaipur-3, (Raj) India.

Phone 65257

Material Photographs in colour or black and white of all types of Indian subject, comprising the work of many leading Indian photographers. Commissions welcomed.

INDIA FOTO NEWS FEATURES

Modern photographs of Indian life and news

Address 44 East Avenue Road, Delhi, India

Phone 273931

Apply to S Paul, proprietor.

Material Photographs covering all aspects of Indian life and news. Colour and black and white.
 Period — 1951 to present.
 Number — many thousand.

Availability Research by staff.
 Requests by writing or visit, not phone.
 Written authorisation required in first instance.
 Appointment preferred.
 Hours — 7 days a week, 6pm to 10pm.

Procedure Some material loaned, others copied.
 Fees: reproduction, search, service, holding.
 Photostat service.

INTERNATIONAL SOCIETY FOR EDUCATIONAL INFORMATION

Japan, past and present

Address Kikuei Building no 7-8, 2-chome, Shintomi, Chuo-ku, Tokyo 100, Japan

Phone 03 552 9481/2

International Society for Educational Information (continued)

Material	Photographs, including photos, prints, etc, relating to Japanese history, people, geography, culture and society. Period — early times to present. Number — 6000.
Availability	Research by staff. Requests by writing or visit, not phone. Written authorisation required in first instance. Appointment necessary. Hours — Monday to Friday, 9.30 to 5.30.
Procedure	Material loaned or copied. Reproduction fee. Commissions sometimes undertaken.
Notes	Written requests advisable, as few staff speak English or other foreign languages.

ORION PRESS

General modern photographs, especially Japan

Address	55-1-chome, Kanda Jimbocho, Chiyoda-ku, Tokyo, Japan
Phone	295 1400
Telex	J2 4447 (ORIONPRS)
Material	A good general agency, which acts for European and American material in Japan, and has its own stock of Japanese material for overseas clients. Period — 1930 to present. Number — 200,000.
Availability	Research by staff or researcher. Requests by writing, phone or visit. Appointment preferred. Hours — Monday to Friday, 9 to 5.30.
Procedure	Material loaned. Fees: reproduction, sometimes search, holding (rates comparable to American). Commissions.
Notes	British researchers have found Orion extremely helpful, and generous with loan material.

DIRECTORY OF SOURCES

B: SPECIALIST

S1 News, Current Events and Recent History

S2 Places and Peoples

S3 Art, Architecture and Archaeology

S4 Natural History

S5 Science and Technology

S6 Sport

S7 Transport

S8 Entertainment

S9 Other Specialist Sources

A good many of the sources in this section are press agencies, which more than any other type of picture source are geared to providing a prompt and efficient service. All the more reason why your requests should be as precise and as helpfully time-saving as you can make them. It's worth getting to know individual contacts, and familiarising yourself with the ways of working in each agency you use.

Here, as with the general modern sources, each assignment is likely to involve you in phoning one source after another until you find the item you want. However, every agency has a bias towards certain areas of interest; noting these down can be a useful time-saver for when you're in a hurry.

Many historical sources bring their files up to the present day, or to the comparatively recent past. So check sources such as the Staatsbibliothek at Berlin or the Radio Times Hulton Library in London in addition to the strictly contemporary sources listed in this section, when you're after news events of the not-too-recent past.

For material which has appeared in a particular magazine, get in touch directly with the publishers even if you know or guess that they obtained the material from abroad — they will be able to tell you the quickest and most convenient way to obtain the material.

BRITAIN and EIRE

ASSOCIATED PRESS

News photographs, worldwide

Address	83—86 Farringdon Street, London EC4, England
Phone	(01) 248 1691
Telex	268287
Apply to	Photo Library.
Material	News photographs — from every country, on every subject. Service geared to needs of newspapers and magazines, but available to book publishers etc. Period — 1935 to present.
Availability	Only for news use or historical — ie, not publicity or commercial. Research by staff. Requests by writing, phone or visit. Appointment preferred. Hours — Monday to Friday, 10 to 6.
Procedure	Material copied (fast efficient service). Fees: reproduction, search. Photostat service.

BRITISH MUSEUM NEWSPAPER LIBRARY

Newspapers and periodicals

Address Colindale Avenue, London NW9 5HE, England

Phone (01) 205 6039 or 4788

Apply to The Superintendent.

Material Definitive collection of newspapers and periodicals, which may be consulted and copied.
Period — 1840 to present.
Number — 500,000 volumes, plus innumerable newspapers.

Availability Research by researcher, personal visit only.
Specific requests may be made in writing but not by phone.
Written authorisation required. For reproduction of publication less than 50 years old, a letter of permission from the proprietor is necessary.
Hours — Monday to Friday, 10 to 5.

Procedure Material not loaned, copies made. Photograph or photostat service available, reasonably fast and very efficient.
Fees: reproduction and handling.

DEMOLIN, Louis

Modern photographs of topical personalities, events, etc

Address 17 Dungarvan Avenue, London SW15 5QU, England (01) 876 2010

Material Modern photographs, particularly of stage, film and TV personalities, politicians, royal family.
Also yachting and other sports.
Period — 1939 to present.
Number — 156,000 also 16mm cine.

Availability Research by staff.
Requests by writing, phone or visit.
Written authorisation required.
Appointment necessary.
Hours — Monday to Saturday, 10 to 6.

Demolin, Louis (continued)

Procedure Material copied.
 Fees: reproduction.
 Commissions.

EMI-PATHE FILM LIBRARY

Cinema newsreels 1896 to 1972

Address 142 Wardour Street, London W1, England

Phone (01) 437 0444

Telex 22760

Material Newsfilm on 35 and/or 16mm. A valuable yet neglected source of unique material. Though most of their business is in film clips, stills can be ordered; selection is made by viewing at a special 'viewing table', a frame selected and a print ordered. The grain of the photograph is coarser than a still photograph, but not usually critically so, and the uniqueness of the material is likely to outweigh this drawback.
 Period — 1896 to 1972.
 Number — over 15 million metres.

Availability Research by staff or researcher.
 Requests by writing, phone or visit.
 Written authorisation required in first instance.
 Appointment necessary, delay up to 4 days.
 Hours — Monday to Friday, 9.30 to 5.

Procedure Some material loaned, usually copied.
 Fees: reproduction and search.

INSTITUTE OF CONTEMPORARY HISTORY & WIENER LIBRARY

Contemporary history, particularly German and Jewish

Address	4 Devonshire Street, London W1, England
Phone	(01) 636 7247
Apply to	The Librarian.
Material	Photographs, posters, propaganda leaflets etc relating to contemporary German and Jewish history, a particularly useful source for researchers in Britain. Period — 1850 to present. Number — 3000.
Availability	Research by staff or researcher. Requests by writing, phone or visit. Written authorisation required in first instance. Appointment preferred. Hours — Monday to Friday, 10 to 5.30.
Procedure	Material not loaned, but copies made. Fees: reproduction, search, handling. Catalogues of books available. Photostat service.

LABOUR PARTY LIBRARY

Photographs of British politics, especially Labour Party

Address	Transport House, Smith Square, London SW1P 3JA, England
Phone	(01) 834 9434
Apply to	The Librarian.
Material	Photographs relating to politics generally but chiefly the Labour Party: also Labour Party posters. Portraits of Labour leaders and personalities, political demonstrations etc. Some material is not their copyright and must be obtained or cleared elsewhere, but the collection is nevertheless very useful for reference purposes. Period — 1900 to present. Number — 10,000.

Labour Party Library (continued)

Availability Research by staff or researcher.
 Requests by writing or phone. Visits by appointment only.
 (delay about 1 week)
 Hours — Monday to Friday, 9.30 to 5.15.

Procedure Some material loaned, others copied.
 Fees: reproduction, search, handling.
 Photostat service.

LENSMEN

Modern photographs, news and features, especially Irish

Address Lensmen House, Essex Street East, Dublin 2, Eire

Phone (0001) 773447 or 773448

Material Press and public relations photography, from 1952 to present.

Availability Research by staff.
 Requests by writing only.
 Written authorisation required in first instance.
 Hours — Monday to Friday, 9 to 6.

Procedure Material not loaned, copies made.
 Fees: reproduction, search, service.
 Commissions.

LONDON EXPRESS NEWS & FEATURES SERVICES

Modern photographs, general news and features

Address 41—42 Shoe Lane, London EC4A 3BS, England

Phone (01) 353 4010

Cables SERVEXPRESS

Apply to Picture Editor.

Material The collection is of material taken for the Daily Express, Sunday Express, Evening
 Standard, Sun, News of the World and certain overseas publications. It covers current

events plus scenic, social, entertainment and political pictures. Colour and black and white. A good general news source.

Availability	Research usually by staff, sometimes by researcher. Requests by writing, phone or visit. Written authorisation required with clear indication of use. Appointment preferred. Hours — Monday to Friday, 10 to 4.30.
Procedure	Material not loaned, copies made. Fees: reproduction, sometimes others. Photostat service. Commissions.

LONDON NEWSPAPER SERVICES

Modern photographs, sport, entertainment, parliamentary

Address	23—27 Tudor Street, London EC4Y 0HR, England
Phone	(01) 583 9199
Telex	265863
Material	Photographs of current events in sport, entertainment and Parliament. Period — 1960 to present.
Availability	Research by staff. Requests by writing, phone or visit. Written authorisation required in first instance. Appointment preferred.
Procedure	Fees by arrangement.

PRESS ASSOCIATION

Modern news photographs

Address	85 Fleet Street, London EC4P 4BE, England
Phone	(01) 353 7440
Telex	22330
Apply to	Miss H Down, Picture Librarian.
Material	Modern photographs, principally of news events and sport in Britain, photographed by staff cameramen; also includes Royal Tours etc. Royal Family 1908 to 1930. Agents for Central News and Alfieri. Period — 1870 to present. Number — 1 million.
Availability	Research by staff. Requests by writing, phone or visit. For large orders or for specific requests, personal visits are recommended wherever possible, perhaps after initial inquiry by phone. Written authorisation required in first instance. Hours — Monday to Saturday, 9 to 6.
Procedure	Colour material loaned, others copied. Normal method is to select required pictures from well-filed contact prints, and order prints which can generally be delivered in 24 hours or less. Efficient service geared to daily press needs. Fees: reproduction, search, holding. Commissions.
Notes	Studios have special facilities for industrial photography, large colour processing and other services.

RUDENI photography

Modern photographs, Lancashire

Address	161 Preston New Road, Blackburn, Lancashire, England
Phone	(0254) 59368
Apply to	Mr G Roland Whiteside MPPA FRSA.
Material	Modern photographs relating to Lancashire — scenes and places, industry, prominent personalities etc.
Availability	Research by staff. Requests by writing, phone or visit. Appointment necessary. Hours — Monday to Saturday, 10 to 5.

Rudeni photography (continued)

Procedure	Some material loaned, others copied. Fees: reproduction. Photostat service. Commissions.

UNITED PRESS INTERNATIONAL

World news photographs from 1921

Address	Now with Popperfoto (p 120)
Phone	(01) 353 9665
Material	Large stock of modern news photographs, international scope. Also access to American material via their New York office. Period — 1921 to present (in New York) — 1927 to present (in London).
Availability	Research by staff. Requests by writing, phone or visit. Written authorisation required. Appointment preferred, 2 days delay. Hours — Monday to Friday, 9 to 6.
Procedure	Material not loaned, copies made. Fees: reproduction, search, service/handling. Commissions.

UNIVERSAL PICTORIAL PRESS & AGENCY

Modern photographs, particularly personalities

Address	New Bridge Street House, 30/34 New Bridge Street, London EC4V 6BN, England
Phone	(Library) (01) 236 6730
Apply to	Library.
Material	Modern photographs in colour and black and white of news and feature material, specialising in leading personalities from all professions, sport etc. Period — 1943 to present. Number — 40,000 colour, 250,000 black and white.

Universal Pictorial Press & Agency (continued)

Availability	Press or TV only. Research by staff. Requests by writing, phone or visit. Written authorisation required. Appointment preferred. Hours – Monday to Friday, 9 to 5.30.
Procedure	Some material loaned, others copied. Fees: reproduction, sometimes search, handling and holding.

VAN HALLAN PHOTO FEATURES

Recent British photographs, mainly society personalities

Address	57 South Street, Isleworth, Middlesex, TW7 7AA, England
Phone	(01) 568 0792
Material	Portrait photographs, chiefly of society personalities. Period – 1950 to present. Number – 100,000.
Availability	Research by staff. Requests by writing or phone, no visits. Hours – daily 10 to 7.
Procedure	Material loaned or copied. Fees: reproduction, service, handling, search, holding. Commissions.

EUROPE

AGIP, Agence

General news photographs, chiefly France

Address	32 rue du Sentier, 75002 Paris, France
Phone	236 4220 and 231 1118
Material	News photographs, chiefly of France, from 1935 to present. Number — over 1 million.
Availability	Research by staff or researcher. Requests by writing, phone or visit. Appointment preferred. Hours — Monday to Friday, 9 to 6.
Procedure	Some material loaned, others copied. Fees: reproduction, service. Commissions.

ANP-FOTO
Dutch General News Agency

Recent and modern news photographs, emphasis on Netherlands

Address	Photo Department, Willem Leevendstraat 30, Amsterdam, Holland
Phone	(020) 82 02 53
Telex	12512
Material	Modern news coverage, with special stock of Royal Family and sports material. Affiliated to international agencies. Period — 1930 to present. Number — 800,000.
Availability	Research by staff. Requests by writing, phone or visit. Appointment preferred, delay 1 or 2 days. Hours — Monday to Friday, 7am to 12pm, Saturday, 11am to 12pm, Sunday, 2pm to 12pm.
Procedure	Material loaned or copied. Fees: reproduction, sometimes others. Photostat service. Commissions.

172

APIS

Modern photographs of current affairs, emphasis on French politics and culture

Address	122 rue Réaumur, 75002 Paris, France
Phone	236 27 58 or 236 74 01
Telex	20748 RINGOP (Abonné 453)
Apply to	M Granier.
Material	This is a modern press agency, handling material relating to all aspects of current affairs. Their own material covers French politics, cultural activities etc, and they act as agents for material from throughout the world. Period — 1930 to present. Number — 1½ million.
Availability	Research by staff or researcher. Requests by writing, phone or visit. Appointment preferred. Hours — Monday to Friday, 9 to 7.
Procedure	Some material loaned, others copied. Fees: reproduction. Photostat service. Commissions.

BIBLIOTHEK FÜR ZEITGESCHICHTE

Special collection relating to the two World Wars

Address	7 Stuttgart 1, Konrad-Adenauer Strasse 8, West Germany
Phone	0711 24 41 17
Material	Photographs, prints and engravings, original paintings and drawings, maps, ephemera, etc. World War I and World War II special collections. Also military, air and sea equipment coverage, ship building and planes from both wars. Warships from 1900. Leibfotograf Edlers — Hoffman collection. Period — 1914 to 1945. Number — 40,000.
Availability	Research by staff or researcher. Requests by writing, phone or visit. Written authorisation in the first instance. Hours — Monday to Friday, 9 to 5; Saturday 9 to 12.

Bibliothek Für Zeitgeschichte (continued)

Procedure Material not loaned, copies made
 Photostat service.
 Fees: reproduction, service.

CZECHOSLOVAK NEWS AGENCY

General modern photographs of Czechoslovakia

Address Photo Department, Praha 1, Opletalova 5, Czechoslovakia

Phone 11141

Telex 1356

Material Photographs covering Czech history and daily life etc from 1920 to present.

Availability Research by staff.
 Requests by writing, phone or visit.
 Appointment necessary, delay 10 days.

Procedure Material loaned or copied.
 Fees: reproduction, search, handling, holding.
 Commissions.

EUPRA GmbH

General modern news photographs from 1917, emphasis on Eastern Europe

Address Postbox 40 05 09, D-8000 München 40, West Germany (Keferloherstrasse 89)

Phone (0811) 35 36 44 or 35 36 45

Telex 5– 215484

Apply to Frau Hopf.

Material This modern press service specialises in material from Eastern Europe, in colour and
 black and white, and reckons to have the largest picture collection of such material
 outside Eastern Europe. As examples they quote: 'about 1000 pictures from the life
 of Marshal Tito', 'The great terror of the Stalin period in Russia', 'pictures of St
 Wenzel's Square, Prague, from 1917 to 1973'.
 Agents for a number of East European agencies and services in East Berlin,
 Czechoslovakia, Poland, USSR etc.
 Period – 1917 to present.
 Number – over 100,000.

Eupra GmbH (continued)

Availability Research by staff.
Requests by writing, phone or sometimes visits.
Hours — 24 hours a day, 7 days a week.

Procedure Material loaned.
Fees: reproduction, sometimes others

GUENA, M -P

Modern photographs of French political and economic life

Address 98 avenue de Versailles, 75016 Paris, France

Phone 527 41 38

Material Photo reportage covering all aspects of French political and economic life, including unions, personalities, congresses, meetings, manifestos etc, and including some aspects of the Common Market.
Period — 1967 to present.
Number — 120,000.

Availability Research by staff.
Requests by writing, phone or visit.
Appointment necessary.
Hours — whenever principals are at home.

Procedure Some material loaned, others copied.
Fees: reproduction.
Photostat service.
Commissions.

HOFFMAN, Heinrich, ZEITGESCHICHTLICHES BILDARCHIV

Photographs of German history during Third Reich and World War Two, particularly Hitler

Addresses 8000 München 40, Bauerstrasse 23, West Germany
2000 Hamburg 39, Possmoorweg 42a, West Germany

Phones München — (0811) 371243
Hamburg — (0411) 302546

Apply to Heinrich Hoffman.

Hoffmann, Heinrich, Zeitgeschichtliches Bildarchiv (continued)

Material
Unique collection of photographs relating to German history from 1919 to 1946. Heinrich Hoffman was Hitler's personal photographer.
Number — 50,000.

Availability
Not available to private individuals.
Research by staff.
Requests by writing or phone, no visits.
Written authorisation required.
Hours — Monday to Friday, 10 to 6.

Procedure
Some material loaned, others copied.
Fees: reproduction, search, service/handling, holding after 30 days.
Photostat service.

ILLUSTRATIONS & PHOTOPRESS

News photographs from 1934, emphasis on Switzerland

Address
Sumatrastrasse 25, 8006 Zurich, Switzerland

Phone
01 28 36 20

Telex
52 615

Apply to
Picture filing department.

Material
Photographs of topical news events from 1934 to present. Also a special collection of glass plates of 1914—1918.
Number — 500,000.

Availability
Research by staff.
Requests by writing, phone or visit.
Appointment necessary, a few days delay.
Hours — Monday to Friday, 10 to 6.

Procedure
Material loaned or copied.
Fees: reproduction, search, service/handling, holding.
Photostat service.

Notes
Available via Associated Press outside Switzerland.

NORDISK PRESSEFOTO

Modern press photographs, 1940 to present, especially Scandinavia

Address	GL Mønt. 1, DK-1117 København K, Denmark
Phone	11 36 17
Telex	2200 NORFOT
Material	Press photographs, particularly of Danish and other Scandinavian interest. Colour and black and white. Period — 1940 to present. Number — 3 million.
Availability	Research by staff. Requests by writing, phone or visit. Appointment necessary. Hours — Monday to Friday, 8 to 4.
Procedure	Material loaned or copied. Fees: reproduction. Commissions.

POLITIKENS PRESSE FOTO (POLFOTO)

Modern news photographs, especially Denmark

Address	Raadhusplads 37, 1585 København V. Denmark
Phone	(01) 118511 ext 312 445 640
Telex	27187 Denmark
Cables	Polfoto
Apply to	Pixdesk.
Credit	Polfoto.
Material	General news agency, with coverage of all Danish affairs and events through association with some of Denmark's leading newspapers, and acting as agents for pictures from sources throughout the world. Period — 1900 to present. Number — 1½ million.

Politikens Presse Foto (Polfoto) (continued)

Availability	Research by staff. Requests by writing, phone or visit. Hours — Monday to Friday 6 to 2.30, Saturday 6am to 11pm, Sunday 2pm to 2.30am.
Procedure	Some material loaned, others copied. Fees: reproduction, sometimes others. Photostat service. Commissions.

PRESS UND INFORMATIONSAMPT DER BUNDESREGIERUNG (BUNDESBILDSTELLE)

Black and white photographs of political matters and politicians in Western Germany

Address	53 Bonn, Welckerstrasse 11, West Germany
Phone	208 447
Telex	0886/741-43
Material	1 million negatives from the Bonn government press office.
Availability	Research by staff. Requests made by writing, phone or visit. Hours — weekdays, 8 to 4.
Procedure	Some material loaned, others copied. Photostat service. Fees: reproduction fee charged ONLY in West Germany.
Notes	The material covers all state visits of foreign politicians and personalities. They are a public relations service and most helpful.

SIROT, Georges

General old photographs, 1850 to 1945

Address	35 rue Jacob, 75006 Paris, France
Material	Old photographs from 1850 to 1945 — personalities, places, events, from all parts of the world. The collection is a very fine one, 'important' in the French sense of the word, but access is made awkward by reason of M Sirot's age. None the less, the effort is well worth while. Number — 100,000.

Sirot, Georges (continued)

Availability Research by staff.
Requests initially in writing. If you wish to make a personal visit, apply in writing and allow at least a week for delay. The collection is normally accessible only on Thursday afternoon and all day Friday.

Procedure Material loaned.
Fees: reproduction, sometimes others.

UNESCO
(United Nations Educational, Scientific & Cultural Organization)

UNESCO activities

Address Place de Fontenoy, 75700 Paris, France

Phone 566 57 57

Telex 27602 Paris

Apply to Photo Library.

Material Photographs illustrating the programmes and activities of UNESCO.
Period — 1954 to present.
Number — 70,000.

Availability Research by staff.
Requests by writing, phone or visit.
Appointment preferred, 1 or 2 days delay.
Hours — Monday to Friday, 10 to 12, 2.30 to 5, except French holidays.

Procedure Material loaned or copied.
Normally no fees — see note below.
Catalogue free on request.

Notes They say:
'The UNESCO Photo Library is a specialised service intended essentially for the use of editors, writers and publishers interested in publicising the programmes and activities of Unesco and/or the United Nations.
There is no charge for this service when the above conditions are met. All other users are required to pay a reproduction fee of 50 French francs per illustration.'

BEYOND EUROPE

AFRICAMERA

Modern photographs, African news, features and sport.

Address	PO Box 1138, Johannesburg, South Africa
Phone	28/1500 EX 541
Telex	AFRICAMERA 43/7044/7045 JH
Apply to	James Soullier, Manager.
Material	Photographs of African news, features and sport. Agents for Rand Daily Mail, Sunday Times and Sunday Express. Period — 1937 to present. Number — several million.
Availability	Research by staff. Requests by writing, phone or personal visit. Written authorisation required. Appointment preferred. Hours — daily 9 to 5.
Procedure	Material not loaned, copies made. Fees: reproduction, search, holding. Photostat service. Commissions anywhere in Africa.
Notes	As material is not loaned, overseas researchers must be very specific, or request stats.

ISRAEL SUN

Modern photographs of news and daily life in Israel

Address	92 Yehuda Halevi Street, Tel Aviv, PO Box 14031, Israel
Phone	(03) 288787 or (03) 280768
Apply to	Mr Avraham Shilo, Managing Director.
Material	Modern photographs covering news and events in Israel, scenes of daily life, feature material of all kinds. Period — 1969 to present. Number — 9000.

Israel Sun (continued)

Availability Research by staff or researcher.
Requests by writing, phone or visit.
Written authorisation required in first instance.
Appointment preferred.
Hours — Monday to Friday, 8 to 6.

Procedure Material not loaned, copies made.
Fees: reproduction, service/handling.
Commissions.

NEHRU MEMORIAL MUSEUM & LIBRARY

Modern photographs, recent Indian history

Address Teen Murti House, New Delhi-11, India

Phone 373203

Apply to The Director.

Material Their own description: A collection of photographs pertaining to the history of modern India with special emphasis on the Indian National Movement. Besides photographs of the Nehru family, the collection consists of photographs of political and cultural events, particularly different phases of the Indian freedom movement and photographs of eminent Indian leaders.
Period — 19th century to present.
Number — 40,000.

Availability Research by staff.
Requests by writing, phone or visit.
Written authorisation required in first instance.
Hours — Monday to Friday, and Saturdays except 2nd in month, 10 to 5.

Procedure Material not loaned, copies made.
Fees: reproduction, service/handling.
Photostat service.

Notes The collection is systematically maintained and well indexed and catalogued to facilitate research.

TAL, Shabtai

Modern photographs of news, features, personalities in Israel

Address	Post Office Box 20151, Tel Aviv, Israel
Phone	03 446382
Telex	333160 TAL IL
Material	Modern photographs of news, features, personalities in Israel, with special collection regarding security items. Mr Tal is Israel photographer for Germany's Stern magazine. Period — 1958 to present.
Availability	Research by staff. Requests by writing, phone or visit. Written authorisation required. Appointment preferred, delay 1 or 2 days. Hours — Monday to Friday any time, but avoid Jewish holidays if possible.
Procedure	Some material loaned, others copied. Fees: reproduction, search, service/handling. Photostat service.

Almost every photographer takes photographs wherever he travels. This section, large as it is, is only a small selection from the available geographical and ethnographical material — and of course there's plenty more in the big general collections! On the other hand, such a proliferation of sources is made necessary by the quantity of subject-matter: it may still take you several inquiries to track down a photographer who has in stock a photograph of the Porta Negra at Trier, and even then it may be shot from the wrong angle to make the point your author wants to make, or be the wrong shape for your layout.

Sources are listed according to the country where the source is located, not by what regions they hold pictures of. The geographical index furnishes cross-references and further suggestions if you need them.

In this field more than in any other, sources are likely to increase their stocks; every year, each of these photographers will have added more material, perhaps even whole areas of the globe. So keep in touch.

Remember, too, that there are other sources which may be useful for this type of material — airlines and shipping companies, travel companies, national tourist offices, oil companies, postcard publishers, firms dealing in raw materials . . .

There are no specialist sources for historical pictures of places and peoples; for these, go to the general sources, public or commercial.

BRITAIN

AEROFILMS

Photographs, mainly aerial views, also British topographical 1890—1910

Address	Elstree Way, Boreham Wood, Hertfordshire, England
Phone	(01) 953 6161
Apply to	Library Manager.
Material	Mostly aerial photographs from 1919 to present, including all countries (agents for many overseas aerial photographers). Special collection ground-level views 1890—1910, mainly London streets. Number — 500,000.
Availability	Research by staff or researcher. Requests by writing, phone or visit. Written authorisation required in first instance. Hours — Monday to Friday, 9 to 5.30.
Procedure	Material loaned or copied. Fees: reproduction, sometimes search, service and holding. Photostat service. Book issued 'Aerofilms book of Aerial Photographs; a guide to the Library' (cost £1.10). Commissions.

AIRVIEWS

Aerial photographs of British Isles

Address	Manchester Airport, M22 5PQ, England
Phone	061 437 2502/5262 ext 3041 (night 061 928 7444)
Apply to	J B Martin.
Credit	Airviews Ltd, Manchester Airport.
Material	Scenic aerial photographs of UK, Ireland and Channel Is. Number — 50,000

Airviews (continued)

Availability	Research by staff or researcher.
	Requests by writing, phone or personal visit.
	Written authorisation required.
	Hours — Monday to Friday, 8.45 to 5.45, or other times by phone.
Procedure	Material loaned or copied.
	Fees: reproduction, sometimes search and holding.
	Commissions.

ANDREWS, Mike

Modern geographical photographs, worldwide

Address	18 Hopefield Avenue, London NW6, England
Phone	(01) 969 4760
Material	Modern photographs of places and people, including Africa, South and Central America, USA, West Indies, Pacific Islands, as well as many places in Europe. Period — 1963 to present.
Availability	Research by staff or researcher. Requests preferably in writing. If you want to visit, make appointment first by phoning in evening. No phone calls taken during the day.
Procedure	Material loaned or copied. Fees: reproduction, search if none used. Subject list available on request. Commissions.

ARCHAEOLOGY & ETHNOLOGY, CAMBRIDGE UNIVERSITY MUSEUM OF

Archaeology and ethnology, worldwide

Address	Downing Street, Cambridge, England
Phone	(0223) 59714
Apply to	The Curator.
Material	Photographs relating to European and general archaeology, African, American, S E Asian and Pacific ethnology. Special coverage of local archaeology including brass rubbings.

Archaeology & Ethnology, Cambridge University Museum of (continued)

Availability For scholastic purposes and serious research only.
Research by staff or researcher.
Requests by writing, phone or visit.
Written authorisation required.
Appointment necessary, delay 7 to 10 days.
Hours — normally Monday to Friday, 9 to 5, except for certain periods during University vacations.

Procedure Some material loaned, others copied.
Fees: reproduction, sometimes service.
Photostat service.

BOLT, Anne

Modern geographical photographs, especially West Indies

Address 34 Homer Street, London W1H 1HL, England

Phone (01) 262 7484 (Ansafone when unattended)

Material Modern geographical photographs, notably extensive coverage of the West Indies and Caribbean. Also North Africa, Western Europe, Malta, Gibraltar.
Period — 1954 to present.
Number — 45,000.

Availability Research by staff or researcher.
Requests by writing, phone or visit.
Appointment preferred.
Hours — Monday to Friday, 9 to 6; genuine emergencies handled at weekends.

Procedure Material loaned or copied.
Fees: reproduction, sometimes search, handling, holding.
List of countries covered supplied on request.
Commissions.

BOTTING, Douglas

Modern geographical photographs, historical on balloons and airships

Address	23 Calonne Road, London SW19, England
Phone	(01) 947 1891
Material	Chiefly modern geographical photographs, covering in particular Russia, Siberia and Soviet Central Asia: Amazon; Africa – East and West, Morocco, Angola, Socotra Island. Also a special collection of modern and historical material on airships and ballooning. Douglas Botting has an explorer's eye for the unusual, and his photographs are unusually vivid and untouristy while retaining a high professional quality.
Availability	Research by staff. Requests by writing or phone, no visits. Written authorisation required in first instance.
Procedure	Material loaned. Fees: reproduction. Commissions.

BRITISH TOURIST AUTHORITY

Photographs of British scenery and way of life

Address	239 Old Marylebone Road, London NW1 5QT, England
Phone	(01) 262 0141
Telex	21231 Tagbandi London
Apply to	Roy Keetch.
Material	Photographs in colour or black and white of British topographical subjects and scenes depicting the British way of life. The well-indexed system facilitates research, and a personal visit is recommended. Period – present day only. Number – 80,000 black and white, over 60,000 colour.
Availability	Research by researcher. Requests by writing or phone, but personal visits strongly preferred. Written authorisation required in first instance. Appointment preferred. Hours – Monday to Friday, 10 to 5.
Procedure	Colour material loaned, black and white copied. Fees: reproduction, holding, sometimes search.

CASPARIUS, H G

Geographical photographs 1928 to present, some specialist areas

Address 10 Tanza Road, London NW3, England

Phone (01) 435 2582

Material Travel photographs of Canada, Africa, Far East etc, including such specialist areas as gold mining in Libya, Alaska and South Africa. Interesting material taken during making of old films such as 'The White Hell of Piz Palu' with which Mr Casparius was associated. Also colour shots of museum items and some book illustrations.
Period — 1928 to present.
Number — 40,000 black and white, of which about 5% colour.

Availability Research by staff.
Requests by writing or phone (only between 8 and 9.30am).
Written authorisation required in first instance.

Procedure Some material loaned, others copied.
Fees: reproduction, sometimes others.
Subject list available.

CENTRAL STUDIOS

Modern photographs, European travel

Address 143—145 Eastbank Street, Southport, Lancashire, England

Phone (0704) 59027

Apply to P Kershaw.

Material Modern photographs of European travel.
Period — 1965 to present.

Availability Research by staff or researcher.
Requests by writing, phone or visit.
Written authorisation required.
Appointment necessary, 2 or 3 days delay.
Hours — Monday to Friday, 9 to 5.30.

Procedure Material loaned or copied.
Fees: reproduction, sometimes others.
Photostat service.
Commissions.

DICKINS, Douglas

Modern geographical photographs, special collection of folk dancing

Address	2 Wessex Gardens, Golders Green, London NW11 9RT, England
Phone	(01) 455 6221
Material	Modern geographical photographs, worldwide but particularly strong on India and S E Asia. Special collection of folk dances of many countries. Period — 1942 to present. Number — 100,000.
Availability	Research by staff. Requests by writing, phone or visit. Written authorisation required in first instance. Appointment necessary. Hours — any, seven days a week.
Procedure	Material loaned or copied. Fees: reproduction, holding after 30 days. Subject list available on request. Commissions.

DIXON, C M

General modern photographs, including archeology and art, international scope

Address	21 Ashley Road, London N19 3AG, England
Phone	(01) 272 5062
Material	A large and helpful library of a generally geographical nature, covering many countries of the world, including archeology and art. Other specialities are scientific experiments, mountaineering, people in everyday life. Period — 30,000 BC to present. Number — 50,000 colour transparencies.
Availability	Research by staff. Requests by writing, phone or visit. Appointment necessary. Hours — Monday to Saturday, 8 to 8.
Procedure	Material loaned or copied. Fees: reproduction, sometimes search, service/handling and holding. Subject list available on request. Commissions.

EDWARDS, Mark

Modern photographs, chiefly ethnographical especially India and other Asian countries, strong human interest

Address	199a Shooters Hill Road, Blackheath, London SE3, England
Phone	(01) 858 8307 (24-hour message service (01) 935 1118)
Material	Photographs in colour and black and white chiefly ethnographical and geographical, covering India, Nepal, Afghanistan, Iran and Turkey, and with the emphasis on social conditions, covering such aspects as drug addiction etc. High quality. Period — 1966 to present. Number — 4000 colour, 3000 black and white.
Availability	Research by staff or researcher. Requests by writing, phone or visit. Appointment necessary. Hours — irregular, but 24-hour message service available.
Procedure	Some material loaned, others copied. Fees: reproduction, sometimes holding. Subject list available.

ESTALL, Robert

Modern photographs, chiefly geographical

Address	38 Langham Street, London W1, England
Phone	(01) 636 0115 When R E unobtainable, access to files may be had by phoning (01) 723 7365, ask for Ann Davies
Material	Modern photographs, chiefly geographical, mainly Europe and Canada. Some natural history. Period — 1960 to present. Number — 25,000.
Availability	Research by staff or researcher. Requests by writing, phone or visit. Written authorisation required in first instance. Appointment necessary, 2 or 3 days delay. Hours — Monday to Saturday, 10 to 6.

Estall, Robert (continued)

Procedure Material loaned or copied.
Fees: reproduction, holding after 30 days.
Commissions.

FEATURE-PIX

Modern geographical photographs

Address 9 Great Chapel Street, London W1, England

Phone (01) 437 2121

Apply to Gerry Brenes or Ken Hackett.

Material Modern photographs of travel and geography, especially Caribbean and Scandinavia.
Agents for a number of travel photographers.
Period — 1968 to present.
Number — 50,000.

Availability Research by staff or researcher.
Requests by writing, phone or visit.
Appointment preferred.
Hours — Monday to Friday, 9 to 5.30.

Procedure Material loaned or copied.
Fees: reproduction, search, service/handling, holding.
Subject list available on request.
Commissions.

FOTOFASS

Modern colour photographs, geography and international reportage

Address 59 Shaftesbury Avenue, London W1, England

Phone (01) 437 5951

Apply to Virginia Fass.

Material Worldwide travel material. Particularly strong on India. Special collection of winemaking in France and Portugal. Agent for Jean-Claude Lonzet, Paris.
Number — 10,000 (colour only).

Fotofass (continued)

Availability Research by staff or researcher.
Requests by writing, phone or visit.
Written authorisation required in first instance.
Appointment necessary.
Hours — Monday to Friday, 10 to 6.

Procedure Material loaned.
Fees: reproduction, search, service/handling.
Commissions.

FOTOLINK

Modern photographs, travel and documentary

Address 7 Robson Close, Enfield, Middlesex, England

Phone (01) 366 4685

Material Modern photographs, general in scope but emphasis on travel and documentary.
Number — 28,000.

Availability Research by staff.
Requests by writing, phone or visit.
Appointment preferred.
Hours — Monday to Friday, 9 to 5.30.

Procedure Material loaned or copied.
Fees: reproduction, sometimes search, holding.
Commissions.

FRAENKEL, Peter

Modern photographs of travel, transport and natural history, Africa and Asia

Address 3 Eden Court, Station Road, Ealing, London W5, England

Phone (01) 997 0247

Material Modern photographs, mainly from Africa and Asia, of places, scenes of daily life, transport and wild animals. Countries covered include India, Iran, Afghanistan and Turkey, and most countries of Africa.
Period — 1966 to present.
Number — 15,000.

Fraenkel, Peter (continued)

Availability Research by staff.
 Requests by writing or phone, no visits.
 Hours — Monday to Friday, 9 to 5. Not usually available in August, when away
 collecting new material.

Procedure Material loaned.
 Fees: reproduction, holding.
 Commissions.

GEOGRAPHICAL SOCIETY, ROYAL

Geography and travel, 1800 to 1940

Address Kensington Gore, London SW7 2AR, England

Phone (01) 589 5466

Apply to Keeper of the Map Room.

Material 'Our photo collection covers the field of general geography, mostly people and places
 all over the world. There is very little natural history and no category of modes of
 travel or types of travellers, although we have a large collection of portraits of
 travellers.' Definitely for serious researchers only, the Society's collection is a
 definitive source for much unique material relating to travel and exploration in the
 19th and 20th centuries. Photographs, prints and engravings, original paintings and
 drawings.
 Period — 1800 to 1940.
 Number — 50,000.

Availability The collection is primarily for the benefit of members of the Society, and researchers
 who anticipate making regular use of its facilities might be well advised to consider
 applying for Associate Membership. Otherwise, application should be made to the
 Keeper of the Map Room, giving full details of proposed use of material.
 Research by researcher.
 Requests by writing, phone or visit.
 Written authorisation required.
 Appointment preferred, 3 days delay.
 Hours — Monday to Friday, 9.30 to 5.30.

Procedure Material not loaned, copies made.
 Fees: reproduction, search, service/handling, holding.
 Photostat service.

GREATER LONDON COUNCIL PHOTOGRAPH LIBRARY

Photographs of London from late 19th century to present

Address	Room B.66, County Hall, London SE1 7PB, England
Phone	(01) 633 3255
Apply to	Miss R E Watson, Photograph Librarian.
Credit	'GLC Photograph Library'
Material	Photographs of London, and expanded towns outside London, from late 19th century to the present. Covers all aspects of London life — eg education, housing, parks — plus comprehensive topographical collection. Number — 180,000.
Availability	Research by staff or researcher. Requests by writing, phone or visit. Written authorisation required. Appointment preferred, delay up to 7 days. Hours — Monday to Friday 9.15 to 5.15 or by special arrangement.
Procedure	Some material loaned, others copied. Fees: reproduction (can be waived for non-commercial uses). Comprehensive and fully cross-indexed catalogue within the library accessible to researchers.

GREATER LONDON COUNCIL PRINT COLLECTION

Topography of London, past and present

Address	Room B66, County Hall, London SE1 7PB, England
Phone	(01) 633 7193 or 3255
Apply to	Curator of Maps and Prints.
Material	Prints, engravings and original paintings and drawings relating to the topography of London. Period — 1550 to early 20th century. Number — 40,000.
Availability	Research by researcher. Personal visit essential. Requests by writing or phone only after personal visit. Appointment preferred. (See note below.) Hours — Monday to Friday, 9.15 to 5.15.

Greater London Council Print Collection (continued)

Procedure Material not loaned, copies made.
 Fees (for profit-making reproduction) reproduction and service.
 Photostat service.

Notes Material is classified and arranged topographically, though subject and artist indexes
 are in course of preparation. Because the Greater London area is now considerably
 enlarged, the scope of the collection is being extended to match the new boundaries;
 but the greater part of the collection still relates to the central areas of London, and
 researchers looking for material relating to the outlying areas are advised to use
 Public Library sources in the appropriate area.

GUILDHALL ART GALLERY & LIBRARY

History of London, and some specialist collections

Address The Guildhall, King Street, London EC2P 2EJ, England

Phone (01) 606 3030, extensions 264, 273, 280

Apply to Keeper of Prints & Pictures or his representative.

Credit Guildhall Library or Art Gallery as applicable, or specialist collections.

Material Photographs, prints and engravings, original paintings and drawings, maps and
 ephemera such as billheads and trade cards largely relating to the history of London,
 for which this is probably the definitive source. The scope covers views, people, social
 life, work and events from the foundation of London till the present.
 Number — Art Gallery 1600, Print room 100,000.
 The Library also houses the collection of the Worshipful Company of Clockmakers,
 comprising some 100 items relating to clockmaking and clockmakers from 1550 to
 the present day. A catalogue is available.

Availability Research by staff or researcher.
 Requests by writing, phone or visit.
 Appointment preferred.
 Hours — Monday to Saturday, 9.30 (Gallery 10) to 5.

Procedure Some material loaned, others copied by researcher's photographer.
 Fees: reproduction, service.
 Catalogues available.
 Photostat service.

HARDWICK, Iris

Modern photographs of gardens, landscapes, flowers, houses

Address	64 Icknield Way, Tring, Hertfordshire HP23 4HZ, England
Phone	(044 282) 3522
Apply to	Mrs Kay Sanecki.
Material	Modern photographs of landscapes and stately homes, cottages, gardens large and small, studies of flowers, shrubs and trees.
Availability	Mrs Hardwick's collection is in the process of being re-filed under new administration. At time of going to press, full details were not available; but Mrs Sanecki will be glad to answer all enquiries.

HEBRIDEAN PRESS SERVICE

Modern photographs of Hebrides, all aspects

Address	1 Maritime Buildings, Stornoway, Lewis, Outer Hebrides, Scotland
Phone	Stornoway 2737
Telex	75158
Apply to	W G (Bill) Lucas.
Material	Modern photographs covering all aspects of Hebrides island life, including the Harris Tweed and fishing industries. Period — 1956 to present.
Availability	Research by staff or researcher. Requests by writing, phone or visit. Hours — daily 9 to 6.
Procedure	Material loaned or copied. Fees: reproduction. Photostat service. Commissions.

KENNETT, Victor

Modern geographical and architectural photographs notably Russia, Peru, India, Bulgaria

Address	31 Gloucester Place Mews, London W1H 3PN, England
Phone	(01) 486 3301
Material	Modern geographical photographs, covering architecture and scenes of daily life as well as views. Especially noteworthy is the collection of Russian material, but the scope of the collection is very wide for an individual photographer and the quality is high. Period — 1962 to present. Number — several thousand.
Availability	Research by staff. Requests by writing, phone or visit. Appointment necessary. Hours — every day, 9 to 6.
Procedure	Material loaned or copied. Fees: reproduction. Subject list available.

KERSTING, A F

Modern photographs, geographical and architectural

Address	37 Frewin Road, London SW18, England
Phone	(01) 874 1475
Material	Modern photographs covering a wide range of geographical subjects, including landscape and architecture. Period — 1938 to present. Number — 40,000.
Availability	Research by staff or researcher. Requests by writing, phone or visit. Written authorisation required. Appointment preferred. Hours — Monday to Friday, 9 to 6.
Procedure	Some material loaned, others copied. Fees: reproduction, search, sometimes handling and holding. Commissions.

MANX MUSEUM

History and life of the Isle of Man

Address	Kingswood Grove, Douglas, Isle of Man
Phone	(0624) 5522
Material	Photographs, prints and engravings, original paintings and drawings relating to the Isle of Man.
Availability	Research by staff or researcher. Requests by writing, phone or visit. Appointment preferred. Hours — Monday to Saturday, 10 to 5.
Procedure	Material not loaned, copies made. Fees: reproduction, service. Photostat service.

MARCH-PENNEY, Janet

Modern photographs, geographical and ethnographical, Europe, North America, Japan etc

Address	27 Wooburn Manor Park, Wooburn Green, Buckinghamshire, HP10 0ET, England
Phone	(06) 285 21171
Material	Big collection of modern photographs in colour and black and white of geographical subjects, also comprising scenes of the ways of life of the countries covered. These include Britain (including offshore islands), most European countries, North America, Mexico, Tunisia, Japan. Period — 1960 to present. Number — 300,000 negatives, 100,000 colour.
Availability	Research by staff. Requests by writing or phone, rarely by visit (appointment needed). Written authorisation required in first instance. Hours — Monday to Friday, 9 to 5, when at home.
Procedure	Some material loaned, others copied. Fees: reproduction, service, holding, sometimes search. Subject lists occasionally issued. Commissions.

MAYNE, Roger

General modern photographs

Address 5 Chislehurst Road, Richmond, Surrey, TW10 6PW, England

Phone (01) 940 0462

Material Photographs taken by Mr Mayne over a wide range of subjects including:
British industrial towns,
Children, schoolchildren, slum children,
British at leisure.
Travel: Greece, Spain, Devon.
Period — 1955 to present.
Number — 3000.

Availability Research by staff or researcher.
Requests by writing, phone or visit.
Appointment necessary, 3 or 4 days delay.
Normal working hours.

Procedure Material loaned or copied.
Fees: reproduction.

MIDDLE EAST ARCHIVES

Middle East Countries and Muslim world, past and present

Address 56a Oakwood Court, London W14, England

Phone (01) 602 2136

Apply to Alistair Duncan.

Material Colour photographs, prints and engravings, original paintings and drawings of the Middle East countries and the Muslim world. Countries covered: Algeria, Egypt, Cyprus, Jordan, Lebanon, Libya, Israel, Saudi Arabia, Syria, Persian Gulf countries. Has access to others. Places, daily life, archeology, religion, history, but not news material, events and personalities.
Number — 30,000.

Availability Research by staff.
Requests by writing, phone or visit.
Written authorisation required in first instance.
Appointment necessary; no delay, unless Mr Duncan is abroad, in which case could be up to 2 or 3 weeks.
Hours — Monday to Friday, 9 to 6.

| Procedure | Material loaned.
Fees: reproduction, holding after 30 days.
Commissions undertaken. Complete brochures etc can be produced. |

PERRY, Roger

Modern photographs of South America and Galapagos

Address	Bulls Cross Cottage, Enfield, Middlesex, EN2 9HE, England
Phone	(97) 24346
Material	Modern photographs of Western South America, Patagonia and the Galapagos Islands. Special collections on: 1 Spanish colonial architecture. 2 Monolithic statues of San Agustin (Colombia). 3 Wildlife and volcanic scenery, Galapagos Islands. Subjects include landscapes, natural history, ethnography, cities, daily life etc. Period — 1957 to present. Number — 3000.
Availability	Research by staff or researcher. Requests preferably in writing. Appointment necessary.
Procedure	Material sometimes loaned, otherwise copied. Fees: reproduction. Subject list available on request.

PHOTO PRECISION

Modern geographical photographs, Britain and some other countries

Address	Caxton Road, St Ives, Huntingdonshire, England
Phone	(0480) 64364 (7 lines)
Apply to	F J Westwood, Sales Director.
Material	Colour transparencies of places in Britain — stately homes, museums, cathedrals, parks, zoos etc in the United Kingdom, Ireland, and some other countries. Period — 1946 to present. Number — 17,000.

Photo Precision (continued)

Availability	Research by staff or researcher. Requests by writing, phone or visit. Written authorisation required in first instance. Appointment preferred. Hours — Monday to Friday, 9 to 5.30 (4.40 Friday).
Procedure	Material loaned or copied. Fees: reproduction. Photostat service.

PITKIN PICTORIALS

Modern photographs, important British buildings

Address	11 Wyfold Road, London SW6 6SG, England
Phone	(01) 385 4351
Cables	Pitkins, London SW6
Apply to	Mrs J Pugh or Mrs E M Goff.
Material	Photographs, mostly used originally in guidebooks published by the company, of important buildings throughout Britain — cathedrals, country houses, city views, museums, castles etc.
Availability	Research by staff. Requests by writing, phone or visit. Written authorisation required in first instance. Appointment preferred — delay 2 or 3 days. Hours — Monday to Friday, 9.15 to 5.15.
Procedure	Material not loaned, copies made. Fees: reproduction, sometimes service.
Notes	This company is not an agency in the normal sense. However, the staff are friendly and helpful and provide a valuable service.

PIX PHOTOS (Aylesbury)

Modern photographs, views, Britain and Europe

Address	13—15 The Green, Quainton, Aylesbury, Buckinghamshire, England
Phone	(0296) 75 296
Material	Colour transparencies of towns, village scenes, countryside, gardens, castles etc throughout Britain, together with a growing collection of similar material from continental Europe. Period — 1960 to present. Number — over 10,000.
Availability	Research by staff or researcher. Requests by writing, phone or visit. Appointment preferred, delay 2 days. Hours — Monday to Friday, 9 to 6.
Procedure	Material loaned. Fees: reproduction, search, holding. Commissions.

REFLEX PRESS AGENCY LTD

General geographical photographs

Address	87 Regent Street, London W1R 7HF, England
Phone	(01) 434 1788
Telex	28604
Material	General geographical coverage including cultural, economic and anthropological aspects. Period — 1965 to present. Number — 30,000.
Availability	Research by staff or researcher. Application by writing, phone or visit. Written authorisation in the first instance. No delay for appointments to visit. Hours — Monday to Friday, 9.30 to 6.

Reflex Press Agency Ltd (continued)

Procedure Some material loaned.
Photographic service.
Commissions undertaken.
Fees: reproduction, holding after 2 months negotiable.

SCOTT POLAR RESEARCH INSTITUTE

Polar regions and related subjects, past and present

Address Lensfield Road, Cambridge, CB2 1ER, England

Phone (0223) 66499

Apply to The Librarian.

Material Photographs, prints and engravings, original paintings and drawings relating to the
Polar regions, their geography, fauna and flora, etc.
Period — 1800 to present.
Number — over 5000.

Availability Research by staff.
Requests by writing, phone or visit.
Written authorisation required in first instance.
Appointment necessary.
Hours — Monday to Friday, 9 to 5.30.

Procedure Material not loaned, copies made.
Fees: reproduction, search, handling.
Photostat service.

SKYE AGENCIES

Modern photographs of NW Scotland, especially Inner Hebrides, geographical and social

Address Portnalong, Isle of Skye, Inverness-shire, Scotland

Phone Portnalong 272

Apply to Calum Mackenzie Neish.

Material Modern photographs covering all aspects of cultural and social activities, scenery and
nature along the north-west seaboard and Inner Hebrides of Scotland.
Period — 1970 to present.
Number — over 2000.

Skye Agencies (continued)

Availability	Research by staff. Requests by writing, phone or visit. Appointment necessary. Hours — daily 9.30 to 6.
Procedure	Material loaned or copied. Fees: reproduction, sometimes others. Photostat service. Commissions.

STEPHANIE PHOTOGRAPHY

Modern photographs, holiday and travel

Address	38 Hillside Court, Finchley Road, London NW3, England
Phone	(01) 435 3695
Apply to	Stephanie Colasanti, Director.
Material	Modern colour photographs of subjects related to holidays and holiday activities. General material, together with scenes from North Africa, Turkey, Israel, Italy, Austria. Number — 6000.
Availability	Research by staff or researcher. Requests by writing, phone or visit. Written authorisation required in first instance. Appointment necessary. Hours — any.
Procedure	Some material loaned, others copied. Fees: reproduction, holding. Commissions anywhere in the world.

TOURIST PHOTO LIBRARY

Modern photographs, resorts in Europe and elsewhere

Address	54 The Grove, Ealing, London W5 5LG, England
Phone	(01) 579 6449
Apply to	Cyrus Andrews, or Photo Librarian.
Material	Modern photographs, mostly colour but including some black and white, of tourist resorts in Europe. These are supplemented by pictures of life in Asia and Africa, animals, insects etc. Number — 10,000.
Availability	Research by staff or researcher. Requests by writing, phone or visit (usually phone). Written authorisation required in first instance. Appointment necessary. Hours — Monday to Friday, 9 to 5.
Procedure	Material loaned or copied. Fees: reproduction, sometimes search, handling, holding after 28 days. Commissions.
Notes	Through worldwide contacts, can usually obtain material not held without additional cost to client.

TRANS-GLOBE FILM DISTRIBUTORS

Modern photographs, historic houses and monuments in Britain

Address	23 Crisp Road, London W6 9RL, England
Phone	(01) 748 0017/8
Material	Despite its name, this collection is of still photographs, mostly in colour, of historic houses, monuments, castles etc, owned either by the National Trust or privately, in England, Scotland, Wales and Northern Ireland. The quality is high, the pictures are well indexed and the service is helpful. Number — several thousand.
Availability	Research by staff or researcher. Requests by writing, phone or visit. Written authorisation required in first instance. Appointment necessary. Hours — Monday to Friday, 10 to 3, Saturdays by arrangement.

Procedure	Some material loaned, others copied. Transparencies sold. Fees: reproduction. Catalogue available at cost of postage.

VISTA OF GLASGOW

Scotland, past and present

Address	22 Royal Crescent, Glasgow, G3 7SL, Scotland
Phone	(041) 332 1241
Apply to	Mr G Borthwick.
Material	Photographs in colour and black and white, old prints and engravings, of places in Scotland, scenes of daily life, industry, people etc. Photographs from 1960 to present. Number — 2000.
Availability	Research by staff. Requests by writing, phone or visit. Appointment preferred, delay 3 days. Hours — Monday to Friday, 9 to 5.30.
Procedure	Some material loaned, others copied. Fees: reproduction, search.
Notes	Will research for pictures not held.

WOODMANSTERNE PUBLICATIONS

General modern photographs, specialising in tourist subjects

Address	Holywell Industrial Estate, Watford, Hertfordshire WD1 8RD, England
Phone	(92) 28236
Apply to	Arthur Sutton, Film Production Manager.
Material	Modern photographs, particularly of tourist subjects particularly in Britain, continental Europe and the Holy Land; cathedrals and museums. Also general material including Space Exploration, Transport, Natural history. Period — 1962 to present. Number — 7000.

Woodmansterne Publications (continued)

Availability Research by staff or researcher.
 Requests by writing, phone or visit.
 Written authorisation required.
 Appointment necessary, 1 day delay.
 Hours — Monday to Friday, 9 to 4.30.

Procedure Some material loaned, others copied.
 Fees: reproduction.
 Photostat service.

BRITISH LOCAL HISTORY IN PUBLIC LIBRARIES

Most British public libraries act as a repository for collections of material relating to local history. Sometimes this is accessible to the public, sometimes not; sometimes it is well organised, sometimes not. Such sources are always worth approaching, because at their best they are enthusiastic and extremely helpful. Besides, if they do not possess appropriate material themselves, they can generally tell you where to go instead.

The following list does not claim to be at all complete. But it includes local archives known to be accessible, and often including collections which are of more than local interest.

Name and address	Special collections and other information
ARNOLD Nottinghamshire, NG5 6JN	
AYR 12 Main Street, Ayr	Apply to: Reference Librarian Special *Robert Burns* collection
BARNET Hendon Library, The Burroughs, Hendon NW4 4BQ	Apply to: The Archivist
BROMLEY Central Library, Bromley, Kent, BR1 1EX	Apply to: Local history section Special Crystal Palace collection
BUCKINGHAMSHIRE COUNTY LIBRARY County Offices, Walton Street, Aylesbury, Bucks, HP20 1UU	Apply to: County reference librarian
CAMDEN, London Borough of St Pancras Library, 100 Euston Road, London NW1 2AJ	Apply to: Archivist Special collections on Keats, Kate Greenaway and other local celebrities.
CROYDON, London Borough of Central Library, Katharine Street, Croydon, CR9 1ET	Mainly Croydon prints and photographs, but also Surrey photographs 1900 to 1930s.

DARTFORD Central Library
Central Park, Dartford, Kent
DA1 1EV

Apply to: Borough Librarian

EALING Central Library
Walpole Park, London W5 5EQ

Apply to: Central Reference Librarian
Special collection: Ealing Photographic
Society's survey of Ealing in 1902

GATESHEAD Central Library
Prince Consort Road, NE8 4LN

Apply to: Archivist

GILLINGHAM Central Library
High Street, Gillingham, ME7 1BG
Kent

Apply to: Borough Librarian
Special collections:
J B McCudden, World War One air ace
Louis Brennan, inventor of torpedoes,
monorail etc.
William Adams (b. 1564) first Englishman
in Japan.

GREENWICH Local History Library
Woodlands, 90 Mycenae Road,
Blackheath, London SE3 7SE

Kent as well as immediate neighbourhood.
Spurgeon collection of very fine photos
of street life in the 1880s.

GUILDFORD
North Street, Guildford, Surrey

Apply to: Reference Librarian
Surrey as well as Guildford itself.

HACKNEY, London Borough of,
Archives Dept, Shoreditch Library,
Pitfield Street, London N1

Covers Hackney, Shoreditch and Stoke
Newington

HERTFORD County Record Office
County Hall, Hertford

Apply to: Mrs M Myddleton
Includes *Stingemore* photo collection of
local views 1909—1939.

ISLINGTON
The Finsbury Library, 245 St John
Street, London EC1V 4NB

KENT County Library
Springfield, Maidstone, Kent

Apply to: County Reference Librarian

LAMBETH, London Borough of
Directorate of Amenity Services,
Archives Dept, Minet Library,
52 Knatchbull Road, London SE5 9QY

Apply to: Archivist or assistant archivist
Large collection comprising whole of pre-
1888 county of Surrey. Special collections
on *Crystal Palace* and *Vauxhall Gardens.*

LEEDS, Local History Library,
City Libraries, Leeds

Predominantly Leeds city, but also some
coverage of rest of Yorkshire.

LEICESTER Publicity Department,
Information Centre, Bishop Street,
Leicester

LEWISHAM, London Borough of
Archives & Local History Dept,
The Manor House, Old Road, Lee
London SE13

Large collection.

LINCOLN City Library
Free School Lane, Lincoln

Apply to: The Director
Special collection on *Tennyson* (apply to
Tennyson Research Centre) comprises other
distinguished Victorians as well.
Banks collection of drawings by *J C Nattes*.
Robey collection of photos of engineering
products.

MALVERN
Graham Road, Malvern, Worcs.

MARYLEBONE (London)
Marylebone Road, London NW1 5PS

Local history of Marylebone
and Paddington.

MERTON & MORDEN
Morden Library, Morden Road,
London SW19 3DA

MITCHAM
London Road, Mitcham, Surrey, CR4 2YR

NEWCASTLE-ON-TYNE
Central Library, New Bridge Street,
PO Box 1 MC, Newcastle-on-Tyne,
NE99 1MC.

Apply to City Librarian
Special *Thomas Bewick* collection.

NEWHAM
Stratford Reference Library,
Water Lane, London E15 4NJ

Apply to: Mrs Taylor.

NORTHAMPTON
Abington Street, Northampton,
NN1 2BA, England

Sir Henry Dryden collection of
architectural drawings and British
archaeology.
John Clare collection.

PETERBOROUGH Central Library
Broadway, Peterborough, PE1 1RX

Apply to: City Librarian

PRESTON
Harris Public Library, Market
Square, Preston, Lancs, PR1 2PP

Apply to: Borough Librarian
Includes Preston Scientific Society's
Collection.

RICHMOND-UPON-THAMES
The Retreat, Retreat Road, Richmond,
Surrey, TW9 1PH

Apply to: Reference Library
Special collections: *Sir Richard Burton*
Ionides collection of paintings of
Richmond and Twickenham

ROCHDALE Libraries & Arts Service
Esplanade, Rochdale, Yorks

Special collection: *Tim Bobbin*

SHREWSBURY Borough Library
Castle Gates, Shrewsbury, Shropshire

Apply to: M F Messenger, Borough Librarian
Covers Shropshire as well as Shrewsbury.

SOLIHULL Central Library
Church Hill Road, Solihull,
Warwickshire, B91 3RG

Apply to Miss C A Miller, Reference
Librarian.

SOUTHPORT
Atkinson Central Library, Lord
Street, Southport, Lancs PR8 1DJ

Apply to: Reference Librarian.

SOUTH SHIELDS
Ocean Road, South Shields, County
Durham

Apply to: Reference library
Large collection, covering local industry,
ships and shipping, social conditions etc
as well as straightforward history.

STOCKPORT Central Library
Wellington Road South, Stockport,
Cheshire SK1 3RS

Apply to: Borough librarian.
Covers Cheshire as well as Stockport.

TEESSIDE LIBRARIES
Central Library, Victoria Square,
Middlesborough, Teesside

Stockton District Library,
Stockton, Teesside

Dorman Museum, Linthorpe Road,
Middlesborough, Teesside

Central Library, Clarence Road,
Hartlepool

THURROCK Central Library
Orsett Road, Grays, Essex

Apply to: Mr D A Wickham, Chief Librarian
Covers Essex as well as Thurrock

TYNEMOUTH
Howard Street, North Shields,
Northumberland

Includes the *Edington* collection of
engravings, lithographs etc.

WALLSEND
Ferndale Avenue, Wallsend,
Northumberland

Includes local industry.

WESTMINSTER
Archives Department, Victoria Library,
160 Buckingham Palace Road, London
SW1W 9UD

WESTON-SUPER-MARE Municipal Library
Boulevard, Weston-super-Mare

Apply to: Borough librarian.

British Local History in Public Libraries (continued)

WEYMOUTH Central Library
Westway Road, Weymouth

Apply to: The Chief Librarian
Some general material relating to Dorset,
more detailed of Weymouth.

WIMBLEDON
Wimbledon Hill Road, London SW19 7NB

WORCESTER City Libraries
Foregate Street, Worcester, WR1 1DT

ADDENDA

BORD, Janet and Colin

Modern photographs, specialising in ancient sites in Britain

Address	34a Barnsdale Road, London W9 3LL, England (01) 969 6997
Material	Modern photographs of British countryside, with ancient sites a speciality (their book *Mysterious Britain* contains many of these and also indicates their interest in the subject). Also general subjects. Period — present. Number — several thousand.
Availability	Research by staff. Requests by writing or phone.
Procedure	Material loaned or copied. Fees: reproduction, holding. Commissions.

ROBERTSON, Kenneth

Modern photographs relating to Scottish Highlands and Islands

Address	Tigh Geal, Daliburgh, Isle of South Uist, Outer Hebrides, Scotland
Phone	Lochboisdale 253

Robertson, Kenneth (continued)

Material Modern photographs covering nearly every facet of Highland and Island life, including scenery as well as people and scenes of daily life. Comprehensive coverage in black and white also some in colour. Drawings and paintings of local subjects can be commissioned.
Period — 1954 to present.
Number — 3000.

Availability Research by staff.
Requests by writing, phone or visit.
Appointment preferred.
Hours — any time.

Procedure Some material loaned, others copied.
Fees: reproduction, holding.

SHERIDAN, Ronald

Modern photographs, mainly geographical and ethnological

Address 11 Harvard Court, Honeybourne Road, London NW6 1HJ, England

Phone (01) 435 3257

Material Modern photographs in colour and black and white of places, peoples, artifacts, architecture and daily life. Countries covered in greatest depth are Egypt, Algeria, Spain and Portugal, Italy, Yugoslavia, Greece, Lebanon, Iran, Israel.
Detailed catalogues are available for each of these areas.
Number — 50 000+.

Availability Research by staff or researcher.
Requests by writing, phone or visit.
Written authorisation required.
Appointment necessary, one day delay.
Hours — any.

Procedure Material loaned or copied.
Fees: reproduction, holding.
Catalogues.
Commissions.

Notes Extensive cross-referencing by subject as well as location.

FRANCE

A A A PHOTO

Modern photographs, geographical and ethnographical, Africa, Asia and America

Address	44 rue de Varenne, 75007 Paris, France
Phone	548 53 11
Material	Photographs in colour or black and white giving comprehensive coverage of all aspects of life in Africa, Asia and America, including scenes from everyday life, culture, folklore, topography etc. Excellent and detailed catalogues are available listing what is available for each country. AAA give the impression of being one of the best organised collections of their kind. Number — 100,000.
Availability	Research by staff or researcher. Requests by writing, phone or visit. Appointment preferred. Hours — Monday to Friday, 9 to 12, 2 to 6.
Procedure	Material loaned or copied. Fees: reproduction, sometimes holding. Catalogues available. Commissions.

BAUGEY, Christian

Modern photographs, geographical and architectural

Address	3 rue Ferdinand Fabre, 75015 Paris, France
Phone	842 37 94
Material	Modern photographs covering landscape and architecture of many countries, particularly Latin America, Japan, Cambodia, Bali and Italy. Special collection of Paris 1946 to 1952 which includes 'secret' Parisian subjects — unusual places and trades, buildings now disappeared etc. Period — 1946 to present Number — 10,000 colour, 8000 black and white.
Availability	Research by staff. Requests by writing, phone or visit. Appointment preferred. Hours — Sunday to Saturday, 10 to 8.

Baugey, Christian (continued)

Procedure Some material loaned, others copied.
Fees: reproduction, service/handling.
Commissions.

BILLON, Yves

Modern photographs, anthropology, sociology, ethnology

Address 20 Allée des Maisons Russes, 93340 Le Raincy, France

Phone 927 09 98

Material Modern photographs relating to anthropology, ethnology and sociology. Special fields — urbanism as exemplified in Parisian housing problems. Anthropological/ethnographical material includes Brazil, Morocco and other African regions. Period — 1960 to present.
Number — 10,000.

Availability Research by staff or researcher.
Requests by writing, phone or visit.
Appointment preferred.

Procedure Some material loaned, others copied.
Fees: reproduction, service/handling.
Photostat service.
Commissions.

BORGE, Guy

History of Lyon and region, trains and cars before 1945

Address 25 quai Saint Vincent, 69001 Lyon, France

Phone 28 08 83

Material 10,000 photographs relating to the history of Lyon and the neighbourhood between 1840 and 1920; also trains and cars before 1945.

Availability Research by staff.
Requests by writing, phone or visit.
Appointment essential, delay 7 days.
Hours — Monday to Friday, 9 to 6.

Procedure Material not loaned, copies made.
Fees: reproduction, service.

BOTTIN, Jean

Modern photographs, worldwide geography especially France

Address	11 rue Thouin, 75005 Paris, France
Phone	633 50 47
Material	Big collection of modern photographs covering geographical subjects; emphasis is on France, but scope is genuinely worldwide and covers artistic subjects, wildlife, racial types etc. Period — 1958 to present. Number — 100,000.
Availability	Research by staff. Requests by writing, phone or visit. Appointment preferred. Hours — Monday to Friday 9.30 to 12.15, 2 to 6; other times by appointment.
Procedure	Material loaned or copied. Reproduction fee, sometimes search. Subject list available on request.

BOUDOT-LAMOTTE, Emmanuel

Modern geographical photographs, also history and cultural subjects

Address	40 rue de Verneuil, 75007 Paris, France
Phone	LIT 52 41
Material	Modern photographs covering places, archeology, history, art etc in Europe, Africa, America and Asia. Number — 200,000.
Availability	Research by staff. Requests by writing, phone or visit. Appointment essential. Hours — any afternoon.
Procedure	Material not loaned, copies made. Fees: reproduction. Subject list available on request.

215

CHABRIER, Jean-Claude & Edith

Modern photographs of Middle East

Address	12 rue Piccini, 75016 Paris, France
Phone	727 0761
Material	Photographs of scenery, architecture, daily life, racial types, religious practices, music and social activities in Turkey, Lebanon, Syria, Jordan, Iraq, Kuwait, Iran and Afghanistan. Period — 1960 to present. Number — 20,000.
Availability	Research by staff. Requests by writing, phone or visit. Appointment necessary, delay between 1 to 10 days. Hours — Monday to Saturday, 9am to 10pm.
Procedure	Some material loaned, others copied. Fees: reproduction.

COMBIER

Photographs of France, Belgium and North Africa, 1900 to present

Address	4 rue Agut, 71010 Macon, France
Phone	(85) 38 00 42
Apply to	Marc Combier.
Material	This printing firm has been manufacturing postcards of French Belgian and North African views since 1900; they now have a collection of 1½ million views, as well as humorous subjects of the type one might expect to find on a postcard. The collection of pre-World War material is likely to be the most interesting item, but there is comprehensive coverage up to the present day.
Availability	Research by staff. Requests by writing, phone or visit. Appointment preferred. Hours — Monday to Friday, 8 to 11.45, 2 to 6.
Procedure	Material loaned or copied. Fees: reproduction, search, service, holding. Photostat service.

EXPLORER, agence de presse

Modern colour photographs, geography, ethnography, sport, leisure activities

Address 32 rue Saint Marc, 75002 Paris, France

Phone 073 71 90

Telex 68390F

Apply to M. Michel Buntz.

Material Modern colour photographs of geography, ethnography, sports and leisure activities.
 Number — 60,000.

Availability Research by staff or researcher.
 Requests by writing, phone or visit.
 Written authorisation required in first instance.
 Appointment preferred.
 Hours — Monday to Friday, 9.30 to 1, 2 to 6.30.

Procedure Material loaned.
 Fees: reproduction and handling.
 Commissions.

HOA-QUI, agence

Modern photographs of Africa — all aspects except news

Address 145 rue Saint Dominique, 75007 Paris, France

Phone 551 16 28

Material 'Twenty years of reportage on black Africa' is their own description of their
 collection which covers all aspects of African life, geography, culture, wildlife and
 flora, scenes and economy.
 Period — 1948 to present.
 Number — 200,000.

Availability Research by staff or researcher.
 Requests by writing, phone or visit. (Written requests preferred).
 Written authorisation required in first instance.
 Appointment preferred, delay 2 or 3 days.
 Hours — Monday to Friday, 9 to 5.

Procedure Material loaned or copied.
 Fees: reproduction, sometimes search, service and holding.
 Photostat service.
 Catalogue available on request.

JOURNAUX, André

Modern colour photographs, geography, geomorphology, geology etc.

Address 19 rue Isidore Pierre, 14000 Caen, France

Phone (31) 81 27 03

Material Colour photographs covering the more technical aspects of geography — vegetation,
 geology, geomorphology, the natural economy of regions. Has made expeditions into
 Arctic and Siberia.
 Period — 1952 to present.
 Number — 35,000.

Availability Research by staff.
 Requests by writing, phone or visit.
 Appointment necessary, delay 8 days.
 Closed during University vacations.

Procedure Some material loaned, others copied.
 Fees: reproduction.

LAJOUX, Jean Dominique

Modern photographs, geography and ethnography

Address 25 rue Fresnel, 75116 Paris, France

Phone 553 40 99

Material Ethnographical and geographical photographs covering France (esp. Paris), Sahara,
 Nubia, Turkey, South Vietnam, French Polynesia. Special collection of the
 prehistoric art of Tassili (Sahara).
 Period — 1952 to present.
 Number — 100,000.

Lajoux, Jean Dominique (continued)

Availability	Research by staff or researcher. Requests by writing, phone or visit. Appointment preferred. Hours — every day when at home, preferably before 10 am or after 8 pm.
Procedure	Material loaned or copied. Fees: reproduction.

MARNE, Archives de la

History of Champagne district of France

Address	1 rue Just-Berland, 51000 Chalons-sur-Marne, France
Phone	(26) 68 06 69
Material	Photographs, prints and engravings, postcards, related to history of the Marne and the Champagne district. Important from the viewpoint of World War One as well as for winemaking etc. Period — 17th century to present. Number — 35,000.
Availability	Research by staff. Requests by writing or visit, not phone. Hours — Monday to Friday, 8.30 to 12, 2 to 6.
Procedure	Material not loaned, copies made. Fees: reproduction.

ROBILLARD, Albert

Modern geographic photographs, exceptionally wide coverage

Address	84 boulevard Pasteur, 75015 Paris, France
Phone	566 44 57
Material	Modern photographs of places, scenes of daily life, customs, transport, industry, agriculture, natural phenomena, buildings etc in almost every country of the world, colour and black and white. Number — over 51,000.

Robillard, Albert (continued)

Availability	Research by staff. Requests by writing, phone or visit. Appointment preferred. Hours — 7 days a week.
Procedure	Material available on short loan, or copies made at very reasonable cost. Fees: reproduction, search, holding after 15 days. List of countries covered and number of pictures available on request.
Notes	The Robillard collection has the widest geographical coverage of any in this Handbook, and is continually being extended. The photographs are classified according to subject-matter as well as location, making for easy research.

REST of EUROPE

ACTUALIT

Modern photographs, geographical and ethnographical, international scope with emphasis on Benelux

Address	89 rue de la Consolation, 1030 Bruxelles, Belgium
Phone	16 58 98
Cables	Actualit Bruxelles
Material	Modern colour photographs, of landscapes, towns, people etc, international in scope — Pacific Islands as well as more familiar regions — but with specially good coverage of Benelux nations. Period — 1950 to present. Number — 50,000.
Availability	Research by staff. Requests by writing, phone or visit. Written authorisation required.
Procedure	Material loaned or copied. Fees: reproduction, handling, sometimes holding. Commissions. Subject list available.

FJELLANGER WIDEROE

Aerial photographs of Norway

Address	Rolfstangveien 12, Fornebu, PO Box 190, 1330 Oslo Lufthavn, Norway
Phone	12 11 20
Telex	Oslo 18764 WFMAPN
Material	Aerial photographs of places and activities, vertical and oblique. Vertical coverage of entire country. Special collection on reindeer herds. Number — 7 million.

221

Fjellanger Wideroe (continued)

Availability Research by staff or researcher.
 Requests by writing, phone or visit.
 Written authorisation required in first instance.
 Hours — Monday to Friday, 8 to 4.

Procedure Material not loaned, copies made.
 Fees: reproduction.
 Photostat service.
 Commissions.

KNUDSENS FOTOSENTER

Photographs of Scandinavia and Arctic from 1900

Address St Olavsgate 28, Oslo 1, Norway

Phone 02 20 21 38

Cables Senterforfoto.

Apply to Arne Knudsen, President.

Material Photographs of Scandinavia and the Arctic. Agents for foreign agencies and for many
 of the best-known Norwegian photographers.
 Period — 1900 to present.
 Number — 270,000.

Availability Research by staff or researcher.
 Requests by writing, phone or visit.
 Written authorisation required in first instance.
 Appointment preferred.
 Hours — Monday to Friday, 8.30 to 4.15.

Procedure Material loaned or copied.
 Fees: reproduction, sometimes others.
 Subject lists available.
 Photostat service.
 Commissions.

LE-BE PHOTO AGENCY

Modern photographs, especially Denmark and Greenland

Address	Frederik den VII's vej, Postbox 31, 3450 Allerod, Denmark
Phone	(03) 180352
Apply to	Mr Palfery.
Material	Modern photographs relating to Denmark and Greenland. Number — 50,000.
Availability	Research by staff. Requests by writing, phone or visit. Written authorisation required in first instance. Appointment preferred. Hours — Monday to Friday, 9 to 4.
Procedure	Some material loaned, others copied. Fees: reproduction, search, handling, holding. Catalogue available for Danish material. Commissions.

LEHTIKUVA OY, picture agency

Modern photographs, Finnish folklore and daily life

Address	Ludviginkatu 6—8, 00130 Helsinki 13, Finland
Phone	648 506
Telex	12 774
Material	Modern photographs of Finland and Finnish life, specialising in Finnish folklore and traditional life, crafts etc. Period — 1952 to present. Number — several thousand.
Availability	Research by staff. Requests by writing, phone or visit. Hours — Monday to Saturday, 7 am to 11 pm, Sunday 4 to 11 pm.
Procedure	Some material loaned, others copied. Fees: reproduction, service. Photostat service. Commissions.

MANGOIAN BROTHERS

Modern photographs of Cyprus, geography and daily life

Address	31—33a Regena Street, Nicosia, PO Box 1698, Cyprus
Phone	62928
Material	Recent and modern photographs of Cyprus — places, historic sites, folklore, daily life. Special underwater collection. Period — 1918 to present.
Availability	Research by staff. Requests by writing, phone or visit. Written authorisation required in first instance. Appointment preferred, delay up to 7 days. Hours — Monday to Friday, 8 to 6 (closed lunchtime).
Procedure	Some material loaned, others copied. Fees: reproduction, search, service/handling, holding. Photostat service. Commissions.

PAYSAN, Klaus

General natural history plus African geography and cultural activities

Address	7 Stuttgart — Feurbach, Bubenhalde 90, West Germany
Phone	(0711) 853187
Material	Natural history, zoology, botany, geography and ethnography with special reference to Africa; art, tribes, peoples as well as natural history subjects. Period: 1950 to present. Number: 50,000
Availability	Research by staff or researcher. Requests by writing, phone or visit. Appointment preferred. Hours: Monday to Saturday, 8 to 4.
Procedure	Some material loaned, others copied. Photographic service. Fees: reproduction, search, handling.

PHOTO & TEXT

Swiss popular culture, crafts, domestic life etc

Address	Post Office Box 8033, Zurich, Switzerland
Phone	01 26 61 48
Material	Photographs relating to Swiss popular culture, folklore, crafts for children and adults, interior design, old trades, traditional domestic activities etc. Text (German) available. Period — 1960 to present. Number — 1000.
Availability	For serious purposes only. Research by staff. Requests preferably in writing. Visits by appointment only, apply in writing or, if by phone, preferably about 8.45 am. The collection is small and housed in a private flat. Hours — Monday to Friday, 8.30 to 5.
Procedure	Material loaned. Fees: reproduction and holding. Commissions.
Notes	Most photographs are accompanied by a text. This can be translated from the German for a fee.

PÖPPEL, Walter, Illustrationsfoto

Modern photographs, Sweden and Europe

Address	Gra Huddingevagen 448, S 125 42 Alvsjo, Sweden
Phone	(08) 475624 or 994943
Material	Photographs of landscapes and towns in Europe, particularly Sweden, also Germany (East and West), Austria, Czechoslovakia, Yugoslavia, Switzerland, Holland etc. Also reportage material and historical portraits, chiefly of Swedish interest. Period — 1938 to present. Number — 100,000.
Availability	Research by staff or researcher. Requests by writing, phone or visit. Appointment preferred. Hours — Monday to Friday, 9 to 5.
Procedure	Material loaned or copied. Fees: reproduction, sometimes search, handling and holding.

TRANSAFRICA

Modern photographs and drawings of Africa, comprehensive coverage

Address	via Trieste 34, 25100 Brescia, Italy
Phone	(030) 55080 or 40800
Material	A big and comprehensive collection of photographs, with some drawings, of every African country — places, people, politics, flora, fauna, daily life. Period — 1955 to present, and kept up to date by annual visits to every country. Number — 100,000.
Availability	Research by staff. Requests by writing, phone or visit. Written authorisation required in first instance. Appointment preferred, delay 2 or 3 days. Hours — Monday to Friday, 9 to 6.30.
Procedure	Material loaned or copied. Fees: reproduction, search, holding after 60 days. Catalogue available. Photostat service. Commissions.

USA and CANADA

AMERICAN GEOGRAPHICAL SOCIETY LIBRARY

Modern geographical photographs

Address	Broadway at 156th Street, New York, NY 10032, USA
Phone	212 AD4 8100
Apply to	The Librarian.
Material	Photographs of geographical subjects, including vegetation and physiography. Special collection of portraits of geographers and explorers. Period — present. Number — 45,000.
Availability	Research by staff or researcher. Requests by writing, phone or visit. Written authorisation required. Appointment necessary; delay 2 days. Hours — Monday to Friday, 9 to 4.30.
Procedure	Material loaned or copies made. Fees: reproduction, handling. (Both modest.) Photostat service available.

ARIZONA PHOTOGRAPHIC ASSOCIATES

Photographs of Arizona and American West, 1860s to present

Address	2350 West Holly, Phoenix, Arizona 85009, USA
Phone	(602) 258 6551
Apply to	Mrs Dorothy McLaughlin.
Credit	'Herb and Dorothy McLaughlin Historical Collection'.
Material	Photographs of Arizona and American West. Also Mexico and Saudi Arabia. Period — 1860s to present. Number — over 150,000.

Arizona Photographic Associates (continued)

Availability	Research by staff or researcher.
	Requests by writing, phone or personal visit.
	Written authorisation required in first instance.
	Appointment essential.
	Hours — Monday to Friday 8 to 5.
Procedure	Material loaned or copied.
	Fees: reproduction, search, service/handling, holding after 14 days.
	Commissions.
Notes	Representatives in London: Barnaby's Picture Library (p 102).

ROSS, Dr Edward S

Modern photographs of tropical environments, ethnography and natural history

Address	California Academy of Sciences, Golden Gate Park, San Francisco, CA 94118, USA
Phone	(415) 221 5100
Material	Modern photographs covering most aspects of tropical regions, particularly in Africa, Asia and South America. Good coverage of native peoples of such areas, especially Africa. Natural history coverage of animals, insects and plants of tropical regions.
	Period — 1950 to present.
	Number — 100,000.
Availability	Research by staff.
	Requests by writing, phone or visit.
	Appointment preferred.
	Hours — Monday to Friday, 8 to 4.
Procedure	Material loaned.
	Fees: reproduction, sometimes search and holding.
Notes	As a scientist, Dr Ross can supply full documentation for his material, indicate points of significance etc. His photographs specialise in candid presentation of the subject in its natural environment.

WEIMER, Charles Perry

Modern photographs of Latin America

Address 693 Park Road, Morris Plains, New Jersey 07950, USA

Phone (201) Jefferson 8 7468

Material Modern photographs in colour and black and white giving comprehensive coverage of all Latin American countries — places, people, daily life, antiquities, archaeology, industry, fauna, flora. Includes West Indies and other islands as well as mainland.
Period — 1940 to 1965.
Number — 200,000.

Availability Research by staff.
Requests by writing, phone or visit.
Written authorisation required in first instance.
Appointment necessary, delay 7 days.
Hours — Monday to Friday, 8 to 5.

Procedure Some material loaned, others copied.
Fees: reproduction, service/handling, holding after 30 days.
Subject list available on request.
Commissions.

WYCOFF, Jerome

Modern photographs on natural science, emphasis on geology

Address 227 Bogart Avenue, Ridgewood, New Jersey 07450, USA

Phone (201) 444 0145

Material Modern collection of geology, conservation, elementary astronomy, meteorology (clouds), geography including national and state parks in USA, Great Britain, Canada, Italy, Germany, Austria and Switzerland.
A large proportion of the geological material relates to geomorphology.
Number — 18,000.

Availability Research by staff.
Requests by writing, phone or visit.
Written authorisation required.
Appointment necessary.
Hours — Monday to Friday, 9 to 5.

Procedure Some material loaned, others copied.
Fees: reproduction, search, sometimes holding, rarely service or handling.

BEYOND EUROPE (except USA)

BRAUN, Werner

Modern photographs of Israel

Address	1 Raphaeli Street, Jerusalem 94558, Israel
Phone	2270 10
Material	First-class photographs of Israel — places, people and everyday life. Speciality, Red Sea underwater photos (colour). Period — 1949 to present.
Availability	Research by staff. Requests by writing, phone or visit. Appointment necessary. Hours — Monday to Friday, 9 to 12.
Procedure	Material loaned or copied. Fees: reproduction, holding. Commissions.
Notes	Represented abroad by:— London: Camera Press, Russell Court, Coram Street, WC1. Dusseldorf: ZEFA, 4 Dusseldorf 11, POB 755, W. Germany (colour only). New York: FPG, 110 West 32nd St., New York, NY 10001, USA (colour only).

CUBITT, Gerald

General geographical collection of international scope

Address	PO Box 11 443, Vlaeberg, Cape Town, South Africa
Phone	Cape Town 41 2791
Material	Black and white and colour transparencies of many countries with a special emphasis on Africa, particularly Kenya, Madagascar, Mauritius, Seychelles, South Africa, South West Africa, and Tanzania. Large European coverage mostly with Camera Press (London). Geography, ethnography, wildlife etc. Period 1960 to present. Number: several thousand.

Cubitt, Gerald (continued)

Availability Research by Staff.
 Requests by writing, phone or sometimes visit.
 Written authorisation required.
 Appointment preferred, no delay.
 Hours — Monday to Friday, 8 to 5, or by arrangement.

Procedure Material loaned or copied.
 Fees: reproduction.
 Catalogue (£3).

DOCUMENTARY PHOTOGRAPHS

Modern photographs of geographical and natural history

Address G D Roberts, Todd's Valley, Nelson RD 1, New Zealand

Phone Nelson 31953

Apply to Mr G D Roberts.

Material Regional geography including New Zealand and Australia, Fiji, Canada, USA, UK,
 and Scandinavia. (Geology, landforms, and social studies.)
 Biology; Plant and animal life, ecology, pollution, conservation — and includes
 features of educational interest such as, 'The Story of Wool' — and World Vegetation
 features.
 Most of the material is on 35 mm colour and is available in film strip form for
 educational purposes.
 Number 30,000.
 Period 1960 to present.

Availability Research by researcher or staff.
 Requests by writing or visit.
 Letter of authorisation required.
 Appointment preferred.
 Hours: by arrangement.

Procedure Material loaned.
 Fees: reproduction, holding after 4—6 months.
 Abbreviated lists available.

Notes Mr Roberts is a school teacher, author and photographer. His experience in supplying
 publishers of educational textbooks etc, enables him to supply suitable material in
 response to written requests.

ISRAEL: MINISTRY OF TOURISM

Modern photographs of Israel, chiefly tourist aspects

Address	24 King George Street, Jerusalem, Israel
Phone	(02) 223366/1
Apply to	Assistant, Films and Photographs Section, Publications and Public Relations Division.
Material	Modern photographs of Israel, chiefly from a tourism angle.
Availability	Research by staff. Requests by writing, phone or visit. Written authorisation required in first instance. Appointment necessary, delay 6 days. Hours — Monday to Thursday 7.30 to 3, Friday 7.30 to 1.
Procedure	Material loaned or copied. Fees: sometimes reproduction.
Notes	Specimens of black and white pictures from printed publications sent on request. Offices in most capital cities, through which requests can be made; see telephone directories for addresses.

TUNISIA: OFFICE NATIONAL DU TOURISME ET DU THERMALISME

Modern photographs of places and daily life in Tunisia

Address	1 Avenue Mohammed V, Tunis, Tunisia
Phone	259 217 or 259 133
Telex	12 381 ONTT tn
Apply to	Service Edition.
Material	Modern photographs of places in Tunisia, scenes, hotels, handicrafts, folklore, daily life, architecture etc. Period — 1958 to present. Number — 5000 black and white, 500 colour, some original paintings.
Availability	Only for purposes which can be shown to be beneficial to tourism in Tunisia. Research by staff or researcher. Requests preferably in writing, not phone; visits by appointment. Hours — Monday to Thursday, 8.30 to 12.30, 2.30 to 6. Friday and Saturday, 8.30 to 1.

Procedure Material loaned or copied.
 No fees.
 Photostat service.

TURKEY, MINISTRY OF TOURISM & INFORMATION

Modern photographs of Turkey, archaeological sites and tourist attractions

Address Demirtepe, Ankara, Turkey

Phone 181180

Material Photographs in colour and black and white of Turkish scenes, places, folklore, tourist
 attractions and archaeological sites.
 Period – 1965 to present.
 Number – 3500 colour, also black and white collection.

Availability Research by staff.
 Requests by writing, phone or visit.
 Appointment necessary.
 Hours – Monday to Friday, 9 to 5,30, Saturday 9 to 1.

Procedure Material loaned or copied.
 Fees: reproduction.
 Photostat service.

Notes Help provided for visiting photographers, including obtaining of permits etc. Staff
 very ready to co-operate with researchers in quest of Turkish material, whether or
 not within the Ministry's own archives.

There is an essential difference between art sources and most others, which is that theirs is basically a 'second-hand' function. An art source collection is made up of copies of material of which the originals are likely to be located elsewhere.

Clearly this presents the researcher with problems. First, more than one art source may have copies of the same original; which do you use? Second, the matter of fees: do you pay both the art source *and* the owners of the original, or have arrangements been made whereby one payment does for both?

A third problem arises in the course of the research itself: how is the material filed? The usual answer is, by artist's name; sometimes by title; very rarely indeed by subject, though this is often the most interesting aspect from the researcher's point of view.

The ideal art source would be not so much a collection of artistic masterpieces as a library of Documentary Art. Material would be filed by subject, with cross-index for artist and title. Rights would be cleared so that only a single payment need be made. A photographic service would supply prints and transparencies at short notice.

In practice, no art source offers this ideal, though many make valiant attempts. The trouble is that most were created when the most important clients were the publishers of art books per se. Today the balance has shifted, and publishers value pictures like 17th-century Flemish genre scenes for their documentary value.

A well-organised art source like Scala of Milan will do its best to help with subject-oriented requests, but inevitably it's a somewhat hit-and-miss business. In the end the likelihood of finding, say, a renaissance painting which shows a man wearing spectacles, or an Egyptian mural depicting glass manufacture, depends on the ability of the researcher or the source staff to recollect whether such a picture exists.

We have included museum sources only if they either possess a substantial library of prints and engravings likely to be of value to the researcher, or possess items of considerable documentary interest, not easily duplicated elsewhere, and which could be new to researchers. Thus we have not included Sir John Soane's Museum, London, though its Hogarth paintings are a natural source of visual documentation for 18th-century society, for these are familiar enough and readily accessible; but we *have* included the Statens Museum für Kunst at København because it contains a number of little known but (in our opinion) very interesting paintings of early 19th-century social life which a researcher would find fresh and rewarding.

BRITAIN

ACADEMY OF ARTS, THE ROYAL

British art, 1758 to present

Address	Piccadilly, London W1V ODS, England
Phone	(01) 734 9052
Apply to	The Librarian.
Material	Prints and engravings, original paintings and drawings, photographs and manuscripts related to British art and artists. Catalogues and photos of exhibitions. Period — 1768 to present. Number — 5000.
Availability	Bona fide scholars and students only, or researchers for genuine serious purpose. Research by staff or researcher. Requests by writing, phone or visit. Written authorisation required, plus recommendation from university or institution. Appointment preferred. Hours — Monday to Friday 2 to 5.
Procedure	Some material loaned, others copied. Fees: reproduction. Exhibition catalogues available. Photostat service.

ARCHITECTS, ROYAL INSTITUTE OF BRITISH: DRAWINGS COLLECTION

Architecture, worldwide

Address	21 Portman Square, London W 1, England
Phone	(01) 580 5533, extension 255 or 287
Apply to	Miss Jill Lever or Miss Margaret Richardson, Assistant Curators.
Material	Working drawings, plus some prints, engravings original paintings covering the history of architecture from about 1520 to the present day. Number — 200,000
Availability	Research by researcher. Requests by writing or visit, not by phone. Appointment preferred, delay 3 days. Hours — Monday to Friday, 2 to 5.

Procedure Material not loaned, copies made.
 Fees: reproduction, service.
 Catalogue of collection and of individual exhibitions available.

ARCHITECTURAL PRESS

Modern photographs of Architecture and related subjects

Address 9–13 Queen Anne's Gate, London SW1H 9BY, England

Phone (01) 930 0611

Apply to Miss W G Constable, Photographic Librarian.

Material Modern photographs of architecture, town planning, landscape and related subjects,
 with emphasis on modern architecture.
 Period – 1930s, and 1946 to present.
 Number – thousands.

Availability Research by staff.
 Requests by writing, phone or visit.
 Written authorisation required in first instance.
 Appointment preferred, 2 days delay.
 Hours – Monday to Friday, 9.30 to 5.30.

Procedure Some material loaned, others copied.
 Fees: reproduction.

AUSTIN, James

Photographs of art and architecture from antiquity to present

Address 31 Malcolm Place, Cambridge, CB1 1LS, England (and see Notes below)

Phone (0223) 65776

Material Photographs of art and architecture in various countries, colour and black and white.
 Medieval French art is a speciality. James Austin's photographs are in public
 collections and university departments throughout the world, and may be consulted
 there.
 Period – 500 BC to present.

Austin, James (continued)

Availability Research by staff or researcher.
Requests by writing, phone or visit.
Appointment preferred — delay 3 to 5 days.
Hours — Monday to Friday, 9.30 to 5.30

Procedure Some material loaned, others copied.
Fees: reproduction, postage charged.
Catalogues available.

Notes COLOUR TRANSPARENCIES are handled by London agent:
Robert Harding Associates, 5 Botts Mews, London W2, England.

BRECHT-EINZIG

Photographs of modern architecture in Western Europe

Address 65 Vineyard Hill Road, London SW19 7JL, England

Phone (01) 946 8561

Apply to Mrs R Einzig.

Material Photographs of modern architecture in England, Denmark, Finland, Sweden, Germany and Switzerland.
Period — 1963 to present.
Covers about 600 different buildings.

Availability Research by staff.
Requests by writing, phone or visit.
Written authorisation required in first instance.
Appointment necessary.
Hours — Monday to Friday, 9.15 to 5.15 (close for lunch)

Procedure Material loaned or copied.
Fees: reproduction, sometimes search, holding after 60 days.
Subject list available on request.
Commissions.

COOPER-BRIDGEMAN LIBRARY

Photographs of fine and decorative arts

Address	51 Sloane Gardens, London SW1 W8ED, England
Phone	(01) 730 1345
Material	Colour transparencies of works of art — fine, decorative and applied. Emphasis on Britain, but also considerable international collection. Agents for Phaidon Press, Scala (Florence and New York) and Medici Society. Active in most London museums. Period — prehistory to 1930s. Number — 15,000.
Availability	Research by staff or researcher. Requests by writing, phone or visit. Written authorisation required in first instance. Appointment preferred. Hours — Monday to Friday 9.30 to 5.30.
Procedure	Material loaned or copied. Fees: reproduction, holding; search fee for photos not in own archives. Catalogue and leaflet available. Photostat service. Commissions.

COURTAULD INSTITUTE OF ART, UNIVERSITY OF LONDON

Reference collection for study of works of art (western)

Address	20 Portman Square, London W1H OBE, England
Phone	(01) 935 9292

This source comprises two separate libraries:—

(1) CONWAY LIBRARY

Material	Collection of western architecture, architectural drawings, sculpture, illuminated manuscripts, metal work, ivories, and stained glass (small collection). It is a study collection and primarily concerned with scholarly research. 1 *Architecture* — buildings, decorative work and sculptural features of buildings in some detail. Photographs are filed under main country headings, topographically. Architects' names are supplied if known.

Courtauld Institute of Art, University of London (continued)

2 *Sculpture* — medieval to 20th Century; filed under location, then by description (eg fonts, tombs, crosses etc) unless the sculptors' names are known, when it is so filed.
3 *Illuminated Manuscripts* from European and American collections; filed under century, country of origin, type of manuscript (secular, Bible etc), present location. The shelf mark of the present collection is essential if you want to trace a specific manuscript. The photographs do not have descriptive captions so it is necessary to know what you are looking for.

Availability Research by researcher only.
Some specific enquiries by phone or letter.
Hours Monday to Friday, 10 to 6.

Procedure Some material copied, others for reference only.
Fees: reproduction.
Copyright clearance may be required in certain cases; the librarian will advise.
Photostat service.

(2) *WITT LIBRARY*

Material Collection of photographs and reproductions of paintings, drawings, and to a lesser extent, engravings in the western European tradition. Mainly black and white, some colour. The library is primarily for art reference and here, as in the Conway, this function takes precedence over commercial operations. Material is filed under national schools and then the artist's name, arranged alphabetically and stored in box files on the open shelves.
There are no subject indexes so researchers should know what they are looking for.
Number: over 2 million.

Availability Research by researcher.
Some specific requests by letter or phone.
Hours — Monday to Friday, 10 to 6.

Procedure If the Courtauld Institute owns the negative, permission for prints and copyright is usually granted although this sometimes depends on the owner of the work of art. Re-photographing of any material is also dependent on the copyright situation and is at the discretion of the librarian.

Notes The Courtauld libraries are available to all and there is no charge for using them. The box files are on open shelves and accessible to researchers without the assistance of the staff. They should not be tipped out nor the items disarranged. In the Conway collection the librarian's help will be needed to direct the researchers to the different collections, but otherwise no assistance is needed except when copies are required.

HALLIDAY, Sonia

Modern photographs, chiefly Mediterranean archaeology and ethnography

Address	Primrose Cottage, Weston Turville, Buckinghamshire, England
Phone	(029) 661 226
Material	Photographs in black and white and colour of ethnographic, archaeological and industrial subjects in Turkey, Cyprus, Crete, Sicily, Tunisia. Also European mosaics, English and German stained glass, Byzantine art, miniatures, material relating to bible history. High quality. Number — 30,000.
Availability	Commercial users only. Research by staff or researcher. Requests by writing, phone or visit. Appointment necessary. Hours — every day, all hours.
Procedure	Material loaned or copied. Fees: reproduction.

HAMLYN GROUP PICTURE LIBRARY

General, particularly arts

Address	Astronaut House, Hounslow Road, Feltham, Middlesex, England
Phone	(01) 751 8228
Cables	PLEASBOOKS, FELTHAM.
Apply to	Picture Librarian.
Material	A general collection largely made up of illustrations used in Hamlyn publications. Chiefly relating to the arts — painting, sculpture, architecture, ceramics, but also other more general material such as war, transport, zoology. Selection and identification are made easier if researchers can indicate specific illustrations, or similar items, from Hamlyn publications. Period — prehistory to present. Number — 6000 colour, 40,000 black and white.

Hamlyn Group Picture Library (continued)

Availability	Research by staff.
	Requests by writing or phone, not by visit.
	Written authorisation required.
	Appointment necessary, 2 to 5 days delay.
	Hours — Monday to Friday, 9.20 to 5.20.

Procedure	Material loaned.
	Fees: reproduction, holding, sometimes search.

HOLFORD, Michael

Photographs of works of art

Address	14 Greek Street, London W1, England

Phone	(01)437 0019 or 508 4358

Material	Subjects from all fields of fine and applied arts from many collections in London and other countries, including the Bayeux tapestry, Greek vases and a great deal of material from the Victoria & Albert Museum, London.
	Period — prehistory to modern.
	Number — 6000 subjects.

Availability	Some material is not available for advertising purposes.
	Research by staff or researcher.
	Requests by writing, phone or visit.
	Written authorisation required in first instance.
	Appointment necessary.
	Hours — Monday to Friday, usual working hours.

Procedure	Material loaned or copied.
	Fees: reproduction.
	Catalogue available.
	Commissions.

HORNAK, Angelo, PHOTOGRAPH LIBRARY

Photographs of architecture, antiques and fine arts

Address	10 Exeter Mansions, 106 Shaftesbury Avenue, London W1V 7DH, England
Phone	(01) 437 2920
Material	Colour photographs of architecture, antiques and fine arts subjects, with American architecture a speciality. Period — prehistory to present. Number — over 8000.
Availability	Research by staff or researcher. Requests by writing, phone or visit. Appointment preferred. Hours — Monday to Friday, 10 to 6.
Procedure	Material loaned or copied. Fees: reproduction Catalogue available. Commissions.

MONUMENTS RECORD, NATIONAL

English historic buildings, 1860 to present

Address	Fortress House, 23 Savile Row, London W1X 1AB, England
Phone	(01) 734 6010
Material	A comprehensive collection of photographs, with some prints, engravings, and architectural drawings, of historic buildings in England. The collection is well indexed under county and name of town or village. Architectural details, stained glass, murals, tombs etc are included. Period — 1860 to present. Number — 800,000 photographs, 20,000 measured architectural drawings.
Availability	Research by staff or researcher. Requests by writing, phone or visit. Hours — Monday to Friday, 10 to 5.30.
Procedure	Some material loaned, others copied. Fees: reproduction. Photostat service.

Monuments Record, National (continued)

Notes In some cases copyright clearance from the original photographer is required; this is always indicated on the reverse of the photograph.

NATIONAL PORTRAIT GALLERY

Portraits of eminent British people

Address *St Martin's Place, London WC2H OHE, England*

Phone *(01) 930 8511*

Apply to *Publications officer.*

Material *Paintings, drawings and some photographs of British public figures from all walks of life. Several group portraits as well as individual sitters. Some copied in colour and/or black and white.*

Availability *Research by researcher, only in the Gallery itself or via the published catalogue. Hours – (Publications Office) Monday to Friday, 10 to 1, 2 to 5 (4 on Friday).*

Procedure *Colour material loaned, black and white copied.*
Application forms are needed for hiring colour transparencies, one form per transparency.
Fees – reproduction (£2) and hiring (£5 per month). Hire fee is prepaid for first month.
Catalogue National Portrait Gallery Concise Catalogue (published by Her Majesty's Stationery Office, 1970) is the essential index to the collection.

Notes *The photographic collection has only recently been started, and its resources were not fully available to the public at the time we went to press. There is no public access, and research is by staff only. There is a search fee in addition to the other fees.*

PHAIDON PRESS

Photographs of works of art, all fields

Address	5 Cromwell Place, London SW7 2J, England
Phone	(01) 589 3264
Telex	919469
Apply to	Photographic librarian.
Material	This archive is largely made up of material commissioned for Phaidon Press books; where such a book is known to contain the item, research is made much easier by quoting title and plate number. The collection covers all aspects of art, under specific headings such as a particular artist, or general headings such as 'Archaeology' or 'Renaissance' Period — cave paintings to present. Number — 2000 colour, 30,000 black and white.
Availability	Research by staff or researcher. Requests by writing, phone or visit. Written authorisation required. Appointment necessary. Hours — Monday to Friday, 9.30 to 5.30.
Procedure	Material copied (black and white) or loaned (colour). Fees: reproduction. Brief subject list with procedure notes available on request. Photostat service.

PICTORIAL COLOUR SLIDES

Modern Colour photographs of historical subjects, museum items etc

Address	242 Langley Way, West Wickham, Kent, England
Phone	(01) 777 8010
Apply to	The Manager.
Material	35 mm colour slides covering a range of historical, archaeological and related subjects, including a wide coverage of items from British provincial museums, views of castles and historic sites etc also illustrated manuscripts. Period — prehistory to present. Number — 2000.

Pictorial Colour Slides (continued)

Availability	Research by staff.
	Requests by writing only.
Procedure	Slides are sold, singly or in sets on subjects such as 'Roman Britain'.
	Fees: reproduction.
	Catalogues available, free of charge.
	Commissions.

ROYAL COLLECTION, BRITISH

The Queen possesses what is probably the finest private art collection in the world, some of which is inaccessible to the public. However, selected items are exhibited from time to time, and others are featured in publications. Application for photographs and permission to reproduce items should be addressed to:

for miniatures, paintings, fine and applied art (including ceramics furniture etc,):
The Comptroller,
Lord Chamberlain's Office,
St James's Palace,
London SW1, England. phone: (01) 930 3007

tor prints and drawings, and items in the Royal Library and Royal Archives:
The Librarian
Windsor Castle,
Windsor, Berkshire, England. phone: (95) 63106

WALES & MONMOUTHSHIRE, ROYAL COMMISSION ON ANCIENT MONUMENTS IN
including:
MONUMENTS RECORD, NATIONAL (Wales & Monmouthshire)

Monuments and buildings in Wales from prehistory to present

Address	Edleston House, Queens Road, Aberystwyth, Cardiganshire SY23 2HP, Wales
Phone	Aberystwyth 4381/2
Apply to	The Secretary (short form of address: RCAM (Wales)).
Credit:	'Crown Copyright' by permission of the controller of HMSO.

Monuments Record, National (Wales & Monmouthshire) (continued)

Material Photographs, prints and engravings, drawings etc, of ancient monuments and buildings in Wales from prehistoric times to present. A special collection of records of ancient structures is available by special arrangement.
Number: 50,000.

Availability Research by researcher.
Written requests must be accompanied by adequate reference to the site (ie: national grid).
Appointment essential.
Initial letter of introduction preferred.
Hours: weekdays, 9.30 to 5.

Procedure Material not loaned, copies made.
Photographic service — advisable to check delay.
Fees: reproduction (modest), waived for educational publications.

Notes Applicants' initial request will be given to a member of the staff who is expert in the particular field involved; it is therefore advantageous to make the application in writing.

WESTMINSTER CITY LIBRARIES (FINE ARTS)

Photographs of fine art items

Address Central Reference Library, St Martin's Street, London WC2H 7HP England

Phone (01) 930 3274

Telex 261845

Material Photographs in colour or black and white of fine arts subjects. Staff are very helpful to serious researchers.
Period — earliest times to present.
Number — thousands.

Availability Research by staff or researcher.
Requests by writing, phone or visit.
Hours — Monday to Saturday, 10 to 8.

Procedure Material not loaned, copies made.
No fees.
Photostat service.

FRANCE

BULLOZ

Photographs of works of art

Address	21 rue Bonaparte, 75006 Paris, France
Phone	326 54 76
Credit	Photographie Bulloz.
Material	Photographs in colour and/or black and white of works of art in museums, galleries and private collections, both in France and elsewhere. The helpful staff will try to satisfy requests for paintings on a given theme, but prefer requests for specific pictures. Number — 260,000.
Availability	Research by staff or researcher. Requests by writing, phone or visit. Written authorisation required in first instance. Hours — normal working hours Tuesday to Saturday.
Procedure	Material loaned or copied. Fees: reproduction. Catalogue of colour material. Commissions undertaken in French collections.

CAISSE NATIONALE DES MONUMENTS HISTORIQUES ET DES SITES (FRANCE)

(Ministry of Cultural Affairs)

Photographs of French historical monuments, museum items, Nadar photographs

Address	Service Photographique, 1 rue de Valois, 75001 Paris, France
Phone	236 95 00
Apply to	Service Photographique.

247

Material	One of the most important archives in France, this comprises three basic collections:
	1. *French historical monuments* — photographs of churches, chateaux, private houses, plans, monuments, mural paintings, stained glass windows, archaeological sites including Lascaux and other grottos, models of towns etc.
	2. *Items from French museums* — Louvre and other Paris museums, French provincial museums, comprising material from prehistory to the present. Paintings, drawings, manuscripts, engravings, sculpture, tapestries etc.
	3. *Nadar portrait photographs* — the unique collection of mid-19th-century portraits by the great photographer, including politicians, scientists, cultural figures etc., to which the collection has exclusive rights.
	Total number of items — 600,000 black and white photographs, colour for limited range of subjects including French churches, tapestries and Lascaux wall-paintings.
Availability	Research by staff.
	Requests preferably by writing, phone or visit only if unavoidable.
	Written authorisation required in first instance.
	Hours — Monday to Friday, 10 to 12, 2 to 5.
Procedure	Material not loaned, copies sold.
	Reproduction fee.
	Normal delay in delivery 1 to 2 weeks: but a 2 to 4 day service is available by extra payment.

CHRETIENNE ET BYZANTINE, COLLECTION

Photographs of Byzantine art and related material

Address	Ecole Pratique des Hautes Etudes, 5e Section, 45 rue des Ecoles, 75005 Paris, France
Phone	633 58 49
Apply to	Mlle Dufrenne.
Material	Byzantine art and occidental comparisons, including manuscripts, wall paintings etc.
	Period — 5th to 16th centuries.
	Number — 20,000 black and white, 5000 colour.
Availability	Research by staff.
	Requests by writing only.
	Written authorisation required in first instance.
	Hours — Wednesday and Friday, 2 to 6.
Procedure	Some material loaned, others copied.
	Fees: according to circumstances.
	Catalogue available for Millet collection of Byzantine art.

FOLIOT, Françoise

Photographs of French art, history and culture

Address	18 rue Brillat-Savarin, 75013 Paris, France
Phone	588 56 16
Material	Photographs of items relating to French culture and history, including architecture, art, literature, music, theatre and historical events. Some examples: literature — Apollinaire, Flaubert, Molière, Pascal, Sand. History — French Revolution, 20th century history, Nazi posters. Number — 5000 colour, 10,000 black and white.
Availability	Research by staff. Requests by writing or visit, preferably not phone. Written authorisation required. Appointment necessary, delay 2 to 3 days. Hours — Monday to Friday, 9 to 6.
Procedure	Material loaned or copied. Fees: reproduction, search, service/handling, holding. Catalogues available. Commissions readily undertaken in French museums and private collections.

GAUD, Georges, EDITIONS

Photographs of architecture and works of art in France

Address	11 rue Brulard, 77125 Moisenay le Petit, France
Phone	438 97 60
Material	Photographs in colour and black and white of architecture, sculpture, paintings, stained glass windows, chateaux and religious buildings in France, with special collection of Provençal archaeology. Number — 25,000
Availability	Research by staff. Requests by writing or visit, not phone. Written authorisation required in first instance. Appointment preferred. Hours — Monday to Saturday, 9 to 7. *Closed August.*
Procedure	Some material loaned, others copied. Fees: reproduction and holding. Brief subject list available on request. Commissions undertaken anywhere in France.

GIRAUDON

Fine and applied arts, architecture and archaeology

Address *9 rue des Beaux-Arts, 75006 Paris, France*

Phone *326 9383*

Material *Enormous and businesslike archive, containing black and white and colour photographs of all aspects of fine and applied arts and other cultural material. International scope.*

Availability *Requests in writing.*
 Cataloguing is by artists or school of artists.

Procedure *Colour transparencies loaned, black and white copied.*
 Fees: reproduction.
 Excellent catalogue of colour transparencies for sale, up-to-date — a high-price item but very detailed.

HERVE, Lucien

Architecture, art, folklore

Address 31 rue Vineuse, 75016 Paris, France

Phone Passy 20 65

Material Photographs, prints and engravings, original paintings and drawings relating to architecture, art and folklore.
 Special collection of Le Corbusier material.
 Period — 2700 BC to present.
 Number — 500,000.

Availability Research by staff.
 Requests by writing, phone or visit.
 Written authorisation required in first instance.
 Appointment necessary.
 Hours — Everyday, 9 to 6.

Procedure Material loaned or copied.
 Fees: reproduction.
 Photostat service.

HUBERT, Etienne

Modern photographs — portraits of artists etc, architecture, African arts etc

Address	21 boulevard Lannes, 75116 Paris, France
Phone	504 13 98
Material	As photographer for *Arts* magazine, M Hubert has built up a big collection of portraits of artists and writers, contemporary art and architecture, and material relating to the arts in French Africa. Period — 1955 to present. Number — 30,000.
Availability	Research by staff. Requests by writing, phone or visit. Written authorisation required. Appointment necessary.
Procedure	Some material loaned, others copied. Fees: reproduction, sometimes search and service.

LE CAISNE, Janet

Modern photographs, art history and archaeology

Address	61 rue de Varenne, 75007 Paris, France
Phone	551 51 24
Apply to	Mme Janet Le Caisne.
Material	Large collection of specialist material relating to art history, especially Romanesque and medieval French; archaeology, including excavations in Iran; and Polish folk art. Period — medieval to present. Number — 25,000.
Availability	Research by staff. Requests by writing, phone or visit. Written authorisation required in first instance. Appointment necessary, few days delay.
Procedure	Material not loaned, copies made. Fees: reproduction, search, service/handling, holding.

MICHAELIDES, Claude

Photographs, chiefly works of art and old scientific subjects

Address	39 boulevard Saint Germain, 75005 Paris, France
Phone	326 15 14
Material	Photographs of paintings and sculptures, drawings, interior decoration, life in South Spain, graffiti, early astronomy, scientific experiments and apparatus (photos of woodcuts). Comprises a good deal of material from the Cabinet des Estampes of the Bibliothèque Nationale. Also old maps. Number — 5000 (the scientific subjects comprise 40% of the collection).
Availability	Research by staff. Requests by writing, phone or visit. Written authorisation required. Appointment necessary, a few days delay. Hours — Monday to Friday, 9 to 12, 2 to 6.
Procedure	Some material loaned, others copied. Fees: reproduction, sometimes others. Photostat service available.

ROUBIER, Jean

Photographs of archaeology

Address	18 rue de Liège, 75009 Paris, France
Phone	874 27 26
Material	Photographs relating to archaeology — architecture, sculpture, sites and monuments. A long-established and important collection. Period — antiquity to present.
Availability	Research by staff or researcher. Requests by writing, phone or visit. Written authorisation required. Appointment necessary — several days delay. Hours — Monday to Friday from 9 am.
Procedure	Some material loaned, others copied. Fees; reproduction and service—
Notes	English and German spoken.

ZODIAQUE

Photographs of works of art, ancient and modern, especially Romanesque

Address Abbaye de la Pierre-qui-Vire, F 89830 St Leger Vauban, France

Phone 8 St Leger Vauban

Material Photographs in colour and black and white of works of art, ancient and modern, specialising in romanesque art taken for art journal.
Number — 33,000 black and white, 1800 colour.

Availability Research by staff.
Requests by writing only.
Written authorisation required in first instance.

Procedure Colour material loaned, others copied.
Fees: reproduction.

REST of EUROPE

ALINARI, Fratelli

Photographs of fine art, chiefly European

Address via Nazionale 6, 50123 Firenze, Italy

Phone 272105 or 262857

Material Reproductions in colour and black and white of paintings, monuments, sculptures etc. Comprises a number of separate collections, each of which is catalogued in topographical order. The Alinari collection is also catalogued alphabetically by artist.
Period — 5th century BC to present.
Number — 200,000.

Availability Research by staff or researcher.
Requests by writing, phone or visit.
Written authorisation required.
Appointment preferred.
Hours — Monday to Friday, 9 to 1, 3 to 7.

Procedure Colour material loaned, black and white copied.
Fees: reproduction, search, handling.
Photostat service.
Catalogues available at prices from L.500 to L.5000 according to subject.

ARCHAEOLOGICAL MUSEUM OF ATHENS, NATIONAL

Photographs of Greek and Byzantine antiquities

Address 1 Tossitsa Street, Athens, Greece

Phone 3220 468

Apply to The Director.

Material Photographs in black and white and colour of Greek antiquities, from prehistoric to classical periods, including sculpture, bronzes, vases etc. Also agents for Byzantine Museum of Athens. The Museum is under the jurisdiction of the Ministry of Culture and Science.
Period — 3000 BC to 16th century AD.

254

Archaeological Museum of Athens, National (Greece) (continued)

Availability	Research by researcher. Requests by writing or personal visit, not by phone. Written authorisation required in first instance. Appointment necessary, delay 15 days. Hours — Tuesday, Thursday, Saturday, 11 to 1.
Procedure	Material not loaned, copies made. Fees: reproduction. Postage charged. Museum guides available in Greek, English, French or German.

ATENEUM, THE ART MUSEUM OF

Finnish art

Address	Kaivokatu 2—4, 00100 Helsinki 10, Finland
Phone	666 693 or 630 412 or 662 459
Material	Original paintings, prints and drawings and photographs of other works of art in the museum's collection. Period — 1300 to present. Number — 14,000 works of art.
Availability	Research by staff. Requests by writing, phone or visit. Appointment necessary. Hours — Monday to Friday, 8.30 to 4.15 in winter, to 3.15 in summer.
Procedure	Some material loaned, others copied. Fees: reproduction. Catalogues of permanent collection and special exhibitions available; write giving details of field in which you are interested.

BLANKOFF, Professor J

Photographs of Russian art and architecture

Address	13 avenue Calypso, 1170 Brussels, Belgium
Phone	730 424
Material	Photographs in colour and black and white of all aspects of Russian art and architecture, including icons, church architecture, Georgian and Armenian art etc. Number — 800 colour, 300 black and white.

Blankoff, Professor J (continued)

Availability	For serious purposes only. Research by staff. Requests by writing, phone or visit. Appointment necessary, delay 5 to 7 days.
Procedure	Some material loaned, others copied. Fees: reproduction.

CYPRUS MUSEUM

Photographs of Cyprus antiquities

Address	Nicosia, Cyprus
Phone	40 2190
Apply to	The Curator.
Material	Photographs of antiquities and archaeology of Cyprus. Period — neolithic to Roman.
Availability	Research by staff or researcher. Requests by writing, phone or visit. Written authorisation required in first instance. Appointment preferred; delay 2 or 3 days. Hours — Monday to Saturday, 8 to 1 and 2.30 to 4.45.
Procedure	Material not loaned, copies made. Fees: reproduction. Museum guide available at £0.40.

CZECHOSLOVAKIA: NARODNI GALERIE v PRAZE (National Gallery, Prague)

Photographs of European and oriental art, especially Czech

Address	Hradcanske namesti 15, 11904 Praha 012, Czechoslovakia
Phone	35 24 41—3
Material	The major source for Czech fine arts. Staff very helpful and prompt to reply or supply. Catalogues should be obtained in the first instance. Graphic art collection. Period — 14th century to present.

Czechoslovakia: Narodni Galerie v Praze (continued)

Availability Research by staff.
Requests by writing only.
Written authorisation required.
Museum hours; daily except Monday, 10 to 6.

Procedure Material not loaned, copies made.
Fees: reproduction, service.
Catalogues available for collection and individual exhibitions.

DENMARK, STATENS MUSEUM FOR KUNST

Danish and Scandinavian and European art, prints and drawings

Address Sølvgade, DK-1307 København K, Denmark

Phone 451 11 21 26

Material Primarily a fine arts collection, but also including prints and drawings of documentary value, chiefly of Danish subjects. Danish art has not received the attention it deserves, and the paintings include many remarkably good scenes of daily life etc of more than local interest.
The prints and drawings collection alone numbers more than 200,000 items.

Availability Research by staff.
Requests by writing, phone or visit (but see Notes below).
Written authorisation required in first instance.
Appointment preferred.
Hours — museum, daily except Monday, 10 to 5. Library closed Saturday and Sunday.

Procedure Material not loaned, copies made.
Fees by arrangement.

Notes The Museum is understaffed, and cannot undertake complex research. Researchers unable to pay a personal visit should therefore make their requests as specific and straightforward as possible.

DEUTSCHES ARCHÄOLOGISCHES INSTITUT (ITALY)

Photographs of classical archaeology

Address	00187 Roma, via Sardegna 79, Italy
Phone	465617
Material	Photographs of sites and artifacts relating to classical archaeology, from prehistory to late antiquity. Number — 90,000.
Availability	Research by staff or researcher. Requests by writing or visit, not phone. Hours — Monday to Saturday, 9 to 1.
Procedure	Material not loaned, copies made. Fees: reproduction. Photostat service. Commissions.

GAD BOREL-BOISSONAS

Photographs of art and architecture, particularly Egypt and Greece

Address	3 rue St Leger, 1205 Geneva, Switzerland
Phone	022 24 06 69
Material	Photographs of art and architecture, particularly of Egypt and Greece, taken between 1860 and present. Number — 100,000 black and white.
Availability	Research by staff. Requests by writing, phone or visit. Appointment preferred. Hours — Monday to Friday, 9 to 12, 2.30 to 6.30.
Procedure	Some material loaned, others copied. Fees: reproduction, search.

HANSMANN, Claus & Liselotte

Photographs of cultural items, folklore, crafts

Address	D—8 München 40, Georgenstrasse 46, West Germany
Phone	(089) 39 19 92
Material	Photographs in colour and black and white of a wide range of cultural material — architecture and archaeology from all countries, all kinds of objects from Greek vases to astrolabes, from Japanese erotic art to fossils all beautifully listed in a splendidly efficient archive-list. International coverage. Also many photographs of graphic subjects, manuscripts etc. In short, an expert and valuable source for material on the perimeter of the fine arts. Period — prehistory to present. Number — some thousands.
Availability	Research by staff. Requests by writing, phone or visit. Written authorisation required in first instance. Appointment preferred, some days delay. Hours — Monday to Saturday, 9am to 10pm. Answering service when out on assignment.
Procedure	Material loaned or copied. Fees: reproduction. Catalogue available on request.

HINZ, Hans, Colorphoto

Photographs of works of art

Address	3 Augustinergasse, CH—4051 Basle, Switzerland
Phone	25 82 98
Apply to	Mrs Lisbeth Herzog.
Material	High quality photographs, chiefly in colour, of works of art from throughout the world, ranging from Lascaux to India, from Goya frescoes to Chinese porcelain.
Availability	Research by staff. Requests by writing, phone or visit. Written authorisation required in first instance. Appointment preferred, some days delay. Hours — Monday to Friday, 8 to 6.

Hinz, Colorphoto Hans (continued)

Procedure	Material loaned or copied. Fees: reproduction. Comprehensive catalogue available on request to serious enquirers only.

HIRMER FOTOARCHIV

Photographs of works of art, archaeology, art history

Address	D—8000 München 19, Marees-strasse 15, West Germany
Phone	(0811) 171713 and 171980
Apply to	Ms Katrin Weiske.
Material	Photographs in black and white and colour of art works, archaeological sites and related subjects. Wide range of material from 5th century BC to 17th century.
Availability	Research by staff. Requests by writing, phone or visit. Written authorisation required in first instance. Appointment preferred, delay 3 days. Hours — Monday to Friday, 8 to 5.
Procedure	Material loaned or copied. Fees: reproduction, handling, holding after 90 days. Catalogues available on request: state field of interest.

MARBURG, BILDARCHIV FOTO

Photographs, art, archaeology, etc

Address	355 Marburg/Lahn, Ernst-von-Hulsen Haus, West Germany
Phone	(06421) 23770 or 282198
Material	Photographs of works of art, archaeology, architecture, sculpture, metalwork, illuminated manuscripts, and items relating to art history. Period — 3000 BC to 1960 AD. Number — 300,000.
Availability	Research by staff or researcher. Requests by writing, phone or visit. Appointment preferred. Hours — Monday to Friday, 9 to 1, 3 to 4.30; Saturday by special arrangement.

Marburg, Bildarchiv Foto (continued)

Procedure Material loaned or copied.
 Fees: reproduction, search, holding.
 Photostat service.

MAS, AMPLIACIONES Y REPRODUCCIONES

Photographs of Spanish art

Address Freneria 5—3ero, Barcelona 2, Spain

Phone 222 11 56

Apply to Montserrat Blanch.

Material Photographs of Spanish fine arts.
 Good quality, efficient service, large stock.
 Number — 500,000.

Availability Research by staff.
 Requests by writing, phone or visit.
 Written authorisation required in first instance.
 Appointment necessary, delay 8 days.
 Hours — Monday to Saturday, 9 to 1. Closed all August.

Procedure Some material loaned, others copied.
 Fees: reproduction, search, service/handling, holding.
 Photostat service.

OSLO: KUNSTINDUSTRIMUSEET

Norwegian applied arts

Address St Olavsgate 1, Oslo 1, Norway

Phone 20 35 78

Apply to Curator, Inger-Marie Lie.

Material Photographs of works of applied art contained in the museum's collection —
 porcelain, glass, silver, furniture, tapestries etc.
 Period — antiquity to present.
 Number — 20,000.

Oslo: Kunstindustrimuseet (continued)

Availability Research by staff.
 Requests by writing, phone or visit.
 Appointment preferred — delay 14 days.
 Hours — Monday to Friday, 9 to 3.

Procedure Some material loaned, others copied.
 Fees: reproduction.
 Photostat service.

PUCCIARELLI, Mauro

General photographic coverage of cultural subjects, museum items etc

Address via Conca d'Oro 300, 00141 Roma, Italy

Phone 812 3020 or 810 2411

Material General photographic coverage of a wide range of cultural and other material,
 including art, history, religion, music, naval and military, historical costume,
 architecture, geography, science and medicine. High quality, excellent indexing and
 cataloguing with efficient cross-references for subjects as well as artists. Signor
 Pucciarelli is always travelling and adding to his material which contains items from
 museums throughout the world.

Availability Research by staff.
 Requests by writing, visit only if essential.
 Written authorisation required in first instance.
 Appointment preferred, delay 10 days.
 Hours — Monday to Friday, 9 to 1 and 4 to 7.

Procedure Material loaned or copied.
 Fees: reproduction, others according to circumstances.
 Catalogue available.
 Photostat service.
 Commissions.

SCALA

Photographs of works of art, art history and history

Address	50011 Antella, Firenze, Italy
Phone	(55) 641541
Cables	Scalafoto Antella
Apply to	Brigitte Baumbusch or Marilar Hoffer.
Material	'They must be the best European art source in the world' is a typical verdict on this excellent, efficient and extremely helpful collection of colour transparencies on all aspects of art and art history. The quality is high, and the staff are ready to accept requests related to subject-matter as well as for specific painters or items. Period — prehistory to present. Number — 50,000.
Availability	Research by staff. Requests by writing, phone or visit. Written authorisation required in first instance. Appointment necessary, delay 3 to 6 days. Hours — Monday to Friday, 10 to 5.
Procedure	Material loaned or copied. Fees: reproduction. Photostat service. Commissions.

SCHWITTER, F N, LIBRARY INTERNATIONAL

General modern photographs, emphasis on cultural material

Address	Juchaker, 8966 Lieli, Aargau, Switzerland
Phone	057 52555
Telex	45383 switr ch (specify; for library)
Apply to	Norma Schwitter.
Material	The photographic work of Norma Schwitter, ranging over a very wide variety of material, specialising in museum items such as modern art and Chinese porcelain, geographical material from several different countries, animals and vegetables — there is a special collection on dahlias; also old engravings ... in fact, her catalogue is essential! Number — over 70,000.

263

F N Schwitter Library International (continued)

Availability Research by staff or researcher.
Requests by writing, phone or visit.
Appointment essential, some delay if Norma Schwitter is in the field.
Hours — phone any time.

Procedure Some material loaned, others copied.
Fees: reproduction, service/handling, holding after 42 days.
Short picture list available free of charge (in English or German).
Commissions.

Notes Though this source is essentially a one-woman affair, the scope is wide and the material well organised, bearing comparison with many more elaborate collections.

UNIVERSITETETS SAMLING AV NORDISKE OLDSAKER (NORWAY)
(University Museum of Norwegian national antiquities)

Nordic archaeology

Address Fredriksgate 2, Oslo 1, Norway

Phone 33 00 70

Material Photographs, prints and engravings, original paintings and drawings relating to Nordic archaeology, from stone age to medieval, and including Viking ships.
Number — 60,000.

Availability Research by staff.
Requests by writing, phone or visit.
Written authorisation required in first instance.
Appointment necessary.
Hours — Monday to Friday, 8.15 to 3.45.

Procedure Material not loaned, copies made.
Fees: reproduction.
Photostat service.
Catalogue available.

VAERING, O

Photographs of works of art, especially Norwegian

Address	Karl Johansgate 2V Oslo, Norway
Phone	Oslo 411922
Material	Photographs of works of art, paintings and sculpture. Emphasis on Norwegian painters and especially Edward Munch.
Availability	Research by staff. Requests by writing, phone or visit. Appointment preferred. Hours — Monday to Friday, 9 to 5, Saturday, 9 to 1.30.
Procedure	Material loaned or copied. Fees: reproduction, holding.

YUGOSLAVIA: NARODNA GALERIJA
(National Gallery of Yugoslavia)

Yugoslavian art, ancient and modern

Address	YU—61001 Ljubljana, Prezihova 1, PP 432, Yugoslavia
Phone	21 249, 21 570, 21 765
Material	Yugoslavian and some general European art, ancient and modern. Particularly important are the collections of Slovenian art from the Middle Ages, and copies of wall-paintings from the medieval period. Period — 13th to 20th centuries. Number — 4467 works of art.
Availability	Research by staff or researcher. Requests by writing, phone or visit. Written authorisation required in first instance. Appointment preferred. Hours — Monday to Friday, 8 to 2. (Extra fee for work after 2.)
Procedure	Some material loaned, others copied. No fees for scientific or educational users. Catalogues of exhibitions available, covering most aspects of the Gallery's collections. A list of these catalogues will be sent on request.

BEYOND EUROPE

BARODA MUSEUM AND PICTURE GALLERY

Indian miniatures and some European oil paintings

Address	Sayaji Park, Baroda 390005, Gujarat State, India
Phone	64805
Apply to	Director of the Museums.
Material	Photographs, prints, engravings, original prints and drawings, graphics etc., from the 15th to the 20th Century. Special collection of Indian Miniature paintings.
Availability	Research by staff or researcher. Application by writing, phone or visit. Letter of authorisation required. Appointment required. Hours — 11 to 5 weekdays, some Saturdays.
Procedure	Material loaned. Photographic service. Fees: no reproduction fee.

LUCAS, Phyllis, GALLERY & OLD PRINT CENTER

Old prints and modern graphics

Address	981 Second Avenue/52nd Street, New York City, USA
Phone	Plaza 5 1516, Plaza 3 1441
Apply to	Mrs Lucas.
Material	Old prints and modern signed graphics. They claim to have the largest collection in the world. There is a special Dali collection.
Availability	Research by researcher. Requests by writing, phone or visit. Written authorisation required in first instance. Appointment necessary. Hours — Tuesday to Saturday, 9.30 to 6 except July and August, when days are Monday to Friday.

Procedure Material loaned.
 Fees: reproduction and service.
 Catalogue of Dali collection.

MAYER, Francis G, ART COLOR SLIDES

Modern photographs, art and architecture

Address 235 East 50 Street, New York, NY 10022, USA

Phone Plaza 3 0053

Apply to Peter H Mayer, President.

Material Big collection of high quality transparencies of works of art including art treasures, sculpture, applied art, tapestries, arms and armour, jewelry and architecture.
 Period — antiquity to present.
 Number — 16,000.

Availability Research by staff or researcher.
 Requests by writing, phone or visit.
 Written authorisation required in first instance.
 Appointment necessary.
 Hours — Monday to Friday, 9 to 5.

Procedure Some material loaned, others copied.
 Feess: reproduction, service/handling, search and holding.
 Photostat service.
 Catalogue available at $3.50 + postage.
 Commissions. The Mayers work for major museums and galleries in the USA and throughout the world.

NEW ZEALAND NATIONAL ART GALLERY

Art, especially New Zealand

Address	Private bag, Buckle Street, Wellington, New Zealand
Phone	59 703
Apply to	Director or Curator.
Material	The Gallery comprises a number of collections of paintings, drawings, prints and engravings. While the collection is primarily aesthetic in character, naturally much of the material has illustrative and documentary value, particularly in the area of New Zealand prints and drawings, notably the work of Chevalier, Richmond and Swainson of which a separate catalogue is available. Period (prints and drawings) 1400 to present. Number — 8000.
Availability	Research by staff, but researchers may view material. Requests by writing, phone or visit. Written authorisation required. Appointment necessary, delay 5 days. Hours — Monday to Friday, 10.30 to 5.
Procedure	Material not loaned, but arrangements made to copy. Fees: reproduction fee. Catalogues of various collections available. Photostat service can be arranged.
Notes	There are strict rules concerning reproduction, all of which are set out on the 'Reproduction Application Form' which must be completed for each individual item.

RADOVAN, Zev

Modern photographs, Israeli views, archaeology and museum items

Address	31 Tchernichowski Street, Jerusalem, Israel
Phone	(02) 62100
Material	Photographic collection covering archaeology, historical sites holy places, coins and other museum exhibits from Israeli museums. Period — 1960 to present.

268

Radovan, Zev

Availability	Research by staff or researcher. Requests by writing, phone or visit. Written authorisation required in first instance. Hours — daily.
Procedure	Material loaned or copied. Fees: reproduction. Commissions.

SANDAK inc

Photographs of works of art in US collections, religious buildings in Europe

Address	180 Harvard Avenue, Stamford, Connecticut 06902, USA
Material	Photographs of works of art from most major United States collections. Also monasteries and cathedrals in France, new churches of Europe. Number — 15,000.
Availability	Research by staff or researcher. Requests by writing, phone or visit. Written authorisation required in first instance. Appointment preferred. Hours — Monday to Friday, 9 to 5.
Procedure	Material not loaned, copies made. Fees: reproduction, handling. Catalogue available.

TUNISIA, MUSEE NATIONAL DU BARDO

Photographs of Tunisian antiquities

Address	Le Bardo, Tunisia
Phone	261 002
Apply to	M. Ali Mlimet.
Material	Photographs of Tunisian antiquities — mosaics, Roman glass, Greek sculpture, Roman bronzes etc. Agents for other national museums.

Availability Research by staff.
Requests by writing, phone or visit.
Written authorisation required in first instance.
Appointment necessary, delay 7 days.
Hours: daily except Monday, 8.30 to 12.30, 2.30 to 6.

Procedure Some material loaned, others copied.
Fees: reproduction.
Guide to museum available.

There are so many sources of modern photographs in the natural history field that we have had to adopt a tabular format, providing only basic information about the source — its address, specialist fields, and other essential information. The need for fuller description is made less crucial by the fact that the work of a great many natural history photographers is handled by agents. We have indicated such agencies whenever the information has been supplied to us, and the agents themselves are also listed. If you live in the same country as the agent, you should always approach him, not the photographer, as this will save time and probably money too. Indeed, unless your needs are really specialised, you will nearly always find it more convenient to approach the larger agencies in the first place.

Most general sources, historical or modern, possess a natural history section, which may well be adequate for most needs. Almost every geographical source listed in our section will contain a certain amount of natural history material (those with substantial amounts are indicated in our subject index). Other useful sources are zoological societies, chemical companies, seedsmen and nurserymen, and university departments.

We know of no historical collection specialising in natural history, rather to our surprise: so for this category of material a general historical source is your only choice — or, for certain types of material, an art source.

For convenience' sake we have divided the natural history material into a few broad categories, which must be understood as being very broad in application:

ANIMALS
BIRDS
REPTILES
INSECTS
MARINE (includes all water and shore life)
PLANTS (includes horticulture, arboriculture,
 specialist agriculture, but not farming as such)
ENVIRONMENT (includes pollution, ecology, conservation)

AFRICA

BROWN, Leslie H. Box 24916, Karen, Kenya Phone Karen 2228	Animals Birds Environment	
JOHNSON, Peter. PO Box 460, P,O. Bergvlei, Transvaal, South Africa Phone Johannesburg 805 2389	General	Wide coverage of most of Southern Hemisphere. No insects. British agent: L H Newman.
KARMALI, John. PO Box 42202, Nairobi, Kenya Phone Nairobi 68528	Animals Birds	British agent: Frank Lane.
ROUT, Alan.	General	British agent: Bruce Coleman.
VIRDEE, R S. PO Box 10808, Nairobi, Kenya Phone Nairobi 25876	General	British agent: Frank Lane.

AMERICA, NORTH

ALLEN, David G. Bird Photographs Inc. 254 Sapsucker Woods Road Ithaca, NY 14850, USA Phone (607) 257 1263	General, mostly birds	Dating from 1910 to present. Covers North and Central America.
ALTMANN, Dr Stuart. Professor of Biology and Anatomy University of Chicago, Illinois 60637, USA	Animals	Speciality: baboons, other primates and animal behaviour. Also East African animals.
ANIMALS, ANIMALS ENTERPRISES. 161 East 82nd Street, New York NY 10028, USA Phone (212) 288 4034	General	
AUDUBON SOCIETY, NATIONAL. 950 Third Avenue, New York, NY 10022, USA Phone (212) 832 3200	General	Big comprehensive collection
BADING, Peter W. Box 6222, Annex, Anchorage, Alaska, 99602, USA	General	Alaskan wildlife generally.

America, North (continued)

BARTLETT, Jen and Des.	General	British agent: Bruce Coleman Wildlife of Africa, America and Arctic.
BROKAW, Dennis. 2052 Galveston Street, San Diego, California 92110, USA Phone (714) 276 0841	General	Western states, mountains, marine scenery.
BUCHSBAUM, Ralph. 4304 Parkman Avenue, Pittsburg Pennsylvania 15213, USA	Invertebrates Animals Birds Marine	Invertebrate animals, ecology, some fish, amphibians, reptiles, birds and mammals.
COLEMAN, Bruce. 107 East 38th Street, New York, NY 10016, USA Phone (212) 683 5227/8	General	US branch of Coleman (UK).
DAVIDSON, W T. 422 West 3rd Avenue, Warren, Pennsylvania 16365, USA	Reptiles Marine Insects	British agent: Frank Lane.
FEININGER, Andreas. 365 West 20th Street, New York, NY 10011, USA	Plants	Trees.
NATURE CLOSE-UPS. H Vannoy Davis and Edward S Ross. 1 California Street, Room 700 San Francisco, California 9411, USA	General	International coverage, emphasis on tropical and sub-tropical regions. Special collection of small animals and insects. Also ecology and ethnography.
OTT, Charlie.	General	Alaskan wildlife. British agent: Bruce Coleman.
PETERSON, Roger Tory.	General	Wildlife British agent: Bruce Coleman.
ROCHE, John P. Box 7, Southwest Harbour Me 04679 USA	Plants	Horticulture, fruit, etc.
RUE III, Leonard Lee	General	Wildlife of North America. British agent: Bruce Coleman.
SCHALLER, George.	General	Leading zoologist and behaviourist. British agent: Bruce Coleman.

America, North (continued)

WEST, Larry. 24 West Barnes Road, Mason, Michigan 48854, USA Phone (517) 676 1890	Insects Plants	Butterflies, autumn close-ups British agent: Frank Lane.
WORMER, Joseph van	General	Wildlife of North America. British agent: Bruce Coleman.

AMERICA, SOUTH

ERIZE, Francesco	General	Wildlife, South America, Antarctica, Galapagos, Africa. British agent: Bruce Coleman

AUSTRALIA & NEW ZEALAND

MOON, G J H. PO Box 30, Warkworth, North Auckland, New Zealand Phone Warkworth 8463	General	New Zealand natural history, all aspects but especially birds. British agent: Frank Lane.
PIZZEY, Graham.	General	Natural history of Australia. British agent: Bruce Coleman.
SOPER, Dr M F.	General	New Zealand wildlife. British agent: Bruce Coleman.

BRITAIN

ALPINE GARDEN SOCIETY (Roy Elliott) 15 West Drive, Handsworth, Birmingham B20 3ST, England Phone (021) 554 0299	Plants	Alpine and rock plants.
ANGLING PHOTO SERVICE 53 Cromwell Road, Hounslow, Middlesex, England Phone (01) 570 2811	Marine	Some general.

274

Britain (continued)

ARDEA PHOTOGRAPHICS 35 Brodrick Road, Wandsworth Common, London SW17, England Phone (01) 672 2067	General	Some historical material, prints and engravings.
A-Z BOTANICAL 54 The Grove, Ealing, London W5 5LG, England Phone (01) 567 2796	Plants	All aspects of botany, trees, gardening etc.
BEAUFOY, S 98 Tuddenham Road, Ipswich, IP4 2SZ, England Phone (0473) 52340	Insects	
BECKETT, Kenneth A. Hortulus, 10 Arundel Gardens, London W11 2LA, England Phone (01) 229 9202	Plants	Worldwide coverage, especially trees and shrubs.
BIOFOTOS Sunset Cottage, Clovelly Road, Hindhead, Surrey, England Phone (042 873) 5414	General	Specialising in marine and water life, photomicrophotographs.
BIRDS, ROYAL SOCIETY FOR THE PROTECTION OF The Lodge, Sandy, Bedfordshire, England Phone (0767) 80551	Birds Environment	Emphasis on birds in relation to environment.
BISSEROT, Sdeuard C. 40 Nugent Road, Bournemouth BH6 4ET, England Phone (0202) 45028	General	All aspects of British natural history, environment, etc
BRACEGIRDLE, Brian. 157 Shooters Hill, London SE 18, England Phone (01) 856 1968	General	Photomicrography and macrophotography, biological or botanical.
BURTON, Jane.	Animals Marine	Malaysia, East Africa, West Indies and Europe. Also animal behaviour. Agent: Bruce Coleman.
COLEMAN, Bruce. 70 Vine Lane, Uxbridge, Middlesex, UB10 0BB, England Phone (89) 32333 or 933989	General	All aspects of natural history. Agent for many photographers throughout the world, office in New York.

Britain (continued)

CORBIN, R J. 107 Kenilworth Avenue, Wimbledon Park, London SW19 7LP England	Plants	Horticulture. Includes landscapes, gardens, job sequences.
DAVID, Peter M. National Institute of Oceanography, Wormley, Godalming, Surrey, England	Marine	Marine biology.
EASTMAN, Ron and Rosemary. Town Mill, Whitchurch, Hampshire, England (025 682) 2336	Birds	Speciality: kingfisher.
FINNIS, Valerie Boughton House, Kettering, Northants., England Phone (0536) 82279	Plants	Horticulture, many aspects.
FISHER, Douglas White Horse House, Mistley, Manningtree, Essex, England	General	Very wide range, from many different parts of the world.
FOORD, Christine and Ron. 155b City Way, Rochester, Kent ME1 2BE, England Phone (0634) 47348	Insects Plants	Wild flowers and insects.
FURNER, Brian. 38 Northend Road, Erith, Kent DA8 3QE, England Phone (38) 30053	Insects Plants	Mainly horticulture, all aspects, fruit, vegetables, etc. also bee-keeping.
GREEN, G H. Windy Ridge, Little Comberton, Pershore, Worcestershire, England Phone (038 674) 377	Birds	
HILL, Mrs Peter 38 Ellington Street, London N7 8PL, England Phone (01) 607 6503	General	Marine biology 1930-1969 East African animals, birds, reptiles and insects. Australia.
HORTICULTURE PHOTO SUPPLY SERVICE, Arkley Manor, Arkley, near Barnet, Hertfordshire, England Phone (01) 449 3031	Plants	All types of gardening, particularly organic.

276

Britain (continued)

HOSKING, Eric 20 Crouch Hall Road London N8 8HX, England Phone (01) 340 7703	General	Very large collection, chiefly European birds and mammals, but including material from all over the world. Well indexed.
HUNT, Peter Holly Tree Cottage, Elham, Canterbury, Kent, England Phone (0303 84) 280	Plants	Horticulture, emphasis on gardens in Britain and abroad, also some wild flowers.
HYDE, George E. 20 Warnington Drive, Bessacarr, Doncaster, Yorkshire DN4 6SS, England Phone (030 276) 8444	Insects Plants	Life histories of moths and butterflies, also general natural history and countryside.
JOHNS, Leslie, Associates Woodleigh House, Coaley, Dursley, Gloucestershire, England Phone (0453 86) 328	Plants	Horticulture, floristry, flower arrangement.
KAYE, Reginald. Waithman Nurseries, Silverdale, Carnforth LA5 0TY, Lancashire, England Phone (052 470) 252	Plants	Rockplants, ferns, lichens, shrubs.
LACEY, Harry 9 Quadrangle, Chippenham, Wiltshire, England Phone (0249) 3232	Birds	Birds commonly kept in captivity, not wild.
LANE, Frank W. Drummoyne, Southill Lane, Pinner, Middlesex HA5 2EQ, England Phone (01) 866 2336	General	Agent for photographers from all over the world, mainly zoological.
MARKHAM, John (late)	General	Wildlife of Britain. Agent: Bruce Coleman.
MORRIS, P. 22 Wolsey Road, Esher, Surrey KT10 8NX, England Phone (78) 65272	General	Very wide coverage, worldwide wildlife, ecology, environment, domestic animals, general scenery colour only.
NATURAL HISTORY PHOTOGRAPHIC AGENCY, The Studios, Betsoms Westerham, Kent, England Phone (51) 62193	General	Very large collection covering all aspects of natural history, worldwide coverage, many specialist collections.

NATURAL SCIENCE PHOTOS 82 Weirdale Avenue Whetstone, London N20, England Phone (01) 361 0227	General	All aspects, comprehensive coverage Prehistoric animals. Agents for Marineland of Florida.
NIMMO, Maurice Pen-y-cefn, Hayscastle Cross, Haverfordwest, Pembrokeshire, Wales Phone Letterton 382	Plants Environment	Trees and shrubs, scenery, weather effects, garden and wild flowers.
OXFORD SCIENTIFIC FILMS	General	Microphotography Agent: Bruce Coleman.
PERRY, Roger Bulls Cross Cottage, Enfield, Middlesex, EN2 9HE England Phone (97) 24346	General	South American and Galapagos Is.
PROCTER, Ray Bordley, 73 Boundstone Road, Rowledge, Farnham, Surrey, England Phone (025 125) 2023	Plants	Horticulture, garden views, plants, fruit.
RODWAY, Gerald East Lodge, Botanic Gardens, Glasgow G12 0UE, Scotland Phone (041) 334 7916	Plants	British flora, speciality orchids.
ROUCH, W W. The Green, Shalbourne, Marlborough, Wiltshire, England Phone (067 27) 593	Horses	1890 to present. Most famous racehorses, other horses of all kinds.
SMITH, Donald Willow Grange, Stanfield, Dereham, Norfolk, England Phone (032 876) 260	Plants	Horticulture, particularly fruit; also nature studies.
SMITH, Harry 9 Merilies Close, Westcliff- on-sea, Essex, England Phone (0702) 40553	Plants	Large collection covering all aspects of gardening, very professional.
THOMPSON, Sally Anne. Animal Photography Ltd., 4 Marylebone Mews, New Cavendish Street, London W1M 7LF, England Phone (01) 935 0503/4 or 9570	Animals Reptiles	Animals, domestic and some wild. Zoos. Galapagos.

Britain (continued)

URRY, Dr David and Katie General Special collection of
Birds in Flight.
Agent: Bruce Coleman.

WILSON, Dr Douglas P. Marine Marine biology,
49 Torland Road, Plymouth photomicrographs
PL3 5TT, England 1920 to 1973
Phone (0752) 771454 Highest scientific standards.

FRANCE

JACANA General Enormous and very professional
30 rue Saint Marc, 75002 Paris collection — 600,000 transparencies
Phone 742 28 99 covering every aspect of natural
or 265 92 41 history. Latin name required when
requesting.

PITCH General Good collection covering most
34 rue St Dominique, 75007 Paris fields, good service.

SIRE Plants Fine botanical collection.
10 rue Raymond Poincare,
92380 Garches

SIX, Jacques General Wide range of colour
36 rue d'Hauteville, material on all aspects
75010 Paris of natural history, also
Phone 246 66 05 mineralogy. List available.
Latin and French indexes.

GERMANY

OKAPIA, Tierbilder Animals German native animals and birds.
6 Frankfurt/main 60 Birds
Roderbergweg 168, West Germany
Phone 448922

PLAGE, Goetz D. General Wildlife of East and
South West Africa,
Himalayas and Ethiopia.
British Agent: Bruce Coleman.

REINHARD, Hans. General Wildlife, especially Germany
British agent: Bruce Coleman.

Germany (continued)

SCHREMPP, Heinz. 7801 Oberrimsingen, Jugendwerk, West Germany Phone 07664 8319	General	Animals, birds, plants, fungus. British agent: Frank Lane.
SIEDEL, Fritz. Natur-Foto, 2945 Sande u. — Wilhelmshaven, Posener Strasse 13, West Germany Phone Sande 623	General	Micro- and macrophotography. General wildlife, fishing, hunting, landscapes, trees and plants.
TODT, Dr D. Albert Ludwig Universität Zoological Institut, 78 Freiburg/Br Katherinenstrasse 20, West Germany	General	Animals, plants, special landscapes, men in nature, and animal behaviour.

SCANDINAVIA

CHRISTIANSEN, Arthur. Torbistvej 15, København- Rodovre, Denmark Phone (01) 94 62 13	General	Particularly strong on birds, but also most other aspects of natural history including zoos. British agent: Frank Lane.
GILLSEATER, Sven. Sweden Phone (08) 320227 or 275410	General	Worldwide natural history, esp. Sweden, Arctic, Galapagos, South America. Swedish agent: Tio-Foto, Stockholm. British agent: Bruce Coleman.
HOLMASEN, Ingmar. Bjurudden, S-640 32 Malmkoping, Sweden Phone (0157) 440 32	General	Mostly from Europe, but also East Africa. Animals and plants from microscopic upwards, including landscapes and environment.
JURKA, Janos. Storangsvagen 5, 77100 Ludvika, Sweden Phone (0270) 39087	Animals Birds	Especially elk, reindeer, north European birds.
NATURFOTOGRAFERNAS BILDBYRA S-740 63 Osterbybruk, Sweden Phone (0295) 21100	General	Very big collection covering all aspects of nature and environment in Europe, Greenland, Alaska, Africa, 1920 to present.

NORSTROM, Lennart. Hasselkilleg 110, 461 00 Trollhattan, Sweden Phone (0520) 318 17 or 36871	Birds Insects Plants Environment	Birds are the chief feature of the collection, but also ecology. Europe and Africa.
NYSTRAND, Georg. Fugelsta 2194, 830 20 Brunflo, Sweden Phone (063) 36049	Birds Plants	British agent: Frank Lane.
SCHMITZ, Arne. Sanekullavagen 34, 217 74 Malmo, Sweden Phone (040) 61885	General	Especially birds and their behaviour, environment management, pollution.

SPAIN

FERNANDEZ, Juan	General	Wildlife of Spain. British agent: Bruce Coleman.

ADDENDA

AMERICA, NORTH

SEA LIBRARY, the. 8430 Santa Monica Boulevard, Los Angeles, California 90069, USA Phone (213) 656. 6115	Marine	Underwater and topside Brochure available on request.

There are very few speclalist sources in the scientific and technological field, but the subject is fairly well covered by general sources, especially on the historical side.

Many manufacturing companies have a photo library relating to their own industry, especially long-established firms. Write to the Press Officer for details. Such material is often supplied free of charge, so long as it is used to arouse interest in the subject or to reflect credit on the company; but of course full acknowledgement must be made.

BRIERLEY, Paul

Modern photographs of science and technology

Address	250 Felmongers, Harlow, Essex, England
Phone	0279 25169
Material	Modern photographs of highly specialised scientific and technological subjects, from lasers to marine biology. Wide scope, high quality.
Availability	Requests by writing or phone in first instance. Subject list available.

CORNING MUSEUM OF GLASS

History and technology of glass-making

Address	Corning Glass Center, Corning, New York 14830, USA
Phone	962 0142
Apply to	Assistant for Slides and Photographs, Mrs Carol Hull.
Material	Photographs in colour and black and white, prints and engravings, original paintings and drawings relating to the history of glass and glass-making. There is a special collection of the drawings of Frederick Carter and Maurice Marmot. Period — 1500 BC to present. Number — 10,000.
Availability	Research by staff or researcher. Requests by writing, phone or visit. Appointment preferred. Hours — Monday to Friday, 9.30 to 5.
Procedure	Some material loaned, others copied. Fees: reproduction and handling.

DRAKE WELL MEMORIAL PARK & MUSEUM

Photographs of oil industry, past and present

Address	R.D.3, Titusville, Pennsylvania 16354, USA
Phone	(814) 827 2797
Material	Photographs relating to oil discovery and allied topics. Includes John A Mather and other early photographic collections. Period — 1850s to present. Number — 4000.
Availability	Research by staff or researcher. Requests preferably in writing; visits by appointment. Hours — Monday to Friday 8.30 to 5.
Procedure	Material not loaned, copies made. Fees: reproduction and handling.

283

EVERWYN, Gerhard

General modern photographs, particularly economic and industrial, of South Africa and Germany

Address	Skuilte, Rossiter Street, Gardens, Cape Town, South Africa
Phone	3 1152
Material	Modern photographs, specialising in engineering, construction, industrial and economic aspects of life in Southern Africa countries (Cape to Congo) and similar material from Germany. Also some general scenic photographs. Period — 1960 to present. Number — 6000.
Availability	Research by staff or researcher. Requests preferably by writing; no phone requests; personal visits by appointment only. Hours — all.
Procedure	Material loaned or copied. Contact prints and captions sent on approval. Fees: reproduction. Photostat service. Commissions.

FORD, Henry, MUSEUM and GREENFIELD VILLAGE

American history, especially technology

Address	Dearborn, Michigan, 48121, USA
Phone	(313) 271 1620
Apply to	Robert G Wheeler, Vice-President.
Material	Their own description is: 'The Henry Ford Museum is a general museum of American history, including decorative arts, home arts, and mechanical arts; the Street of early American shops; the Ford Archives, an incomparable research facility covering the first half of the 20th century, containing photographs, documents and related memorabilia; and the Tannahill Research Library covering the 17th, 18th, 19th and 20th centuries. At Greenfield Village over 100 American buildings of the past three centuries exhibit, in 3-dimensional fashion, many examples of American and European craftsmanship. Traditional American craft processes are also demonstrated at the Village.'

Ford, Henry, Museum and Greenfield Village (continued)

Availability Research by staff or researcher.
Requests by writing, phone or visit.
Written authorisation required.
Appointment preferred.
Hours — Monday to Friday, 8.30 to 5.

Procedure Material copied.
Fees: reproduction, service, holding after 3 months.
Catalogues; many special publications are available, write for brochure 'List of Publications'.

KITROSSER, I

Modern photographs of scientific subjects; also French politics and theatre

Address 7 square Desaix, 75015 Paris, France

Phone SUF 30 02

Material M Kitrosser's photographic collection falls into two distinct categories. The more recent and important collection is of scientific subjects — biology, electronics etc., for which he has a specially equipped laboratory. Also included are scientific subjects from the Louvre.
Dating from the period 1930 to 1955 is a collection of photos of political and theatrical subjects.
Number — 10,000

Availability Research by staff.
Requests by writing, phone or visit.
Appointment necessary, delay 3 days.
Hours — Monday to Friday, 9 to 7.

Procedure Some material loaned, others copied.
Fees: Reproduction.
Commissions.

PLATRE, SYNDICAT NATIONAL DES INDUSTRIES DU

Modern photographs, French gypsum industry and related subjects

Address	3 rue Alfred Roll, 75849 Paris, France
Phone	754 77 64 or 754 28 16
Material	Modern photographs in colour and black and white of subjects relating to the gypsum and plaster industry in France — quarries, factories, building sites, applications etc. Period — 1962 to present. Number — 2500
Availability	Research by staff. Requests by writing or visit, not phone. Appointment necessary, delay 7 days. Hours — Monday to Friday, 8.30 to 5.30.
Procedure	Some material loaned, others copied. No fees.

RONAN PICTURE LIBRARY

History of science and technology

Address	39 New Road, Barton, Cambridge, CB3 7AY, England
Phone	(022) 026 3135
Material	Photographs, prints and engravings, medals etc covering the history of science and technology, including personalities; also social science from the industrial revolution to 1900. Period — circa 1500 to 1900 Number — 80,000.
Availability	Research by staff. Requests by writing, phone or visit. Appointment necessary. Hours — Monday to Friday, 9 to 5.30, or by arrangement.
Procedure	Material loaned or copied. Fees: Reproduction and handling.

SCIENCE MUSEUM

History of science and technology

Address	Exhibition Road, London SW7 2DD, England
Phone	(01) 589 6371
Apply to	The Director (for Enquiries, the Information Officer).
Material	Photographs, prints and engravings, original paintings and drawings relating to all aspects of science and technology, with the emphasis on British contributions but by no means entirely so. The best first approach to the collection is to obtain the lists of photographs and lantern slides available; this gives the subject headings under which more detailed requests may be made. Period — antiquity to present. Number — very great.
Availability	Research by researcher. Requests by writing, phone or visit. Written authorisation required in first instance. Appointment necessary, delay according to nature of enquiry. Hours — specimen photos can be seen during museum opening hours, Monday to Saturday, 10 to 5, Sunday 2.30 to 5.
Procedure	Material not loaned, copies made. Fees: reproduction, facilities fee for photography by outside agencies. Photograph lists available on specific subjects (see note on material above). Many publications contain reproductions of material in the museum, and can be obtained at the museum or through Her Majesty's Stationery Office. The Museum has provided the following note on procedure: 'Indexes showing the photographs available of exhibits in specific Museum collections are available free on request. Specimen prints are available for consultation in the Information Office. PLEASE NOTE: Prints are supplied to order only; there is no across-the-counter sale. Normal length of time from order to supply of photographic prints is 14 days. Rush orders cannot be undertaken. We are unable to supply 35mm colour transparencies; a limited service of half-plate colour transparencies is operated.'

SHELL INTERNATIONAL PETROLEUM COMPANY/Photographic Library

Modern photographs of oil and petrochemical industries, agriculture and pest control

Address	OAL/41, Shell Centre, London SE1 7NA, England

Shell International Petroleum Company (continued)

Phone (01) 934 4817

Apply to The Librarian.

Material Photographs covering the oil industry, petrochemicals and other associated industries;
 also (deriving from Shell's involvement in the agricultural field) material relating to
 agriculture, plant diseases and pests, animal husbandry etc.
 Period — 1900 to present. Scope — worldwide.
 Number — 30,000.

Availability Not available for publicity use: requests are carefully vetted in this respect.
 Research by staff or researcher. Staff are expert and helpful.
 Requests by writing, phone or visit.
 Appointment preferred.
 Hours — Monday to Friday, 9 to 5.

Procedure Some material loaned, others copied.
 No fees except for any production costs involved.

UNITED KINGDOM ATOMIC ENERGY AUTHORITY

Modern photographs related to use of atomic energy

Address 11 Charles II Street, London SW1, England

Phone (01) 6262 extension 368

Apply to Mrs M C Evans, Photographic Librarian.

Material Modern photographs related to work of the UKAEA, use of isotopes, and all matters
 relating to development and use of atomic energy.
 Period — 1957 to present.
 Number — 15,000 black and white, 5000 colour.
Availability Research by staff.
 Requests by writing, phone or visit.
 Appointment preferred.
 Hours — Monday to Friday, 9.30 to 12.30, 2 to 4.30.

Procedure Material loaned or copied.
 Fees: depending on use. Special facilities for educational and technical uses. Holding
 fee for certain material.

Sporting events are news, and as such are generally well covered by the press agencies; the material of many of the sources we list here may also be available from sources in our news section. But for in-depth coverage — background material regarding the training of athletes or the testing of racing cars, and for less publicised sporting activities, these primary sources are very valuable.

Except for such special establishments as the Marylebone Cricket Club, we have found no specialist historical sources in the sporting field. For this type of material it is necessary to go to the historical sources, particularly the commercial ones.

CAMERA SPORT INTERNATIONAL

Modern photographs of football

Address	Pangbourne House, Magpie Hall Road, Bushey Heath, Hertfordshire, England
Phone	(01) 950 1141
Apply to	Owen Barnes.
Material	Big and comprehensive collection of photographs in colour and black and white covering football — in Britain, Europe and elsewhere. Period — 1970 to present. Number — over 30,000 (mostly colour).
Availability	Research by staff. Requests by writing, phone or visit. Appointment necessary. Hours — 7 days a week, 24 hours a day.
Procedure	Some material loaned, others copied. Fees: reproduction, holding. Commissions.
Notes	Some experience with three-dimensional photography.

COLORSPORT

Photographs of sport, especially in Britain, 1884 to present

Address	44 St Peters Street, London N1 8JT, England
Phone	(01) 359 2714
Material	Black and white and colour photographs of all sporting events, including the Albert Wilkes Library of cricket and football photos, dating from 1884. Helpful service. Period — 1884 to present (football); 1920 to present (cricket); 1969 to present (other sports). Number — thousands.
Availability	Research by staff. Requests by writing, phone or visit. Written authorisation required in first instance. Hours — Monday to Friday, 9 to 7.
Procedure	Material loaned or copied. Fees: reproduction, holding, sometimes search. Commissions.

COOKE, JERRY

Modern photographs of sport, including nine Olympics

Address	Animals Animals Enterprises Inc., 161 East 82nd Street, New York, NY 10028, USA
Phone	(212) 288 2045
Apply to	Jerry Cooke collection.
Material	Modern photographs covering all sports, and including the last nine Olympic Games. Also travel especially in East European countries, personalities etc. Mr Cooke has visited 85 countries as a photographer, chiefly with a sporting interest.
Availability	Research by staff or researcher. Requests by writing, phone or visit. Appointment necessary. Hours — daily 10 to 6.
Procedure	Material loaned. Fees: reproduction, service/handling, search, holding.
Notes	Mr Cooke's photographic files are handled by this big natural history agency which is included in the Natural History section of this Handbook.

CRANHAM, Gerry

Modern photographs of international sport

Address	80 Fairdene Road, Coulsdon, Surrey, CR3 1RE, England
Phone	71 53688
Material	Photographs, all colour, of 80 different sports including African Game Parks, mud-larking, gliding etc as well as the more conventional pastimes. Period — early 1960s to present. Number — 250,000.
Availability	Research by staff. Requests by writing, phone or visit. Written authorisation required. Appointment necessary. Hours — Monday to Friday, 10 to 4.30.
Procedure	Material loaned or copied. Fees: reproduction, search, service and holding. Subject list available. Commissions.

HYAM, John

Modern photographs, particularly sport

Address	25 Glynde Street, Brockley, London SE4, England
Phone	(01) 690 4609
Material	Modern photographs, especially of sporting activities including speedway and motor racing. Some news events, eg opening of new London Bridge. Documentary coverage of South East London.
Availability	Research by staff. Requests by writing, phone or visit. Written authorisation required in first instance. Appointment necessary, delay 7 days. Hours — Monday to Friday, 9 to 5.
Procedure	Material loaned or copied. Fees: reproduction, service, holding. Catalogue in preparation. Commissions.

IMPACT PRESS SPORTS SYNDICATION

Modern photographs of sport

Address	Dundee Press Centre, 12 Victoria Chambers, Dundee, Scotland
Phone	(0382) 21320
Apply to	Mr F Elder.
Material	Contemporary photographs of sport, particularly soccer and ice hockey. Number — 1000.
Availability	Research by staff. Requests by writing, phone or visit. Appointment preferred. Hours — Monday to Saturday, 10 to 12, 2 to 6.
Procedure	Some material loaned, others copied. Fees: reproduction. Photostat service. Commissions.

KLEMANTASKI, Louis

Modern photographs of motor racing and touring, from 1937

Address	44 Clareville Street, London SW7, England
Phone	(01) 370 3258 or 1212
Material	Photographs of motor racing, some touring and motoring in general, including pre-World War Two colour photographs of motor racing. Period — 1937 to present. Number — tens of thousands.
Availability	Research by staff. Requests by writing, phone or visit. Appointment necessary, 2 or 3 days delay. Hours — daily 9 to 5.30.
Procedure	Material loaned or copied. Fees: reproduction, holding for colour after 14 days, others sometimes. Catalogue. Commissions.

LACEY, Ed

Modern photographs, sport

Address	16 Post House Lane, Great Bookham, Leatherhead, Surrey, England
Phone	(53) 259 3077
Material	Colour and black and white photographs of all sports, including equestrian events. Period — athletics from 1952, others from 1964.
Availability	Research by staff. Requests by writing or phone. Visits by appointment only. Hours — Tuesday to Saturday, 9 to 6. Mornings preferred.
Procedure	Material loaned or copied. Fees: reproduction, holding after 14 days. Commissions.

LONDON ART TECHNICAL DRAWINGS

Modern photographs, motor sports

Address	Standard House, Bonhill Street, London EC2A 4DA, England
Phone	(01) 628 4741
Telex	Mocycsport 888602
Material	Modern photographs, mostly in colour, of motor racing, on an international basis. Pictures of notable cars, individual drivers etc. Some general motoring material. Agents for Motor Sport and Motoring News. Period — 1950 to present. Number — 40,000 colour, 150,000 black and white.
Availability	Research by staff or researcher. Requests by writing, phone or visit. Written authorisation required in first instance. Appointment necessary. Hours — Wednesday to Friday, 9 to 1 and 2 to 5.
Procedure	Material loaned or copied. Fees: reproduction, search, holding after 30 days. Photostat service. Commissions.

MARYLEBONE CRICKET CLUB LIBRARY

History of cricket and real tennis

Address	Lord's Ground, London NW8 8QN, England
Phone	(01) 289 1611
Apply to	The Curator.
Material	Photographs, prints and engravings, original paintings and drawings relating to the history of cricket and real tennis. Period — 1500 to present. Number — several thousand.
Availability	Research by staff or researcher. Requests by writing, phone or visit. Appointment preferred. Hours — Monday to Friday 9.30 to 5.30, also Saturdays. May to August inclusive.
Procedure	Material not loaned, copies made. Fees: reproduction. Photostat service.

NORTH ATLANTIC PRESS AGENCIES

General modern photographs, especially sport

Address	11 Wakefield Drive, Welford, Rugby, England
Phone	(064) 581 346
Cables	Presspix, Rugby
Material	General feature material, but with special coverage of yachting, motoring, and sporting events and shows involving cars and boats, air shows etc. All major international motor events and rallies, and power boat and yachting events are regularly covered, likewise London Motor Show, and Boat Show, and Farnborough Air show. Agents for overseas photo agencies. Number — 1 million.
Availability	Research by staff. Requests by writing or phone — visits by appointment only. Hours — 7 days a week, 24 hours a day.

294

North Atlantic Press Agencies (continued)

Procedure	Material loaned or copied.
	Fees: reproduction.
	Photostat service.
	Commissions.

PRESSE-SPORTS

Modern photographs, sport

Address	10 faubourg Montmartre, 75009 Paris, France
Phone	824 70 80
Material	Modern photographs of all kinds of sport, with emphasis naturally on France.
Availability	Research by staff or researcher.
	Requests by writing, phone or visit.
	Appointment preferred.
	Hours — Monday to Friday, 9.30 to 7.
Procedure	Some material loaned, others copied.
	Fees: reproduction, sometimes service.
	Photostat service.
	Commissions.

RACING PIGEON publishing company

Pigeon keeping and racing, past and present

Address	19 Doughty Street, London WC1N 2PT, England
Phone	(01) 242 0565
Material	Photographs, prints and engravings, original paintings and drawings relating to the history of pigeon keeping and racing.
	Period — 1930s to present.
	Number — 3000.
Availability	Research by staff or researcher.
	Requests by writing, phone or visit.
	Written authorisation required.
	Appointment necessary.
	Hours — Monday to Friday, 8.30 to 5.30.

Racing Pigeon Publishing Company (continued)

Procedure	Some material loaned, others copied. Fees: reproduction, sometimes search. Photostat service available. Commissions.

SPORTAPICS

Modern photographs of sport, especially in Scotland

Address	No 2 LU, Arthur Street, Clarkston, Glasgow G76 7AW, Scotland
Phone	(041) 638 6143
Apply to	George Ashton.
Material	Modern photographs, colour and black and white, of sporting events, scenes and personalities, particularly in Scotland; chiefly football, swimming, boxing, rugby, golf. Many action sequences. Period — 1965 to present. Number — 43,000.
Availability	Research by staff. Requests by writing, phone or visit. Written authorisation required. Appointment necessary, delay 3 days. Hours — Monday to Friday, 10 to 5.
Procedure	Material loaned or copied. Fees: reproduction, search, service/handling, holding. Photostat service. Commissions.

SPORTSWORLD

Modern photographs of sport

Address	27 Tudor Street, London EC4Y 0HR, England
Phone	(01) 583 9199
Telex	265863
Apply to	Graeme Murdoch, Art Editor.

Sportsworld (continued)

Material	Modern photographs of sport, including not only the better known forms but also lesser publicised forms such as weight lifting, winter sports, fencing, volleyball etc. Chiefly in Britain but also international events such as Olympic Games. Period — 1965 to present. Number — 12,000 colour.
Availability	Research by staff. Requests by writing, phone or visit. Written authorisation required in first instance. Appointment necessary, delay 2 days. Hours — Monday to Friday, 10 to 6.
Procedure	Some material loaned, others copied. Fees: reproduction, search, handling, holding.

ADDENDA

ALL-SPORT

Modern photographs of all sports

Address	83 Sutton Heights, Albion Road, Sutton, Surrey, England
Phone	(01) 643 5790
Material	Modern photographs covering a comprehensive range of sports, generally 35mm. Period — contemporary. Number — ¼ million (about 75 per cent black and white, but percentage of colour increasing).
Availability	Research by staff. Requests by writing, phone or visit.

S7 TRANSPORT

The most useful, as well as the cheapest, sources of modern pictures relating to transport are the transport undertakings themselves — airlines, railway companies, shipping firms and so on. They will often allow material to be used free, with a suitable acknowledgement; write to the Press Officer.

Historical material is not so easy. Most general sources have a transport section, which is likely to be adequate for most purposes. But if what you're after is an accurate representation of a particular class of Great Western locomotive in a particular year, you will need to track down an enthusiast; and regrettably, enthusiasts with collections accessible to the public are few in number. The best ways to trace them are via clubs or groups devoted to vintage cars, paddleboats, narrow-gauge railways and the like, or via publications dedicated to the same noble causes. (The catalogue of David and Charles, publishers of this handbook, would make as good a starting-point as any for such a search.)

AERONAUTICAL SOCIETY, THE ROYAL:

History of aviation

Address	4 Hamilton Place, London W1V 0BQ, England
Phone	(01) 499 3515
Apply to	A W L Nayler.
Material	Photographs, prints and engravings relating to the history of aviation, from 1700 to the present. Includes all aspects of aerospace development including ballooning, gliding etc, and incorporates several special collections, notably the Cuthbert, Hodgson and Poynton collections. Number — 12,000 photos, 600 prints and engravings.
Availability	Research by staff. Requests by writing, phone or visit. Written authorisation required in first instance. Appointment necessary, 3 days delay. Hours — Monday to Friday, 9.30 to 5.
Procedure	Some material loaned, others copied. Fees: reproduction, search, service/handling. Photostat service.

JACKSON, Bryan H

British railways and industrial archaeology

Address	Maple Cottage, Ashburnham Avenue, Harrow-on-the-Hill, Middlesex, England HA1 2JQ
Phone	(01) 427 2902
Material	Photographs, prints and engravings, original paintings and drawings relating to railways in Britain and industrial archaeology. Period — 1860 to recent past. Number — 8000.
Availability	Research by staff. Requests by writing, phone or visit. Written authorisation required. Appointment necessary. Hours — Monday to Saturday, 10 to 7.

Jackson, Bryan H (continued)

Procedure Some material loaned, others copied.
Fees: reproduction, search, service/handling.
Catalogue published annually (50p).
Commissions.

LEICESTER MUSEUMS & ART GALLERY: NEWTON COLLECTION

Railways in Britain

Address New Walk, Leicester, England

Phone (0533) 26832

Apply to The Director.

Material 3000 photographs mainly of Great Central Railway from Huckwall to London. Fine shots of navvies and their living conditions, contractors, locos and crews.
Period — 1894 to 1905.

Availability Research by staff or researcher.
Requests by writing, phone or visit.
Written authorisation required in first instance.
Appointment preferred, delay 7 days.
Hours — Monday to Friday, 10 to 1, 2 to 5.

Procedure Material not loaned, copies made.
Fees: reproduction, sometimes others.
Photostat service.

Notes Our request for further information about the collection was not answered; however, in view of the rarity of visual material relating to transport, we think the collection should be included.

LONDON TRANSPORT EXECUTIVE

History of London's public transport

Address	Griffith House, 208 Old Marylebone Road, London NW1 5RJ, England
Phone	(01) 262 3444
Apply to	Publicity Department.
Material	Photographs, a few prints, engravings and posters, covering the history of public transport in London from about 1880. This includes the archives of the old underground railways and many historic photographs, but documentation is more complete for the 20th century. Period — c.1880 to the present. Posters 1914 to present. Number — 100,000.
Availability	Research by staff or researcher. Requests by writing, phone or visit. Written authorisation required. Appointment preferred, no delay. Hours — Monday to Friday, 9 to 4.30 (4pm on Friday).
Procedure	Material copied. Fees: only for print, no reproduction fee. No catalogues, but there are a number of publications by the Executive showing their material, including the Poster Book (£1).

MARITIME MUSEUM, NATIONAL

Maritime, past and present

Address	Greenwich, London SE10 9NF, England
Phone	(01) 858 4422
Apply to	either: The Director, or for pictures and historic photos: Head of Department of Pictures; for photos: Co-Ordinator of Museum Services; for draughts and ship plans: Head of Ships Department; for charts: Head of Navigation Department; for astronomical instruments etc: Head of Astronomy Department.

Maritime Museum, National (continued)

Material A magnificent collection of photographs, prints and engravings, original paintings and drawings relating to maritime affairs, including navigation and astronomy. The emphasis is naturally on British naval history, but is far from being exclusively so. The staff are extremely helpful with serious researchers but appreciate specific rather than general requests.
Period — pre-1066 to present.
Number — ¾ million pictures, ½ million ships' plans.

Availability Research by staff or researcher.
Requests by writing, phone or visit.
Appointment advised if requiring assistance of staff.
Hours — Tuesday, Wednesday, Thursday only, 11 to 4.

Procedure Material not loaned, copies made.
Reproduction fee.
Catalogue in preparation.

MARSEILLE, MUSEE DE LA MARINE

French maritime and colonial history

Address Chambre de Commerce et d'Industrie de Marseille, Palais de la Bourse, La Canebière, 13001 Marseille, France

Phone 39 62 19

Telex 41 091 EXCOMER-MARSL

Material Photographs, prints and engravings, original paintings and drawings and miscellaneous material relating to French maritime history, former colonies, history of Marseille and region, and related subjects ranging from enthnographical material to the Fonds de Cantelar collection of documents relating to the development of steam navigation from 1850 to the present.
Period — 17th century to present.
Number — 12,000 photographs, 10,000 prints and engravings, 175 original paintings or drawings, plus other material.

Availability Research by staff.
Requests by writing, phone or visit.
Appointment necessary, delay 7 to 15 days.
Hours — museum: daily except Tuesday, 10 to 12, 2 to 4.30.
workrooms and material not on display: weekdays except Tuesday, 8.15 to 1, 2 to 5.30.

Procedure Some material loaned, others copied.
Fees: reproduction, holding.
Photostat service.
Card-index catalogue in museum. Brief guide to the museum available at 2 francs.

MOTOR MUSEUM, NATIONAL

History and development of motor road transport

Address	Beaulieu, Hampshire, SO4 7ZN, England
Phone	(0590) 612345
Material	Photographs, a few prints and drawings, and a big collection of catalogues and similar material, making up what is possibly the most comprehensive collection of motoring documentation in the world. Besides the collection of 50,000 motoring photographs there is a great deal of material in the books in the BP Library. Period — 1880 to present.
Availability	Research by staff or researcher. Requests by writing, phone or visit. Appointment necessary, 1 or 2 days delay. Hours — Monday to Friday, 10 to 5. Saturdays and Sundays by appointment.
Procedure	Material loaned or copied. Fees: reproduction, occasionally others. Photostat service.

VIE DU RAIL, La

History of railways, especially in France

Address	11 rue de Milan, 75009 Paris, France
Phone	874 82 89 or 874 06 75
Apply to	M. Jean Salin (Director) or M. Paul Delacroix (Chief Editor).
Material	Photographs in colour and black and white, original paintings and drawings, prints and posters relating to railways, from the earliest days to the present.
Availability	Research by staff or researcher. Requests by writing or visit, not phone. Written authorisation required. Appointment preferred. Hours — Monday to Friday, 9 to 5.
Procedure	Some material loaned, others copied. Fees: reproduction, search, handling, holding. Photostat service.

The world of entertainment inevitably overlaps largely with that of straight news — the unions and separations of movie stars are headline material everywhere. So the press agencies will give coverage of showbiz functions of the more publicised type, and carry portraits of leading personalities. Other sources are record companies, film companies, television and broadcasting companies, impresarios, theatrical agencies — from many of which you may be able to obtain publicity material which can be used without charge: write to Press or Public Relations Officer.

When it comes to the historical side, entertainment has its countless devotees. Many national museums have special Theatre and Music collections, and every general source will have its related sections. But few such sources will ever approach their subject with the loving devotion of collectors like Raymond Mander and Joe Mitchenson . . .

BRITAIN

AUERBACH, Erich

Photographs of music and musicians

Address	29 Abercorn Place, St Johns Wood, London NW8 9DU, England
Phone	(01) 624 5208
Material	Photographs of musicians and other aspects of music including instruments and buildings. Transparencies of paintings of baroque composers. Early Mahler material. Knowledgeable and reliable. Period — from late 1930s, except as mentioned above.
Availability	Research by staff. Requests by writing, phone or visit. Written authorisation required. Appointment necessary. Hours: Monday to Saturday, normal business hours.
Procedure	Material loaned, copies made. Fees: reproduction, search, holding, sometimes service/handling. List of personalities available. Commissions.

BRITISH BROADCASTING CORPORATION PICTORIAL PUBLICITY LIBRARY

Modern photographs of BBC activities

Address	10 Cavendish Place, London W1A 1AA, England
Phone	(01) 580 4468 extension 5117/8
Telex	22182
Apply to	The Librarian.
Material	Modern photographs relating to broadcasting — production stills, technical photographs, personalities etc. Although the entire collection is based on broadcasting, this covers a wide range of activities and much of the material is general in its application. Period — 1920 to present. Number — 750,000 black and white, 75,000 colour.
Availability	Not available for advertising purposes. Research by staff. Requests by writing or phone. Hours — Monday to Friday, 9.30 to 5.30.
Procedure	Black and white loaned, colour material duplicated and purchased. Fees: reproduction, sometimes search and service.
Notes	Requests relating to specific programmes or personalities can be processed very quickly — usually the same day. General subjects usually within 1 or 2 days.

BRITISH THEATRE MUSEUM ASSOCIATION

History of theatre in Britain

Address	12 Holland Park Road, London W12 8LZ (BUT SEE NOTE BELOW)
Phone	(01) 602 3052
Apply to	The Curator.
Material	Photographs, prints and engravings, posters and ephemera relating to the history of the theatre in Britain. Period — 17th century to present.

British Theatre Museum Association (continued)

Availability At present (end of 1973) access is restricted to material actually on exhibition in their collection, but when they have completed their forthcoming transfer to Somerset House, London, they will be able to provide wider access to their archives. Research preferably by visit at present.
Appointment necessary.
Hours — Tuesday, Thursday and Saturday, 11 to 5 (except public holidays).

Procedure Material copied by researcher or commissioned photographer.
Fees by arrangement.

DOMINIC PHOTOGRAPHY

Modern photographs of entertainment world

Address 9a Netherton Grove, London SW10 9TQ, England

Phone (01) 352 6118

Cables Domphot London SW10

Apply to Zoe Dominic, proprietor.

Material Modern photographs, mainly black and white but some colour, of the entertainment world including theatre, opera, ballet, musicians, movie stars, but *not* pop music stars.
Period — 1957 to present.
Number — 200,000.

Availability Research by staff or researcher.
Requests by writing or phone in first instance.
Written authorisation required.
Appointment necessary, one or two days delay.
Hours — Monday to Friday, 9.30 to 5.30.

Procedure Material loaned or copied.
Fees: reproduction, service, holding.
Commissions.

FILM ARCHIVE, NATIONAL

Cinema past and present

Address	81 Dean Street, London W1, England
Phone	(01) 437 4355
Apply to	Stills collection.
Material	Photographs and posters relating to cinema history from the origins of cinema to the present day. Includes some documentary as well as feature films. Period — 1895 to present. Number — 700,000.
Availability	Research by staff. Requests by writing, phone or visit. Hours — Monday to Friday, 11 to 6.
Procedure	Material not loaned, copies made. (Photoprint service is 3 days after receipt of official order or remittance.) Fees: reproduction, sometimes search. Photostat service.
Notes	All stills are filed under film title, or name in the case of portraits. There is no subject index, and subject enquiries cannot be dealt with.

GRANT, Ronald

Film stills, portraits, posters

Address	The Guildhall, High Street, Clare, Suffolk, England
Phone	078 727 669
Material	Film scene stills, portraits and posters. Period — from 1916 to present, but mostly after 1930. Number — over 100,000
Availability	Research by staff. Requests by writing, phone or visit. Appointment necessary. Hours — normal working hours.
Procedure	Material loaned. Fees: reproduction, holding, sometimes search.

HOLTE PHOTOGRAPHICS

Photographs of Stratford-on-Avon and district, and Royal Shakespeare Theatre productions

Address 8 Church Street, Stratford-on-Avon, Warwickshire, England

Phone (0789) 2336

Apply to Thomas F Holte.

Material Productions at the Royal Shakespeare Theatre, and photographs of Stratford-on-Avon and district including all Shakespeare associations.

Availability Research by staff.
 Requests by writing, phone or visit.
 Written authorisation required.
 Appointment preferred.
 Hours — Mon, Tues, Wed, Fri — 9 to 5.

Procedure Some material loaned, others copied.
 Fees: reproduction and search.
 Catalogue available (5p).
 Commissions.

KOBAL, John, COLLECTION

Photographs of cinema industry, stars and film personalities

Address 38 Drayton Court, Drayton Gardens, London SW10 9RH, England

Phone (01) 373 9366

Apply to John Kobal.

Material Colour transparencies and black and white photos covering the history of films and the people who have made them. Although the collection does not act as an agency, film stills not held in the collection can generally be obtained. The photos include not only material directly related to film-making but also such items as VIPs visiting studios.
 Period — 1900 to present.

Availability Research by staff.
 Requests by writing or phone.
 Visits by appointment only.
 Hours — Monday to Friday, 10 to 5.

Procedure Some material loaned, others copied.
 Fees: reproduction, sometimes others.
 Some material requires copyright clearance.

LONDON PHOTO AGENCY

Pop and light music, chiefly in Britain

Address LPA House, Lambs Conduit Passage, London WC1, England

Phone (01) 242 0707 or 0708

Apply to A Byrne.

Material Photographs of pop and light music and related subjects — personalities, recording sessions, concerts etc in Britain and some elsewhere.
 Period — 1966 to present.

Availability Research by staff.
 Requests by writing, phone or visit.
 Written authorisation required in first instance.
 Appointment necessary, 2 days delay.

Procedure Some material loaned, others copied.
 Fees: reproduction, holding.
 Commissions.

MANDER & MITCHENSON
(The Raymond Mander and Joe Mitchenson Theatre Collection)

History of stage entertainment

Address 5 Venner Road, Sydenham, London SE26, England

Phone (01) 778 6730

Material This is Britain's definitive collection of all material relating to theatre, circus, music hall, opera, ballet etc., including theatre archives, theatrical family histories and all kinds of documentation. The collection also includes posters, manuscripts, press cuttings and unique ephemera. The proprietors are widely known for their expert knowledge of the subject, and have written many books on different aspects of it: the collection reflects their personal interest, and they are glad to put their knowledge at the disposal of serious researchers. Casual browsers, students etc are discouraged. Period — earliest times to present.

Mander & Mitchenson (continued)

Availability Research by staff; researchers should have a definite purpose and clear idea of their requirements.
Requests by writing, phone or visit.
Written authorisation in first instance.
Appointment necessary.
Hours — Monday to Friday, afternoons only.

Procedure Some material loaned, others copied.
Fees: reproduction and service.
Photostat service.

Notes Material is filed under the names of people and/or theatres. Programmes are under Theatres; press cuttings under people.

MODERN ART, MUSEUM OF: Film Stills Archive

Cinema history

Address 11 West 53rd Street, New York, NY 10019, USA

Phone (212) 956 4213

Cables Modernart

Material Photographs illustrating the history of film production from its first experiments to present releases. Scenes from films, portraits of actors, directors etc, and some original set designs. Incorporates the Photoplay Collection, comprising 1 million rare stills used in Photoplay Magazine 1920—1948, and the Essanay Collection, comprising 5000 stills of that company's productions 1912—1919.
Number — 2½ million items.

Availability Publishers and educational researchers only.
Research by staff.
Requests by writing, phone or visit.
Appointment necessary.
Hours — Monday to Friday, 1.30 to 5.

Procedure Material not loaned, copies made.
Fees: reproduction.

Notes The majority of the material is filed under original film title: it is essential that these titles are quoted when ordering material relating to specific films.

MOVIE STAR NEWS

Cinema stills and portraits

Address	212 East 14th Street, New York, NY 10003, USA
Phone	GR7 8526
Apply to	Paula Klaw, Manager.
Material	Big collection of film stills and actor portraits dating from 1900 to present, comprising both American and international films. Items can be ordered either by film title, by actor name, or by subject — eg 'damsels in distress'. Number — 1 million.
Availability	Research by staff. Requests by writing, phone or visit. Hours — Monday to Friday, 11 to 5.30, Saturday 1 to 5.
Procedure	Material not loaned, copies made. Fees: reproduction, search, service/handling. Catalogue available ($1 postpaid).

MUSIC, ROYAL COLLEGE OF

Music, past and present

Address	Prince Consort Road, London SW7, England
Phone	(01) 589 3643
Apply to	Oliver Davies, Keeper of Portraits.
Material	Photographs, prints and engravings, original paintings and drawings, concert programmes and musical ephemera. While the chief value of the collection is in its specific material — the portraits, programmes etc — the printed music and other ephemera can be valuable sources of illustrative material. Period — chiefly recent or contemporary. Number — several thousand.
Availability	Research by staff. Requests by writing, phone or visit. Appointment necessary. Hours — *Wednesday only* 10 to 5, occasionally other times by appointment.

Music, Royal College of (continued)

Procedure Material not loaned, copies made.
Fees: reproduction sometimes charged.
Photostat service.

NEAL, John

Modern photographs, particularly relating to film and tv

Address Quinton House, Bath Road, Maidenhead, Berkshire, England

Phone (0628) 25010

Material Modern photographs specialising in stills work — programme histories, special effects, optical and chemical effects, publicity material etc — for film and television companies. Also a special collection on the painter Stanley Spencer and his work. Number — 130,000.

Availability Research by staff.
Requests by writing, phone or visit.
Written authorisation required in first instance.
Appointment necessary, delay 8 days.
Hours — Monday to Friday, 10am to 10pm.

Procedure Material not loaned, copies made.
Fees: reproduction.
Commissions.

NEW ORLEANS JAZZ MUSEUM

Jazz, New Orleans history, black history and related subjects

Address 340 Bourbon Street, New Orleans, Louisiana 70130, USA

Phone 525 3760 (museum); 522 7803 (archives)

Apply to Justin A Winston, Chief Curator.

Material The scope of this collection goes beyond that indicated by its name, covering the social background to jazz which includes black history, New Orleans, and other related subjects. The collection comprises photographs, prints and engravings, original paintings and drawings, sheet music, handbills, manuscripts and other ephemera. Period — 17th century to present. Number — 30,000.

New Orleans Jazz Museum (continued)

Availability Research by staff or researcher.
Requests by writing, phone or visit.
Appointment necessary.
Hours — Wednesday, Thursday, Friday, 10 to 5.

Procedure Material not loaned, copies made.
Fees: reproduction.
Photostat service.
Commissions.

PARAMOR, David

Theatre and music, specific fields

Address 179c West Heath Road, Hampstead, London NW3, England

Phone (01) 387 2811 extension 120 (working hours)
(01) 458 4133 (weekends)

Material A personal collection of Victorian sheet music including covers, theatre postcards and prints.
Period — 1830 to 1930.
Number — 2000.

Availability Research by staff.
Requests by writing or phone.
Written authorisation required.
Hours — Monday to Friday, 9.15 to 5.45. Can be phoned at weekends.

Procedure Material sometimes loaned, more usually copied (researcher must make arrangements).
Fees: reproduction, holding.

PETIT, Michael

Modern photographs, theatrical and cultural subjects, especially dance and mime

Address 147 boulevard Saint Germain, 75006 Paris, France

Phone 033 89 12

Material A collection of modern photographs covering various aspects of cultural activity, including music and literary portraits, but specialising in what a French source describes as 'toutes les formes d'espressions corporelles' by which is meant mime, dance, ballet etc. Photos of dancers, productions, etc.
Period — 1947 to present.
Number — 186,000.

Availability Research by staff.
Requests by writing, phone or visit.
Written authorisation required.
Appointment preferred.
Hours — Monday to Friday, 10 to 6.

Procedure Some material loaned, others copied.
Fees: reproduction.

PINEL, Vincent

Cinema — shots from films

Address 11 rue Henry-Génestal, 76 600 Le Havre, France

Phone 35 42 07 38

Material Vincent Pinel has a collection of film material which is reproduced from the films themselves, not from specially taken still photographs which may not have been precisely the shots used in the film itself. Thus they possess an authenticity which more than compensates for the inevitable loss of quality due to graininess and wear and tear caused during projection.
Period — from earliest films to present.
Number — 30,000 (about 1500 colour).

Availability Only for use in serious publications concerned with the cinema — not for publicity etc.
Requests preferably by writing; research by staff.
Visits by appointment only, delay 7 to 15 days.
Hours — Tuesday to Saturday, 9 to 6.

Procedure Material not loaned, copies made. The only charge is for the making of the copy.
Catalogue available.

ROGERS, Houston

Photographs of stage arts, 1936 to present

Address	10 Phillimore Gardens, London W8 7QD, England
Phone	(01) 937 1445
Apply to	Mrs Houston Rogers.
Material	Photographs relating to theatre, ballet and opera, including personalities. Colour and black and white. Period — 1936 to 1970. Number — 40,000.
Availability	Research by staff. Written requests preferred; personal visits by appointment only. (3 days delay). Hours — Monday to Friday, 11.30 to 5.
Procedure	Some material loaned, others copied. Fees: reproduction, holding.

SHAKESPEARE BIRTHPLACE TRUST

Shakespeare material, theatrical history, local topography

Address	Shakespeare Centre, Henley Street, Stratford-on-Avon, Warwickshire, England
Phone	(0789) 4016
Apply to	The Director.
Material	There are two separate collections:— 1) *RECORDS OFFICE* comprising photographs, prints and engravings, original paintings and drawings specialising in Shakespeare material, local topography etc. The collection includes the James Saunders collection of early 19th century topographical watercolours. Period — c.1600 to present. 2) *LIBRARY* comprising English theatrical history, the Bram Stoker collection of Irving material, and the archives of the Royal Shakespeare Theatre from 1879 to the present. The Library collection as a whole covers the period from the 18th century to the present.

Shakespeare Birthplace Trust (continued)

Availability Research by staff.
Requests by writing, phone or visit.
Written authorisation required.
Appointment preferred for Library — delay 3 days.
Hours: Records office — Monday to Friday, 9.30 to 1, 2 to 5, Saturday 9.30 to 12.30.
Library — Monday to Friday 10 to 5, Saturday 9.30 to 12.30.

Procedure Material not loaned, copies made.
Fees: reproduction, service.
Photostat service.

SKR PHOTOS INTERNATIONAL

Modern photographs — popular music, jazz, football

Address 22a Baker Street, London W1M 1DF, England

Phone (01) 486 3295 and 935 4849

Apply to Sales: Ron Mulvaney.
Libray: David Brewster.
Picture desk: Stuart Richman.

Material Modern photographs of popular music, jazz, and football.
Associates in Switzerland, Holland and Japan.
Period — 1958 to present.

Availability Research by staff or researcher.
Requests by writing, phone or visit.
Written authorisation required in first instance.
Hours — Monday to Friday, 9.30 to 5.30.

Procedure Material loaned or copied.
Fees: reproduction fee.
Commissions.

TEATRALE ALLA SCALA, MUSEO

Theatrical history, past and present

Address	via Filodrammatici 2, Milano, Italy
Phone	89 34 18 or 89 95 35
Material	Photographs, prints and engravings, original paintings and drawings, books, stage sets, architectural drawings and ephemera relating to all aspects of stage entertainment and spectacle. Period — 345 BC to present.
Availability	Research by staff or researcher. Requests by writing, phone or visit. Appointment preferred. Hours — Monday to Saturday, 9 to 12 and 2 to 6.
Procedure	Some material loaned, others copied. Fees: reproduction. Catalogue. Photostat service.

TRANSATLANTIC PHOTO SERVICE

Modern photographs of film and tv celebrities

Address	7100 Hillside Avenue, Suite 309, Hollywood, California 90046, USA
Phone	(213) 874 1284
Material	Photos of American and visiting film and tv stars at all major Hollywood events, candids out and about town, portraits of stars singly or in groups, parties, premieres etc. Period — 1961 to present. Number — vast!
Availability	Research by staff. Requests by writing, phone or visit. Written authorisation required. Appointment necessary.
Procedure	Material loaned or copied. Fees: reproduction, sometimes service/handling. Commissions.

VICKERS, John

Modern photographs, particularly London Theatre productions 1942-1958

Address	52-4 Kenway Road, London SW5 0RA, England
Phone	(01) 373 3091
Apply to	John Vickers.
Material	General modern photographic studio, with large specialist collection covering serious drama in London between 1942 and 1958 — scenes, portraits etc. Also geographical, Italy, France and Spain. Period — 1937 to present. Number — 100,000.
Availability	Research by staff. Requests by writing, phone or visit. Written authorisation required. Appointment preferred, delay 1 to 3 days. Hours — Monday to Friday, 10 to 1, 2 to 5.
Procedure	Material not loaned, copies made. Fees: reproduction, search, service, holding. Commissions.

WILKES, George

Modern photographs of pop music and showbiz personalities

Address	13 St Albans Road, Kingston-upon-Thames, Surrey, KT2 5HQ, England
Phone	(01) 546 4173
Material	Modern photographs of personalities in pop music and other fields of showbiz, scenes of pop music events and activities. Period — 1968 to present. Number — several thousand.
Availability	Research by staff. Requests by writing or phone, no visits. Written authorisation required in first instance. Hours — Monday to Saturday, 9 to 6.
Procedure	Some material loaned, others copied. Fees: reproduction.

WILSON, Reg

Modern photographs of performing arts

Address	55 Beechwood Avenue, London N3 3BB, England
Phone	(01) 346 7776
Material	All aspects of performing arts — theatre, ballet, opera, musicians, singers, dancers, foreign theatre, ballet and dance, in colour and black and white. Within its field, this is probably one of the world's largest collections of colour material. All subjects are card-indexed and cross referenced, so a researcher can quote eg opera title, company, performer, conductor, composer or production. Period — 1961 to present. Number — 12,000 colour; 250,000 black and white
Availability	Research by staff. Requests — initially by phone preferably, then by writing or visit. Written authorisation required. Appointment preferred, no delay. Hours — Monday to Saturday, 9 to 9.
Procedure	Material sometimes loaned, usually copied. Fees: reproduction, sometimes others. Commissions.

WOOD, Roger

Modern photographs in various special fields

Address	18 Garway Road, London W2 4NH, England
Phone	(01) 229 7671
Cables	Rolleiflex, London W2
Material	Modern photographs in colour and black and white in two main areas: 1. Ballet and opera in Britain between 1950 and 1960 2. Antiquities and travel, chiefly in North Africa, Near and Middle East, from 1960 to the present. Number — 30,000.

Wood, Roger (continued)

Availability Research by staff or researcher.
 Requests by writing, phone or visit.
 Written authorisation required in first instance.
 Appointment necessary.
 Hours: Monday to Saturday, 9.30 to 6.30.

Procedure Material loaned or copied.
 Fees: reproduction, search, service/handling, holding.
 Subject list available on request.
 Commissions.

WEILL, Etienne Bertrand

Modern photographs, especially of French theatre, mime, etc

Address 75 rue Eugene Caron, 92400 Courbevoie, France

Phone 788 35 30

Material Modern photographs, particularly of French theatre, mime etc., also modern art. Has
 made a speciality of non-figurative photography.
 Period — 1946 to present.
 Number — 20,000.

Availability Research by staff or researcher.
 Requests preferably in writing, or phone or visit.
 Written authorisation required.
 Appointment necessary.
 Hours — Monday to Friday, normal working hours.

Procedure Material sometimes loaned, usually copied.
 Fees: reproduction, search.

ARMY MUSEUM, NATIONAL

British and Commonwealth military history

Address	Royal Hospital Road, Chelsea, London SW3, England
Phone	(01) 730 0717
Apply to	Mr B Mollo, Keeper of Records.
Material	Prints, engravings, photographs, original paintings and drawings, books and scrap-books illustrating military history of Britain and British Commonwealth. The collection includes a great many uniforms and details of uniforms, illustrations of campaigns etc. Good transparencies are available of most of the museum's painting collection. Expert advice is forthcoming from the staff.
	Period — British army 1485 to 1914.
	Indian army 1660 to 1947
	Commonwealth armies up to independence
	Number — 10,000 prints, 100,000 photos, 20,000 books.
Availability	Researchers should obtain a *Reader's Ticket* (obtainable free on application to The Director, apply in writing).
	Research by staff or researcher.
	Requests by writing, phone or visit.
	Written authorisation required.
	Researchers not holding a Reader's Ticket should make an appointment.
	Hours — Tuesday to Saturday, 10 to 4.
Procedure	Material not loaned, copies made.
	Fees: reproduction.
	Photostat service.

BASSANO & VANDYK (incorporating Elliot & Fry)

Photographic portraits, 1880 to present

Address	78 Wigmore Street, London W1, England
Phone	(01) 935 0271 or 0272
Apply to	Miss Williams.
Material	This leading portrait photographer's establishment has unique archives comprising portraits of leading men and women in all walks of life, particularly social leaders and royalty. Period – 1880 to present. Number – 15,000.
Availability	Research by staff. Requests by writing, phone or visit. Appointment preferred, 2 days delay. Hours – Monday to Friday, 9.30 to 5.
Procedure	Material loaned or copied. Fees: reproduction. Photostat service. Commissions.

BEKEN OF COWES

Marine photography, 1880 to present

Address	16 Birmingham Road, Cowes, Isle of Wight, England
Phone	(098 382) 2223
Material	Photographs of all aspects of marine photography, including colour posters, prints and engravings, paintings and drawings. The oldest collection of yachting photographs in the world. Period – 1880 to present. Number – 55,000.
Availability	Research by staff. Requests by writing, phone or personal visit. Appointment preferred. Hours – 24 a day, 7 days a week.

Beken of Cowes (continued)

Procedure Material not loaned, copies made.
 Fees: reproduction, sometimes search.
 Commissions.

BODLEIAN LIBRARY: JOHN JOHNSON COLLECTION

Printed ephemera

Address Johnson Collection, Bodleian Library, Oxford, OX1 3BG, England

Phone (0865) 44675

Apply to Mr M L Turner.

Material Almost certainly the world's finest collection of printed ephemera, a unique collection of fugitive items ranging from paper money to children's games, labels to posters, broadsides to greetings cards.
 Period — 16th century to 1939.
 Number — millions.

Availability Research by researcher. (See notes on Western Manuscripts collection for information about Reader's Tickets, hours etc.)

 There is no catalogue, but the catalogue of an exhibition held in the Library in 1971 (price £1.50) describes how the collection was created and gives a good idea of its scope.

BRACEGIRDLE, Brian

Biological photomicrographs and macrographs, industrial archaeology

Address 157 Shooters Hill, London SE18 3HS, England

Phone (01) 856 1968

Material High quality photographs in two distinct fields:
 1. Photomicrographs and macrographs of any living or once-living thing, plant, animal or human, made either with a microscope or in close detail. Every possible scientific technique is used, and Mr Bracegirdle's scientific background ensures full understanding of the subject.
 2. Industrial archaeology — industrial monuments of all kinds.
 Number — 10,000.

Bracegirdle, Brian (continued)

Availability	Research by staff.
	Requests by writing or visit, not phone.
	Written authorisation required.
	Appointment necessary, 2 or 3 days delay.
	Hours — daily 11 to 9.
Procedure	Material sometimes loaned, otherwise copied.
	Fees: reproduction, holding.
	Published books give indication of scope and quality.
	Commissions.

CHILDHOOD, MUSEUM OF (EDINBURGH)

All aspects of childhood, education etc, past and present

Address	38 High Street, Edinburgh, EH1 1TG, Scotland
Phone	(031) 556 5447
Apply to	Curator.
Material	The collection includes photographs, prints and engravings and ephemera relating to all aspects of childhood, especially toys and games, literature and education, from birth to about 12 years of age.
	Number — several thousand.
Availability	Research by staff or researcher.
	Requests by writing, phone or visit.
	Appointment preferred.
	Hours — Monday to Friday, 10 to 5.
Procedure	Some material loaned, others copied.
	Fees: reproduction, if for commercial use.
Notes	Though non-commercial in character, the museum (which is owned by the city authorities) is efficiently organised and comprehensive records are maintained. As the captions to the museum exhibits indicate, the Curator and his staff are very 'human' in their approach to their subject and successfully blend enthusiasm with their efficiency. The Curator and staff are glad to co-operate with serious enquirers.

COOK, Charles J

Photomicrography, macrophotography

Address	Tritone, Downsview, Edington, Westbury, Wiltshire, England
Phone	(038 083) 514
Material	Photomicrography and macrophotography of biological and scientific subjects.
Availability	Research by staff. Requests by writing, phone or visit. Written authorisation required. Appointment necessary. Hours — Monday to Friday, 9 to 6 or by arrangement.
Procedure	Material loaned or copied. Fees: reproduction. Catalogue available. Commissions.
Notes	Advisory service in microscopy. Agents for similar material from other sources.

COSTUME, UNION FRANCAISE DES ARTS DU

History of costume from 18th century to present

Address	105 boulevard Malesherbes, 75008 Paris, France
Phone	387 19 26
Material	Once again the French display their unique ability to create a specialist collection of dazzling virtuosity . . . Here is a collection of 4000 complete actual costumes, along with 20,000 accessories such as shoes and underclothes; 40,000 samples of textiles, complemented by a library full of fabric designs. The picture collection comprises 25,000 original costume drawings, 9000 fashion plates, 70,000 photographs (dating from 1860!), vast quantities of fashion magazines, catalogues, books and what have you. In short, a quite incredible collection . . . Period — 18th century to present. Number — countless black and white, about 5000 colour transparencies.

Costume, Union Française des Arts du (continued)

Availability Research by staff or researcher.
Requests by writing, phone or visit.
Appointment preferred.
Hours — Monday to Friday, 9.30 to 12.30, 2.30 to 6. Closed August.

Procedure Some material loaned, others copied.
Fees: reproduction, search.
Brief leaflet available with more detailed information.

DESIGN COUNCIL

Photographs of modern industrial design

Address The Design Centre, 28 Haymarket, London SW1Y 4SU, England

Phone (01) 839 8000

Apply to The Librarian.

Material Photographs of industrial design subjects. This includes many thousands of products indexed by the Council, covering all aspects of industrial design including furniture, household goods, transport, engineering products, architecture and building, crafts. Also special areas of interest such as the Bauhaus, the Festival of Britain, poster design and other graphics.
Period — 1950 to present.
Number — 35,000.

Availability Research by staff or researcher.
Requests by writing, phone or visit.
Hours — Monday to Friday, 10 to 5 (closed for lunch).

Procedure Some material loaned, others copied.
Fees: reproduction, service.
Catalogues: full descriptive slide catalogue available at £1 (£1.15 posted).
Leaflet giving full particulars of slide loan fees may be obtained from the librarian.

ENGLISH RURAL LIFE, MUSEUM OF (University of Reading)

English rural life and agriculture

Address	University of Reading, Whiteknights, Reading, Berkshire, RG6 2AG, England
Phone	(0734) 85123 extension 475
Apply to	The Keeper.
Material	Photographs, prints and engravings, original paintings and drawings, ephemera, comprising all aspects of English rural life, farming methods, agricultural equipment, rural trades and crafts, etc. Period — 1850 to 1950. Number — 400,000.
Availability	Research by staff or researcher. Requests by writing in first instance, or phone, followed by visit. Written authorisation required for students in first instance. Appointment necessary, 4 days delay. Hours — Tuesday to Friday, 9 to 5.
Procedure	Material not loaned, copies made. Fees: service, sometimes handling. Photostat service.
Notes	There is a classified index at the museum.

FRIENDS' HOUSE LIBRARY
Religious Society of Friends (Quakers)

Quakers, past and present

Address	Friends' House, Euston Road, London NW1 2BJ, England
Phone	(01) 387 3601
Material	Photographs, prints and engravings, original paintings and drawings relating to the history and activities of the Society of Friends, popularly known as Quakers. Period — 1650 to present. Number — more than 10,000.

Friends' House Library (continued)

Availability	Research by staff or researcher. Requests by writing, phone or visit. Appointments preferred. Hours — Monday to Friday, 9.30 to 5.30.
Procedure	Some material loaned, others copied. Fees: reproduction. Photostat service.

GIBBONS, Stanley, INTERNATIONAL

Philately

Address	391 Strand, London WC2R 0LX, England
Phone	(01) 836 9707
Telex	28883
Apply to	D R Lyon.
Material	Photographs of postage stamps and related items (special covers etc). Period — 1840 to present. Number — many thousand.
Availability	Research by staff. Requests by writing only. Written authorisation required. Hours — Monday to Friday, 9 to 5.
Procedure	Some material loaned, mostly copied. Fees: search and service. No catalogue of their photo collection is available, but of course they have their own stamp catalogues of which they are the world's foremost publishers.

HUNT, Robert, LIBRARY

Military and political history, 18th and 19th centuries

Address	4 Windmill Street, London W1P 1HF, England
Phone	(01) 580 7132
Apply to	Sarah Kingham

328

Hunt, Robert, Library (continued)

Material Photographs, prints and engravings relating to military and political history of 18th
 and 19th centuries, also some general material.
 Number – 250,000.

Availability Research by staff or researcher.
 Requests by writing, phone or visit.

Procedure Material not loaned, copies made.
 Fees – reproduction, research.

Note Their material is largely drawn from other collections, with whom copyright must be
 cleared and whose fees must be paid in addition to those charged by the Robert Hunt
 Library. None the less, this can be a useful specialist source as the collection is
 comprehensive and international in scope.

IMPERIAL WAR MUSEUM

Twentieth century warfare

Address Lambeth Road, London SE1 6H2, England.

Phone (01) 735 8922

Apply to Keeper of the Department of Art *or* Head of the Department of Photographs.

Material The museum started after World War I as, hopefully, a final memorial to war.
 Unfortunately they have had to add to their collection subsequently each time
 Britain has been involved in further wars. The bulk of the collection is made up of
 paintings, photographs and ephemera dealing with the two World Wars and other
 aspects of military affairs. Some of the photographs are still in copyright with news
 agencies and must be cleared, which can cause delays.
 Period – 1914 to present.
 Number – 4 million photographs, 9000 works of art, 50,000 posters, 10,000 coins,
 medals, paper currency etc.

Availability Research by researcher.
 Requests by writing, phone or visit.
 Appointment necessary.
 Hours – Monday to Friday, 10 to 5.

Procedure Material not loaned, copies made.
 Fees: reproduction, service.
 Catalogue of art collection available (2 vols £0.70 for both).

Notes The museum's own photographic service is somewhat slow, but they will recommend
 outside photographers who visit the museum regularly and will carry out assignments
 very quickly.

JEWISH NATIONAL & UNIVERSITY LIBRARY

Photographs of Jewish subjects

Address	P.O.B. 503, Jerusalem 91-000, Israel
Phone	531221 extension 255
Telex	2367
Material	Photographs of Jewish subjects, including portraits of well-known Jews.
Availability	Research by staff or researcher. Requests from abroad in writing, otherwise by personal visit, by appointment. Hours — Monday to Thursday, 8 to 3, Friday, 8 to 1.
Procedure	Material not loaned, copies made. Fees: reproduction, service. Photostat service.

KODAK MUSEUM

History of photography

Address	Kodak Ltd, Headstone Drive, Harrow, Middlesex England
Phone	(01) 427 4380, extension 76
Material	This is definitely a museum rather than a commercial agency; only serious researchers should apply, and make a personal visit. They will find that the Curator is extremely knowledgeable about all aspects of the history of photography and about photographers. Interesting exhibitions are periodically mounted at Kodak House, Holborn, London. Period — 1840 to present. Number — many thousands.
Availability	Research by researcher. Requests by writing, phone or visit. Written authorisation required in first instance. Appointment necessary, several days delay. Hours — Monday to Friday, 9.30 to 4.30.

Kodak Museum (continued)

Procedure Material not loaned, copies made.
No fees except material costs.
Photostat service.

Notes Some time should be allowed for printing and supply, as the museum staff can complete orders only as their time permits.

LAMBETH PALACE LIBRARY

Ecclesiastical, medieval and Irish history

Address Lambeth Palace, London SE1, England

Phone (01) 928 6222

Apply to The Librarian.

Credit 'Reproduced by permission of the Archbishop of Canterbury and the Trustees of Lambeth Palace Library'.

Material Unique collection of material, largely relating to ecclesiastical and medieval history, with a substantial quantity relating to Irish history. The most important items for the picture researcher are the medieval manuscripts of which colour transparencies are available in many cases.
Period – 9th century to present.
Number – 110,000.

Availability Bona fide students only, or for serious publication.
Research by researcher.
Requests in writing wherever possible, otherwise visits by appointment.
Written authorisation required in first instance.
Hours – Monday to Friday, 9.30 to 5.

Procedure Material loaned if available in transparency form, otherwise copied at researcher's request and expense.
Fees: reproduction.
List of transparencies available.

Notes Researchers from overseas are required to place a substantial deposit before borrowing material, except in special circumstances.

331

LORDS GALLERY

Posters of 19th and 20th centuries

Address	26 Wellington Road, London NW8 9SP, England
Phone	(01) 722 4444
Apply to	Philip Granville (Director) or the Secretary.
Material	Though the collection also includes some interesting fine art, its chief distinction for the purposes of this handbook is the unique collection of over 2000 posters, available in transparency form, dating from the 19th century to the present. These are accessible by subject matter, which ranges from showbiz in all its forms to such subjects as abortion, satanism and women's lib (the latter dating from the 1890s). The collection comes up to date, including all major wars and such events as the Paris riots of 1968. Period — 1866 to present. Number — more than 2000.
Availability	Research by staff or researcher. Requests by writing, phone or visit. Written authorisation required. Appointment necessary, delay 2 days. Hours — Monday to Friday, 10 to 6, weekends only by appointment.
Procedure	Material not loaned, copies made. Fees: reproduction, search. Various catalogues available, including Cheret, Patriotic items, Gay '90s, all at 0.25p each plus postage.

MEDICEA LAURENZIANA, BIBLIOTECA

Firenze and the Medici family

Address	Firenze, Italy,
Apply to	The Director.
Material	Prints and engravings and old manuscripts relating to the Medici family and to Firenze. Period — Middle Ages to the present.

332

Medicea Laurenziana, Biblioteca (continued)

Availability Written application advisable in first instance. Where a specific item is required, this
 will probably be sufficient; if not, personal research is most likely to be satisfactory.

Procedure Material not loaned, copies made.
 Photostat service available.

METEOROLOGICAL OFFICE LIBRARY

Modern photographs, Practical meteorology and weather phenomena

Address London Road, Bracknell, Berkshire, RG12 2SZ England

Phone (0344) 20242 Extension 2255

Telex 848160 and 847010

Apply to Visual Aids Officer.

Material Photographs and slides relating to meteorology and weather phenomena. Compre-
 hensive documentation of such subjects as cloud types. Expert and helpful staff.
 Period — 1879 to present.
 Number — over 10,000.

Availability For British Isles only.
 Research by staff or researcher.
 Requests by writing, phone or visit.
 Appointment necessary, 3 to 5 days delay.
 Hours — Monday to Friday, 9 to 5.

Procedure Material loaned.
 Fees: (usually only where Crown Copyright is involved): reproduction, search,
 service/handling and holding.

MICRO COLOUR

Microphotographs, specialising in histology, botany and zoology

Address	Hooper's Pool, Southwick, Trowbridge, Wiltshire, BA14 9NO England
Phone	(022 14) 3562 or 3194
Apply to	Miss Gene Cox.
Material	Microphotographs and Stereo-scan pictures, specialising in histology, botany and zoology. Expert and efficient service.
Availability	Research by staff. Requests by writing, phone or visit. Appointment necessary (please apply as far ahead as possible). Hours — Monday to Friday, 9 to 5.15.
Procedure	Material loaned. Fees: reproduction. Free catalogues available on request; please specify subject. Photostat service.

NATIONAL TRUST

Modern photographs of British historic houses and their contents, country views

Address	42 Queen Anne's Gate, London SW1, England
Phone	(01) 930 0211
Apply to	Miss Francesca Barran.
Material	Photographs of National Trust properties throughout Britain — historic houses, areas of countryside etc. Also special collections of contents of specific properties. This collection is in process of reorganisation, and will eventually be a very important source of architectural and artistic material, and already comprises extensive coverage of many important buildings.
Availability	Not for advertising etc. Research by staff. Requests by writing, phone or visit. Written authorisation required in first instance. Appointment preferred, delay 2 days. Hours — Monday to Friday, 9.30 to 5.30

National Trust (continued)

Procedure Material loaned or copied.
 Fees: reproduction, search, holding.
 No catalogue available, but list of properties serves as basis for requests. Photographs
 exist of most properties owned by the Trust.
 Commissions.

NUFFIELD COLLEGE LIBRARY

Historic material on certain sociological and economic subjects

Address The Library, Nuffield College, Oxford, OX1 1NF, England

Phone (0865) 48014 extension 38

Apply to The Librarian.

Material The material possessed by the Library is limited but valuable.
 The most important items are:—
 1 Fabian Society, portraits and group photographs.
 2 William Cobbett, drawings illustrating his correspondence.
 3 Robert Owen, pictures of New Lanark Mill.
 4 Lord Nuffield, personal photographs, cars and car factories.
 5 Parliamentary elections, printed ephemera including much material for those of
 1880 and 1885.

Availability Research by researcher.
 Requests by writing in first instance, followed by visit. Not by phone.
 Written authorisation required.
 Appointment preferred.
 Hours — Monday to Friday, 9.30 to 1 and 2 to 6. Saturdays 9.30 to 1, but closed in
 August.

Procedure Material copied, researcher must make arrangements.
 Photostat service.
 No fees, but some copyright is held elsewhere.

PEABODY MUSEUM

American maritime history, ethnology of non-European peoples, local natural history

Address 161 Essex Street, Salem, Massachusetts 01970, USA

Phone (617) 745 1876

Apply to Mark Sexton, Staff photographer.

Material Photographs, prints and engravings, original paintings and drawings, and numerous artifacts, falling under three main headings:—
1) *Maritime history* — 3000 marine paintings, 10,000 prints and drawings, ½ million marine photographs, plus ship models, instruments, tools, ships' gear, figureheads and the like (photographs of all of these are available or can be supplied to order). Special emphasis on whaling and the maritime history of the north-eastern seaboard of the USA.
2) *Ethnology* — material derived from Salem's shipping business during the 18th and 19th centuries, supplemented by more recent acquisitions. The most interesting sections are those relating to Japan and China, but there is also good material on the Pacific, Africa, Middle East, America, Arctic and SE Asia.
3) *Natural history* — although largely confined to local material, this is both extensive and well organised, including such items as a collection of 1100 water colours of mushrooms!
The Museum also administers the collections of the Bostonian Society.

Availability Research by staff or researcher.
Requests by writing, phone or visit.
Written authorisation required in first instance.
Appointment preferred, delay 1 to 3 days.
Hours — Monday to Friday, 9 to 4.30.

Procedure Material not loaned, copies made.
Fees: reproduction, sometimes search, service, handling, holding.
Museum guide and catalogues of specific exhibitions available; these are listed in their List of Publications, free on request.

PHOTOGRAPHIC SOCIETY, THE ROYAL

Historical photographs from 1830 to the present

Address	14 South Audley Street, London W1Y 5DP, England
Phone	(01) 493 3967
Apply to	Ms Gail Buckland.
Material	A big and important collection of historical photographs, particularly outstanding for the Victorian period. Period — 1830s to present. Number — 20,000.
Availability	Research by staff. Requests by writing, phone or visit. Written authorisation required. Appointment necessary. Hours — Monday to Friday, 9.15 to 5.15.
Procedure	Material copied. Fees: reproduction, handling, search (non-members only). 'We will supply copy prints of any photograph in our Collection over 50 years old. If a negative does not exist, we charge the client to have one made. If there is already a negative, we charge the client only the cost of the print. There is a 10% discount for RPS members on all orders. If a photograph is still in copyright we will not supply a print unless we have written permission from the copyright holder.'
Notes	The Collection is indexed by photographer's name, and requests should be by name wherever possible. Subject oriented enquiries are possible, but involve search and consequently a search fee.

PHOTOGRAPHIE, SOCIETE FRANCAISE DE: Historical department

History of photography

Address	9 rue Montalembert 75007 Paris, France
Apply to	M Marillier or M Boucher.
Material	A unique collection of material relating to the history of photography, including the work of such pioneers as Niepce, Daguerre, Poitevin, Bayard, Talbot, Ducos du Hauron etc. Period — 1827 to present. Number — 100,000.
Availability	Research by staff. Requests preferably by writing. Written authorisation required in first instance. Appointment necessary.
Procedure	Material loaned for exhibitions, otherwise copied. Fees: reproduction, search, service/handling, holding. Photostat service.

PHOTOGRAPHY, INTERNATIONAL MUSEUM OF

History of photography

Address	George Eastman House, 900 East Avenue, Rochester, New York 14607, USA
Phone	(716) 271 3361
Apply to	Print service.
Material	Photographs, selected for their interest *as* photographs rather than for their subject-matter. Catalogued by photographer. Number — 100,000.
Availability	Research by researcher. Requests by writing or visit, not phone. Written authorisation required. Appointment preferred, delay 5 to 10 days. Hours — Tuesday to Friday, 10 to 12, 1.30 to 5.

Procedure	Material copied; reproduction forms sent on request. Fees: reproduction, handling. $5.00 charge for making negative if none already made.

POSTAL MUSEUM, NATIONAL

British and Commonwealth postal services from 1680

Address	King Edward Building, King Edward Street, London EC1A 1LP, England
Phone	(01) 432 3851
Apply to	The Curator.
Material	Material related to the history of postal services in Britain and the British Commonwealth — stamps, preparatory material for stamps such as artist's drawings, proofs, essays etc, together with archival material such as correspondence. Period — 1680 to present. Number — over 300,000.
Availability	Research by staff or researcher. Requests by writing, phone or visit. Appointment necessary, minimum 2 days delay. Hours — Monday to Friday, 10 to 4.30.
Procedure	Material copied. Fees — only for print or transparency; no reproduction fee Photostat service

POST OFFICE RECORDS

Postal history 1700 to 1940

Address	Room Sub-ground 28, Postal Headquarters, St Martins-le-Grand, London EC1A 1HQ, England
Phone	(01) 432 4521
Material	Photographs, prints and engravings, original paintings and drawings relating to post office history and the development of postal and telecommunications services. Period — c.1700 to 1940.

Post Office Records (continued)

Availability	Research by researcher. Requests by writing, phone or visit. Hours — Monday to Friday, 9 to 4.30.
Procedure	Material copied. Fees: search, no reproduction. Photostat service.

PSYCHICAL RESEARCH, SOCIETY FOR

Psychical research and related topics

Address	1 Adam and Eve Mews, London W8 6UQ, England
Phone	(01) 937 8984
Apply to	The Secretary (Miss E O'Keeffe).
Material	The SPR is the foremost institution of its kind in the world and has pioneered the scientific study of this field. Although the society has no picture library as such, its book library includes such items as albums containing photographs of leading personalities associated with psychical research, and material relating to the activities of the society, its investigations etc. In addition, the book library has many rare books which contain unusual visual material. Some of this is confidential and restricted to members of the Society, but the Secretary will willingly give guidance to researchers.
Availability	Serious research only. Requests preferably by visit and by appointment. Hours — Monday to Friday, 10 to 5.
Procedure	Material not loaned, copies made. Fees: by arrangement.

RADIO TELEFIS EIREANN Illustrations Collection

Material collected for television documentary and other uses.

Address	Donnybrook, Dublin 4, Eire
Phone	(0001) 693111
Telex	5268
Apply	Film and Illustrations Librarian.
Material	Photographs, prints and engravings of general subject matter, including history. The collection is primarily for the use of RTE news, programme and design staff. Since much of it has been obtained from other collections, it is not always possible to provide reproductions for non-RTE researchers. However, the staff are most helpful and can prove valuable in their expertise on matters relating to Irish subjects. Number — 300,000.
Availability	Research by staff or researcher. Application by writing, phone or visit. Appointments preferred. Written authorisation required. Hours: weekdays, 9.30 to 5.30.
Procedure	Some material available on loan, no photographic service. Photostat service. Fees: reproduction of RTE copyright material, service charge.

REFERENCE PICTURES inc

Pictorial references of every kind

Address	100 Fifth Avenue, New York City, NY 10011, USA
Phone	242 9535
Material	For reference only, not reproduction (unless original is in the public domain where copyright is not involved). This unique collection comprises tear-sheets from periodicals and books on every subject, for artists, designers etc. Period — antiquity to future. Number — many million.

Reference Pictures Inc (continued)

Availability For professional use only.
Research by staff.
Requests by writing, phone or visit.
Appointment preferred.
Hours — Monday to Friday, 9 to 5.

Procedure Material loaned.
Fee: service fee of S7.00 (1973 rate) charged for up to 15 pictures on any one subject. They bill after return of pictures.

Notes Files are kept continually up-to-date on people, places and things.

SEAPHOT

Underwater photographs, from Britain and elsewhere

Address Little Wildings, South Chailey, Lewes, Sussex, England

Phone (079) 153 465

Material Underwater photos, and surface photos of marine interest. Primarily British, but also America, Europe and Australia.
Official agency of the British Society of Underwater Photographers, representing the work of 32 of them.
Period — 1950 to present.
Number — over 3000.

Availability Research by staff or researcher.
Requests by writing, phone or visit.
Appointment necessary.
Hours — any time. Ansaphone service.

Procedure Material loaned or copied.
Fees: reproduction, sometimes search, holding after 30 days.
Commissions.

SPELLMAN, Doreen & Sidney

19th century music covers

Address	3 Oakeshott Avenue, London N6 6NT, England
Phone	(01) 340 7130
Material	The Spellmans' collection is of interest not only musically, but also artistically — for the high quality of the lithographs used to decorate the covers — and as documentation, providing unique colour illustrations of daily life, personalities and events of the period, and offering an interesting alternative to 'straight' documentation. Period — 1810 to 1900. Number — over 5000.
Availability	Research by staff or researcher. Requests preferably by writing in the first place; visits may then be made by appointment, allow 7 days delay. Hours — evenings and weekends only.
Procedure	Material loaned. Fees: reproduction, service, holding.

STURMER, Prof Dr Wilhelm

Photographs of Fossils

Address	Burgberstrasse 20, 852 Erlangen, West Germany
Phone	09131 22188
Material	Several thousand X-ray exposures of fossils, Silurian, Devonian, Jurassic.
Availability	Research by staff. Requests by writing. Visits by appointment only. Two weeks delay for appointments.
Procedure	Material loaned. Fees: reproduction.

SUTCLIFFE GALLERY, WHITBY

Sutcliffe's photographs of scenes, daily life etc, late 19th century
Also collection relating to Captain Cook.

Address	1 Flowergate, Whitby, Yorkshire, YO21 3BA, England
Phone	Whitby 2239
Apply to	Bill Eglon Shaw, Gallery Director.
Material	Photographs of Whitby and district, its people and daily life, taken by Frank Meadow Sutcliffe (1853–1951) chiefly dating from the period 1875 to 1890. The quality and interest are outstanding, and quite transcend their local interest. Number – 1700. The Gallery also houses a collection of engravings relating to Captain Cook's voyages, dating from 1785.
Availability	Research by staff or researcher. Requests by writing or phone, but personal visit preferred. Written authorisation required in first instance. Appointment preferred. Hours – Monday to Saturday (except Wednesday), 9 to 5.
Procedure	Some material loaned, others copied. Fees: reproduction, sometimes search. Catalogue is planned.

TEXAS UNIVERSITY, HUMANITIES RESEARCH CENTER
(including Gernsheim & Hoblitzelle Theatre Arts Collections)

Historic photographs, theatre arts, visual documentation of all aspects of literature etc, 18th century to present

Address	Humanities Research Center, The University of Texas at Austin, Austin, Texas 78712, USA
Phone	(512) 471 1833
Apply to	F W Roberts, Director.
Material	This unique collection comprises a definitive source of visual documentation for study of the humanities. The most important fields covered are:– 1 English and American literary portraits and book illustrations.

2 The Gernsheim collection of historic photographs, which probably ranks as the world's finest photographic collection, starting with what is probably the world's first photograph.
3 The Hoblitzelle Theatre Arts Library, containing more than 25,000 photographs, prints and engravings, original paintings and drawings covering all aspects of theatre arts — theatre, circus, magic, movie, design, marionettes, costume etc, and including many special collections relating to or donated by individuals associated with the theatre arts.

Availability Research by staff or researcher.
Requests by writing, phone or visit.
Written authorisation required in exceptional cases.
Appointment preferred, delay 2 or 3 days (Hoblitzelle 7)
Hours — Monday to Friday, 9 to 5, Saturday, 9 to 12.
(Hoblitzelle) Monday to Friday, 8 to 12, 1 to 5, Saturday 9 to 12.

Procedure Material not loaned, copies made.
Fees: reproduction.
Photostat service.
Catalogues of specific exhibitions available. Also a useful booklet *Twentieth Century Research Materials,* by Warren Roberts, which provides a helpful description and introduction to the collections.

TSIGANES, Les Etudes

Photographs of gypsies, their life and culture

Address 2 rue d'Hautpoul, 75019 Paris, France

Phone 607 99 12 (afternoon office hours only)

Material Photographs of gypsies, their life and culture. Covers all aspects of their life — portraits, costume, feeding, nomadism, transport, education, crafts, leisure activities, social organisation, ceremonies and beliefs, magic and medicine, relations with the outside world. Serious and dedicated.

Availability Strictly speaking, this is an association catering for its members only, but some of its material is available for public reproduction in responsible publications.
Research by staff.
Requests by writing, phone or visit.
Appointment necessary.
Hours — Monday to Friday, 2.30 to 6.

Procedure Material copied, occasionally loaned.
In view of the special nature of this collection, procedure, fees etc will inevitably depend on circumstances.

UNITED SOCIETY FOR THE PROPAGATION OF THE GOSPEL

Missionary activities, past and present

Address	15 Tufton Street, London SW1P 3QQ, England
Phone	(01) 222 4222
Apply to	Photographic Bureau.
Material	Photographs, prints and engravings, original paintings and drawings relating to missionary activities throughout the world. Also includes scenes of daily life in regions which come within the scope of the missionary work. Period — 1701 to present.
Availability	Research by staff. Requests by writing, phone or visit. Written authorisation preferred in first instance. Appointment preferred. Hours — Monday to Friday, 9.30 to 5.
Procedure	Material loaned. Fees: reproduction.

USSR, SOCIETY FOR CULTURAL RELATIONS WITH

Historical material on Russian culture

Address	320 Brixton Road, London SW9, England
Phone	(01) 274 2282
Apply to	Miss Timbey, Mrs Maria Johnson.
Material	Photographs, prints and engravings, a few original paintings and drawings, relating to various aspects of Russian culture. Photos mostly black and white. Collection includes reproductions of paintings, drawings etc. Special collections of key figures such as Tolstoi, Chekhov, Lermontov, Gogol, Pushkin, Rimski-Korsakov, Glinka etc. Friendly and helpful staff.
Availability	Research by staff. Requests by writing, phone or visit. Written authorisation required in first instance. Appointment preferred, delay 2 days. Hours — Monday to Friday, except Wednesday, 10.30 to 5.

USSR, Society for Cultural Relations with (continued)

Procedure Material usually loaned, sometimes copied.
 Fees: reproduction, sometimes search and holding.
 Photostat service.

VG FAMILY PIX

Modern photographs of children and family situations

Address 15/16 Gough Square, Fleet Street, London EC4, England

Phone (01) 353 4964

Material Modern photographs of babies, children and family situations.

Availability Research by staff or researcher.
 Requests by writing, phone or visit.
 Appointment preferred.
 Hours — Monday to Friday, 9.30 to 6.

Procedure Material loaned or copied.
 Fees: reproduction, search, service/handling, holding.
 Catalogue available at £5.
 Commissions.

ZIONIST ARCHIVES, THE CENTRAL

Zionism and modern Israel

Address Post Office Box 92, Jerusalem 91000 (Ibn Gvirol Street no 1) Israel

Phone 39261

Material Photographs and a few other items relating to Zionism and to modern Israel.
 Period — about 1890 to the present.
 Number — 300,000.

Availability Research by researcher.
 Requests by writing or visit, not phone.
 Written authorisation required in first instance.
 Appointment preferred.
 Hours — Monday to Thursday 8 to 2.45, Friday 8 to 12.45.

Procedure Material not loaned, copies made
 Photostat service.

ADDENDA

SAINT BRIDE PRINTING LIBRARY

History of printing and related activities

Address	St Bride Institute, Bride Lane, Fleet Street, London EC4Y 8EE, England
Phone	(01) 353 4660
Material	This is a public reference library of books and periodicals on the practice, design and history of printing and such related trades as papermaking, typefounding and bookbinding, publishing, bookselling and newspapers. It consists of over 30,000 books and pamphlets and over 700 periodicals. Although the collection is primarily a practical one, it does include examples of the work of many of the major printers of all periods. There is a growing collection of printing machinery and other items of historical interest relating to printing, typefounding and illustration processes, some of which are on permanent display. Special collections include 18th- and 19th-century broadsheets, 19th-century wood-blocks, portraits of printers and booksellers, and typefounders' specimens. There is a photographic collection of 2300 negatives, mainly of items in the Library, but including a collection of photographs of William Morris and his circle. There is a slide loan collection of 2200 35mm slides (colour and black and white).
Availability	Research by staff or researcher. Requests by writing, phone or visit. Hours — Monday to Friday, 9.30 to 5.30.
Procedure	Some material loaned, usually copied. Fees: reproduction. Photostat service. Catalogue of slide loan collection £0.25.

SOURCES NOT LISTED

Many picture sources exist which are not listed in this handbook. Some are Museums and Galleries handling only pictures of material in their own collections; there are too many of these to list here. Others are too small, or too limited in scope to justify inclusion here. Yet others failed to respond to our inquiries, and we can give no useful information. (In a few cases we felt that sources were so important that we should include them even though they did not reply to our questionnaire; these are printed in italic type.

There are also a few others whose names are well-known, but who for one reason or another cannot be included:

HISTORIA PHOTO (Bad Sachsen, Germany) — Present proprietors are giving up the collection, future plans uncertain.

TOURING CLUB DE FRANCE (Paris) — Collection being transferred to the Bibliotheque Nationale.

UNITED STATES EMBASSY LIBRARY (London) — Picture Library closed.

WARBURG INSTITUTE (London) — Pictures not available for reproduction to the general public.

WELLCOME INSTITUTE OF THE HISTORY OF MEDICINE (London) Future policy for the supply of illustrations is at present (August 1973) under consideration.

PART THREE

INDEXES

INDEX 1: SUBJECTS DISCUSSED IN PART ONE

INDEX 2: GEOGRAPHICAL

The references are to sources which have specifically indicated that they hold material on that country. However, the sources who offer 'worldwide coverage' may hold material equally good or better.

Most of these sources offer only modern photographic material. However, sources between pages 45 and 100 may offer historical material such as paintings and prints.

If a country is not listed here, it simply means that no source specifically offers material on it. In which case you must go to a worldwide source, or hopefully try a source which holds material on a neighbouring country. This applies particularly in the case of newly created states or those which have recently changed their names: in respect of Africa and South-East Asia, library catalogues can hardly avoid being constantly out of date.

Note that this list includes not only individual countries, but also geographical regions such as Latin America or the West Indies.

INDEX 3: SPECIALIST SUBJECTS

This index lists subjects for which a specialist source exists, either as an independent collection or as a special collection within a general source. (For instance, Leicester Public Library has a special collection of photographs of rail construction.)

If a subject is not listed here, we do not know of a specialist source, and you should refer to a general one, historical or modern as appropriate. Unless otherwise indicated, most sources in section G2 will cover every aspect of history, including specialist themes from astronomy to zoos, though they may not cover them in great depth. Modern sources in G3 are less comprehensive, but on the other hand there are more of them to try!

Acting, see Theatre
Advertising, see Ephemera, Posters, G2 for
 historical
Aerial views, 115, 157, 184, 221, and many in S2
Agriculture, see Farming
Alchemy, see Science
Animals, see Natural History
Anthropology, S2; also 72, 76, 79, 128; see also
 Ethnography
Archaeology, many sources in S3; also 80, 81, 89,
 92, 157, 185, 189, 200, 211, 215, 224, 229,
 232, 233, Northampton Library, 211
Archaeology, industrial, 299, 323; also G2 and S3
Architecture, S3
 general, 92, 197, 334, Northampton Library,
 211
 specific places and categories, 72, 194, 196,
 200, 284
Art, S3
 general, 47, 57, 62, 79, 85, 86, 89, 93, 119,
 135, 189, 346
 specialist categories, 46, 63, 72, 73, 81, 129,
 132, 218, 312, 329, 332, 334, 343,
 Newcastle-on-Tyne Library, 210
Athletics, see Sport
Atomic energy, 288; also S1, S5
Automobiles, see Transport
Aviaries, see Natural history
Aviation, see Transport

Babies, see Children
Ballet, see Dance
Balloons, see Transport
Beach scenes, see Tourism and S2
Beauty, see Glamour
Bible and biblical scenes, 46, 47, 67, 99, 114, 240
Bicycles, see Transport, Sport
Biology, see Natural history
Birds, see Natural history

Boating, see Sport, Transport
Books, pictures of, 47, 61, 79, 139, 344
Botany, see Natural history
Boxing, see Sport
Broadcasting, see Radio

Canals, see Transport
Cannibalism, see Anthropology
Caricatures, see Cartoons, Art
Cartoons, 72, 83, 89, 97; also G2, many Art
 sources, newspaper collections
Cave paintings, see Archaeology, Art
Ceramics, see Art
Children, 83, 105, 112, 117, 121, 199, 324, 347;
 also Archaeology, Ethnography, S2
 generally
Cinema, 75, 95, 96, 151, 165, 306, 307, 308,
 310, 311, 312, 314, 317, 344
Circus, 75, 131, 309, 344
Climbing, 101, 189; many in G2, G3, S1 and S2
Clocks and watches, 195; some in S5
Communism, see History, News, Politics
Conservation, see Environment
Cooking, see Food and drink
Costume, 57, 61, 325; also G2 and S2
Country life, see Farming, Rural life, Social
 studies, Natural history
Cowboys, 88; American sources in S2
Crafts, 116, 129, 196, 223, 225, 232, 233
Crime, 88, 122; also History, News
Customs, 128, 132, 189, 223, 224, 225, 232,
 233, 250; also Anthropology, Ethnography,
 Religion

Dance, 75, 87, 189, 305, 309, 314, 315, 319
Design, 326; also Art sources
Domestic animals, see Farming, Natural history
Dress, see Costume
Drug-taking, 190; also G2, G3, S1

Physics, see Science and Technology
Pin-ups, see Glamour
Places, see S2; also G1 and G2 for historical
Plants, see Natural history
Plays, see Theatre
Politics, 91, 116, 119, 125, 133, 135, 139, 285,
 335; also G1, G2, G3, S1
Political cartoons, see Cartoons, Politics,
 Ephemera
Pollution, see Environment
Portraits, see Art, People
Postal, 326, 339
Postcards, 56, 64, 91, 130, 216; also Ephemera
Posters, 64, 75, 89, 326, 332; also Art, Ephemera
Pottery, see Art, Crafts
Psychical research, 340
Puppets, 75, 131, 344

Quakers, 327; also History, Religion

Racing, animals, see History, News
 vehicles, see Sport, Transport
Radio, 75, 305; also S5
Railways, see Transport
Regalia, 53
Religion, 67, 68, 117, 216, 327, 329, 331, 346;
 also general sources and S2
Reptiles, see Natural history
Rural life, 327; and general sources

Sailing, see Sport, Transport
Schools, see Education
Science and Technology, S5; also 61, 83, 139,
 189, 229, 252, 325
Sea, see Geology, Transport, S2
Settlers, see Emigration
Sex, 114; also Glamour, Costume
Shells, see Natural history
Ships, see Transport, Science
Slavery, 72, 73, 75, 83, 88, 97, 312
Slums, see Architecture, Environment, Social
 studies

Social studies, 83, 89, 92, 95, 100, 109, 113,
 114, 150, 190, 199, 214, 284, 312, 344
Space travel, 106, 153; also S1
Sport, general, S6; and 104, 122, 125, 133,
 151, 217, 316
 boxing, 85
 horse racing, 278
 yachting, 322
Stamps, see Postal
Suffragettes, see Women's rights

Theatre and theatre arts, 57, 64, 65, 75, 87, 93,
 99, 151, 285, 305, 306, 308, 309, 313,
 315, 317, 318, 319, 344
Timber industry, 76
Tourism, 187, 204, 205; also G3 and S2
Toys, 324, 326
Transport, S7 and all general sources; also
 road, 122, 130, 214, 284, 291, 301, 303, 335
 rail, 69, 72, 214, 299, 300, 301, 303,
 Gillingham Library, 208
 air, 84, 130, 187, 291, 299
 water, 120, 264, 301, 302, 322, 336
Travel, see Exploration, Tourism, Transport; also
 all general sources
Trees, see Natural history

Underwater scenes, 224, 230, 281, 342; also S2
 and Natural history sources

Vegetables, see Natural history

Weapons, see Military
Wine, 191, 219; also Food and drink and general
 sources
Witchcraft, see Occult; and general historical
 sources
Women's rights, 55, 91, 102; also G2 and S1

Yachting, see Sport, Transport and general

Zionism, 347; also History, News
Zoos and zoology, see Natural history

359

INDEX 4: ALPHABETICAL LIST OF SOURCES